picasso birth of a genius

picasso

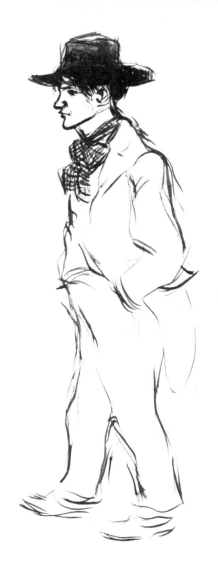

birth of a genius

Juan-Eduardo Cirlot

Foreword by Juan Ainaud de Lasarte
Director of the Barcelona Art Museums

PRAEGER PUBLISHERS
New York · Washington

In memory of José Ruiz Blasco and Maria Picasso López

Acknowledgments

The author wishes to express his gratitude to those without whose help he could never have undertaken the labour of seeking out and reconstructing information after more than half a century—or at least would never have succeeded in it. First of all thanks are due to the artist himself, Pablo Picasso, who consented to examine the photographs of his early works and attempt to remember their dates, and the people and places shown in them. Then to his wife Jacqueline, who supported the idea of the donation with such interest. The author also thanks the Picasso Museum for the facilities extended to him, and would like specifically to mention the Director of the Barcelona Art Museums, Don Juan Ainaud de Lasarte, and the curator of the Museum, Señora Rosa Maria Subirana de Aguirre. Thanks also to Señorita Maria Rosa Padrós, assistant at the Barcelona Cultural Institutes, for her valuable services.

BOOKS THAT MATTER

Published in the United States of America in 1972
by Praeger Publishers, Inc., 111 Fourth Avenue,
New York, N.Y. 10003

Designed by Harold Bartram
and produced by Paul Elek Ltd, London

Published in Spain with the title 'El Nacimiento de un Genio'

© 1972 by Editorial Gustavo Gili, S.A.
Translation © 1972 by Paul Elek Ltd.

Library of Congress Catalog Card Number: 72-186477

Printed in The Netherlands.

Title page Self-portrait from a sheet of pen
sketches. Barcelona, 1899–1900.

Contents

Foreword

In February 1970 Picasso donated to the city of Barcelona, in memory of his faithful friend Jaime Sabartés, a collection of works that had been kept until then in the artist's family home, in the care of his mother and sister, and later of his sister's children. The collection is an essential part of his work, indeed of his life.

The laborious task of arranging and cataloguing was carried out with enthusiasm in the Barcelona museums, and the donation was shown to the public for the first time in December of the same year in an extension of the existing Picasso Museum. The artist had already suggested, before the Museum catalogues were produced and thus quite independently of them, that this first collection of his early works should be introduced by means of a comprehensive study. The Barcelona publisher Gustavo Gili, a friend of our museums and an enthusiastic admirer of Picasso, showed interest in the project from the start, and made it possible to bring out this sumptuous volume. The text was entrusted to the distinguished art historian Juan-Eduardo Cirlot, whose researches into Picasso's work, detailed in this book, render superfluous any remarks I might make on the subject. However, I feel it is not out of place to stress the importance we should attach, from every point of view, to the collection of works which Picasso has so generously given to us.

In the first place it is one of the most complete records in the world today of the first stages in the development of an artist—in quantity as well as in quality. Sometimes we have by chance a relatively large number of specimens of the work of someone whose name is likely soon to be forgotten, and sometimes all we have left of someone really important is a few scattered relics. Here, on the other hand, we have hundreds of examples, easily accessible to us in one single public place; and we are more fortunate still in that they are the work of an artist so extraordinarily gifted.

Any method of classification is perfectly legitimate so long as we realize its limitations. Cirlot prefers to determine the phases of the artist's career by the way he worked rather than by where he was. Others would take the changes in Picasso's domestic situation as a basis for fixing the different stages of his life. I think both these methods are possible, although they can give us only a partial view of the central figure, Picasso himself. Nevertheless I believe in spite of everything that geographical location is important because it determines the artist's environment, although obviously it can only count to the extent that any external factor does; that is to say we can see it as limiting or stimulating, but it cannot give us any real insight into the inner experiences of an artist.

We can see Picasso in all his works. We can see how the world impinged upon him, and, especially in the later stages, we can see his influence upon his surroundings.

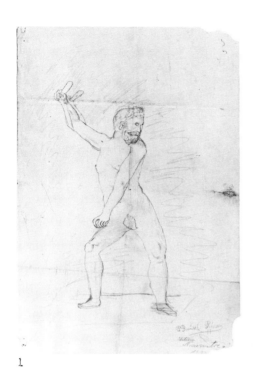

1. Hercules. Malaga, XI-1890

Later, in conversation with Hélène Parmelin, Picasso said that he never did childish drawings, mentioning in support of this his pictures of Hercules with his club, copied from a plaster statue in his family home. One version **1** of it, dated 1890, is included in the donation and confirms Picasso's statement. But we must not forget that drawings of a different nature exist side by side with it. These are lively sketches of soldiers and crowd scenes, which form **12** a link between childish drawing and caricature. We can include in this second category—and Cirlot stresses the large number of different threads running through Picasso's enormous output in all his phases—the scenes sketched on loose sheets, and most of the illustrations in the manuscript magazine he wrote in Corunna, calling it 'Asul y blanco', which was a faithful **7** transcription of his Andalusian accent. In Barcelona and in Paris he produced **381** different types of caricature. He often adopted the strip cartoon technique of **733** the Catalan *auques*, called *aleluyas* in Castilian, similar to some kinds of French cartoon and the forerunner of present-day comics. Only rarely did he express himself in mock-childish form, and then in a calculated way. An example is the caricature of a South African Boer sketched on a proof of **820** the menu of the restaurant Els Quatre Gats in Barcelona.

But although these caricatures serve to emphasize Picasso's irrepressible **825** sense of humour, in my view they are not of prime importance. The artist's statement that he never drew childishly may have deeper roots in the precocious maturity of his mind and way of thought. Apart from questions of skill or lack of it, I think this maturity is very obvious in the figures and scenes he drew in Corunna, and even more so in his later school work. It continued to develop during his first years in Barcelona as it did in Málaga, Madrid, Horta de Ebro and Paris.

Our knowledge of Picasso's deeply intuitive nature is confirmed and richly amplified by the scraps of his correspondence that have been published. With the help of such few precious documents as there are, and of the reproductions of early work in the Zervos catalogues, the great collection in Barcelona makes it possible for us to follow with assurance Picasso's youthful career, which, complex though it may be, now becomes fairly clear.

Three main influences can be traced through it: his home environment, his early school training (and then the 'exemplars' of other artists' work which took its place) and what we may call *free* or non-academic art. Obviously the third factor did not exist in Corunna, or at any rate could not have been important; this is one of the radical differences between his work there and in Barcelona.

In Corunna the first influence must have been closely linked with the second through his father and teacher Don José Ruiz Blasco, who gave him pigeons and bulls as subjects, offered him plaster models to copy, and taught him watercolour, pen-drawing and finally oil-painting on canvas or small wood panels. This was all that the academic world at the end of the 19th century had gleaned from the theory and practice of the century before. But we must not forget the importance of Picasso's own personality. His genius was already manifest in Corunna in such works as *The girl with bare feet* and *The beggar with a tin*, still in the artist's possession.

Picasso's progress at that time in what we may call his *craft* was certainly extraordinary. But we know also that he became progressively more dissatisfied with the kind of career which aimed at producing large-scale pictures for official exhibitions, with genre or social themes. The supreme examples of these in his own work are *The First Communion* of 1896 and

Science and Charity of the following year, both in the donation, which should have set him on the road to academic and official success, strewn with medals and awards. For Picasso this road came to a dead end. His attack of scarlet fever in Madrid in 1898 broke that thread almost without his realizing it. The following months spent in Horta de Ebro and Barcelona were interludes, albeit productive ones, leading up to the moment when the problem of choice between Munich and Paris, between reason and illusion (expressed in a letter from Madrid to a friend in Barcelona), was solved by going to Paris. However, the choice of illusion does not imply that the demands of reason were forgotten. This shows itself in Picasso's keen and conscious interest in a fundamental classicism as compared with the decadent and decayed academic formulas taught at the end of the 19th century.

Living by turns in Barcelona and Paris, Picasso was intensely involved in the Modernist movement represented by the circle at Els Quatre Gats. Though he was attracted on the one hand by classical and Mediterranean art, he was moved on the other by a new form of social concern, reflecting both the conventional attitudes shown in *Science and Charity* and the real or theoretical anarchism of certain Modernists. The difficulty—and sometimes impossibility—of reconciling such conflicting influences is shown to the full in the drawings of the Blue Period, some of which show the sharp opposition between uplifting speeches and the reality of old people, women and children trapped in their miserable existence.

During the period not directly represented here, the great adventure of Cubism in Paris (which was, however, geographically linked with Catalonia as Picasso did much of his work in Barcelona, Horta, Cadaqués and Céret) opened new roads and new experiences to the artist. When he returned to Barcelona for his long visit in 1917—preceded by a shorter one a few months earlier—all the preoccupations of his earlier phases were raised once more: Cubism and colour pointillism and classicism, expressionism and decorative art. This is the real interest of the last group of canvases of this period included in the donation. They are the symbol of a world that was in a constant state of flux, both political and artistic, veering between the nostalgic elegance of the *Ballets Russes* and the terrifying reality of the last stages of World War I.

The city of Barcelona, which the artist always loved, was itself living through a period of restlessness and insecurity which could be seen in every field from the intellectual avant-garde to social revolution. The interaction between Picasso and the world he lived in gave him a twofold role, as chronicler and prophet. And the simplest explanation of all this is perhaps the hardest for some of us to accept—that geniuses exist, though obviously they are few, and that Picasso is one of them.

Don Juan Ainaud de Lasarte

Introduction

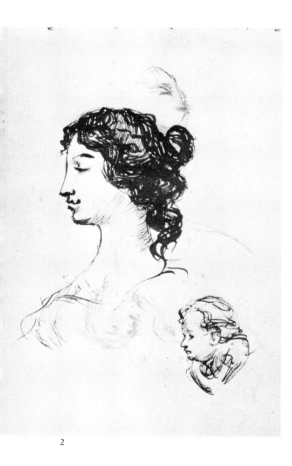

2

2. Female profile and other sketches.
Album 3. Barcelona, 1895.

The publishers and myself felt it was only right that this book should be dedicated to Picasso's parents, for it deals with the work of his childhood and early youth. Without their loving interest in everything—even the most apparently insignificant sketch—produced by their son, and their unshakeable belief that he was to be the greatest artist of the twentieth century, all this wealth of paintings, drawings, sketch-books, and even school-books with drawings in the margins, would have been irretrievably lost to art historians and to humanity. We are also grateful to his sister Lola for the same reason.

Recently Picasso, who still kept all this early work at the home of his relatives in Barcelona, donated it to the Picasso Museum in our city. The donation consists of 213 oil-paintings on canvas, board and other materials, 681 drawings, pastels and watercolours on paper, seventeen sketch-books and albums, four books with marginal sketches, one etching and various other objects. Fourteen canvases or paintings on wood, and 504 of the drawings, have another work on the back, and we still have to add the 826 pages of drawings in the sketch-books. So Picasso's generous gift comprises more than 2,200 works, with dimensions varying from less than 10 × 10cm. to 197 × 249.5cm.

These works are extremely varied. This is due mainly to the artist's development; they cover a long period, stretching from 1890, when he was nine years of age, tó 1904, when he was twenty-three. There is also an important group consisting of work done in Barcelona during the years 1916 and 1917. We can consider as childhood works only those few which were done between 1890 and 1892, and even they are the work of a most unusual child. The works which follow show how Picasso was forging ahead during the ten years between 1893 and 1903. He passed at incredible speed through the whole evolution of painting from the academic style of the 19th century to the vanguard of the new movements which began the 20th.

The donation reveals a great variety not only of styles and techniques, but also of themes and ideas. It includes academy figures from the years 1894 to 1898, an incredible quantity of free sketches, drawings from life (in the early years often of the artist's own family and friends), finished drawings, sketches for paintings or illustrations. In painting there are small sketches on board, genre paintings, landscapes, seascapes, human and animal figures, portraits, including self-portraits, and caricatures, though the latter are more often found in the form of drawings. Different sketches, jostling each other on the page at random or with a sureness born of instinct, appear chaotic but make fascinating patterns, full of the vitality which has always distinguished the work of Picasso. We are watching a gradual movement forwards, which is never a simple one. From the very beginning Picasso followed various parallel—or divergent—paths rather than one single road. Even while obeying

134

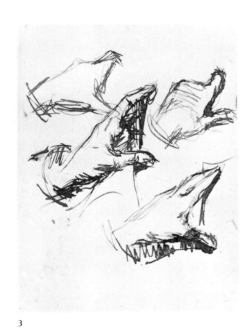

3

academic rules, he gave himself complete freedom in other works; while his work was leading up towards Modernism he was already pressing forward, within this international movement, towards the great revolution which was to mark for him the beginning of the road into the future.

But in everything he does Picasso is a realist, and therefore steeped in what has been called Mediterranean materialism—if we understand by materialism a conviction of the reality of matter, without any attempt to dominate it by real or specious spiritual values. Form is the painter's own ground, and Picasso does more than transcend it; he seeks to give it an infinite variety, even to bend it to his will. Rapid development, the simultaneous pursuit of different aims, variety, freedom of line—all these are characteristic of this early period of Picasso's work. This we are now able to explore, thanks to his parents' interest and devotion, and to the fact that Picasso too loved his own creations and wished them to be preserved and exhibited in the city where he spent his formative years (1895–1901), even though he did not stay there all his life.

We shall understand better how fortunate we are to be able to study this initial period if we compare two other cases in the history of Spanish art. These, it is true, belong to the past, but serve nevertheless to show the huge gaps that so often exist in the earlier history of an artist. In the case of Francisco Goya we have nothing between the Fuentetodos reliquary, painted about 1762, when he was sixteen and *The Virgin of the Pillar*, painted in 1768 or 1769, six or seven years later. In that of Zurbarán, a picture painted in 1616, when he was eighteen, is followed by a gap of ten years about which we know absolutely nothing. In instances like these it is more difficult to follow the stylistic development of a painter than when we have a definite point of departure. We are grateful to Picasso for his wish to give us as much help as possible.

It was, of course, no easy task to study this vast quantity of early work. Only about fifty works were dated, and we have been able to deduce in various ways the date of approximately fifty more. We put a few problems to the painter himself, who was able to solve them with some considerable degree of certainty, but however prodigious his visual memory, he can scarcely be expected to remember, after seventy years, the exact moment when a picture was painted. However, the few dated pictures were sufficient for us to establish some definite landmarks. We were then able to note similarities between dated and undated paintings or drawings, and so place undated pictures in reasonable order between the dated ones. We succeeded thus in cataloguing the essential part of the donation, which is reproduced in this book. Where we have not been able to give an exact date, we have given an approximate one preceded by c.[*irca*], or indicated a period of two or three years during which the work could have been done, judging by the style in comparison with others of a similar date, and sometimes taking into account also the subject or the place where it was executed.

The sketch-books are all dated, more or less accurately, and gave us a starting-point for dating a large number of drawings. But we have to take into account Picasso's prodigious genius, which, besides following several trends at once, leaps forward or backward at will. Moreover, the great majority of the drawings in the sketch-books are life studies and sketches which, while they do not lack intellectual freedom, do not have it as their main purpose, and so are always more conservative than other works of the same period. We may perhaps except a few expressionist drawings of

3. Studies of hands. Barcelona, 1895–7.

4. Study for an illustration for 'El clam de les verges'. Barcelona, 1900.

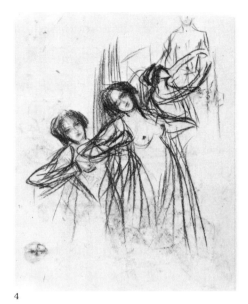

4

chimneys in a Madrid sketch-book (1897–1898).

We drew up separate chronological tables for the paintings and the drawings, and then had only to consider their development, in a continuous or interrupted line, from one point in time to the next. Our aim was to give a broad description of the donation, with information on the painter's life and artistic contacts, and a general study of the various phases of his work, rather than a prolonged and detailed analysis; so we selected. We have tried to explain the ideas and the technique underlying every phase, mentioning its most significant paintings and groups of drawings. We believe that in this way the reader will be able to follow accurately the long road travelled by the classic Picasso, and will realize that from the age of nine, or perhaps even earlier, he spared no effort to attain supremacy over line, space, colour and form.

During the period considered in this book, 1890 to 1903 (there are only a couple of works dating from 1904—plus a group of works done in the years 1916 and 1917), Picasso was living in different places, mainly in Málaga, Corunna and Barcelona, with long stays in Madrid and in the village of Horta de Ebro in Tarragona, and eventually short visits to Paris. But even though each new place implies a new artistic environment and new contacts, rather than influences, the book is not divided according to where Picasso was living, but according to the phases of his development as we see them. It seemed inappropriate to leave such a wide gap as exists between 1904 and 1916, so we have inserted a brief summary of Picasso's development in those years, when he was already living in Paris. It is important to remember that the purpose of this book is to study the Picasso *donation*, and that it excludes all works other than those contained in the donation (which are for the most part unpublished; we believe that not more than 130 of them are known or have been reproduced). We do not include such work done by the painter in Barcelona as is already known—all of it produced around 1900. There is, moreover, no doubt that some even earlier work, such as the pictures in the Málaga museum and a few others, have become known—to a very limited extent—to art critics and the public.

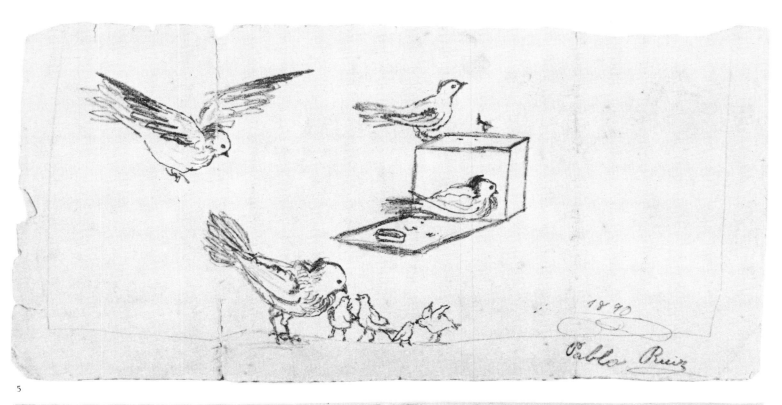

5

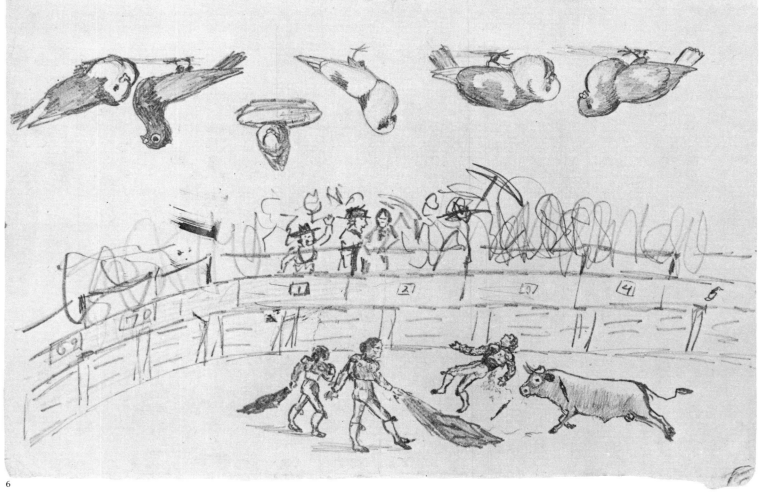

6

Beginnings

Pablo Ruiz Picasso was born on October 25, 1881, in Málaga, at 15 Plaza de la Merced, now numbered 36. He was the son of José Ruiz Blasco (1841–1913) and Maria Picasso López (1855–1939). The Ruiz family came from Guadalajara, and the painter's family tree goes back to the 16th century. Picasso has eight family names, known in Andalusia at least since that century. With regard to his mother's name, there was an Italian painter, Matteo Picasso (1794–1879), whom research has proved to have had nothing to do with the artist's maternal ancestry. Scholars tend to regard the name Picasso as a corruption of Picacho. Be this as it may, there can no doubt that the man who painted *Guernica* was a devoted and patriotic Spaniard.

Don José Ruiz Blasco was professor of drawing at the San Telmo School of Art in Málaga, and also curator and restorer at the municipal museum. He was an artist of the academic type, and such works of his as have come down to us show a photographic realism; the detail is meticulously accurate, but the composition is weak. Sometimes they have a kind of idealized naturalism. He was tall and fair, but his son inherited his mother's small, swarthy type and lively personality which combined with his father's sensitivity to give him the vigour that has always been his most important quality. His father was much less active, more reflective; his interest was in the finished work of art rather than in its execution. But he must have sensed at an early date his son's determination to scale heights that he himself could never reach, and from that moment—we do not know exactly when, but it was before 1890—he became Pablo's first teacher. Since he specialized in painting birds, especially pigeons, he had the claws of a dead pigeon nailed to the wall, and made little Picasso draw them until he could reproduce the shape exactly. That is perhaps why his childish drawings of pigeons are surer and more mature than those of other subjects, which are more fantastic and distorted, though they already show an obvious artistry and an unusual grace of rhythm and design.

At that time Málaga was no mean artistic centre. Its School of Art at San Telmo was founded in 1849, but did not reach its zenith until the arrival of the Valencian painters Bernardo Ferrándiz (1855—1885), who had been influenced by Mariano Fortuny, and Antonio Muñoz Degrain (1841–1924). Ferrándiz became professor of painting at San Telmo as early as 1868. He had been in Paris, and was the teacher of one of the most outstanding historical, genre and portrait painters, José Moreno Carbonero of Málaga (1858–1941). Another disciple of Fortuny at the Málaga school was José Denis Belgrano (1844–1917). There was a general taste for preciosity and an excessively detailed 'miniaturistic' style. On the death of Ferrándiz, Muñoz Degrain became the dominant personality of the Málaga school.

There is no doubt that at nine years old, on the evidence of his Málaga drawings, Picasso could not have experienced anything which even the

5. Doves. Malaga, 1890.

6. Bullfight scene and doves. Malaga, 1890.

13

least cautious observer could call 'influence'. But on the other hand he must have known his father's painter friends, particularly Muñoz Degrain. Later, when he was in Corunna, still a child but moving towards adolescence, some memories of what he had seen in his birthplace may have come to the surface and acted upon his natural artistic sensibility. His father's influence too must have had its effect, even though one critic described the paintings of Don José Ruiz as 'pitifully mediocre'. Nevertheless, the painter of *The Dovecot* had won medals at municipal exhibitions, and from the technical point of view he was a painter not to be despised. It was not unfitness for his job so much as his natural propensities that led to his giving it up altogether. He evidently had not the instincts of the true artist who, beginning with mere technique, can create beauty by a twofold process of sublimation and intensification.

In Málaga, Picasso did not only draw; he painted too. There are no paintings from this period in the donation, but, in his book on the artist, Pierre Daix reproduces a little picture called *The Picador*, dating it 1889 to 1890. The skill and vigour of this childish composition are really extraordinary. Don José often took his son to see bullfights, those carnivals of light and colour to which Picasso has been faithful all his life, and which he has recorded in innumerable magnificent paintings and drawings throughout his career. Apart from the visual stimulus they gave him, he must have sensed in the confrontation of man and beast the reflection of his own great need to hurl himself into life, to face both the enemy within himself and the enemy without. He had a deep affection and even admiration for his father, and must have felt obscurely what negative forces threatened him. His decision to enter the profession of artist, which he saw as a life-and-death struggle, must thus have been strengthened. We all know the result of that decision.

Picasso's parents were married in 1880, and besides their son had two daughters, Lola (1884–1958), who spent almost all her life in Barcelona, and Conchita (1887–1895), who died in Corunna.

For in September 1891 Don José Ruiz Blasco accepted a post as lecturer in art at the La Guarda Institute in Corunna. The family went by sea to Vigo and then by land to their destination. They were not very happy in Corunna, partly because of the terrible loss they suffered there in the death of their younger daughter, partly because of the change in climate from the south to the north, and perhaps also for other reasons at which we cannot really guess. We do know, however, that the artistic atmosphere of Corunna was much more provincial than that of Málaga; it was also rigidly academic and governed by rules emanating from the Royal Academy of San Fernando in Madrid. The family spent four years there, which can be divided into two well-defined periods as far as Picasso's artistic development is concerned. From 1891 to 1892 and part of 1893, a certain juvenile quality persists, but from 1893, and more obviously still in the following year, the boy's career as a painter begins. Eye, hand, imagination and judgement were now all concentrated on this single all-dominating vision.

Although at eleven and twelve Picasso did not entirely cease to be a child—that would have been abnormal—he began to indulge in pastimes like the creation of art magazines of his own invention, like *'Asul y Blanco'* (Blue and White) and *'La Coruña'*, filling them with charming drawings of young couples, soldiers, dogs at play, children in conversation, and sketches showing how single-mindedly he was striving to master forms, particularly the oval of the head. He was to continue in this pursuit for years, as well as

sketching hands in every imaginable position. Sometimes there is a suggestion of caricature, but more often naturalism prevails—the stark naturalism, reduced to the bare essentials, which is an undeniable characteristic of this period.

Picasso was now living with his family at 14, 2, Calle de Payo Gomez. However absorbed he may have been in drawing and painting, he did not neglect his studies at the secondary school. Evidently he already possessed the capacity for work which is perhaps his chief characteristic. His genius is, without any loss of quality, of the kind that might be called 'quantitative', and we must not forget that quantity, beyond a certain point, naturally becomes quality.

There is in the donation a small oil-painting on canvas—all the works of this phase are small—showing a cottage in shades of pink and yellow, highlighted in white, standing out against the sky. The clumsy perspective is not without charm, despite the lack of technical skill. This skill he was soon to acquire perfectly (in the following year, in fact, as we believe this picture

9

7

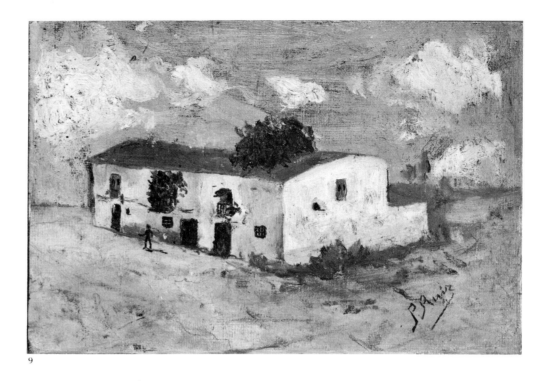

9

8

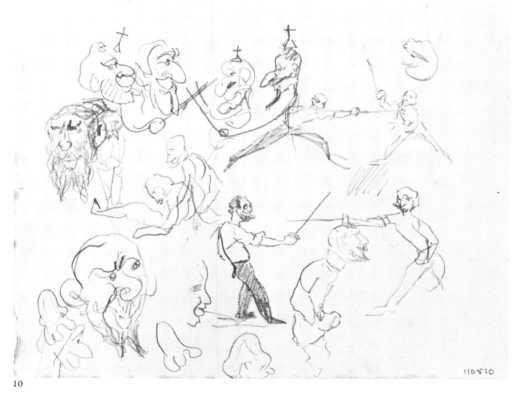

10

may well date from 1893) at the La Guarda school where his father was teaching.

There are several small oils on canvas; one of them shows a seated girl 293 and another a group of children. These, in my opinion, show the transition 292 to the Corunna phase with its greater firmness and assurance of form and spatial construction.

8. Head of a cat (trimmed). Corunna, 1891–2.

9. Country house. Corunna, c. 1893.

10. Fencers and caricatured heads. Corunna, 1893–4.

11. Seventeenth-century scene.
Corunna, 1893–4.

12. Battle scene. Corunna, 1893–4.

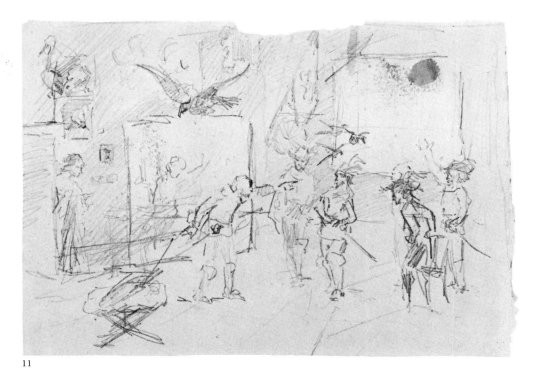

11

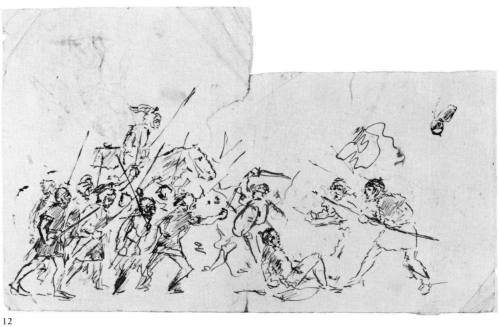

12

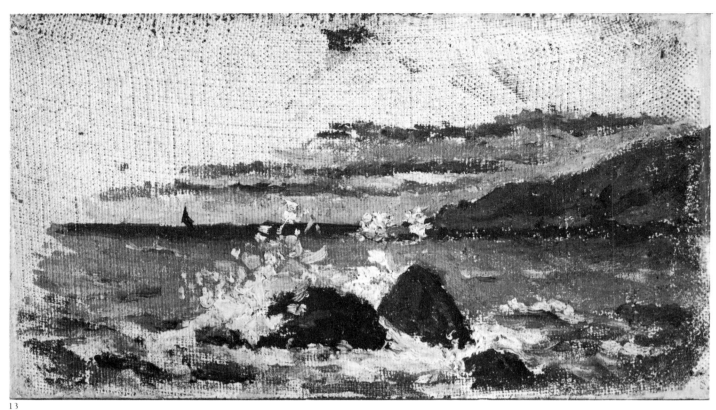

13

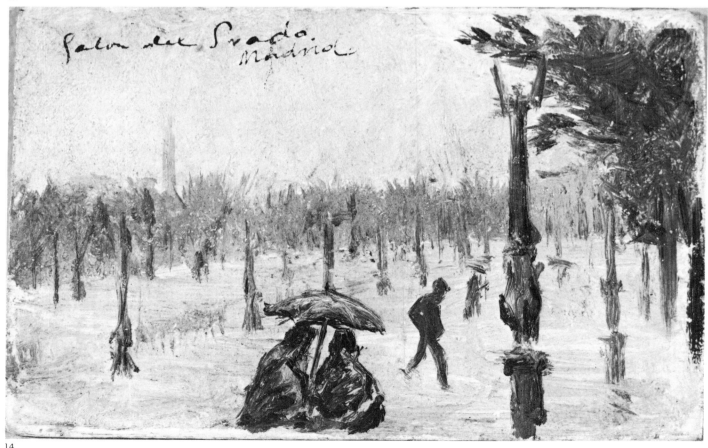

14

Before Modernism I (1894–1897)

15

We can fix convenient limits for this period, but we have to admit a certain lack of unity within them. There are two reasons for this: Picasso's work developed very rapidly during these years, and he lived in, or passed through, a great variety of places. In 1894 and 1895 the family was still in Corunna. They moved to Barcelona in 1895, but the summers of 1895, 1896 and 1897 were spent in Málaga. In July 1895, moreover, Picasso went to Madrid for the first time. He was there only a few days, but it made a great impression on him, and we have a record of his visit in the form of a sketch in oils on wood of the *Salon del Prado*.

But I am anticipating. In Corunna, in 1894 and 1895, Picasso did some studies, four of which are included in the donation. They are completely objective copies of plaster casts ranging from a Renaissance-style frieze to a

14

16

13. Breakers. Corunna, 1894–5.

14. 'Salon del Prado'. Madrid, 1895.

15. Boy's head and other sketches.
Album 1. Corunna, 1894.

16. A bull (trimmed). Album 1. Corunna, 1894.

17. Moroccan scene. Album 1. Corunna, 1894.

17

18

19

grotesque mask. There are also in the collection two sketch-books from the Corunna period, one dated 1894 and the other 1895. The pencil and pen-and-ink sketches range from a picture of a bull to a realistic Hercules-figure (not unlike the early Málaga one) sketched in a monumental style and with a certain amount of distortion, and they all show the same rapid development. Besides the studies of hands and heads there are imaginative sketches evolved from some done the year before, showing battles or scenes from a 17th century which existed only in his imagination. Clearly he was emotionally still a child.

As I have already said, there was evidently no outstanding artistic personality in Corunna at that period. But the teaching at the La Guarda school was adequate if the student was capable of taking advantage of it. It is also possible that at this time Picasso was remembering his childhood experiences of art in Málaga and choosing all that was best in them. Perhaps the Ferrándiz *tableautin*—influenced by Fortuny—contributed towards the thirteen-year-old boy's instinct for the composition of a painting. There are no echoes of this work in the two little pictures of which one—dated 1894, in oils on paper—is called *Galician Peasants*, and the other *Breakers*, but we find a distinct relationship to it in the pair of equally small sketches on wood of interiors in the house of Don Raimundo Perez Costales. In these the paint is rather thick and the colouring rich; there is some preciosity in his use of colour, based on contrast-effects which he was later to abandon. The collection also contains sketches on wood of pigeons and other birds, and these, together with the two small pictures previously mentioned, may date from 1895. They all show the same preoccupation with making colours sparkle like jewels. These extremely decorative pigeons are a far cry from the stiff lifeless birds painted by Picasso's father. Don José, professional painter that he was, could not fail to be aware of his own shortcomings. The biographers tell us that in 1894 he handed his paints and other equipment over to Pablo and never painted again. It was not only an act of homage to his son's precocious genius; it was also the willing surrender of power to the one who could make the best use of it.

Two canvases in oils with male figures date, we believe, from the end of Picasso's time in Corunna. One is a *Portrait of an old man* shown full-face, and the other is a *Man with a beret*. They are compact, sober works moving towards a more expressive kind of painting, more human and less precious. They are the only works in which we may perhaps detect the stimulus of a local art, rustic and naturalistic. If this is the case it was simply one more experience for the painter to store up in his memory.

We cannot leave Picasso's Corunna period without mentioning another work of his which, although it does not form part of the donation (it is in the artist's own collection) is of outstanding artistic and emotional interest. This is *The girl with bare feet* (1895), a seated figure staring straight ahead but seeing nothing, her eyes vacant and withdrawn.

Feeling unsettled in Corunna, the Ruiz family longed to go back to the Mediterranean coast. At last they had their opportunity. Thanks to an order dated March 17, 1895, Don José Ruiz Blasco was able to transfer to Barcelona as a professor at the School of Fine Arts at La Lonja, by exchanging posts with Don Ramón Novarro Garcia, who moved to Corunna. He took up his appointment on April 16, 1895.

But before beginning a new phase of his work in Barcelona, Picasso went to Madrid in July 1895, where he visited the Prado and saw the paintings

18. Hercules. Album 2. Corunna, 1894–5.

19. Man with a beret. Corunna, 1895.

20. *The painter's palette*, used in Corunna or Barcelona, c. 1895.

21. *Head of a man*. Corunna, c. 1894.

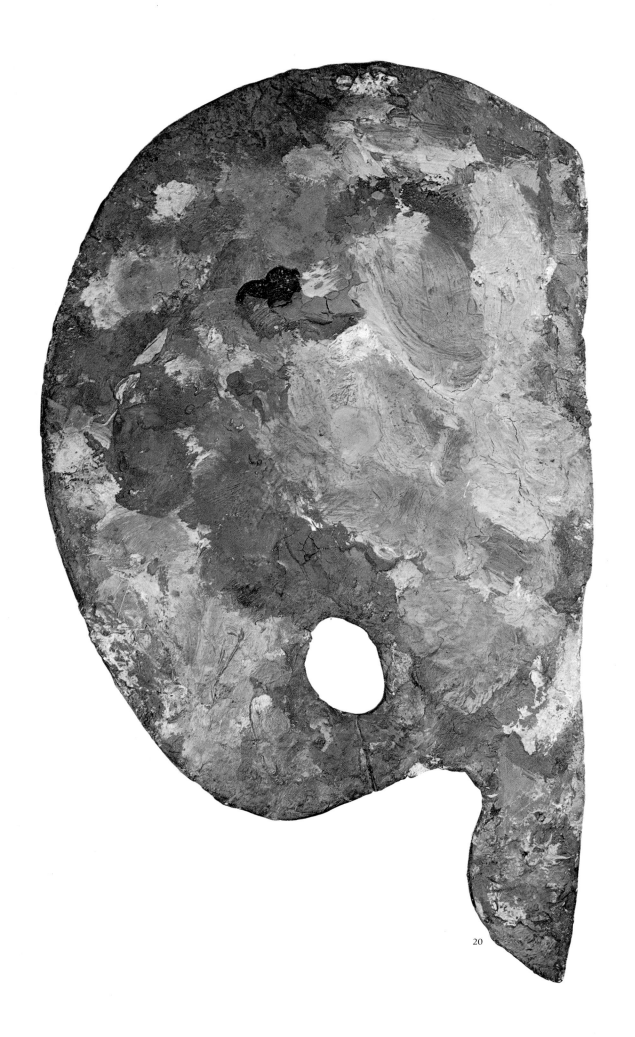

20

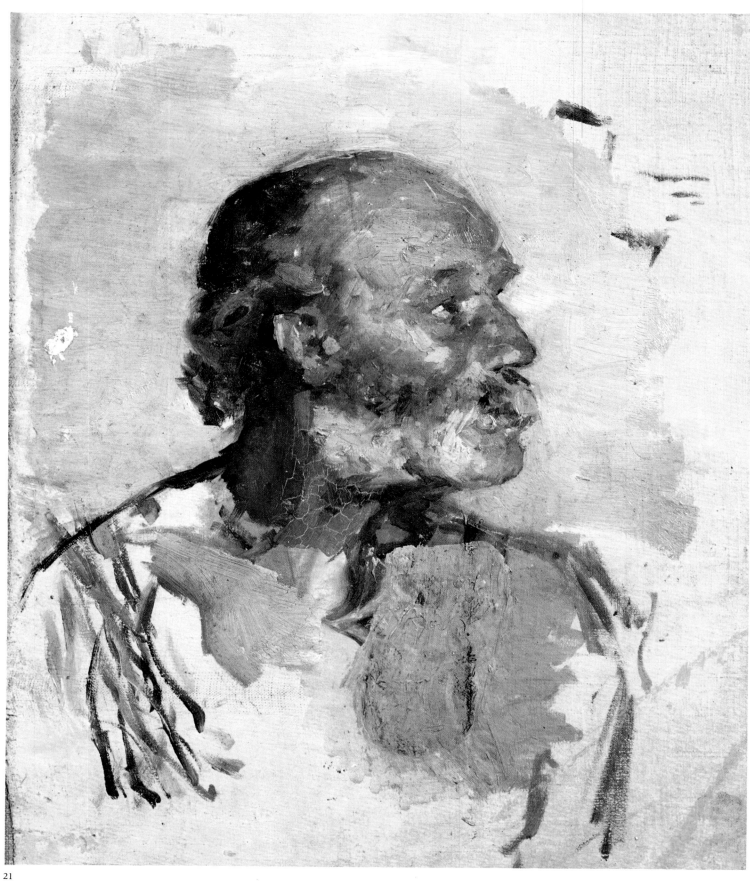

21

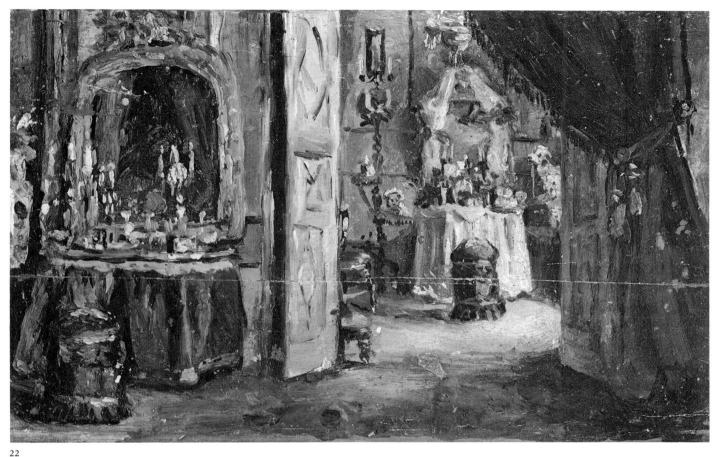

22

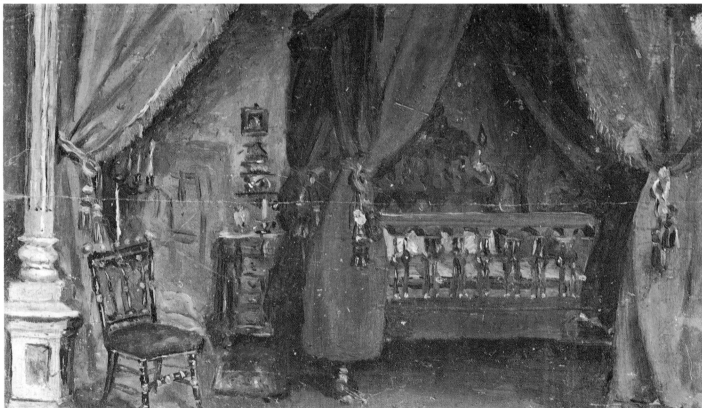

23

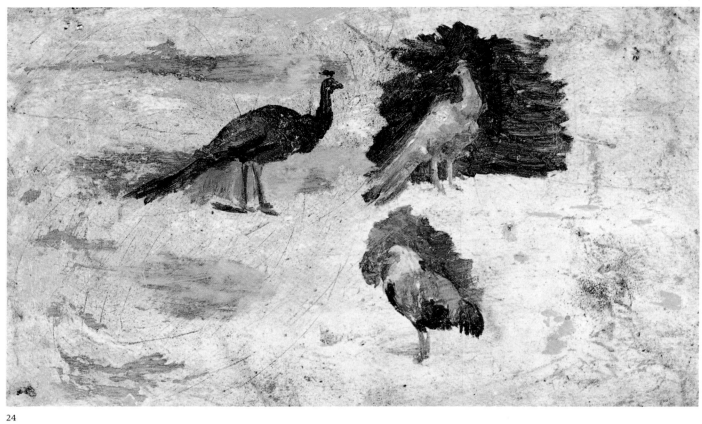

24

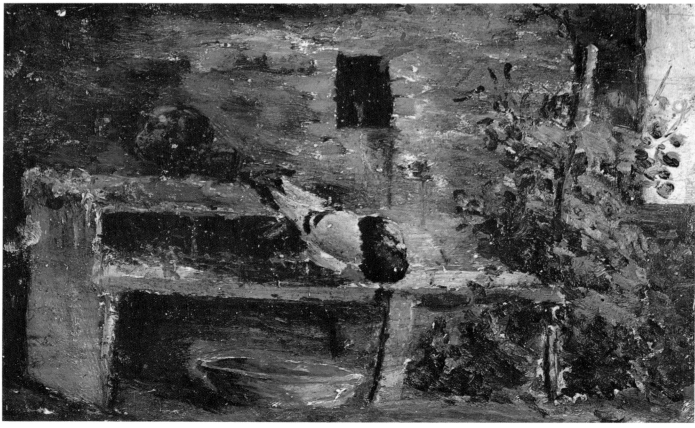

25

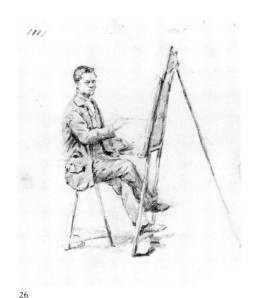

26

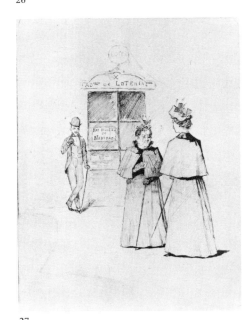

27

22. *Interior in the house of D. Raimundo Perez Costales.* Corunna, 1895.

23. *Bedroom in the house of D. Raimundo Perez Costales.* Corunna, 1895.

24. *Birds.* Corunna, 1895.

25. *A dove.* Corunna, 1895.

26. The artist's friend Pallarés (trimmed). Barcelona, 1895.

27. Outside the lottery shop. Corunna, 1895.

of Velasquez. In one of his 1895 sketch-books there is a pencil drawing of the clown Lezcano, later portrayed in *Las Lanzas.* He remained in Málaga until September and then went north to Barcelona by sea. Sketches on wood 77 or canvas in the donation bear the titles *Cartagena* and *Valencia,* doubtless 309 marking stages on his journey.

In Barcelona, Picasso was living in a great city for the first time. It had a population of over half a million—much larger than most cities at that time—and was very wealthy. Its industry, art and literature were flourishing. Its School of Fine Arts at La Lonja, active since the 18th century, had existed in its present form since 1834.

There were various artistic movements, each with its own vigorous, intelligent personalities, engaged in friendly rivalry. Historical painters included Francisco Torrescasana (1845–1918) and Antonio Casanova y Estorach (1847–1896). Social and genre painting was finely represented by Arcadio Mas y Fontdevila (1851–1934), who was one of the first painters to interest the young Picasso, and Luis Graner (1869–1929), among others. Landscape painting was being radically reformed by Graner, Modesto Urgall (1830–1919), Francisco Gimeno (1860–1932) and Enrique Galwey (1864–1931), not to mention those who followed the new trends from the north, mainly Paris, which were gradually taking possession, if not of the whole artistic horizon, at least of its most lively and significant sector.

On arrival in Barcelona, the Ruiz Picasso family settled in the Calle Cristina close to the docks. Then they moved to 4 Calle Llauder, and in 1896 to 3 Calle de la Merced. This became their permanent home, and after Don José's death Señora Picasso continued to live there with her daughter Lola, by then the wife of Dr Juan Vileto Gomez.

Picasso passed two entrance tests at La Lonja, on September 15 and 30, 406 1895. He took the examination for the advanced course—classical art, life, and painting—but did not take the course in general drawing, which he had already studied in Corunna. Once accepted, he entered upon his studies for the academic years 1895–1896 and 1896–1897. In the latter year, as we shall see, his life took a new turn.

At La Lonja he made his first real friends, the most intimate of all being Manuel Pallarés. He made the acquaintance of Manolo Hugué, José Cardona, 26 who was a sculptor as well as a painter, the brothers Angel, Mateo, and Wenceslao Fernandez de Soto, Sebastian Junyent, Carlos and Sebastian Junyer Vidal and Carlos Casagemas, who later committed suicide at the age of twenty. Most important of all, at La Lonja Picasso maintained the objective approach which was most in accordance with his natural tendency towards realism. He quickly absorbed the artistic atmosphere of Barcelona, but was never attracted by any fashionable trend which might have led to a break in continuity with what he was doing at the moment. Thus *The Notary* shows 28 figures markedly similar to those appearing in the painting by Eduardo Rosales (1836–1875), *Presentation of Don John of Austria to Charles I,* which he may have seen during his brief visit to Madrid in the Museum of Modern Art; while a sketch on wood of a nude is copied from a detail of a painting by 38 Mas y Fontdevila.

It has been suggested that the broad lines of Picasso's development in portrait painting were laid down by Antonio Caba (1838–1907). The idea cannot be discounted, since portrait-painting was Caba's speciality, and he was director of the School of Fine Arts when Picasso was a student there. In general, Picasso's development as a painter in the years 1895 to 1897 consists,

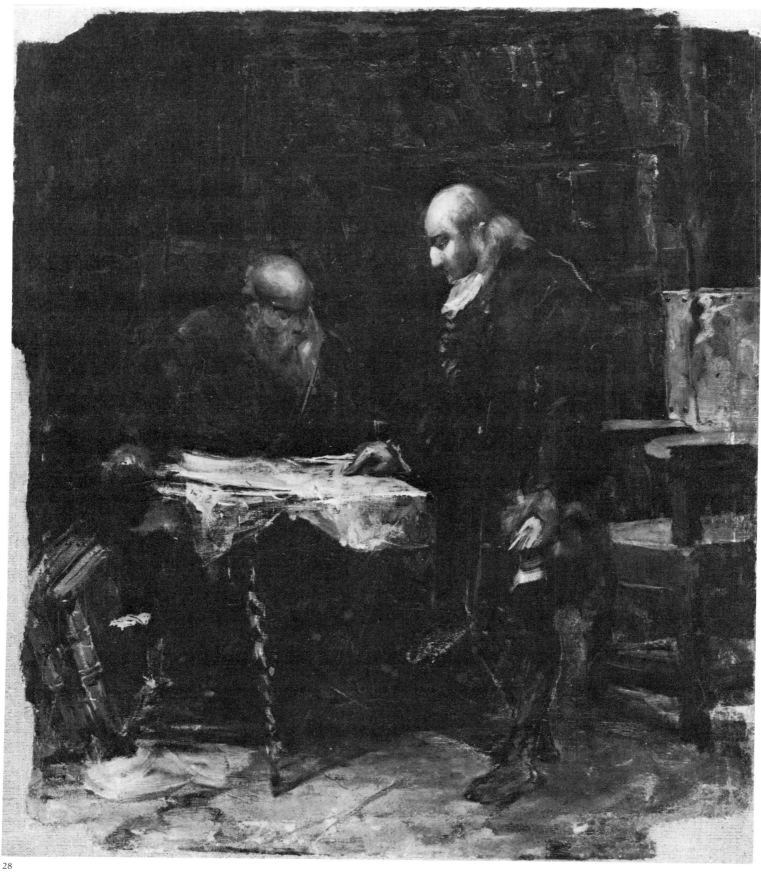

28

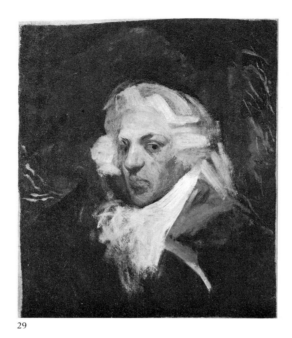

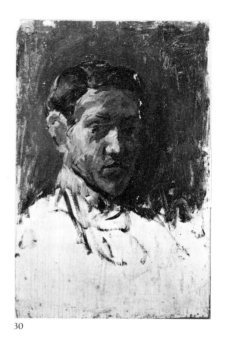

basically, in the constant expansion of his forms, a tendency which was to continue throughout the following years. The period from September 1895 to October 1897 was a decisive one for him, whether he was in Barcelona, or during the summer months in Málaga.

The 'expansion of forms' can be seen in the donation in the extended series of sketches in oils on wood and small landscapes in oils, as well as a few watercolours and pastels created in the same spirit. Picasso's feeling for beauty shows in the rose-pink and yellow skies, and in the seascapes, which are simply delicate gradations of colour—pale shades of blue, grey, yellow 36 and rose, with white. After 1896 we notice especially some small oil-paintings 85 of details of the cathedral and other churches.

His portraits include three of his father, one in oils and two in watercolour, 64 one of which has a red ground and the other a blue one. Another compact 90 work is the pastel portrait *The artist's mother* (1896). There are three self- 39 portraits belonging to the period 1893 to 1897, besides the *Self-portrait with* 29 *a wig* of the same year, in which the dishevelled brushwork gives promise of future liberties. In 1896 Picasso also painted his sister Lola at night in a white 289 dress, under a beautiful pale blue-grey light.

April 1896 saw the opening of the largest to date of the art exhibitions held in Barcelona. Brull, Mas y Fontdevila, Rusiñol, Graner, Casas, Mir, Nonell and others exhibited. Picasso entered *The First Communion*, a large 46 canvas in the academic style of Mas y Fontdevila; his model was his sister Lola, who very often appears in his drawings. In the same year he painted *The Choir-boy* (Sala collection, Barcelona). I mention it because, although it is not part of the donation, the latter contains a preliminary sketch for it. 60

In the summer of 1896 in Málaga he painted one of the best of all his youthful works, the intensely emotional portrait of *Aunt Pepa*, an old 40 woman with a strong face, dressed in black, against a dark ochre back-ground. The brushwork has an independence, vigour and meaning of its own which Picasso had never achieved before. It remains an isolated work, because its expressionism—descended from Rembrandt—did not for the moment provide the fresh creative stimulus he needed. He was not yet

28. The notary. Barcelona?, 1895.

29. Self-portrait with a wig. Barcelona, 1896.

30. Self-portrait. Barcelona, 1896.

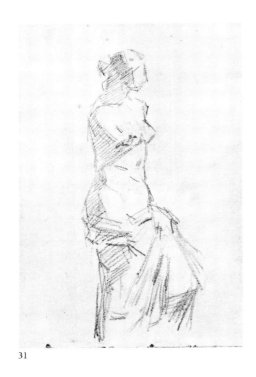

31

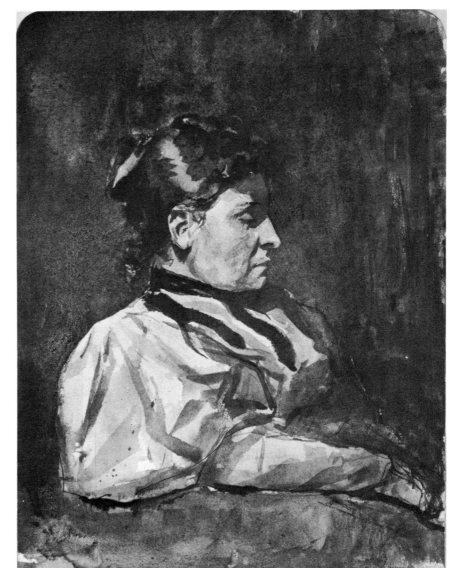

32

31. Sketch of the Venus de Milo. Album 4.
Barcelona, 1895.

32. Portrait of the artist's mother. Album 5.
Barcelona, III-VI, 1896.

33. Sketch of a man. Album 3.
Barcelona, 1895.

34. Sketch of the artist's grandmother,
Dña Inés (trimmed). Barcelona, 1895–6.

35. *Portrait of an old man*. Corunna, 1895.

36. *Seascape*. Barcelona, 1896.

37. *Seascape*. Barcelona, 1896.

38. *Seated nude* (copy from a detail of a
painting by Mas y Fontdevila).
Barcelona, 1895.

39. *Portrait of the artist's mother, Dna Maria
Picasso Lopez*. Barcelona, 1896.

40. *Portrait of Aunt Pepa*. Malaga, 1896.

33

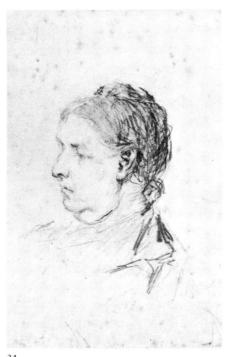

34

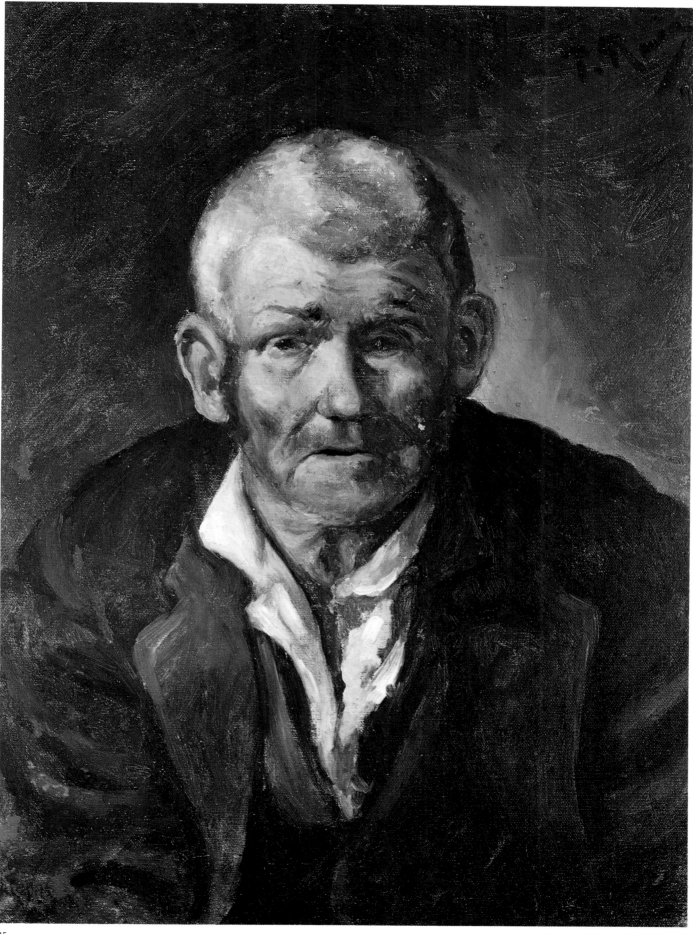

35

36

37

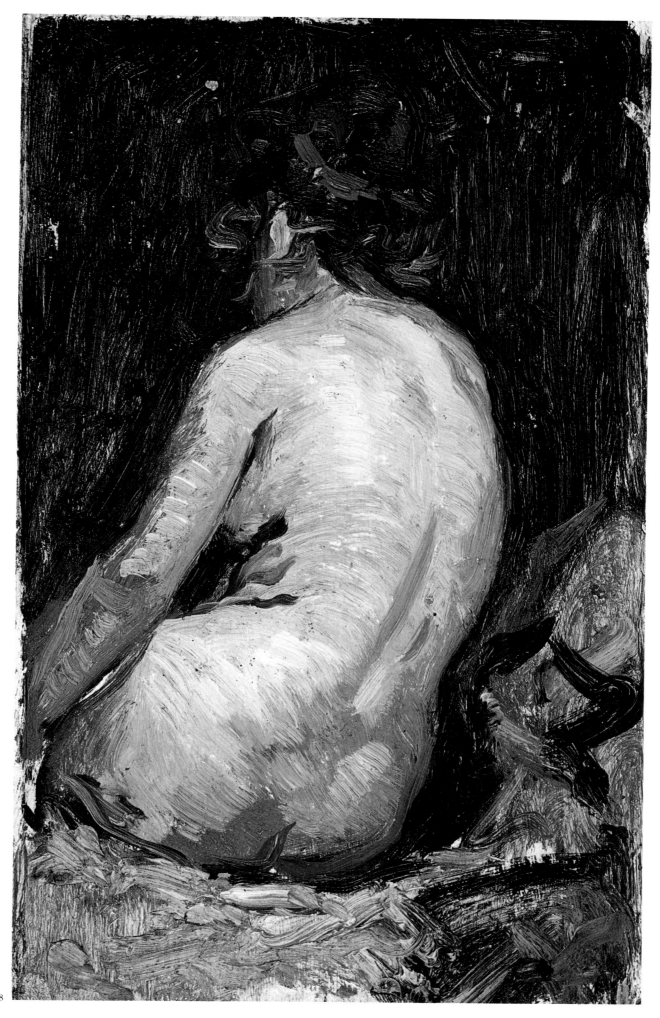

39

40

41

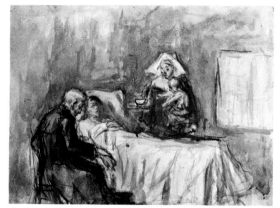

42

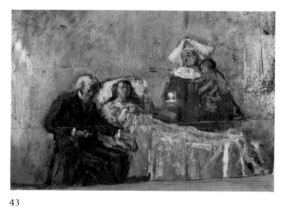

43

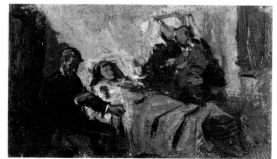

44

45

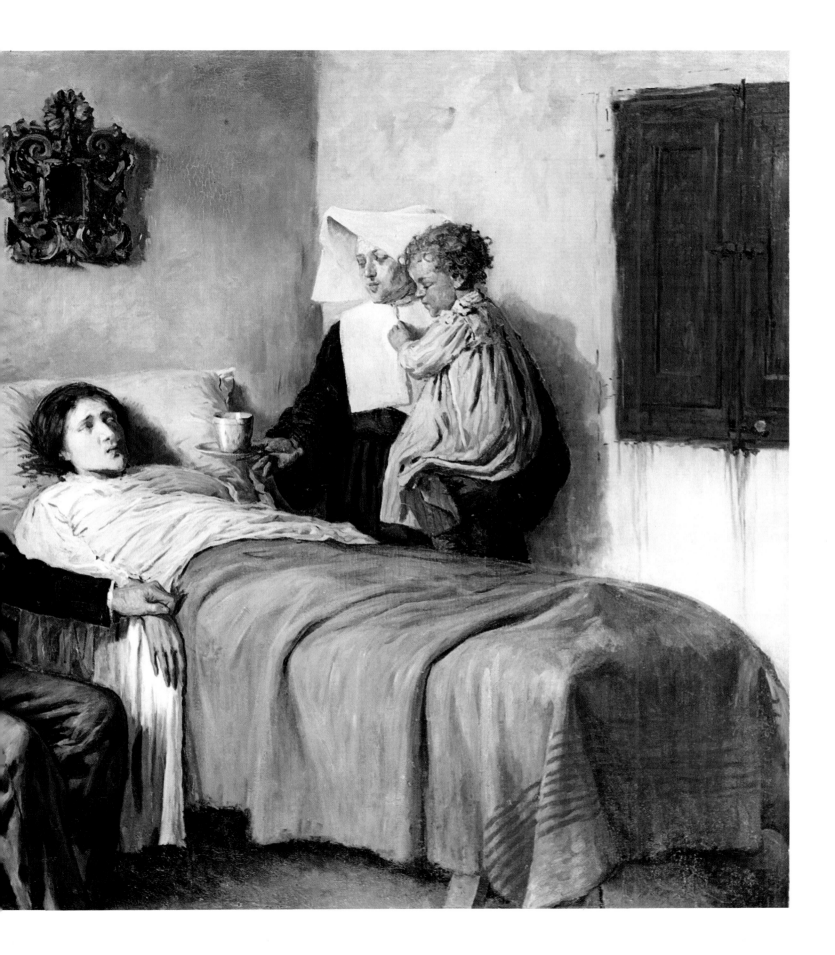

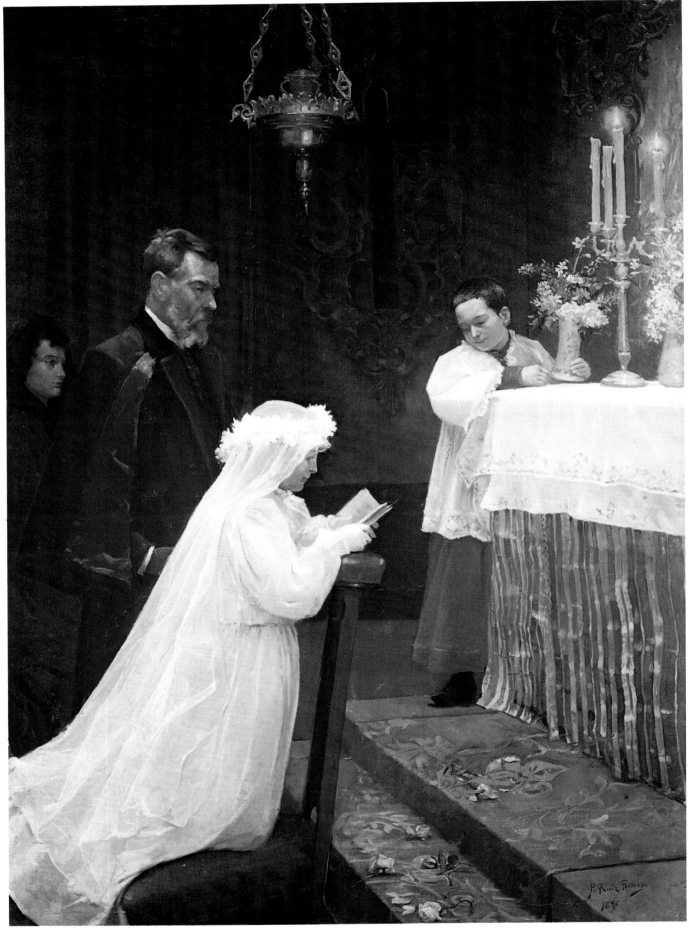

47

fifteen, but this portrait is without a doubt one of the greatest in the whole history of Spanish painting. He also painted a superb landscape in Málaga in 1896, and we have the preliminary sketch for this too; it is similar in style and approach, but less precise. 91

At the end of 1896 and the beginning of 1897, Picasso created a new work in the contemporary trend of social realism, using an academic technique with *fin-de-siècle* colours (mauves, white shading to lilac, and green verging on ochre). This is the large canvas *Science and Charity*, symbolized by the doctor and the nun at the bedside of a sick woman. Seven preliminary 45

48

41/4 *Studies for 'Science and Charity'*. Barcelona, 1896–7.

45. *Science and Charity*. Barcelona, 1897.

46. *The First Communion*. Barcelona, 1896.

47. Sketches including a preliminary study for 'The First Communion'. Album 5. Barcelona, III–VI, 1896.

48. Hagiographical painting. Barcelona, IV-1896.

49. Hagiographical painting. Barcelona, 1896.

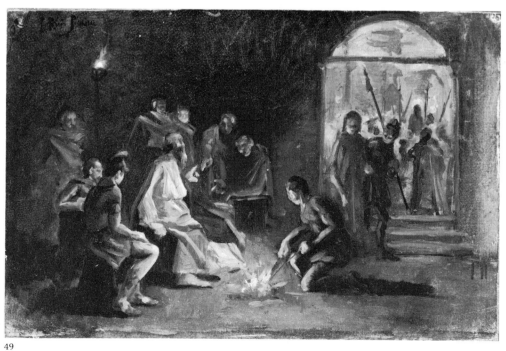

49

50

51

52

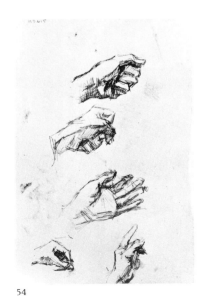

53

54

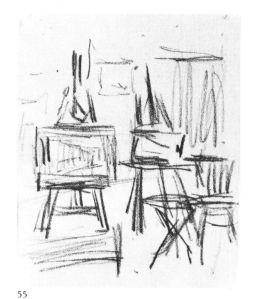

55

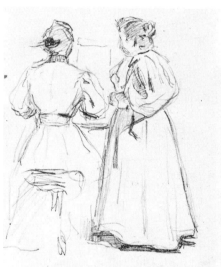

56

sketches for this work are known, two drawings, a watercolour and four oil-paintings. One drawing, the watercolour and three oil-paintings are in the donation. These vary in details, and there are also variants in the final canvas. We may not approve today of the taste of this picture, but it was a bold and successful effort, and if we place it in its context, that is to say outside the new movements which began in France as early as the 1860s with Impressionism and some aspects of Symbolism, then it challenges comparison with the work of artists at the very peak of their careers. *Science and Charity* was sent to the National Exhibition of 1897, where it won an honourable mention, and to the provincial exhibition at Málaga, where it was awarded a gold medal. 41

In 1897 a change can be seen in his landscapes. The effects he sought 89 became less brilliant. His dry, heavy impasto gave place to a more fluid technique, with colours melting one into another, in a *sfumato* manner. 95 To the influence of Graner and Galwey was added that of Eliseo Meifrén (1859–1940) and Santiago Rusiñol (1861–1931). Picasso must have realized the importance attached to the mere name of the latter; he grew beyond him within two years. It has been said that Picasso was always more concerned with tone gradations than with colour, but at least as far as the period covered by this book (and one or two years afterwards) is concerned, colour is used equally with tone to build up forms. Later Picasso preferred to use lines and tones to construct shapes, and colour to express space, which thus acquires an atmospheric quality, not openly Symbolist, but undoubtedly showing great sympathy with Symbolism.

I must reiterate that the period 1895 to 1897 was a decisive one for Picasso. Besides the works we have mentioned, he painted numerous preliminary sketches, and a few paintings, on religious themes. Two hagiographical 48 pictures are contained in the donation, treated with a kind of rudimentary 49 neoclassicism which is certainly very effective.

There are also the 'academy figures' in oils and crayon, anatomically 51 perfect, with the feeling of strength or weakness which comes from live 357 models, young or old, and the large copies of casts drawn with equal spirit, and sometimes emphasizing geometrical forms. We could certainly follow 471 his progress towards Cubism almost year by year by observing the extent to 484 which his figures are geometrically constructed.

The drawings and sketches in ink, pencil or charcoal show a distinct variety of styles, which means that he was experimenting with ways of indicating shape. There are six albums of drawings in the donation belonging to this period: two dated 1895, two 1896 and another two 1896–1897. The first two are more disciplined and uniform than the others. The style is 2 naturalistic. Those of 1896 show more variety of style and technique: geometrical shapes, a certain schematic quality at times, and also the beginnings of a taste for ink drawings in separate, lightly traced lines, used to construct scenes which are intended for paintings, historical or dramatic. 47 One of these albums, dated June 1896, contains two fine watercolour 32 portraits of his mother. There are also numerous sketches of his family, a few nudes, and some preliminary studies for the watercolours and oil-paintings on religious themes which, as we know, he painted that year. The 1896–1897 sketch-books show real progress. The lines are vigorous and absolutely 52 assured. His drawing could be markedly naturalistic, or it could tend to be stylized in one of two ways—either angular and geometrical or gently 55 curved. The latter tendency predominated in the following years, though

50. Study of a plaster bust. Barcelona?, 1895.

51. 'Colour tests'. Barcelona, 31-I-1896.

52. Various studies. Album 7. Barcelona, 1896–7.

53. Studies of hands. Album 6. Barcelona, VI-1896.

54. Studies of hands. Barcelona?, 1895–7.

55. The studio. Album 8. Barcelona, 1896–7.

56. Two women. Album 8. Barcelona, 1896–7.

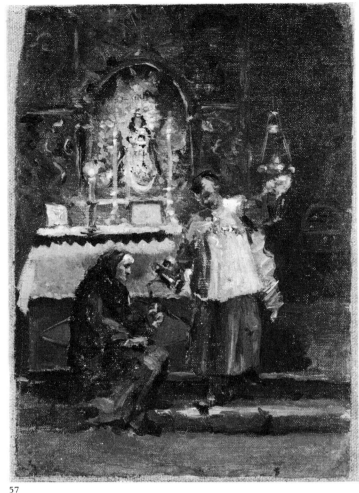

57

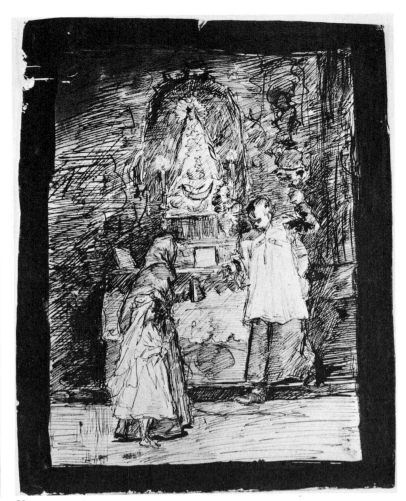

58

59

60

61

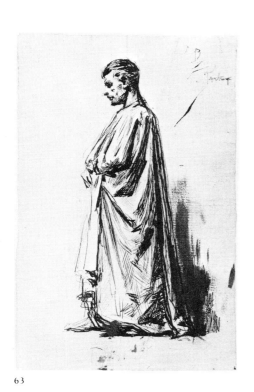

63

62

the other styles were never completely abandoned.

After this, Picasso was able to work more freely, because at some uncertain date between the spring and autumn of 1896, his father had given him permission to rent a studio at 4 Calle de la Plata. This must have given him more self-confidence, if—as seems unlikely—he needed it.

The drawings done in this period show a development in style as radical as it could possibly be. Those at the beginning of the period belong to the 19th century with its naturalistic regard for detail. They include the pen-and-ink sketch for *The Choir-boy* and a couple of preliminary studies, one in pencil and the other in ink, for a small oil-painting, *Old woman receiving* 60 58

64

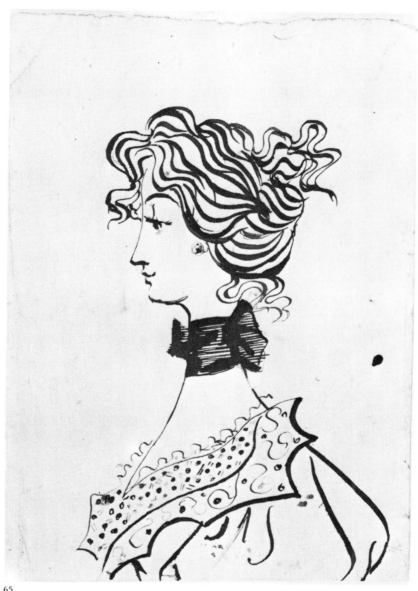

65

holy oil from a choir-boy. The strength here is latent, and the form restrained. 59
He is seeking a plastic, chiaroscuro effect. Others, such as a fine drawing 56
of a woman seen from behind, are freer and more impulsive.

There are also drawings reflecting his studies at La Lonja. Though these
are not purely academic exercises, they show that he was voluntarily sub-
mitting to classical standards. One such is the pen-and-ink portrait of a 63
man wrapped in an ample cloak. The contrast between 1895 and 1896 is,
I believe, typified by the contrast between the works I have described
and a drawing, conceived as such, called *Flight*. It shows an orderly group 62
of people fleeing from some threatened danger. There are mothers clutching
children in their arms or leading them by the hand, old men with burdens,
and a horseman mingling with the crowd, which streams from right to left.
It is intensely dramatic. A head and shoulders portrait of a woman, belonging
to the same period, has a decorative quality all its own, arising from the
harmony between the ringlets of hair and the ornamentation round the
neckline of the dress. The drawing is firm and clear. The woman has a 65

64. The artist's father. Barcelona, 1896.

65. Bust of a woman in profile (detail).
Barcelona, 1896.

43

66

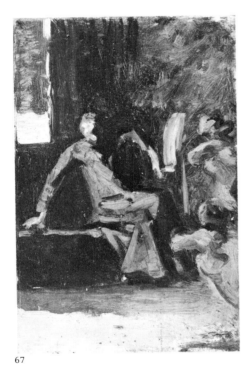

67

66. Various sketches. Album 6.
Barcelona, VI-1896.

67. Interior with seated figure.
Barcelona, 1896.

68. The artist's sister Lola.
Barcelona, 1899–1900.

68

69

69. The artist's sister Lola (trimmed).
Barcelona, *c.* 1897.

70. The artist's sister Lola. Barcelona, *c.* 1897.

70

Grecian beauty, and we catch a glimpse of the 'Hellenism' which Picasso was to show over the years in the most varied ways.

A series of female studies, mostly half-length, were done in 1896 and 1897. The model may have been his sister Lola. In these, naturalism and geometrical style are intricately woven together, and we begin to see a subtle tinge of Modernism which, as in the 1897 oil-paintings, presages Picasso's openly Modernist period. There are two portraits, one of Lola and one of Don José Ruiz, showing the head only, surrounded by a network of parallel lines (a large part of his father's head, supported on an arm, is treated in the

69
70

127

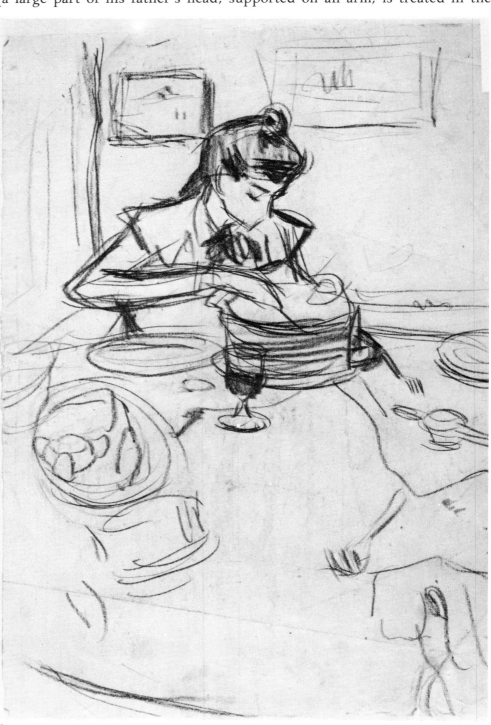

71. The artist's sister Lola. Barcelona, *c.* 1899.

71

same way). Their similarity to the works we have just mentioned suggests that they were executed in 1897, but they have the clarity of form and the utter confidence which we find a little later on—which is not to say that they could not perfectly well belong to this date. There are also drawings of interiors done in 1897 which are frankly schematic. Straight lines are of 72 paramount importance in these works. By leading the eye respectively in a horizontal or vertical direction they give to space a centrifugal or centripetal effect.

Everything suggests that Picasso began the change which was to lead on to his next period when he was in Barcelona at the beginning of 1897. It was a start that had no direct development mainly for external reasons. He was now at liberty to experiment, first with rigid discipline, then with a completely free treatment of nature. But he was able to give fresh vigour and substance to the qualities developed between 1895 and 1897, so that the aspirations that took shape at the end of that period could reach a surer and richer outcome. Nevertheless, even as late as 1900 we see Picasso still working in a spirit of total liberty, accepting every idea that came his way, trying one thing, then its opposite, achieving works of art by his innate ability rather than intentionally; it is quite obvious that in many of the sketches he was simply amusing himself.

I must emphasize again that for Picasso 'exercises' such as sketches and studies are never purely technical; themes and ideas are at least as important as technique. As he studies his chosen subject he also studies the different ways in which it can be represented. Looked at from the avant-garde point of view—that of Picasso's later works—those in the donation appear relatively moderate. But there is a fermentation beneath the surface, a fertile chaos full of contradictory ideas, which betrays the artist's inner restlessness as well as his extraordinary powers. We never meet the type of study from life in which only the subject changes, while the conceptual and technical approach remains the same. To express it in terms of the cinema, we might say that in Picasso's studies the 'camera' moves at least as much as the subject on which it is focused. There are thus two different sources of movement combining to produce the most unexpected variations. This quality was present, though comparatively restrained, from 1894 to 1896, but from 1897 onwards it began to develop at an enormous rate. That is why the twenty-year-old painter at the beginning of his Blue Period was able to become the most advanced artist of his time.

72. Sketched scene. Barcelona?, c. 1897.

73. Street scene. Barcelona?, 1897.

74. The artist's dog Klipper. Corunna, 1895.

75. Family scene. Corunna or
Barcelona, 1895.

72

73

74

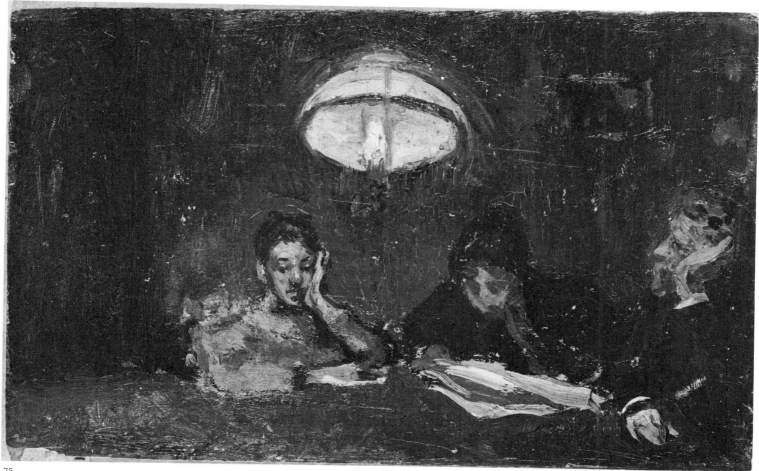

75

49

76

76. Galician peasants. Corunna, 1894.

77. View of Cartagena. En voyage, IX-1895.

77

78. Head of a woman. Barcelona, 1896.

79. Roses. Barcelona, 1895–6.

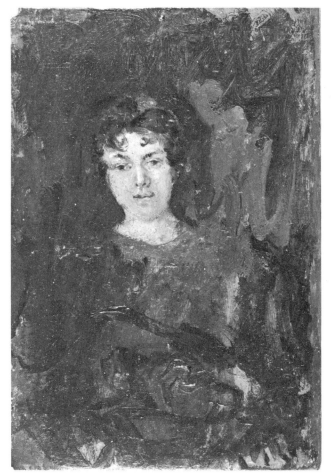

78

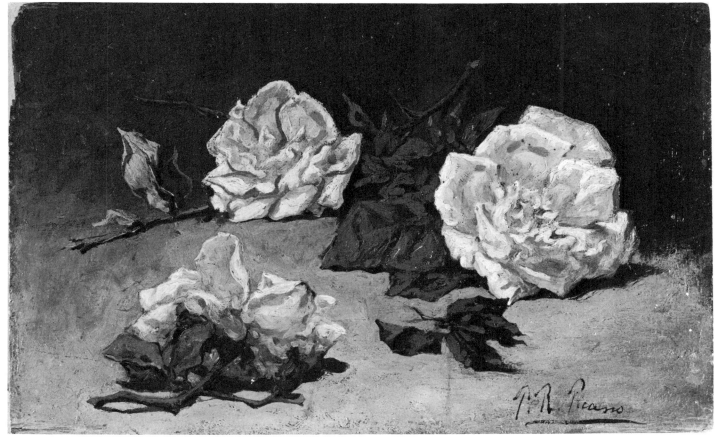

79

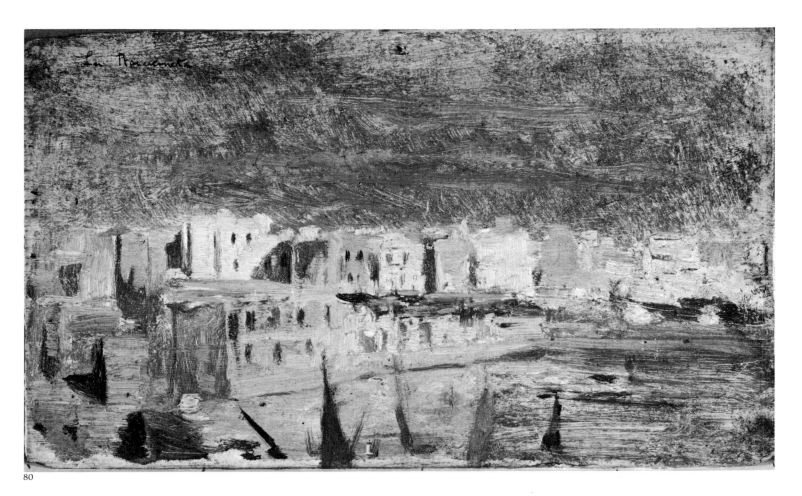

80

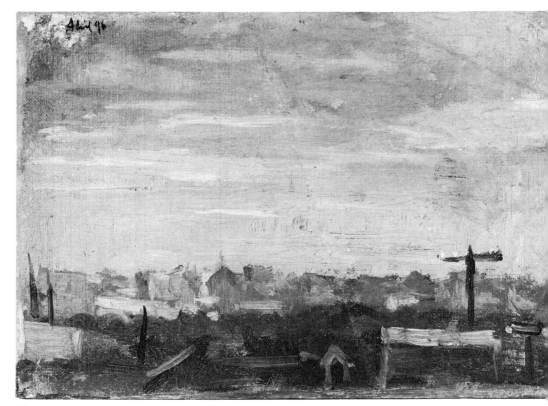

80. 'La Barceloneta'. Barcelona, I-1897.

81. Urban view. Barcelona, IV-1896.

81

82

83

82. Sunset. Barcelona, 1896.

83. Sunset. Barcelona, 1896.

84. A candle. Barcelona, 1896.

85. Corner of the cloister of San Pablo del Campo. Barcelona, XII-1896.

85

84

86

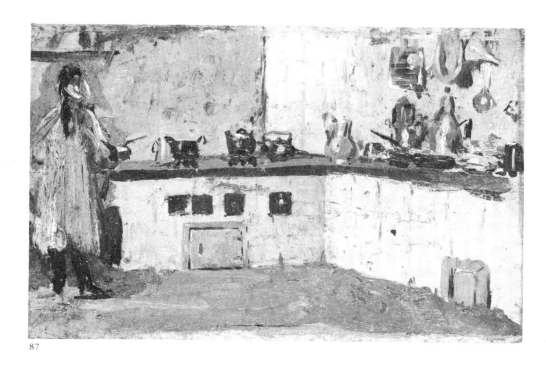

86. Scene in a park. Barcelona or Malaga, 1896.

87. The kitchen. Malaga, 1896?

87

88

88. A woman from behind. Barcelona, 1896.

89. Landscape with trees. Barcelona, 1896–7.

90. *Portrait of D. José Ruiz Blasco, the artist's father*. Barcelona, 1896.

91. *Study of a hillside*. Malaga, 1896.

92. *Hillside*. Malaga, 1896.

89

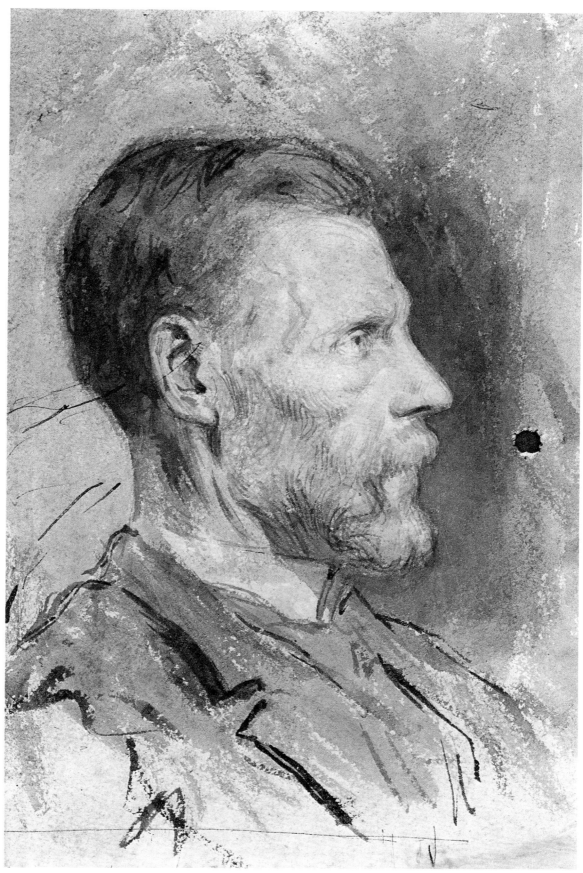

90

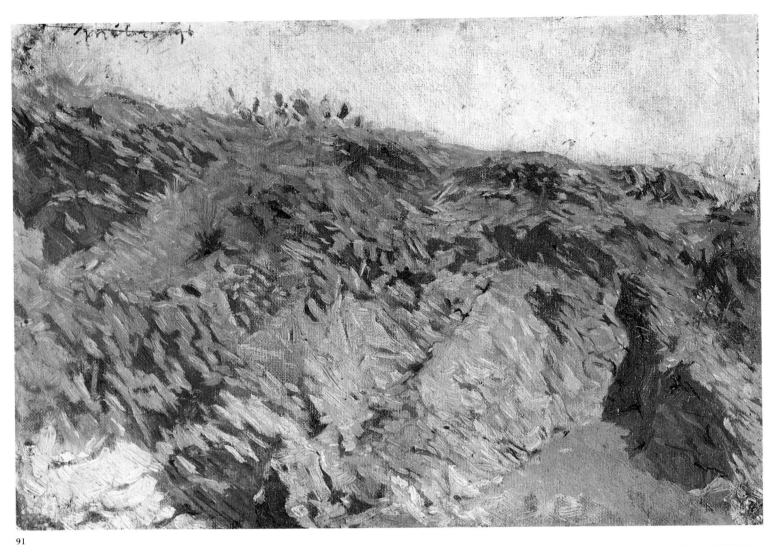

91

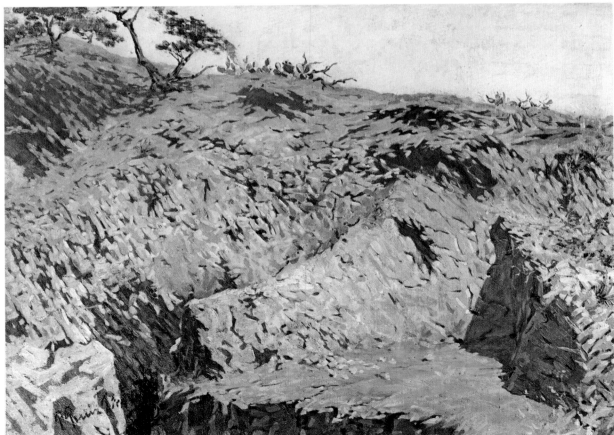

92

93

94

95

96

93. *Scene with trees.* Malaga, 1896.

94. *Trees.* Malaga, 1896.

95. *Modernist landscape with figure.* Barcelona, c. 1897.

96. A bullfight. Barcelona, 1896.

97. Two figures in a landscape. Barcelona or Malaga, 1896.

97

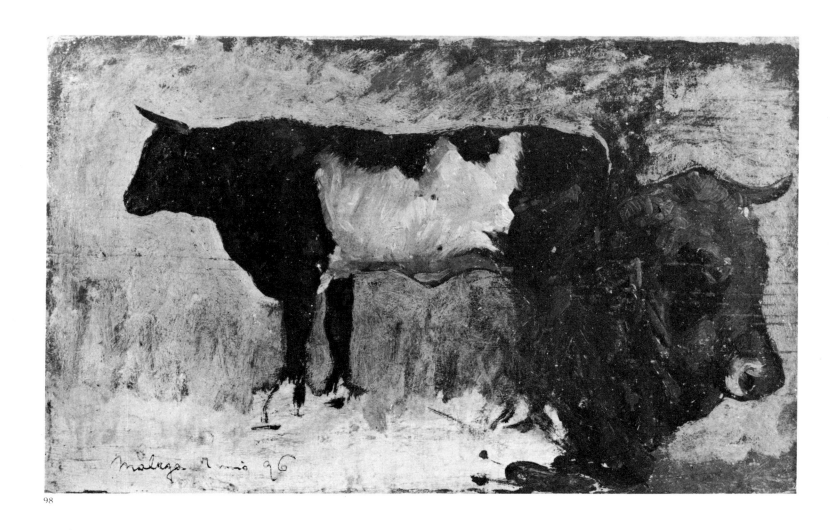

98

99

98. Bull and bull's head. Malaga, 1896.

99. Fisherman and children. Barcelona or Malaga, 1896.

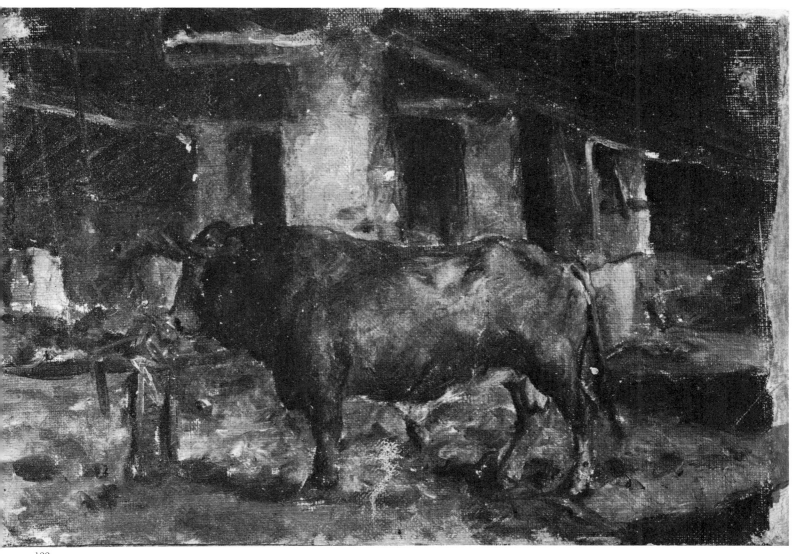

100

100. Bull before a fight. Malaga, 1896.

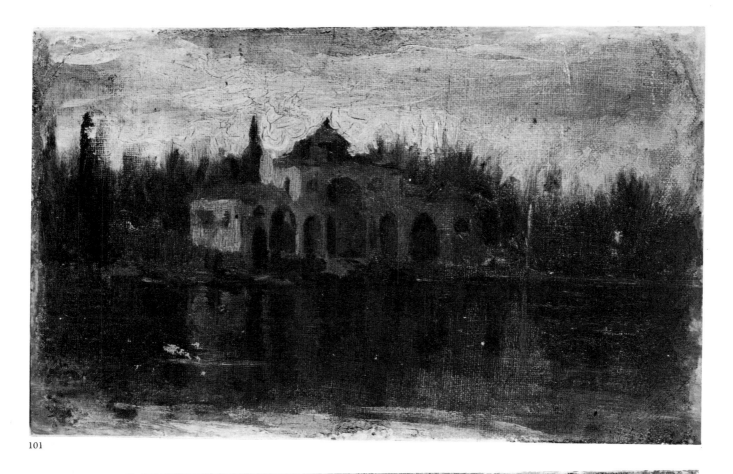

101

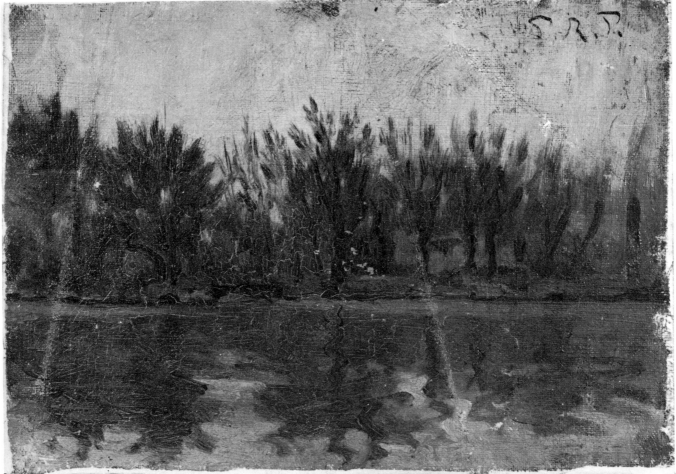

102

Before Modernism II (1897–1899)

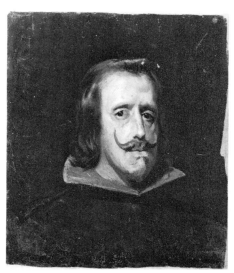

103

Picasso spent the summer of 1897 in Málaga, though at sixteen the ties that bound him to his native city had probably lost their strength. Then in the autumn, despite the attractions of the environment in Barcelona, he took the entrance examination for the Royal Academy of San Fernando. That year the dominant personality in Madrid was Moreno Carbonero, who was outstanding in every branch of painting. Muñoz Degrain was one of the most influential professors at the Academy, and this seems to have decided Picasso to study there. He easily passed the examination, and his name appears on the register for 1897–1898. He described himself in his application as 'pupil of Muñoz Degrain', although, as we have seen, he could have learnt little or nothing from him in Málaga, and his work, even in the early years, shows no similarity to Degrain's. He certainly does not seem to have done this out of disrespect towards his father, who was his first and most assiduous teacher, but rather out of youthful pride. He had to assert his own personality and appear independent of his father, however much he might respect him.

In 1897 and 1898, Picasso often went to the Prado to copy the works of the great masters. At least, the donation contains a copy of *Philip IV*, painted by 103
Velasquez in 1652–1653, and his drawings include sketches of the equestrian 134
portrait of Philip IV. Picasso, to judge by the character and development of his work, was never a traditionalist, and the idea of using what he had learned from the great painters of the past to evolve a traditional style for his own work could never have crossed his mind. He simply wanted to test himself in one more discipline. Such activities were very important to him during the last decade of the century.

On the other hand the donation includes two canvases in oils, painted in Madrid, which are distinguished by the *sfumato* already mentioned, in mauves, misty greens and greys. In conception, that is, they belong among the paintings done in Barcelona in the spring of 1897, and can be considered as preceding his Modernist period. The forms are naturalistic, but the tone, the colour and the atmosphere are subtly elusive. Both canvases were painted in the Retiro park. One of them shows a summer-house backed by an 101
irregularly shaped clump of trees, and the other a grove. Both are reflected 102
in the lake which occupies the foreground in both paintings, which are small and of equal size. Most of the donation consists essentially of works done by Picasso among his own family, wherever they might happen to be living; it is thus no wonder that there are so few examples of what he produced during his stay in Madrid.

These two pictures reveal the first stirrings of Modernism in Picasso. The same ferment comes to the surface in his drawings. The donation contains five sketch-books of drawings done in Madrid, three with uncertain dates in 1897 or 1898, and two dated March 1898. None of them suggests any definite influence of, or even contact with, the artists working in the

101. El Retiro. Madrid, 1897–8.

102. A lake at El Retiro. Madrid, 1897–8.

103. Copy of Velasquez's portrait of Philip IV (1652–3). Madrid, 1897–8.

104

105

capital at that time, but they show very clearly Picasso's development from the phase immediately preceding, and we can sense in them some of the loneliness and disillusion of those months in Madrid.

The sketch-books dated 1897 and 1898 show two types of sketches, those drawn from life, which have an objective clarity of vision, tremendous vigour and great subtlety of drawing, and those springing from the imagination. The first are sketches of things seen in the street—people, horses, carriages and so on—interiors, trees in the Retiro park sketched in sanguine, children, cats and details of hands or heads. Among the imaginative sketches two themes predominate—chimneys in an expressionistic style, intensely black, flat, and including a fragment of wall above which the chimneys rise at an oddly oblique angle, and very unusual drawings of women with long bell-shaped skirts striped horizontally in black and white, like zebras. One of these drawings is in ink on a sepia watercolour background, and others are in pencil or charcoal. Some of the drawings of workers in these sketch-books must have been done in Barcelona, as they are mostly carters of a Catalan type, wearing long smocks and Catalonian caps. They are interesting for their vigorous lines. There are some interesting pictures in the two books dated March 1898: a portrait of Pepe Illo taken from some old print, a copy from one of Goya's *Caprichos*, and the first known picture by Picasso of a balconied window and nothing else, a subject he returned to in an oil-painting in Barcelona, and which he later elaborated in his *Windows* around 1919. There is also a curious caricature inscribed '*Rechs pre-rafaelista*' (doubly interesting as it shows that Picasso was acquainted with the English movement founded in 1848) showing the figure surrounded by a series of outlines like haloes. A sketch on a loose sheet of a girl full-length and in profile is outlined in the same way, and probably belongs to the same time and place. Picasso may have become acquainted with English trends in painting through his friend Sebastian Junyent (1865–1915) who had been in England before he met Picasso in Barcelona.

This tendency to stylize is balanced by sketches of street-fights which seem to be taken from life, apparently minor drawings, but with an extraordinary freedom of line, giving an immediate sense of action and movement. The same style appears in a drawing of a girl in profile with a kerchief on her head, *Manola*.

But Picasso's stay in Madrid was rudely interrupted. He fell ill with scarlet fever at the beginning of June 1898, and decided to convalesce in Barcelona, where his friend Manuel Pallarés invited him to spend a holiday with him in his village, Horta de Ebro (called Horta de San Juan since 1919), a mountainous spot in the province of Tarragona. On June 24 the two friends left for Horta de Ebro. They did not remain in the village all the time, but in fine weather went up into the mountains, sleeping in caves where provisions were sent up to them, making friends with the shepherds and living close to nature. It is very important to remember that Pablo Picasso said 'Everything I know I learnt in Pallarés' village'. This is even more interesting when we realize that the work he did there—a few oil-paintings, a sketch-book and some single drawings—apparently does nothing to justify this belief. But it was an inward, psychological happening rather than any discovery of new techniques. From Málaga to Madrid, Picasso, though he always exercised some freedom of invention, had been constantly tied by art-school disciplines, and influenced to a greater or less degree by his artistic environment. In Horta de Ebro, although he did not immediately record everything

106

107

104
108
110
111

109

527

130
538
105

104. A carter. Album 11. Madrid, 1897–8.

105. Profile of a woman, a 'Manola' (detail). Madrid, II-1898.

106. Chimneys. Album 13. Madrid, 1897–8.

107. Women dancing. Album 13. Madrid, 1897–8.

108. Portrait of Pepe Illo. Album 14. Madrid, III-1898.

109. 'Rechs prerafaelista.' Album 15. Madrid, III-1898.

106

107

108

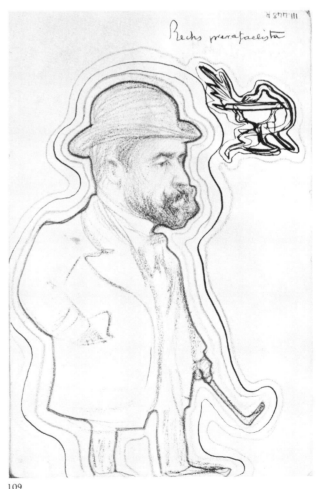

109

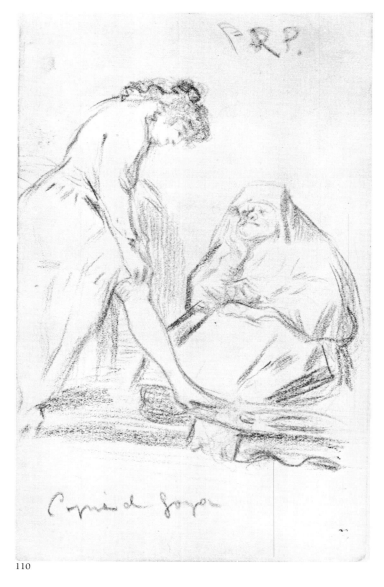

110

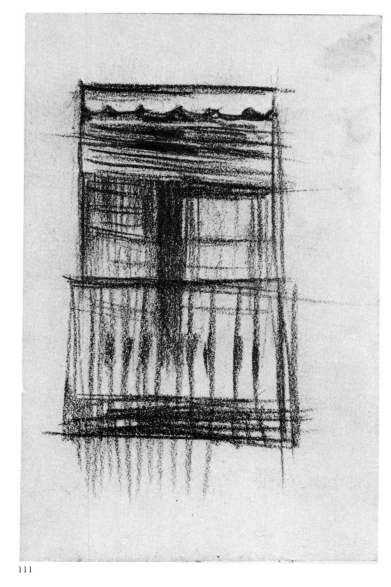

111

he saw and felt, he took stock and realized his isolation, his need for self-reliance, his independence in the face of the world, both personal and artistic. This mountain solitude in the company of simple villagers and goatherds who knew nothing of art—for at this time remote country districts were not yet contaminated by industrial civilization—must have refreshed his spirit, strengthened his resolves, and confirmed his lofty ambitions. He stayed in Horta de Ebro until February 1899, when he returned to Barcelona.

Obviously the new situation is expressed in the work done at Horta de Ebro by a greater directness and naturalism, with a more luminous colour-range in the oil-paintings. Although some which may have been painted there continue with the lilac, mauve and violet range, the most characteristic ones are dominated by yellow and blue. They are small paintings of houses, village streets, interiors of buildings with carts, or mountains partly covered with vegetation.

However, Picasso was not only concerned with visual experience, since he painted at this stage a picture which does not belong to the donation, but which reveals the constant ferment of his mind—*Aragonese Customs*,

112

113

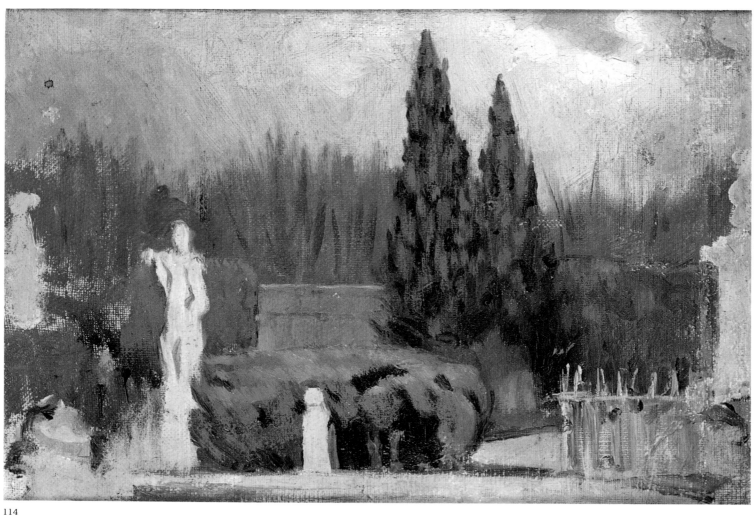

114

115

116

117

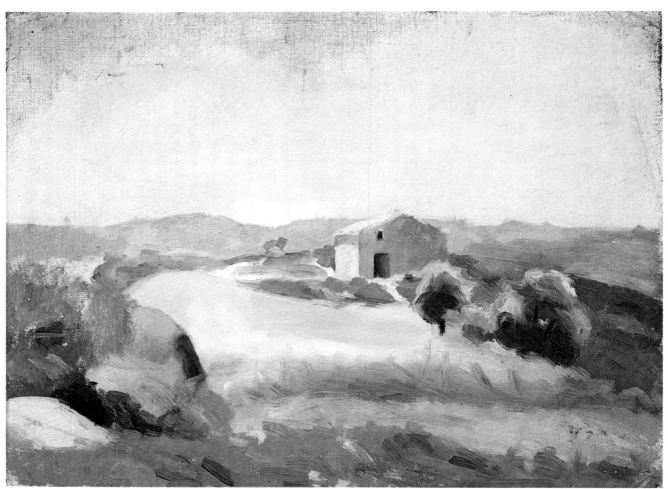

118

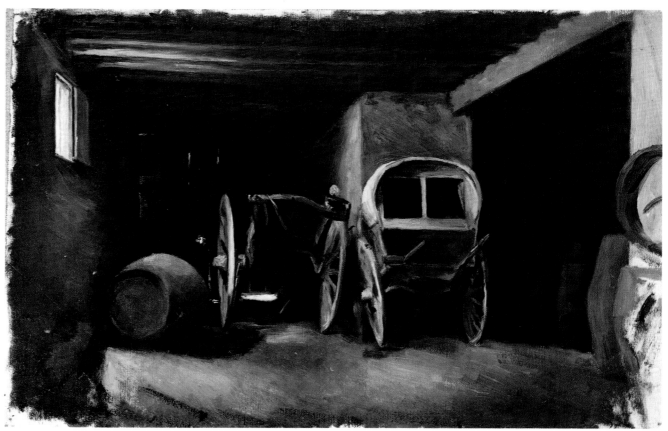

119

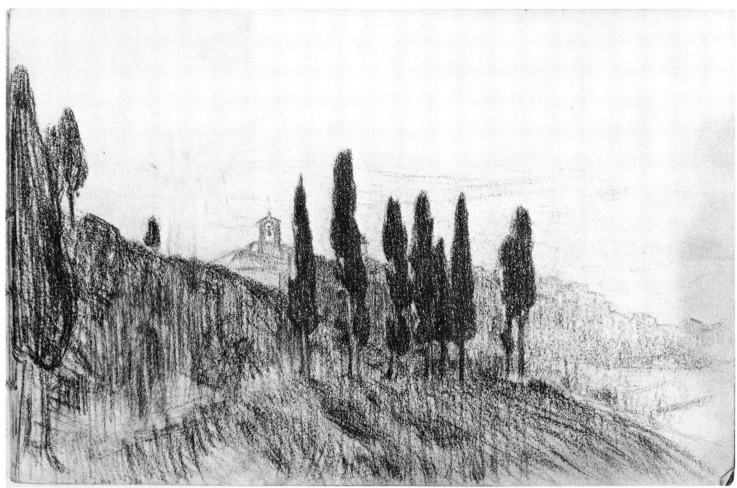

120

116. *Mountain landscape.*
Horta de Ebro?, 1898–9.

117. *Mountain stream.*
Horta de Ebro?, 1898–9.

118. *Landscape with a house.*
Horta de Ebro, 1898–9.

119. *Interior with carts.* Horta de Ebro, 1898–9.

120. View of Horta de Ebro. Album 16.
Horta de Ebro, 1898–9.

121. Olive-oil plant belonging to the Pallarés
family. Horta de Ebro, 1898–9.

121

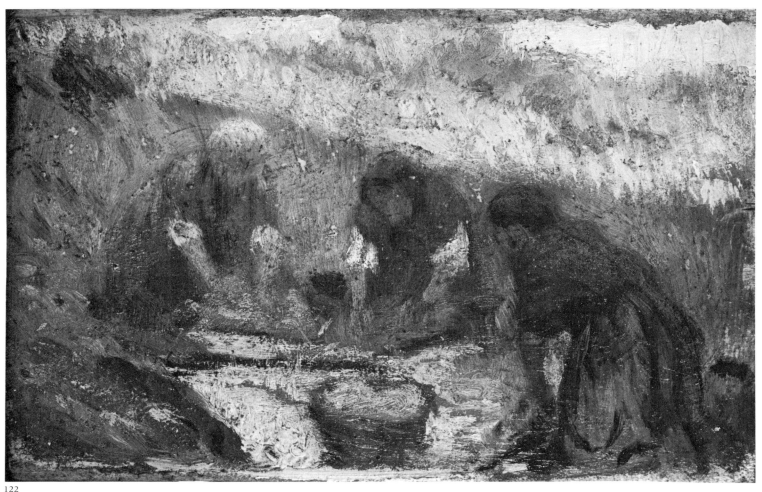

122

123

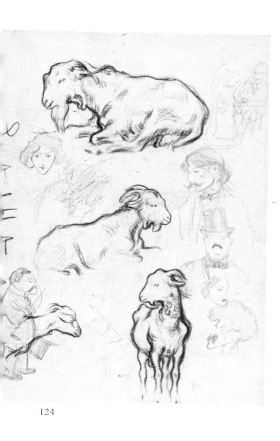

124

which won honourable mention at the National Exhibition of Fine Arts and a gold medal at the provincial exhibition in Málaga.

But his need at present was to convey the impressions he received in the Puertos del Maestrazgo, alternating with the peaceful life of the village, at the highest point of which, 500 metres above sea level, stood the Pallarés' house, at 11, Calle Grau.

The sketch-book from Horta de Ebro (1898–1899) is chiefly distinguished by the vigour and realism of the drawings. There are landscapes and their details in abundance, and the artist delights in such powerful contrasts as the intense blackness of cypresses against a soft background. This smoothness, 120 combined with precision of line and some very effective surface shading, appears in other pictures of trees, houses, churches or village streets. Figures of regional types, probably sketches for the painting just mentioned, have the same quality. The dominant characteristic is always firmness. In other 602 drawings we can see a new feature which Picasso was to develop in his next phase, leading up to 1900—a darkly shaded effect over all or part of the work, which may be a scene with several figures, or one figure alone. Both the 146 background and the figure are treated in the same way, with a series of lines very close together. The direction of the lines clearly indicates the different surfaces, though the artist also outlines the figure for greater emphasis. There are also drawings with delicate, extremely intricate lines, and sketches done by the more usual methods for drawing from life, with hands, cypresses, women, children or other figures flung on to the page at random, without 594 any regard for their relationship to each other.

There is also a quantity of drawings on loose sheets done in Horta de Ebro. Some outstanding ones show a country landscape, peasants, or washer- 136 women at work. The gradation of tone is perfect, and though they are not 137 always fully representational there is a strong feeling of reality. Picasso knows how to obtain the effect he wants, and he knows, too, that he can do it in very different ways, either drawing the object directly or suggesting it by outlines, shadows and intricate line-patterns which are not in them-selves strictly representational. There are also figure drawings and sketches of goats, fascinating by the way they evoke sensations of touch as well as by 124 perfection of their form. Here Picasso reveals, or rather confirms, that he is a great animal painter. His pictures of donkeys, horses and bulls done in 556 the same period already clearly show his mastery in this field.

122. Three washerwomen. Barcelona or Horta de Ebro, 1896–8.

123. Market scene. Horta de Ebro?, 1896–8.

124. Studies of goats and other sketches. Horta de Ebro, VIII-1898.

125

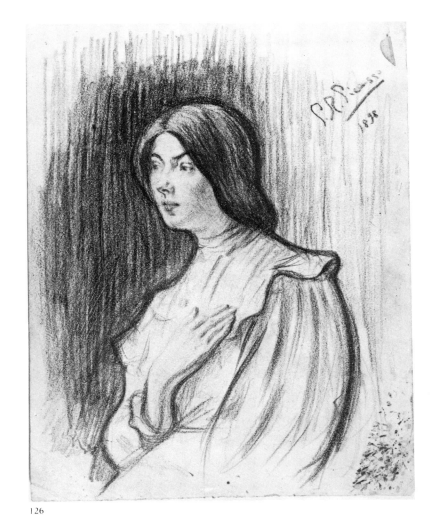

126

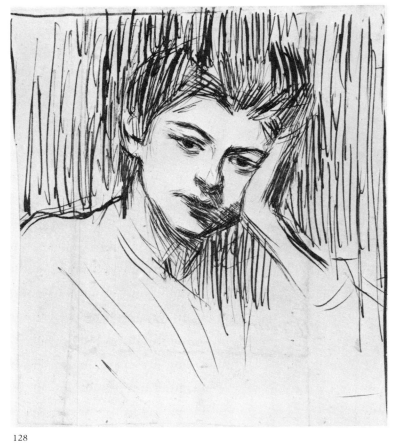

128

127

76

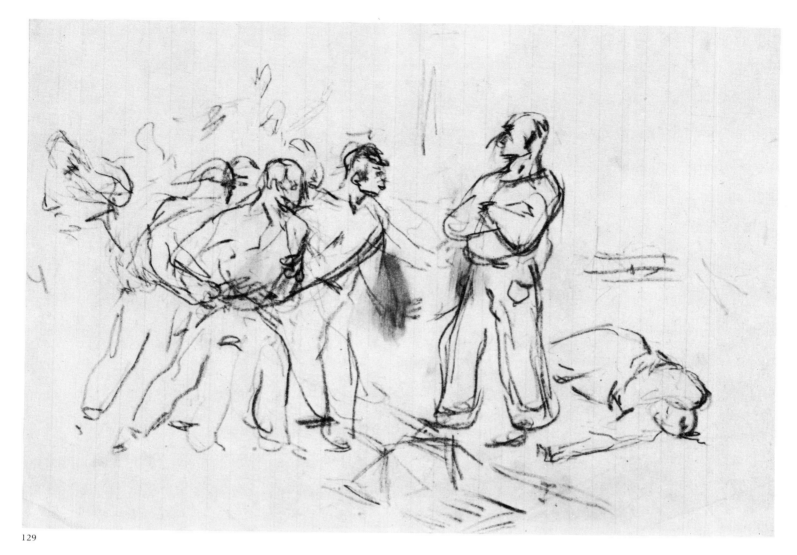

129

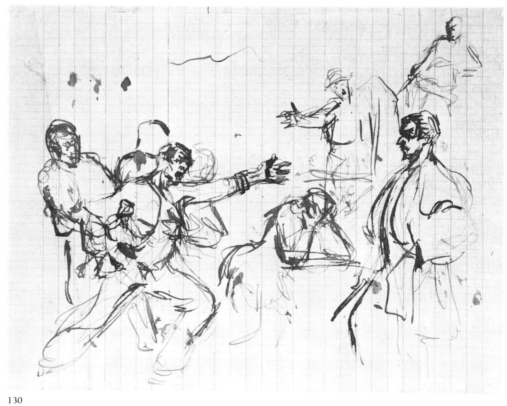

125. Tree at El Retiro. Album 15.
Madrid, III-1898.

126. The artist's sister Lola. Barcelona, 1898.

127. Sketch of the artist's father (trimmed).
Barcelona, 1898–9.

128. The artist's sister Lola. Barcelona, *c.* 1899.

129. Street fight. Madrid, 1897–8.

130. Street fight (detail).
Madrid, XII-1897.

130

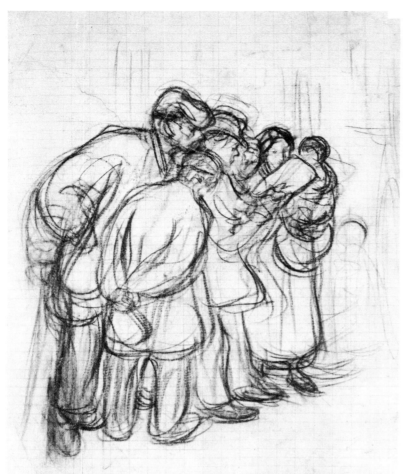

131

132

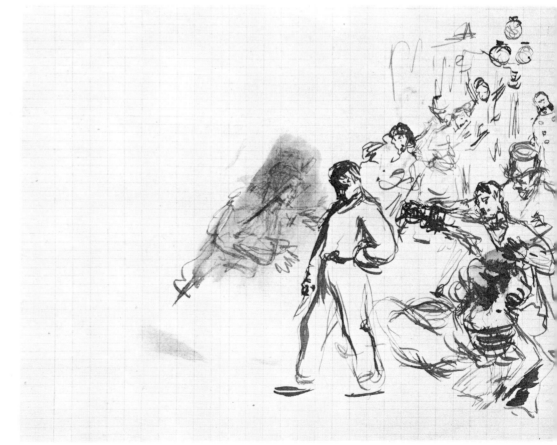

131. Onlookers. Barcelona?, 1897–9.

132. Beggars. Barcelona? 1897–9.

133. Street scene. Madrid, 1897–8.

134. Various sketches. Madrid, 1897–8.

133

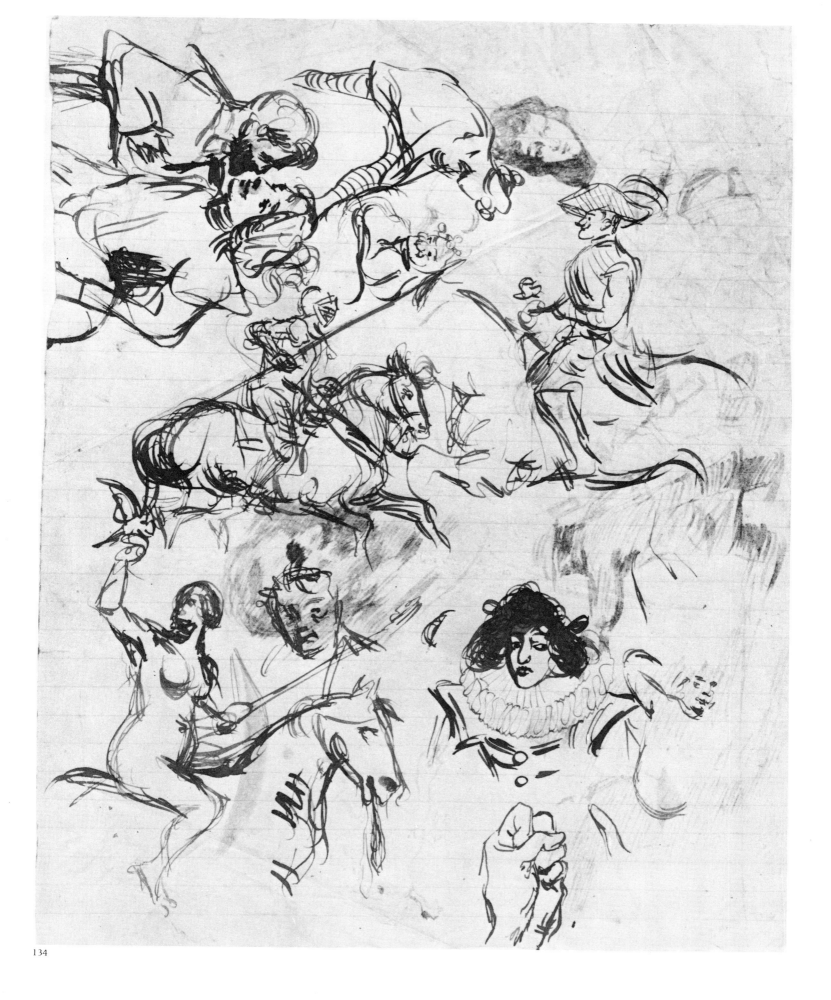

134

135

136

137

135. Study of a hillside.
Horta de Ebro, 1898—9.

136. Washerwomen. Horta de Ebro, 1898—9.

137. Landscape with a peasant.
Horta de Ebro, 1898—9.

138. Landscape with a peasant.
Horta de Ebro, 1898—9.

138

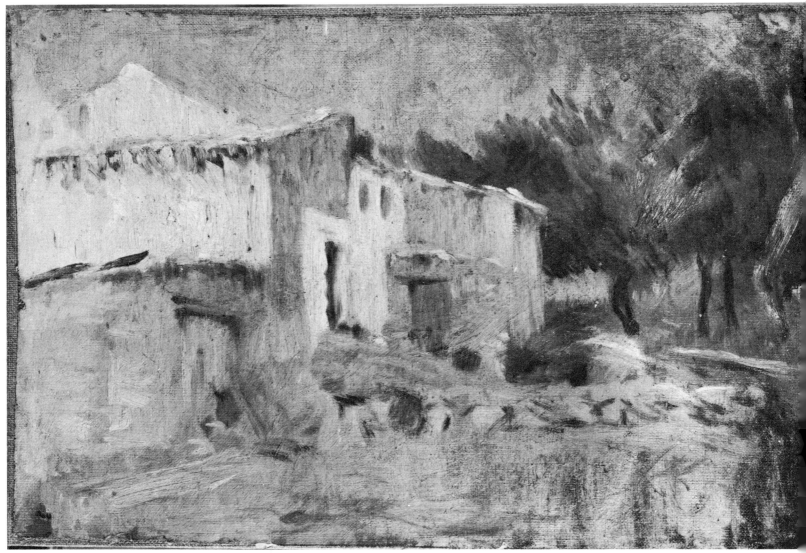

139

139. View in the village of Horta de Ebro?
1898–9.

140. A passageway.
Horta de Ebro?, 1898–9.

141. Landscape. Barcelona or
Horta de Ebro, 1898–9.

142. Woodland. Barcelona or
Horta de Ebro, 1896–8.

140

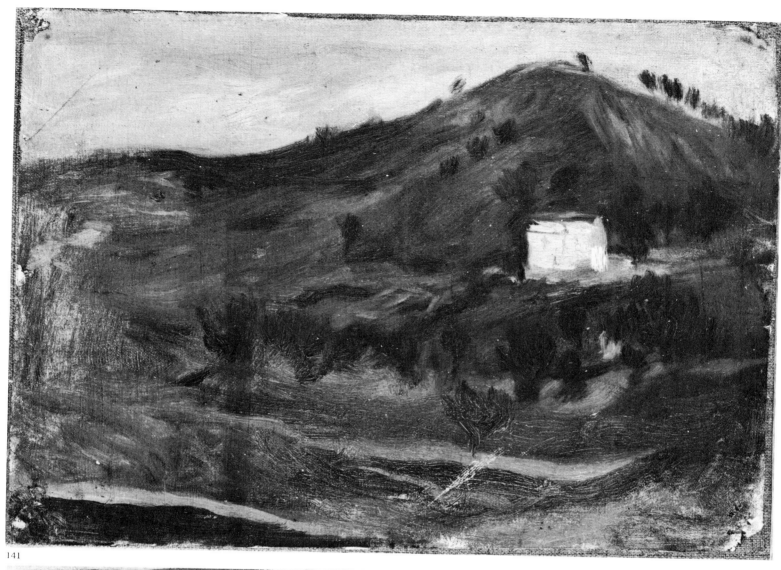

141

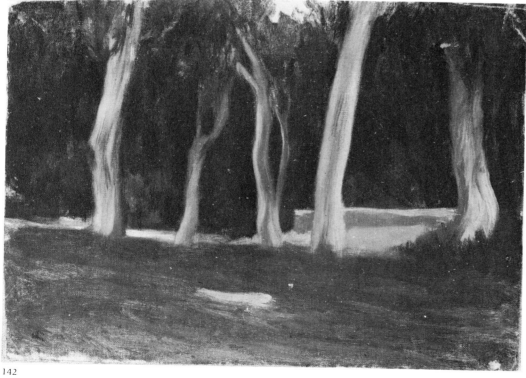

142

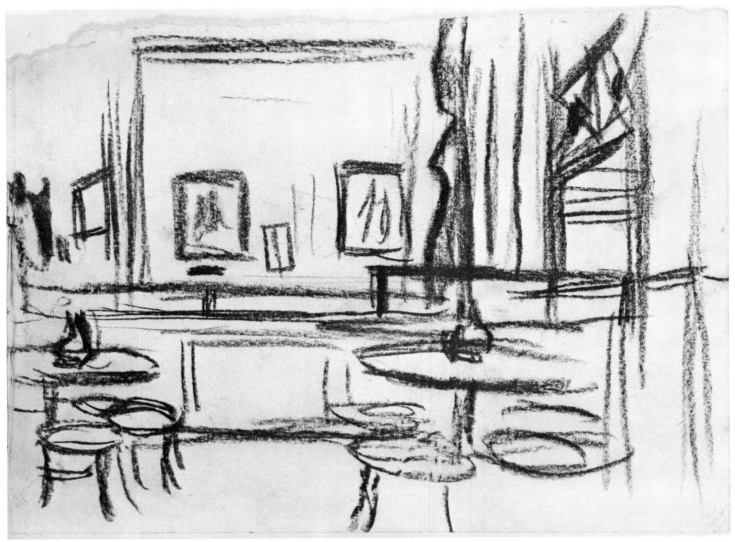

143

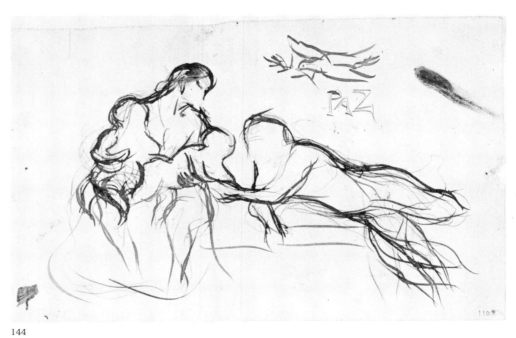

143. Café interior. Barcelona, 1897–9.

144. 'Peace'. Barcelona?, c. 1899.

144

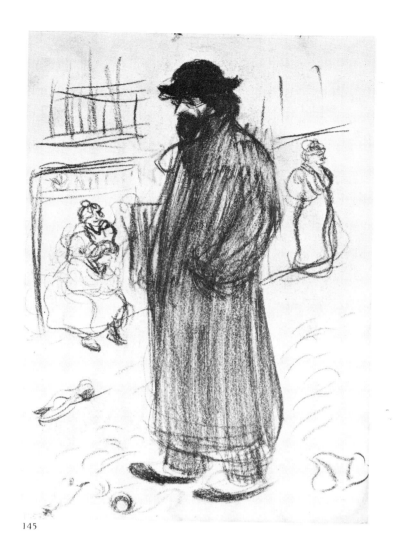

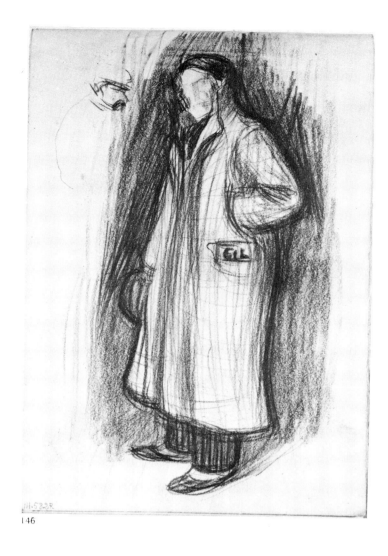

145. Figure and street scene. Album 16.
Horta de Ebro or Barcelona, 1898–9.

146. The artist's father. Album 16.
Horta de Ebro or Barcelona, 1898–9.

147

147. Printed menu for 'Els 4 Gats'.
Barcelona, 1899–1900.

The Modernist Period (1899–1900)

As I have said, Picasso went back to Barcelona in February 1899. But he had differences with his family, and left home to go and live at the studio of the sculptor Cardona's brother at 1, Calle de Escudillers Blancs. He was tired of nature and of solitude and longed for human contact. Within a very short period (1899–1900) his art was to undergo a great change, stimulated by the ideological vitality and wealth of techniques of the Modernist movement.

I have already pointed out that Modernism was flourishing when Picasso arrived in Barcelona, but that before coming into contact with the new approaches in form, line and colour, he had to follow the road begun in Corunna. I have also said that before leaving for Madrid in the spring of 1897 he was already showing signs of interest in some aspects of the immense and varied Modernist (Art Nouveau) movement centred upon Paris.

But it was the café 'Els Quatre Gats' (Catalan for 'The four cats') that did most to keep Picasso in constant touch with the new trends which were opening the way to the 20th century. This establishment, which had plenty of room for exhibitions, recitals and a marionette theatre, was what has been called a 'cabaret of the arts', inspired by Aristide Bruant's 'Mirliton'. In Berlin, Wolzogen opened the 'Überbrettl' with the same end in view, except that there was a vast difference in atmosphere between the French and German capitals. The founder of the '4 Gats' was Pere Romeu, and its moving spirits were the designer and painter Ramón Casas (1866–1932) and the painters and writers Santiago Rusiñol (1861–1931) and Miguel Utrillo (1863–1934). The establishment was opened on June 12, 1897, in a building belonging to the architect Puig y Cadafalch (1869–1956)—who, with Gaudí and Doménech Montaner, was in the forefront of Barcelona's Modernist movement in architecture—at the junction of Calle Patriarca and Calle Montesión, near the Puerta del Angel. It remained open until July 1903 and then came into the possession of the Circle of Saint Luke. The avant-garde of Barcelona met there and held some interesting exhibitions.

It goes without saying that the artistic creed followed at the '4 Gats' was that of Modernism. The movement was ideological, literary and artistic, blending symbolism with a new element, hard to define because it was still in an embryonic stage, which later developed into the style of the 20th century. The Modernists admired Nietzsche, Wagner, Huysmans, Maeterlinck and Ibsen. In painting, they were interested not only in French artists like Toulouse-Lautrec (1864–1901), but also in Whistler (1834–1903), Steinlen (1859–1923) and the English Pre-Raphaelite movement led by Dante Gabriel Rossetti (1828–1882). Anthony Blunt and Phoebe Pool have proved that the artists of the '4 Gats' knew and admired the work of the Norwegian Edvard Munch (1863–1944), which meant that they had also had some indirect contact with Expressionism. This is not surprising if we remember that they had visited Paris even if they had not studied there, and

148

149

148. Seated man. Album 10. (?), 1897–9.

149. Street figures. Album 10. (?), 1897–9.

150. *El Greco figure*. Barcelona, 1899.

151. *Calle Riera de San Juan*. Barcelona, 1900.

152. *Seated woman reading*. Barcelona, 1899.

that Munch had studied in Paris with Bonnat and exhibited there in 1897 his great *Frieze of life*. Casas studied in Paris with Carolus Durand in 1882, and Santiago Rusiñol paid many short visits to Paris, mostly between 1887 and 1894. Isidro Nonell (1878–1911), another important avant-garde painter who frequented the '4 Gats', was in Paris in 1897 and in 1900, and exhibited there both times. Thus the essence of European culture reached Barcelona by way of Paris, and had inevitably to find an outlet in literature and art. There is almost no need to mention Rusiñol's revolutionary fervour; we need only recall the 'Fiestas Modernistas' he organized at Sitges (Barcelona) in 1892, 1893, 1894 and 1897. In 1893 Rusiñol founded the Cau Ferrat in Sitges, and the following year he bought in Paris two paintings by El Greco, *San Pedro* and *Santa Magdalena Penitente*, which were carried in procession to Sitges. The interest in El Greco revived by Rusiñol influenced Picasso's work at one point, and Sabartés has said that El Greco fascinated him. In 1899 and 1900 Barcelona became almost an antechamber to Paris, where Picasso was to go in a few years, after several trial visits.

Picasso began to visit the '4 Gats' as soon as he came back to Barcelona. He made friends with Nonell and began to see more of Rusiñol, Casas, Pitxot, Mir and other artists whom he must have known already. Other friends of his were the brothers Ramón and Cinto Reventós and the poet Jaime Sabartés who was brought to the studio in the Calle de Escudillers Blancs by Mateo Fernández de Soto. Years later he became Picasso's secretary. At the beginning of 1900 Picasso moved to a studio at 17 Riera de San Juan with Carlos Casagemas, to whose literary circle he belonged.

I have already referred to the exhibitions of drawings and paintings in the '4 Gats'. In 1897 the exhibitors were Casas, Rusiñol, Utrillo, Nonell, Canals, Mir and Pitxot. Later the famous tavern launched the work of the typical Modernist Xavier Gosé (1876–1913), the ill-starred Carlos Casagemas (1881–1901) and Ricardo Opisso (1880–1906), whose work always remained in the style of 1900. But in February 1897 the work shown was Pablo Picasso's. He exhibited a few watercolours, but mainly portraits in pencil, ink or charcoal (sometimes on a tinted background) of all his friends, Rusiñol, Mir, Sabartés, Nonell, Cinto Reventós, Juan Vidal Ventosa, Mateo Fernández de Soto, and so on. About this time his colleagues began to urge him to sign his work 'Picasso' instead of Pablo Ruiz Picasso. He did not reach this point until 1900 or 1901, and then only gradually, after shortening his signature to 'Pablo R. Picasso' and 'P.R. Picasso'.

Having described the artistic life of Barcelona when Picasso rejoined it, I can turn to his work during this period, although I ought to give some idea of the Modernist style and principles, since Picasso adhered to them fairly closely.

In painting, Modernism came to Barcelona mingled with Impressionism, but more Whistler's Impressionism than Monet's, more that of Degas then of Renoir, with delicate greys, mauves, blues and white, ochres shading to violet, a more or less *sfumato* effect, and gently curving lines.

Picasso could make masterly use of all the range of sombre tones, and he was using them increasingly from 1897 onwards. But he followed the trend mainly in drawing, occasionally alternating Modernism with an element of Expressionism or using the two side by side. The whiplash line, characteristic of Art Nouveau ornamentation, appealed both to the lyricism and to the natural impulse towards freedom in Picasso's temperament. As for the undulating, bell-shaped, sinuous forms, he saw them all around because

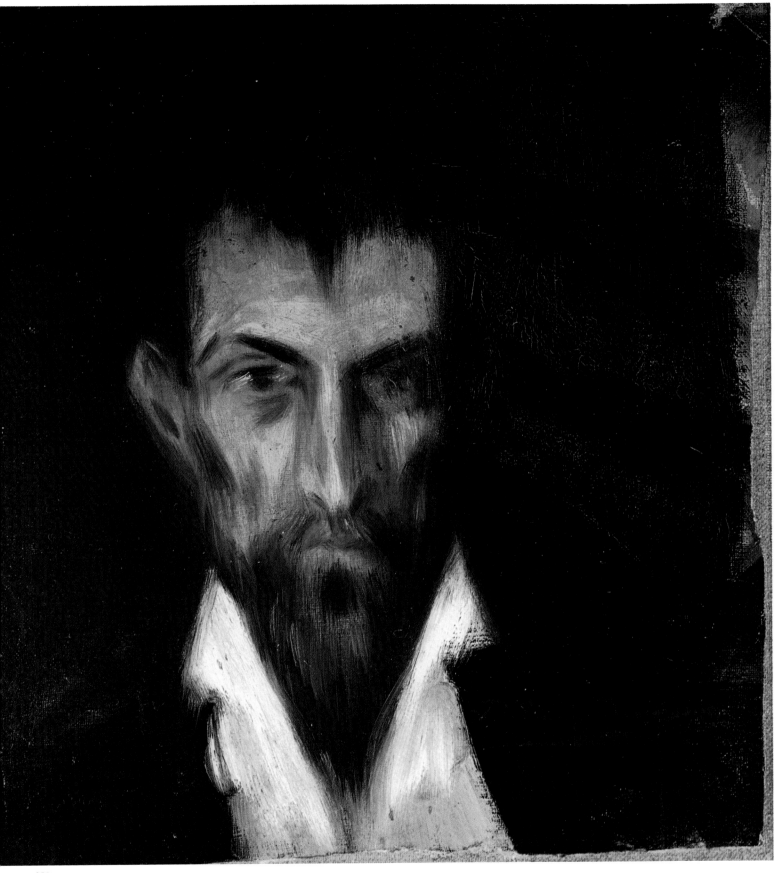

150

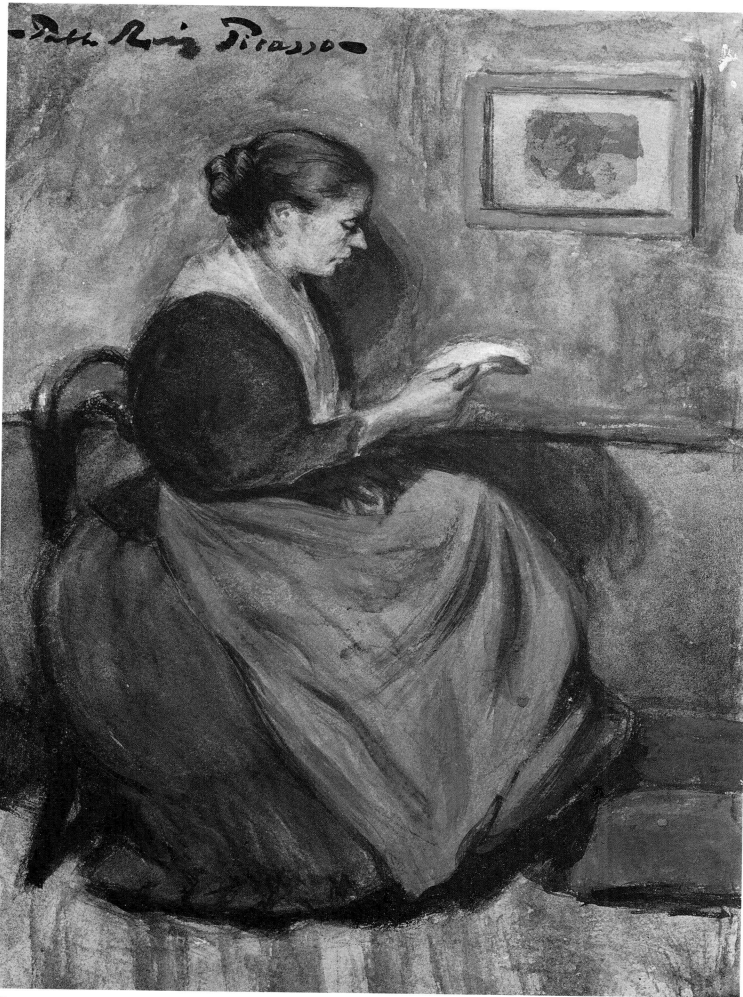

152

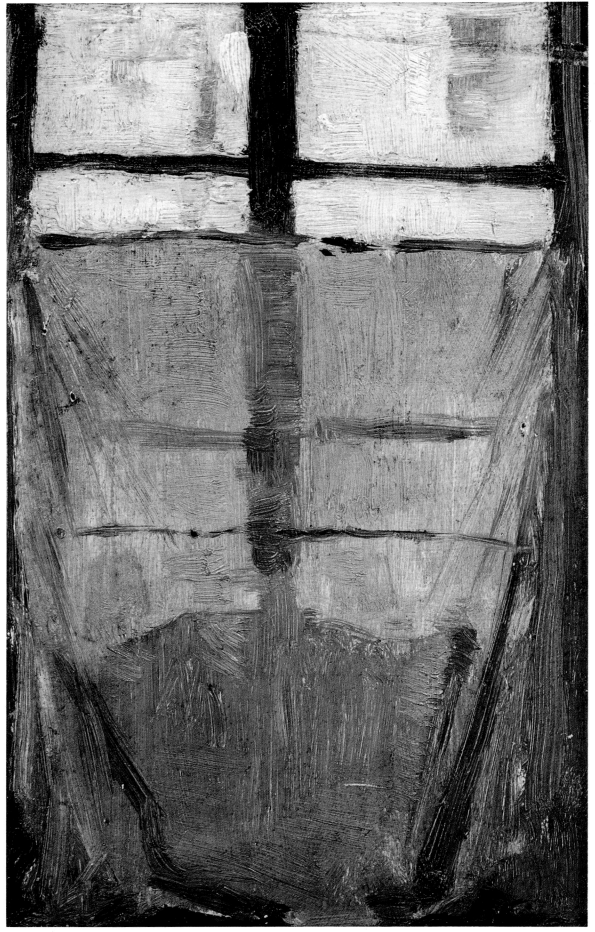

153

154

155

153. *The window*. Barcelona, 1899.

154. Profile of a seated woman and a cock.
(?), 1897–9.

155. Portrait of the writer Ramon Reventos.
Barcelona, 1899.

Modernism was bound up with fashion, and indeed with his whole environment. He made the acquantance of Steinlen's work through his *Gil Blas Illustré*, and he doubtless had access to reproductions of Rossetti, Munch and Lautrec. In fact, even before staying in Paris from October to December 1900, he had indirect knowledge of the European movement and could observe its influence on the painters of the '4 Gats'.

But now that a large number of Picasso's Modernist drawings have come to light—they are most abundant in the years 1899 to 1900—nothing could be more wrong than to try to explain the style of these drawings by definite influences. Some aspects of them may remind us of Nonell, others of Casas, Steinlen or Munch. But this is all superficial. Picasso's work is another, completely independent, facet of the universal European movement, the sequel to the earlier periods we have seen, and the forerunner of his Blue Period from 1900 onwards. Picasso's 'independence' is the same phenomenon as we always find when we go deeply into the work of any great artist of any period. How much of Caravaggio is there in Velasquez? Nothing. But of course if we look, as we must, at the broad outlines of history, the painter of *Las Meninas* falls within the wide and varied current of Baroque art, which began with Caravaggio. Critics find it very useful to be able to talk about 'influences', because it enables them to explain something they do not understand by something they do—often completely erroneously and resulting in utter confusion.

We have to look more closely at the paintings done at this stage, when Picasso was eighteen or nineteen, because they show a notable advance in the clarification and simplification of his forms which become increasingly monumental. In 1899 he painted *Closed window*, which, as he himself remembers today, was that of the house opposite his studio in the Calle de Escudillers Blancs. We have already said that in Madrid he drew the same architectural feature in one of his sketch-books, and we also mentioned its connection with the famous *Windows* of around 1919, but basically this is something quite different. In the later works Picasso uses his own window or balcony to symbolize an opening on to the wide and beautiful world outside. The *Closed window* is alive with hidden drama, not because we imagine something tragic going on behind the limp blinds, but because it is mysterious by the mere fact of being closed. Yellow and grey shades predominate.

That year Picasso also painted the window of his studio, half-covered with a translucent yellow curtain. The contrast of this colour with the strong white light from above and the black window-frame provides a more strictly visual and realistic theme. In 1899 or 1900 Picasso painted *Riera de San Juan*, a view of the street with people walking along it. Its great interest lies in the fact that for the first time the artist is beginning to discard the completely representational style. Houses and people are indicated by simple brush-strokes, and we have a general impression of light, depth, and accuracy of detail. For example, a spot of paint indicating a person is divided into two at the bottom to form legs; the mind supplies what is missing. Every stroke is pregnant with meaning, and though the pointers we are given are few, they are sufficient. This oil-painting is small, but it is one of the masterpieces of this phase. Obviously it is not every artist who can create a sense of perspective with such simple forms. Sight-lines meeting at sharp angles link the patches of colour and make the composition into a coherent whole.

About sixty years later, Picasso again used barely differentiated spots of

156

153
151

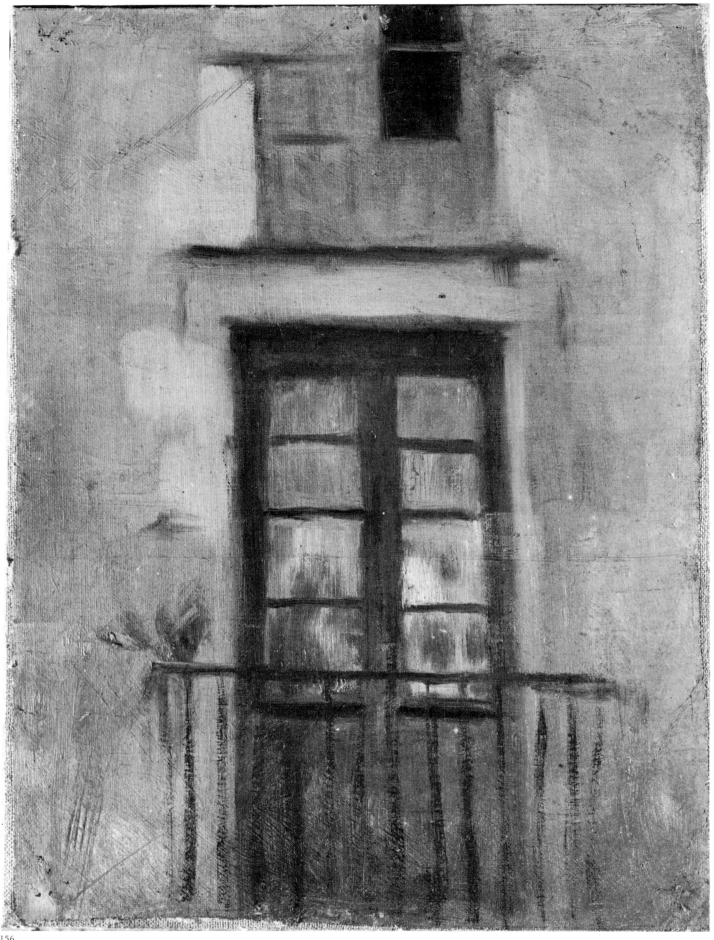

157

158

colour—this time in watercolour—to create the masterly pictures of *La Tauromaquia*, published by La Cometa in Barcelona.

Three canvases, all similar in feeling, in a predominantly dark colour-range, must belong to 1899. They are portraits, head and shoulders or rather less than half-length. Greys, black, dark blues and ochres so dark as to be almost black are the only shades contrasting with the flesh. The impact of El Greco is obvious, at least in the *Greco figure* which shows little more than 150 the head, so that there is no period costume to help in identification. It is of a Spanish grandee type with a long face and pointed beard. The brushwork is irregular, but has a distinct relationship with the scraping and rubbing which El Greco used in his canvases to give special effects in certain parts of the painting. Another of these three canvases, *Unknown man*, shows the same 158 technique, although the type of face, and the character implicit in it, belong to our time. The third canvas, the most realistic of the three and the farthest from El Greco, is a portrait of Casagemas, the painter better known for his 157 friendship with Picasso than for his suicide at the age of twenty. These three pictures have an undeniable maturity, quite different from the natural precocity or the sudden explosion of genius which produced the sombre portrait of *Aunt Pepa* in 1896, when Picasso was fifteen.

A number of other oil-paintings were done in 1899 and 1900, or at any rate before his first visit to Paris. Four of them, showing a man sitting by a sick woman and embracing her, are related in theme and composition to the drawings of similar subjects done about the same period. Picasso had probably had some contact with Munch's expressionist paintings, but the style is entirely his own. All four paintings are small, and broader than they are high. One of them has its subject in the shadow thrown by the light which 186 comes through the window in the background. Their colour and atmosphere

156. Closed window. Barcelona, IV-1899.

157. Portrait of Carlos Casagemas. Barcelona, 1899.

158. Portrait of an unknown man. Barcelona, 1899.

159

159. Kissing the corpse.
Barcelona, 1899–1900.

160. Interior by candlelight.
Barcelona, 1899–1900.

160

96

161

162

161. Various sketches of heads.
Barcelona, 1899.

162. A beggar. Barcelona, 1899–1900.

owe more to Rossetti and the Pre-Raphaelites than to Nordic expressionism. It is known that before going to Paris, Picasso considered visiting England. But the Pre-Raphaelite school, traces of which appear, as we have seen, in a drawing in one of the Madrid sketch-books (1897–1898), offered no more than a fleeting temptation. Picasso is a Mediterranean, and it was France that was to provide the perfect stimulus for his creative urge. His interest was in form and its variations rather than in using shapes and colours to capture the fleeting moment. In these works it is interesting to compare the variants, which chiefly occur in the use of colour and light. The colour becomes 160 gradually thicker, reaching a point in one picture where the lines are almost indistinguishable. On the other hand the subject is not exactly identical in 365 the four; the symbolic representation of the lonely death of the genius 368 appears more clearly in one of them. A fifth picture shows a series of barely indicated figures by a bier. One of them is bending to kiss the corpse, while 159 others appear to be weeping. The *fin-de-siècle* pathos which, for some unknown reason, has been called 'decadent', appears to the full in this whole series of works, the subject of which is less interesting than their qualities as paintings.

Three fine paintings in the donation were carried out during the same period, perhaps a little later. One shows a pair of lovers in bright shades of red, green, rose and black against a whitewashed wall. In the left foreground 187 two pigeons are billing, sketched in a few lines—quite different from the pigeons so carefully drawn in Corunna. But in this painting everything is subordinated to the general effect; although the girl is seen full-face with the light full upon her, the features are not shown at all. And this does not surprise or worry us in the least. Another painting, *Girl in white in an* 188 *interior* (Lola), uses contrast between a dazzling white figure, again with none of the features indicated, the dark shadows, and the yellowish white light penetrating into the interior. Its effect is one of suggestion rather than statement. It has the sinuous curves already described as typically Modernist. A wonderful sense of balance is achieved by the perfect harmony of tone and by the way the central figure imposes a definite order on all the other elements of the picture.

Another *Window* belongs to this phase and was probably done in 1900. 189 It is much bolder and more advanced than the one we have described, which probably belongs to the preceding year. In this the unity of subject, form, light and colour is even stronger and more complete than in the *Girl in white in an interior*. The texture of the painting itself is as alive and interesting as the colour or the line. The effect is achieved by the relative thickness of the impasto, the smooth outlines, the vagueness of detail and the general impression of unity.

In 1900, before going to Paris, Picasso also painted a curious composition *Mask* (he called it 'the bride of El Greco') which shows a face, without the rest of the head, against a white ground enlivened by stylized flowers. 190 Greenish and greyish lilac shades predominate. Like the last painting, it goes beyond Modernism and enters the 20th century. Except in some minor, almost negligible details, Picasso had moved, in the five years between 1895 and 1900, through all possible stages of development—except Impressionism proper—between academic naturalism and a type of art verging on Fauvism and Expressionism. This mask, outwardly less 'constructed' but more enigmatic, is a milestone in the painting of our time. But Picasso himself changed, in a wild shuttle movement backwards and forwards. We have

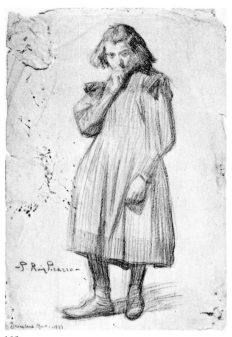

163

163. Life study of a girl. Barcelona, 1899.

164. Portrait of Santiago Rusiñol.
Barcelona, 1899–1900.

165. Portrait of Pujolá y Vallés?
Barcelona, 1899–1900.

166. Portrait of Joaquín Mir.
Barcelona, 1899–1900.

167. Portrait of Oriol Marti.
Barcelona, 1899–1900.

here only one more proof of what we know already—the strange contra-dictoriness of Picasso's work, tending towards the past and the future, revolutionary and traditionalist at the same time.

Picasso's Blue Period was about to begin, after his first visit to Paris, and with it his experiments with colour to create atmosphere, as the symbol of a situation, both moral and social. Or it might be more accurate to say that colour was the unalterable projection of a state of mind which persisted in him for some years. It ceased to be a factor in the plastic construction of a picture, and became instead a light suffusing the whole composition, as though from outside the situation portrayed.

We have now to move backwards a little, in view of the incredible speed of Picasso's development in the nineteen months between February 1899 and September 1900, and study his drawings in the same period, or rather a representative selection of them.

When he came back from Horta de Ebro to his studio in the Calle de Escudillers Blancs, Picasso put into practice the deep feeling for naturalism awakened in him by the mountains and fields of Tarragona. We find, for instance, dated March 1899 in Barcelona, a wonderful drawing of a girl, almost a child, in which the slightly geometrical effect of parallel strokes 16. gives strength, clarity and smoothness to the form. In a portrait of his sister Lola, a little later in date, the naturalistic style is softened by a lyricism which 19 later dominated his 'Ingres' period. The series of portraits of his friends which he exhibited in the '4 Gats' combines intensity, grace, sometimes a touch of caricature, and sometimes a very individual subtlety of characterisation. An outstanding portrait is that of Santiago Rusiñol, in black ink on a sepia 16 ground; the flesh is the same colour as the background, but slightly paler.

His deepening interest in Modernism is seen in the progressive increase in undulating rhythms and sinuous outlines, many of which are left open; these generally contrast with the thicker lines forming heads and hair. He drew at this time a series of female figures in ink, pencil or charcoal, and 17 very occasionally in coloured pencils. They are young women, either gay or 17 thoughtful, and we can imagine them as either professional models or ladies who took pleasure in sitting for their likeness, even if it was only a sketch. 20 There is a large number of drawings with one single figure to the page, and an equally large number of single pages—there are unfortunately no sketch-books for this period—crowded with a great variety of sketches from life, lyrically elongated figures side by side with caricatures, vague shapes next 19 to details sharply defined. They are treated by either filling in the shapes or 19 basing them on a convoluted line which is sufficient on its own to suggest volume and even texture.

There are also nudes, geometrically treated up to a point, but very 16. emotionally conceived and carried out. Although these are studies, the 16. beauty of the form, the pose and the style make them into real works of art. 17 Seeing the firm smoothness of these nudes—neither academic, lyrical nor 17 schematic, and yet all three at once—we can better understand what liberties the author of such works could allow himself.

This was the period, as we have seen, when Picasso had his first exhibition; it was also the time when he began to emerge as illustrator in an occasional art magazine. Besides the huge quantity of pages of sketches we have mentioned as belonging to this phase, the donation includes groups or series of drawings done for definite practical purposes, which are of great historical and biographical interest. There are, for instance, some sketches to illustrate

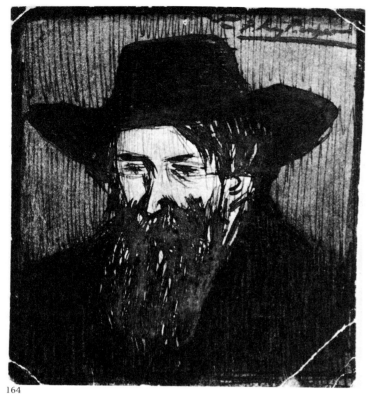

164

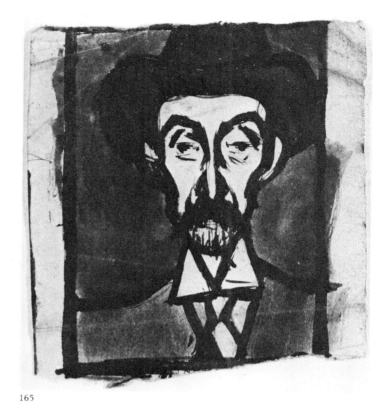

165

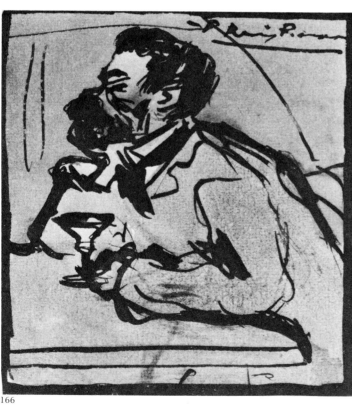

166

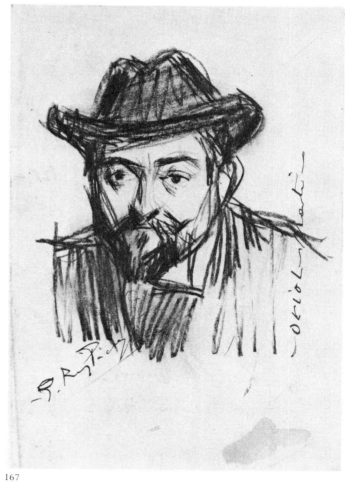

167

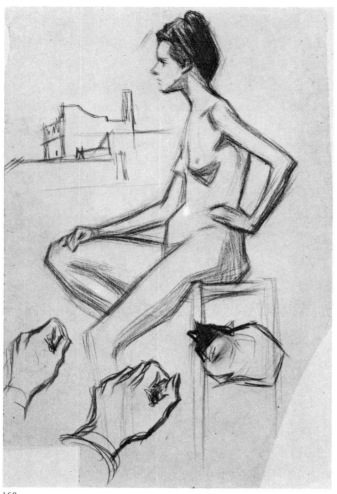

168

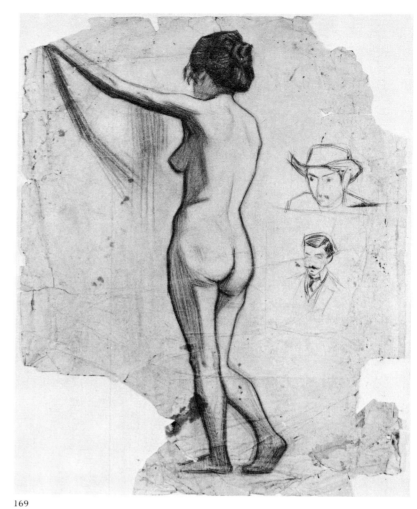

169

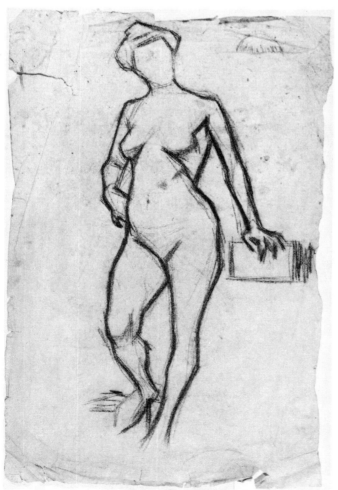

170

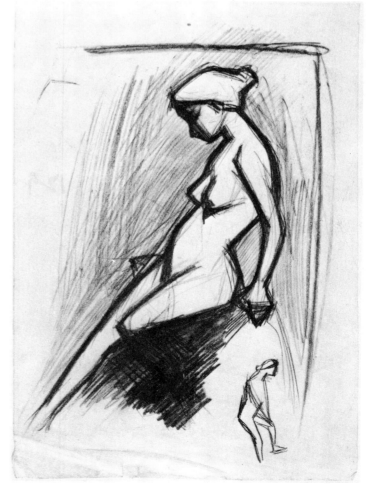

171

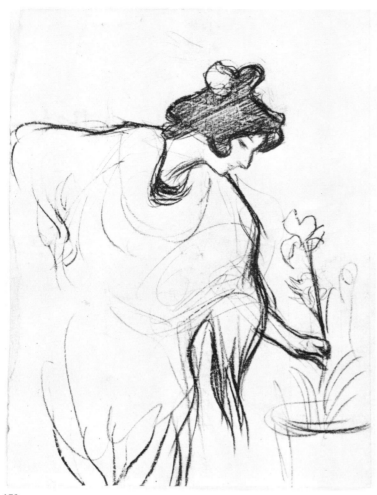

172

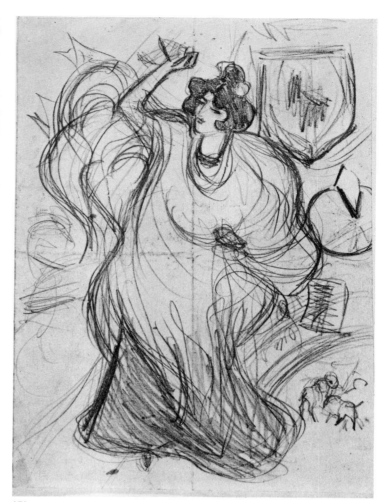

173

168. Seated female nude and other sketches. Barcelona, 1899.

169. Back view of a female nude. Barcelona, c. 1899.

170. Female nude. Barcelona, 1899.

171. Female nude in profile. Barcelona, 1899.

172. Woman with flower. Barcelona, 1899–1900.

173. Figure of a woman. Barcelona, 1899–1900.

the pamphlets of the '4 Gats', showing its distinctive ogival doorway and various figures in the dress of the period. More interesting still are three very different sketches for a poster for the 'Caja de Prevision y Socorro' (Social Insurance) for the year 1900. One of them shows a matron, full-face, in a protective attitude, but the other two illustrate the aspect of bereavement and poverty, showing a seated woman dressed in black, with a poignant expression of grief, holding a tiny child on her knee. We can class with these posters the large group of expressionist drawings showing hospital wards and patients, women with grief-stricken men at their side, or girls kneeling in prayer by the sufferers' beds. All these drawings are very beautiful. The techniques vary from very thick pen-strokes to networks of delicate pencil or charcoal lines like those appearing in the sketch-books of the preceding stage. One particularly fine one shows a sick girl holding up the sheet in her hands. The perfectly accurate way the folds of linen fall, the smooth lines, the use of shadow—enough, but not too much—make this drawing into a masterpiece although the artist could not have considered it as such, since on the same page, below the drawing, he added a series of juxtaposed sketches, very different in form, technique and spirit. The ghost-like figure of a kneeling girl sketched on a sheet used widthways, appears alone on another page, vertical this time, in simple outline, extremely delicate and spiritual. Picasso is clearly at the end of a phase and ready to pass on to the next by one of those swift changes that his unerring instinct demanded. It was another Spaniard, Manuel de Falla, who said that in art, intelligence could be no more than the servant of instinct.

The years 1899 and 1900 also produced a series of drawings of bullfighters

693
694
175
204

177

176
174

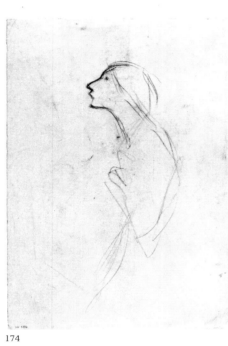

174

175

and bullfighting scenes formed entirely of curves and loops like beautiful handwriting, with every figure so perfectly placed that it seems to be surrounded with exactly the space it needs. There are sheets of paper covered with drawings on this subject, and one watercolour of a *Picador and his assistant*, both on horseback, with intense colour and opulent shapes, dominated by yellow and red, with black, blue and white as supporting colours.

It cannot be said that the illustrated press in Barcelona at the time paid great attention to the young Picasso. His work must have seemed too unruly, and perhaps many people would have preferred the more ordered technique of Casas. However, two reviews published his drawings. *Joventud* (Youth), in the issue for July 12, 1900, carried an illustration by Picasso to the poem by Juan Oliva Bridgman, *El clam de les verges*, and in the August 16 issue in the same year Picasso illustrated another poem by the same author, the title of which was a quotation from *Hamlet*, '*Ser o no ser*' ('To be or not to be').

174. Female profile. Barcelona, 1899–1900.

175. Sketch for a poster for 'Caja de Prevision y Socorro'. Barcelona, 1899–1900.

176. Kneeling woman and other sketches. Barcelona, 1899–1900.

177. Sick woman (detail). Barcelona, 1899–1900.

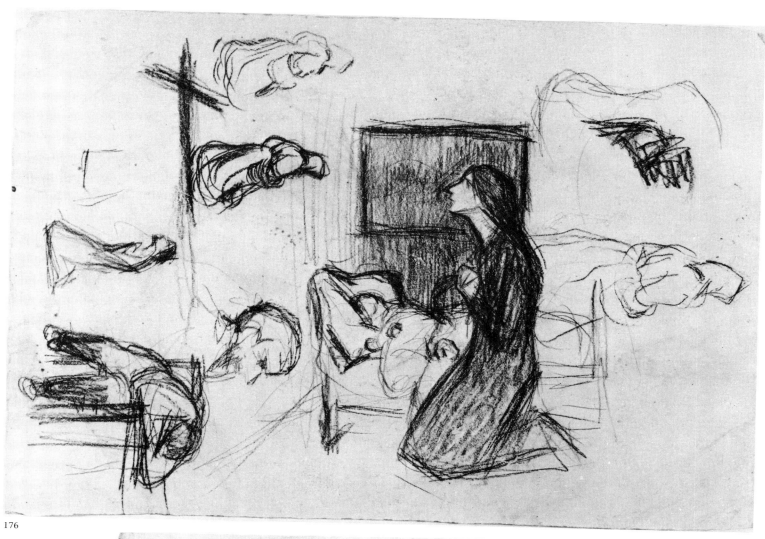

176

177

103

On September 6, 1900, *Catalunya Artistica* published a portrait by Picasso of the poet Antón Busquets, and on October 4 the same periodical carried an illustration by Picasso to Surinyac Senties' short story *La Boja*. The donation contains some very fine drawings of female nudes which are preliminary sketches for the illustration to *El clam de les verges*. We notice in them the admirable combination of the closed outline, a Modernist way of indicating the movement of the bodies, and the single lines which may indicate the clothes the girls are taking off, or simply be used for emphasis.

There is a wonderful crayon sketch in the donation for a carnival poster, also done in 1900, and of regular size and shape. Here the technique is one of sharp angles and abrupt movement. Other drawings and sketches which must belong to the same period, since they use exactly the same technique, are also of great interest; among them is *The Kiss*.

We cannot possibly mention all the huge quantity of sketches on loose sheets, with a wealth of very beautiful drawings among them. So we will end this period with three self-portraits which we believe to date from 1900, though one of them may belong to the following year. One is in ink and shows Picasso full-face, among other sketches. He is wearing a cravat and has his hair parted in the centre. The intensity of gaze and the purity of the drawing are striking. Another, in charcoal, takes a closer view of the face, with a strong contrast between the dense black of the hair and the pallor of the skin. The eyes are even more impressive than in the first self-portrait. The third, in pencil, is considered more as a design and less as an absolute likeness.

At the end of October 1900, Picasso, having outgrown his interest in the Pre-Raphaelite movement and all it implied, and thus given up the idea of visiting England, went to Paris with his friend Carlos Casagemas. There they stayed in Nonell's studio, 49 Rue Gabrielle. Some biographers say that this

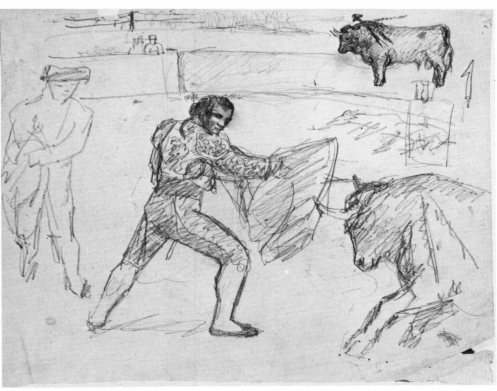

178. Bullfight. Barcelona or Malaga, *c*. 1900.

178

179

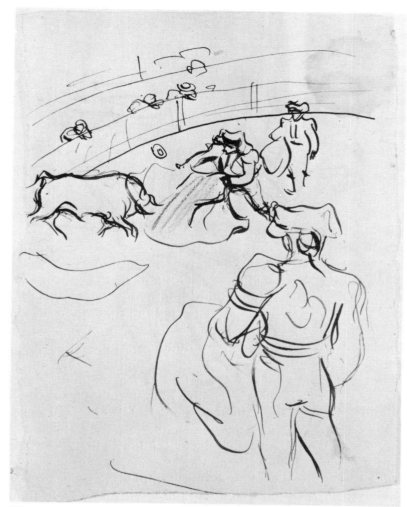

180

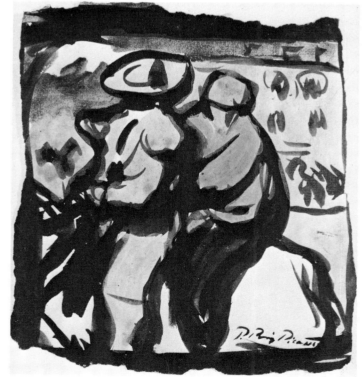

181

179. A bullfighter. Barcelona, 1899–1900.

180. Bullfight scene. Barcelona or
Malaga, 1899–1901.

181. Picador and his assistant.
Barcelona, 1899.

was when he finally adopted the simplified form of his signature, or at least when he began to use it regularly. One reason why he went to France at this stage may have been that the World Exhibition was taking place there. In fact this first short stay in Paris was not unfruitful. In the first place it was artistically successful. 'In Paris', he said, 'I discovered what a great painter Lautrec was.' He made the personal acquaintance of Steinlen. He sold three small works (an oil-painting and two gouaches) to Berthe Weil, in whose gallery he was later to exhibit. Of all that he saw in Paris, the work of Lautrec and Steinlen attracted him most, not only by the pointed elegance of their style, but also by their bold choice of subjects—less openly dramatic, however, than that of Edvard Munch. This was the period when Picasso did pastels in glowing colours, like *The lovers in the street* in the Picasso Museum. There is no work of this type in the donation, but there is a sketch-book, probably dating from the months in Paris, the pages of which are chiefly filled with fine, boldly stylized figures of women and girls in charcoal, pastels and watercolours. The predominant colours are various shades of red, together with violet and blue, supported by ochres and greys. The out-lines and the patches of colour do not always exactly coincide. The artist has paid as much attention to the attitude of the figure as to the colour, and there are some charming silhouettes like that of the girl in a bright red skirt and violet blouse, carrying a hatbox in her left hand, or graceful sketches like that of the woman in a blue hat and cape, where a few lines suffice to define the figure and its details against the creamy-white background of the paper; it is a back view in which we see neither hands nor face. This books also contains sketches for portraits of men (head only) and male figures treated in the same way as the female ones, and a vigorous sketch which must be a self-portrait. There are also some curious combinations of lines crossing in various ways to produce genuinely abstract designs, though

182. Self-portrait and other sketches. Barcelona, 1900.

183. Self-portrait. Barcelona, 1899–1900.

184. Study for a carnival poster. Barcelona, 1900.

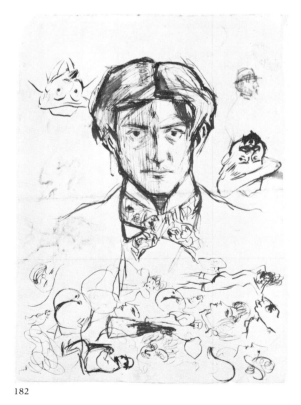

182

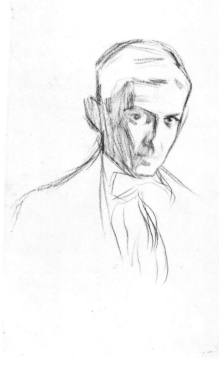

183

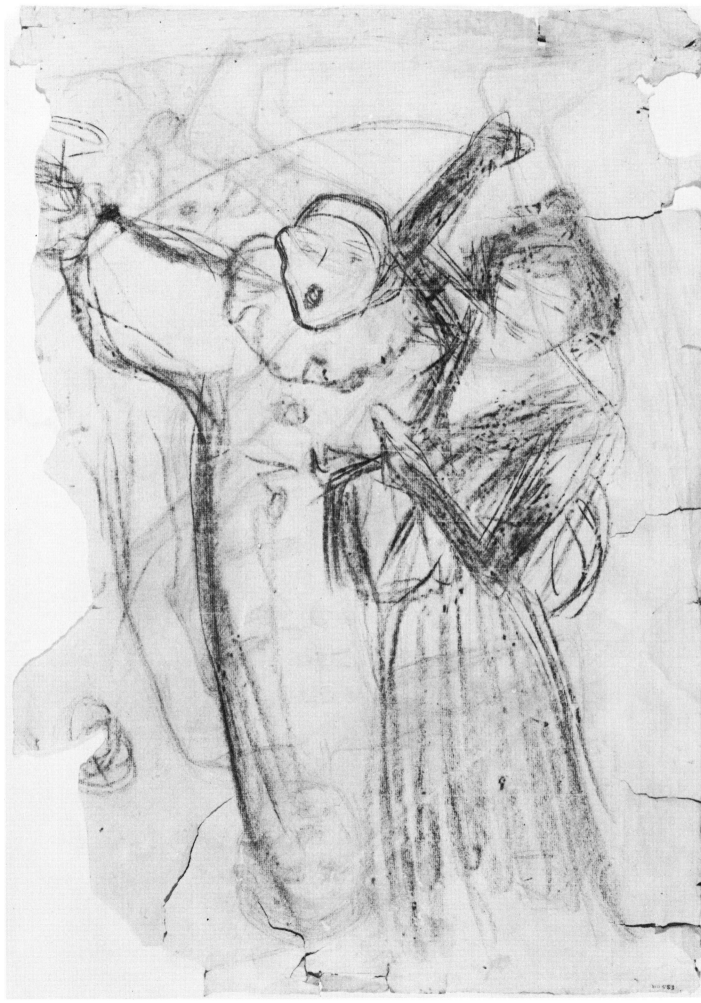

184

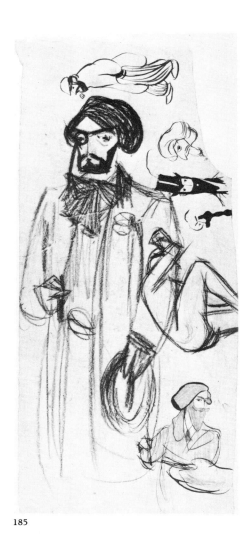

185

Picasso was not interested in going further in this direction.

The freedom, strength and fluency of these pictures contradict any suggestion of influences, whatever superficial resemblances there may be. As with the Barcelona drawings of the same period, this is Picasso's own version of Modernism.

On December 24, 1900, Picasso and Casagemas went back to Barcelona. In an attempt to distract Casagemas from his deep depression following an unhappy love affair, Picasso took him to Málaga, remaining there, however, for only a few days. In February 1901 Casagemas was again in Paris, where he took his own life in the Café de l'Hippodrome on the Boulevard de Clichy.

185. Sketch of an artist and other sketches. Barcelona, 1899–1900.

186. *Interior scene*. Barcelona, 1899–1900.

187. *Andalusian courtyard*. Barcelona, 1899–1900.

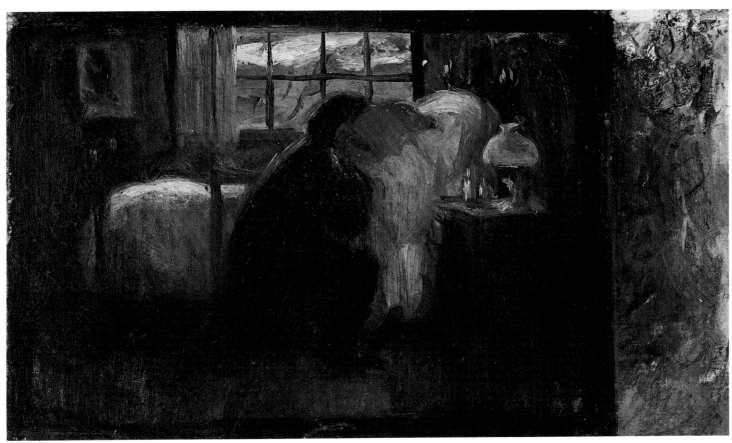

186

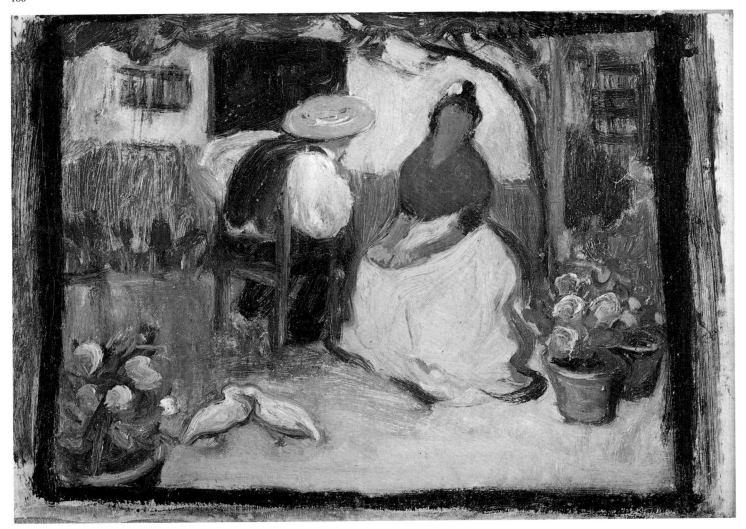

187

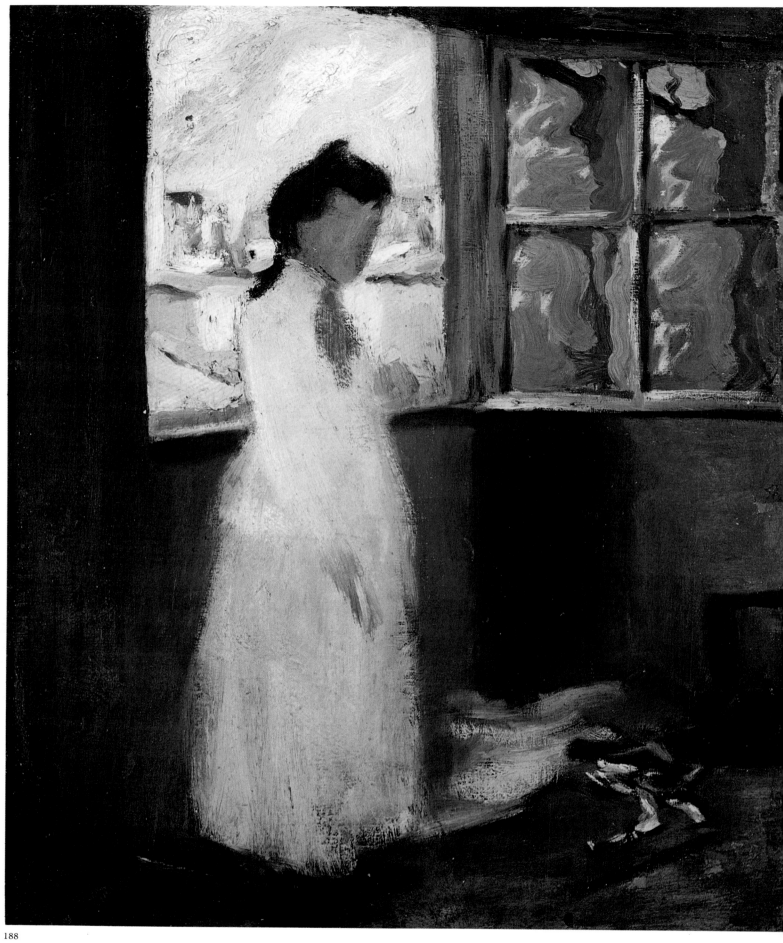

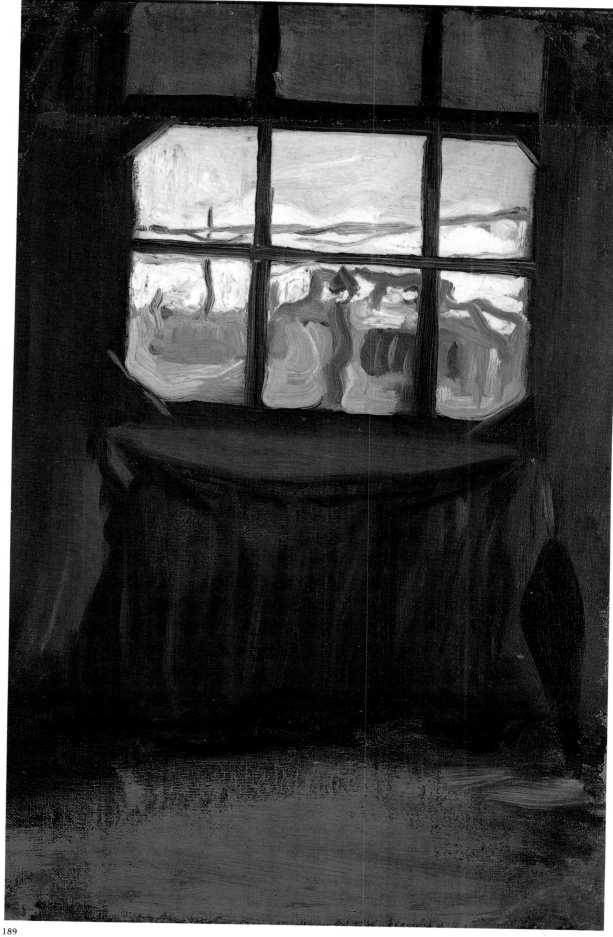

189

190

188. *Girl in white by a window* (Lola in the studio of Riera de San Juan). Barcelona, 1900.

189. *The window*. Barcelona, 1900.

190. *The mask* ('The bride of El Greco'). Barcelona, 1900.

191. The artist's sister Lola. Barcelona, 1898.

191

113

192. Female figure. Barcelona, 1899.

193. Self-portrait. Barcelona or Paris, 1900.

192

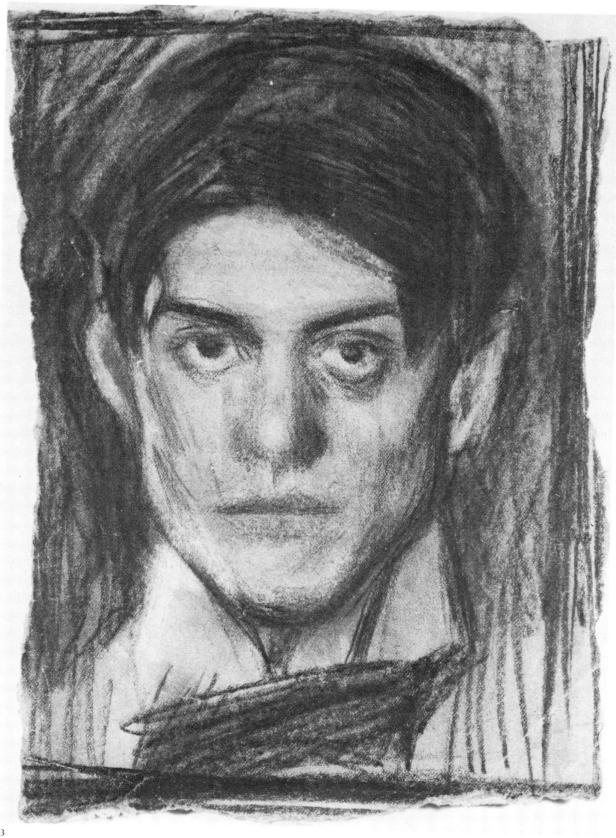

193

194

195

194. The Muse. Barcelona, 1899–1900.

195. Woman with a Pekinese and other sketches. Barcelona, 1899–1900.

196. Development of a linear sketch. Barcelona, 1899–1900.

197. Study for an illustration for 'El clam de les verges'. Barcelona, 1900.

196

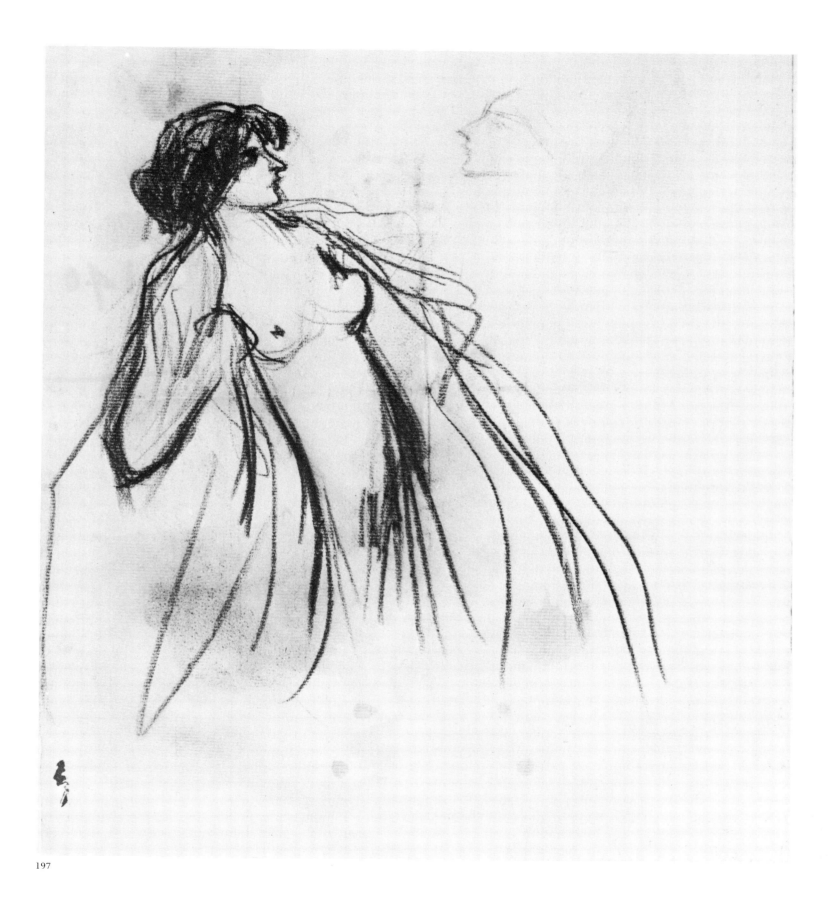

197

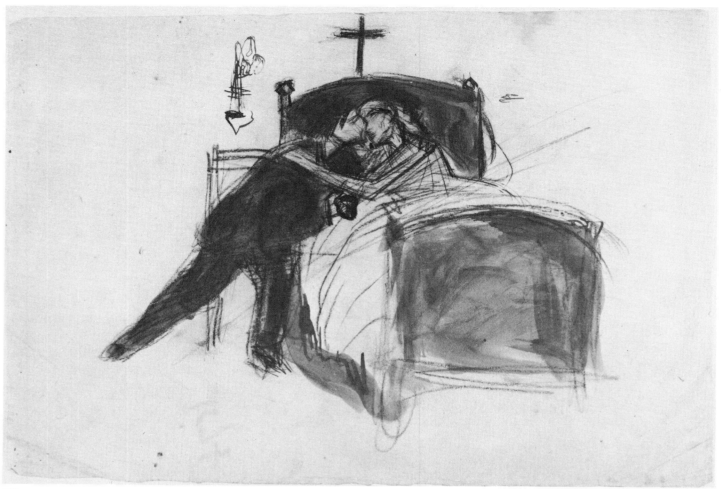

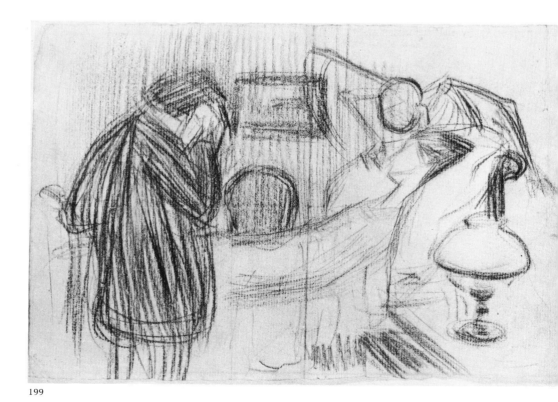

198. Dramatic scene. Barcelona, 1899–1900.

199. The kiss of death. Barcelona, 1899–1900.

200. Sketch of invalids. Barcelona, 1899–1900.

201. Invalids. Barcelona, 1899–1900.

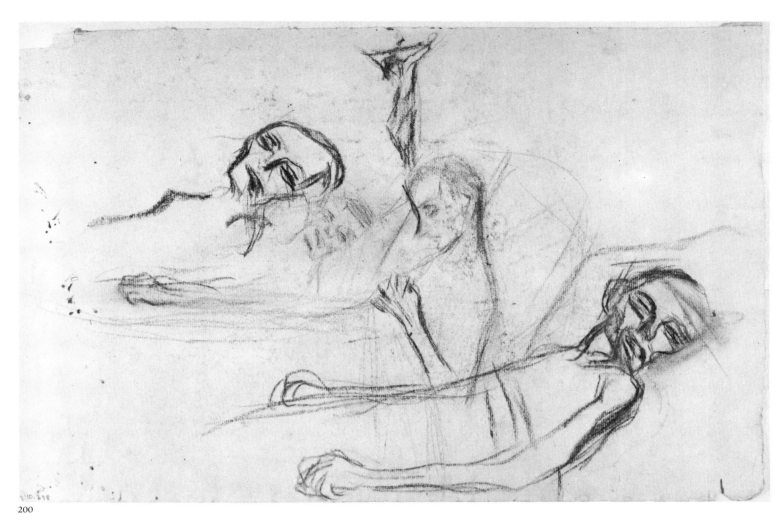

200

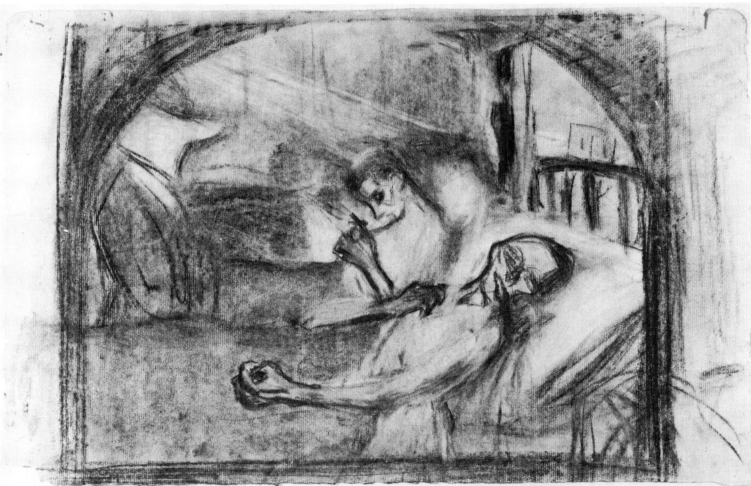

201

202

203

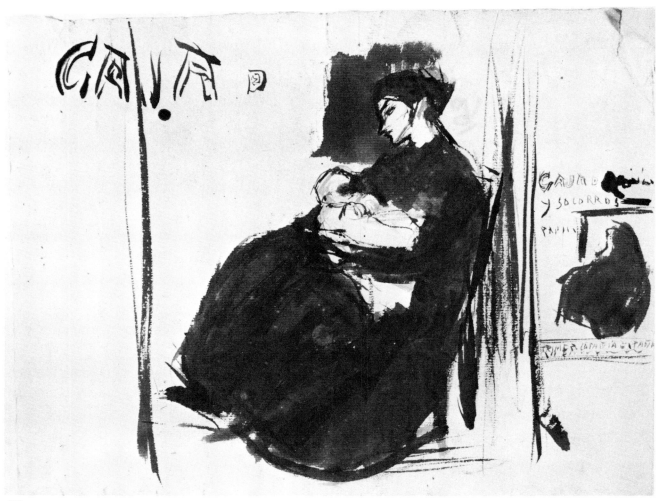

204

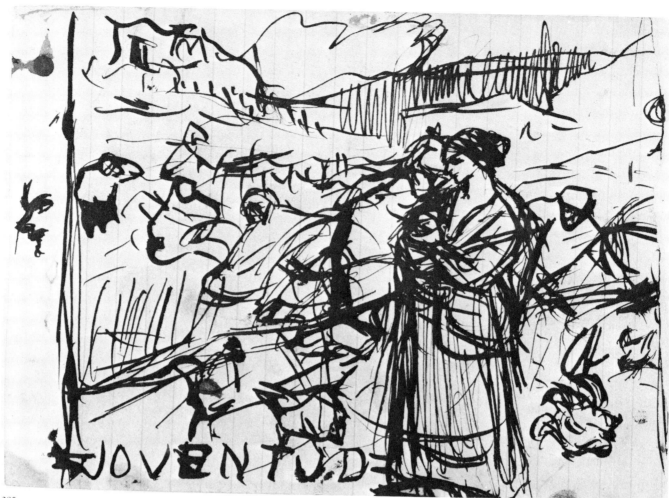

205

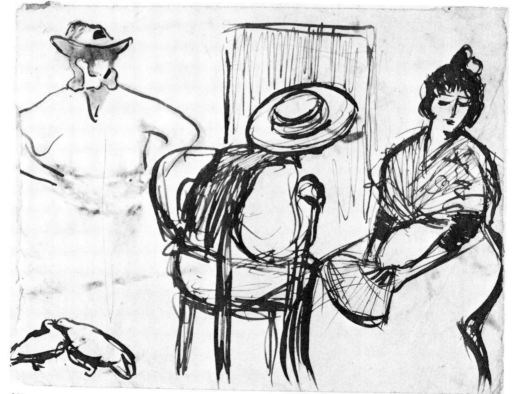

202. Kneeling figure. Barcelona, 1899–1900.

203. A monk (trimmed). Barcelona. 1899–1900.

204. Sketch for a poster for 'Caja de Prevision y Socorro'. Barcelona, 1899-1900.

205. Drawing for the magazine 'Joventud'. Barcelona, c. 1900.

206. Preliminary study for 'Andalusian courtyard'. Barcelona, 1899 1900.

206

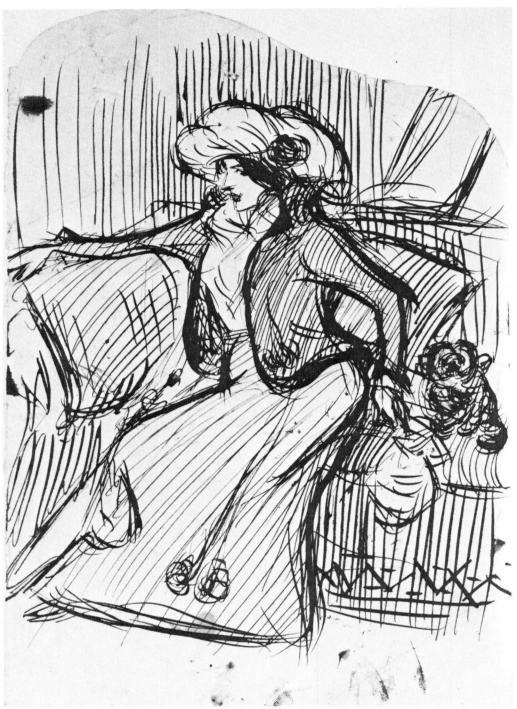

207

208

207. Fashionable woman.
Barcelona, 1899–1900.

208. Study of a woman. Album 17.
Paris?, 1900.

209. The kiss (a). Barcelona, IV-1899.

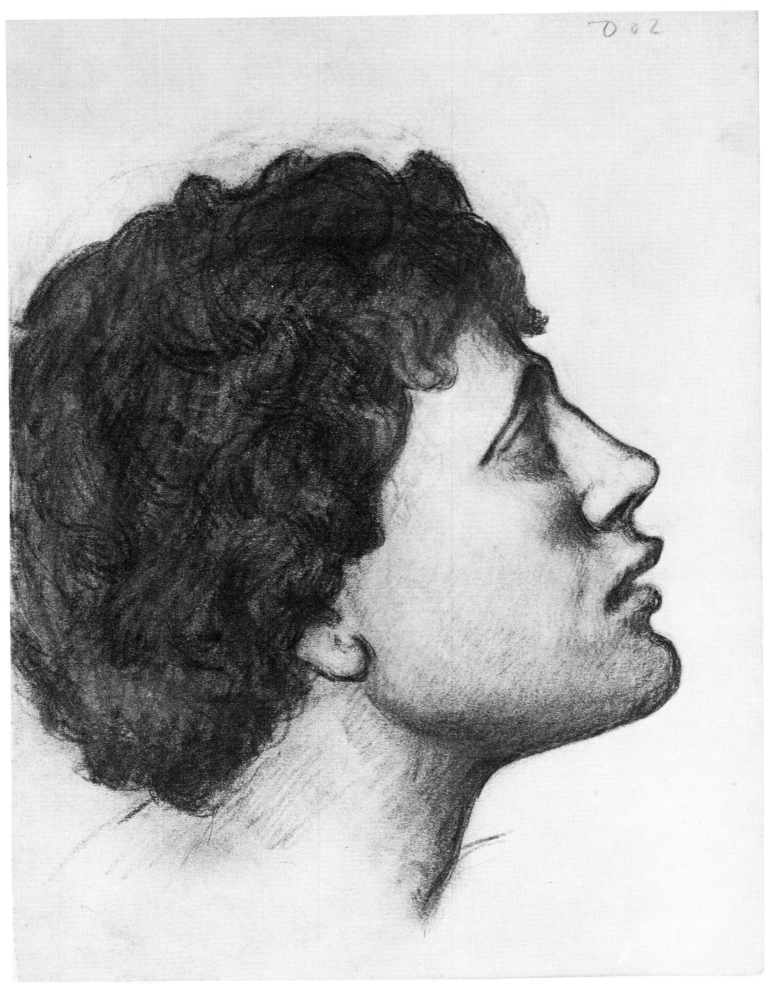

The Blue Period (1901–1904)

211

212

210. Study of a head. Barcelona, 1902.

211. The studio. Barcelona?, 1902.

212. Self-portrait with a dog.
Barcelona or Paris, c. 1902.

The Blue Period does not actually begin at the very beginning of 1901, but according to scholars it certainly begins during the first half of that year, when Picasso was in Spain. He spent the second half of the year in Paris. It is hard to guess what feelings of restlessness or discontent prevented him from returning to Barcelona after his short visit to Málaga. We may suppose that artistic circles in Barcelona were entirely dominated by the Catalan Modernists, and that he would have had difficulty there in making his way. But his stay in Madrid from January to mid-May 1901 convinced him that prospects were no better there, and that Madrid had the additional disadvantage of being artistically more backward and less in touch with contemporary European trends. Although he made friends in Madrid with Azorin, the two Barojas (the writer and the painter) and other intellectuals, he soon sensed that his way lay across the Pyrenees. However, he took three years to come to a final decision—or perhaps he had to wait until his new style had matured and he had built up sufficient contacts.

On March 31, 1901, there appeared the first of the five numbers of a review *Arte Joven* ('Young art') founded and edited by the Catalan writer Francisco de Asis Soler, and illustrated by Pablo Ruiz Picasso, who, although his name was given in this form in the publication, was already signing his paintings and drawings simply 'Picasso'. This weekly review very soon collapsed. In the middle of May Picasso returned to Barcelona. He must have been enthusiastically welcomed, for during June and July an exhibition of his pastels promoted by the review *Pel i Ploma* ('Fur and Feather') was held in the Sala Parés, the leading gallery in Barcelona. Miguel Utrillo reviewed the show.

But Picasso went back to Paris in the middle of June, just when his show opened. He was invited by a friend who aspired to be an important art dealer, Pedro Manyach, who offered to buy all his work for 150 francs a month. Picasso was accompanied this time by Jaime Andreu Bonsoms, and they took a studio at 130 ter Boulevard de Clichy, not far from where Casagemas committed suicide. From June 25 to July 14, the Galerie Vollard (6 Rue Lafitte) showed oil-paintings and drawings by Picasso together with works by the Basque painter Iturrino. The poet Max Jacob visited the exhibition and made friends with Picasso. According to reports, the exhibition was a sell-out, which explains why Picasso was able to stay about six months in Paris this time; he did not return to Barcelona until January 1902.

During his short stay in Barcelona in 1901, Picasso was completely reconciled with his family. (There is no reason to believe that he broke with them entirely between 1897 and 1901; portraits and sketches of his father included in the donation can in my opinion only be dated around 1899.) When he returned from Paris in January 1902 he had no other means of support, and went to live with his family in the Calle de la Merced. With his

213

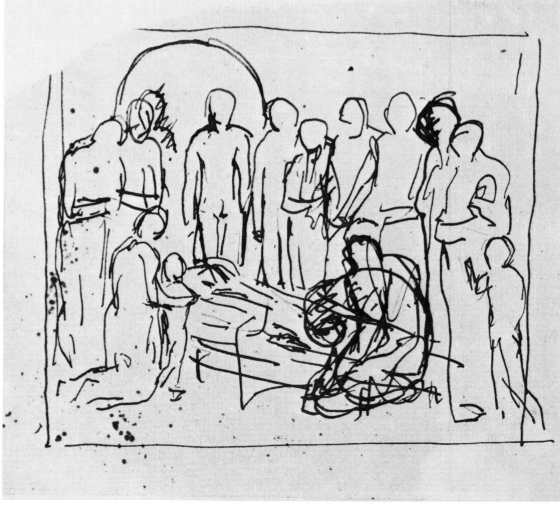

214

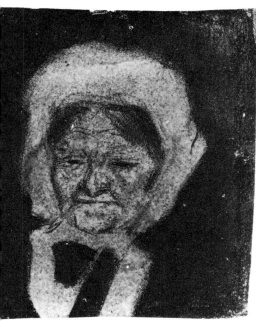

215

friend Angel Fernandez de Soto he rented a studio at 6 Calle Conde del Asalto. In the following months he was an active member of the literary circle which met in the studio of the engraver and photographer Juan Vidal Ventosa at 4 Plaza del Oli. The group was called 'Valhalla', but its members nicknamed it 'Guayaba'. It was attended by Eugenio d'Ors and some of Picasso's friends from the '4 Gats'.

Meanwhile an exhibition of paintings and pastels by Louis Bernard-Lemaine and Picasso, organized by Manyach, took place at the Berthe Weil Gallery in Paris (25 Rue Victor-Massé) from April 1 to April 15. In the course of 1902 Picasso exhibited twice more in the same gallery, from June 2 to June 15 and from November 15 to December 15. They were joint exhibitions, and in the first of the two one of his fellow-exhibitors was Matisse. Among the first buyers of Picasso's works were Fabre, Ackemann, Personnas, Virenca, Sainsère, Mesdames Kollwitz and Besnard, the Stein brothers, Shchukin and Morozov.

But in the spring of 1902 Picasso was still in Barcelona. He was interested in making practical use of his drawings, and that summer he drew a poster for the '4 Gats', and, a little earlier, designed the card announcing the birth of a son to Pere and Gorina Romeu. He worked with great intensity, and began to think on a larger scale. He felt the call of Paris, and went there for the third time, staying from October 1902 to the end of January 1903. On his return to Barcelona he went back to the studio at 17 Riera de San Juan which he had formerly shared with Casagemas; this time he was joined by Angel Fernandez de Soto. He now remained in Barcelona for some time, making the colour blue the keynote of his painting, and drawing forms that became progressively clearer and more monumental. He began to acquire a certain prestige in Barcelona, and even some material success, since he was able at the beginning of 1904 to take a studio by himself at 28 Calle de Comercio. Nevertheless he returned to Paris in April of the same year, this time in the company of Sebastian Junyer Vidal, and settled there finally. He went to live in Montmartre, in an apartment block at 13 Rue de Ravignan. Several writers and artists lodged in this house, which was known as the 'Bateau-Lavoir'. The donation contains a portrait of the concierge of the house, sketched on a colour-washed background. A new life began there for Picasso. He met Fernande Olivier, his first love, and began a rapid ascent which does not come within the scope of this book, and will be mentioned only briefly, in the 'Interlude' chapter which follows this one.

Having dealt with the main events in Picasso's life from 1901 to 1904, we pass on now to the paintings and drawings in the donation which he did during this time. It is extremely difficult to tell whether the work was done in Paris or Barcelona. In the case of the drawings, which are easier to analyse, it is possible that some were done in Paris and that Picasso brought them back to Barcelona with him and left them at home when he returned to Paris in 1904. Some of the paintings show clearly by their subject that they were done in Barcelona.

But before turning to individual works, we ought to say something about the Blue Period in general. We do not know exactly when it began. Some say it began in Paris in the second half of 1901, and some say in Spain, probably during the month he spent in Barcelona (May 15 to June 15) or even earlier, in Madrid. The idea of using one dominant colour, not just for one picture but for many, goes further than the concept of a 'series', like Monet's cathedrals; it would be more accurate to call it a 'cycle' or even a whole

213. Sketch for 'The Death of Casagemas'. Barcelona or Paris, 1901.

214. Sketch for 'The Death of Casagemas' (trimmed). Barcelona or Paris, 1901.

215. The concierge of the 'Bateau-Lavoir'. Paris, 1904.

216

217

216. Reclining nude. Barcelona or
Paris, 1902–3.

217. The couple. Barcelona, 1903.

218. The procuress. Barcelona, c. 1900.

218

221

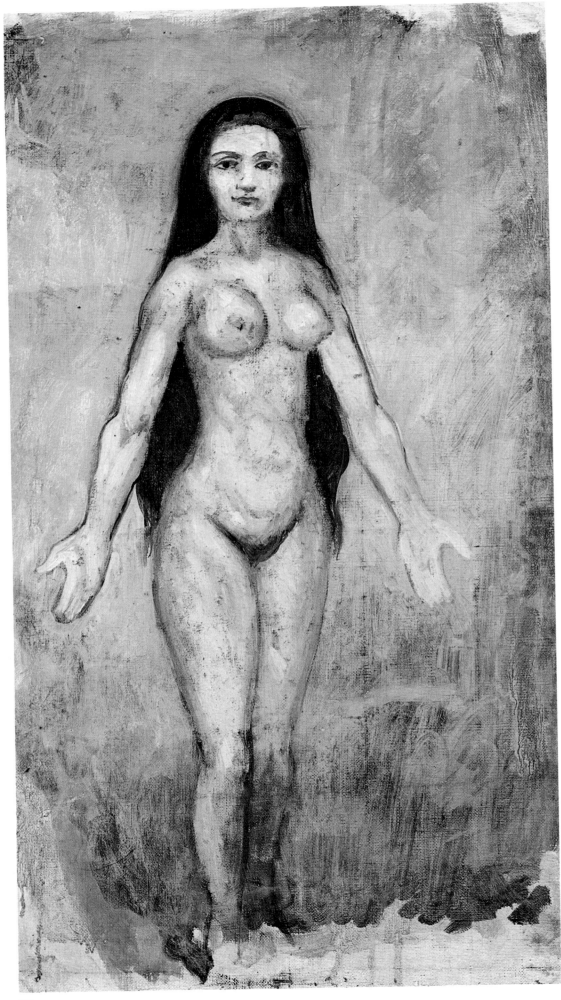

223

microcosm. Picasso's idea was to live in a permanently blue world, and we say *live* because for him painting *is* life. This blue can be treated in the most varied ways—as a flat wash, to show contrasting light and shade (light blue against dark blue), with superimposed patches of greenish blue, lightened or intensified with various types of illumination. It can be restricted to the background and the dress of the figures or it can even be used in the flesh-tints. Some critics have distinguished a 'pre-Blue Period'—in which blue predominates but with accents of red, white, green or other colours—from the Blue Period proper; but the distinction is not actually as clear as that, because even within the Blue Period there are works in which other colours are introduced. However, blue is the predominant colour between 1901 and 1904. It is a blue which makes us think of night, but it is the symbol rather of maternal protection, of rest and forgetful dreams to soothe the sufferings of humble people, than of dark hostile power. Picasso has always been deeply humanitarian. Financial problems continually harassed him at the very moment when his genius was beginning to burn more brightly (though not with revolutionary ardour—that came later). Obviously the difficult material circumstances in which his family had sometimes lived in earlier years as well as youthful idealism had made him sensitive to human suffering, and he seems to have been strongly impelled to translate it into paint. Perhaps both the Blue Period and the Rose Period, which lasted barely two years, were Picasso's lingering farewell to Symbolism, a trend which had attracted him several times in different ways. After this, though he never denied the importance of the content of his pictures, vision and interpretation meant more to him than the sentimental implications of his subjects.

In addition, although Modernism did not suddenly disappear from Picasso's work, it weakened rapidly and irreversibly. Picasso was also interested in other artistic trends, which we can trace sporadically in his work though they never become obvious. He had perhaps a fleeting interest in the neoclassicism of Puvis de Chavannes (1824–1898) and one or two drawings have a touch of David and Ingres. He appears to have paid more attention to Gauguin (1848–1903) and the French Symbolists. But when we are studying the work of so eminent and so completely original an artist, points of similarity with other artists can serve as milestones along his way, but have no more importance than that.

Four paintings in the donation are entirely typical of the Blue Period. The first is a female nude in fairly light blue, with very dark blue shadows. 222 The woman is standing, full-face, with her arms hanging down, the palms spread outward in a gesture of offering. We have already seen Picasso's uncompromisingly naturalistic nudes; in comparison there is something deliberately naive about this painting. If this work belongs to 1901, it may be one of the first examples of the exclusive use of blue. There is in the donation a drawing of a nude woman in the same attitude, dated June 2, 1903, but this makes no difference to our hypothesis, because the treatment is quite different; it is delicately drawn, with very light shadows. On the other hand we cannot help an obscure feeling that this blue nude has a kind of magic that brings it very close to the *Mask* in shades of lilac and violet, painted in 1900. The other three paintings are known to date from 1902. One of them, *The blue goblet*, has as its only subject a glass goblet, tall and 220 narrow in shape, with the smoothness of the glass perfectly rendered, and two red flowers rising gracefully out of it. Apart from this red and the bluish white of the glass, the whole painting is blue. A beautiful night-piece called

219. *Portrait of Sebastián Junyent.* Barcelona, 1902.

220. *The blue goblet.* Barcelona, 1902.

221. *Roofs of Barcelona.* Barcelona, 1902.

222. *Blue nude.* Barcelona, 1901.

223. Nude (trimmed). Barcelona, 1903.

133

Roofs of Barcelona is an admirable study in the building up of forms by the use of different shades of blue. It is closely related to two other works on similar subjects dated 1903, of which one is in the Bührle Foundation in Zurich and the other in the artist's own collection. The fourth work is a portrait of Sebastian Junyent, more naturalistic than the other three, with the flesh tints in their natural range of colours. But blue predominates in the clothing and the background, which shows a patch of dark blue at the top of the picture against a paler blue. **221** **219**

The donation contains two small paintings on wood, tall and narrow in shape. They prove that even in his Blue Period Picasso might, if the fancy took him, paint pictures of a different colour and character. One of these little pictures, *The green stockings*, shows a nude woman seated on the ground. It is almost a back view, but her face is turned towards the painter. Her legs are covered by coloured stockings which give the picture its name. In a private collection in Paris there is a companion piece to this work, a *Seated nude with a green stocking* (originally in the Gertrude Stein collection). The other picture shows a *Mother and son by the sea*. It is in our opinion one of the finest works in the donation. The colours are blue, red and ochre, and in spirit and form it is close to Symbolism, even recalling—though of course indirectly or fortuitously—certain works by Gustave Moreau (1826–1896). **245** **246**

Finally we may mention the decoration of a broad wooden picture or mirror frame made by his father, although it is earlier than the works just described, dating from 1901. It is decorated with mythological or fairy-tale pictures in blue, red, green and yellow on white. The style is deliberately naive. **224**

We come now to the coloured drawings. Two are portraits, dating from

224. Decoration for a frame. Barcelona, 1900.

225. Fishermen. Barcelona or Paris, 1901–2.

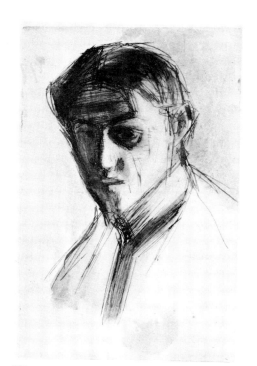

1901. One of them, a self-portrait in ink and watercolour on paper, is fairly geometrical in style and shows a curious arrangement of the colours (yellow, rose and blue) in zones, without any resemblance to natural colouring. The other, in pencil and watercolour, is a vigorous portrait of Joaquin Mir. It contains greens and ochres, but blue predominates to such an extent that it can be considered as one of the works of this period from the stylistic and not merely the chronological point of view. 226 247

The paintings of the Blue Period show a gradual enlarging and simplification of the forms, generally accompanied by an increase in the size of the pictures. If we compare the drawings of the period from 1901 to 1904 with those of earlier periods in the donation, we notice a parallel with what happens in the paintings. The number of drawings as such increases, and the number of pages covered with sketches decreases. Even in the case of preliminary studies for paintings, the sketch is treated as a work of art in its own right, and usually appears alone on a sheet of paper of the appropriate size. If, as sometimes happens, it is accompanied by two or three more sketches, they are carefully arranged on the page. These drawings, particularly those done after 1902, often seem to foreshadow some of the female figures of the Rose Period.

First come the drawing of an *Amazon* (which he went over in a blacker outline, slightly altering it as he did so), a scene showing a woman in classical dress giving a vessel to a child, and drawing of boats. All these mark Picasso's momentary interest in neoclassicism. Three moving sketches for *The burial of Casagemas* (or *Evocation*) were done in 1901; they are simple, almost hurried, and their emotional effect is unparalleled. The same year produced a head and shoulders portrait of a woman, shaded in short parallel strokes 227 228 225 213 214 261

226. Self-portrait. Barcelona, *c.* 1901.

227. An Amazon (a). Barcelona or Paris, *c.* 1901.

228. Sketch for 'La Soupe' and others (detail). Barcelona or Paris, 1902.

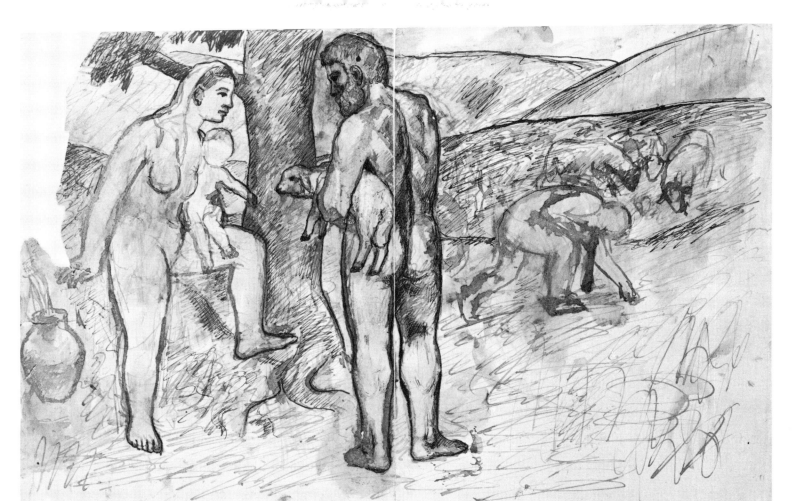

230

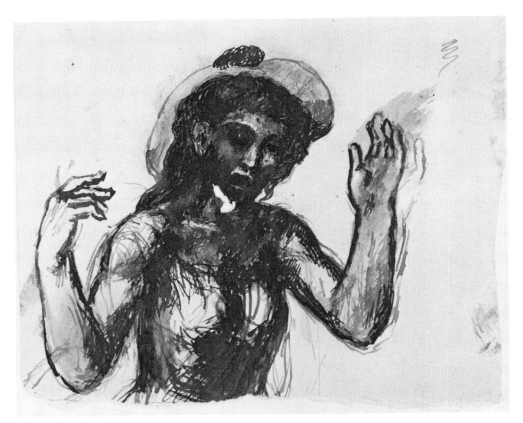

229. Man with a sack on his back.
Barcelona or Paris, 1902.

230. Pastoral scene. Barcelona or Paris, c. 1902.

231. Head and shoulders of a woman.
Barcelona or Paris, 1902.

231

232

233

234

235

of the pen, closely related to paintings of this period such as the *Painted* 913
woman in the Picasso Museum in Barcelona, and even more to the *Woman*
with a chignon in the Harry Bakwin collection in New York. There is a series
of drawings showing men and women seated or standing, seen from the 252
front or from behind, in which vigour is the dominant characteristic. In one 255
of them the curving form reminds us of a gipsy by Nonell. A *Portrait of the* 236
sculptor Fontbona (1902) shows him full-length and in profile.

Three more series dating from 1902 and 1903 (mainly 1902) show dockside 259
scenes, boats, and gesticulating figures. There is a pastoral scene in the 231
Gauguin manner, with the woman holding a child in her arms and the man, 230
mature and vigorous, with a lamb under his left arm. The same man appears
in other drawings carrying a heavy load or lifting a sack from the ground. 229
There are also heads, treated in a very vigorous and grandiose manner;
two of them have something of the character of studies, but beneath their
apparent realism they are completely new. A *Head of a woman* in Conté is 232
less timeless than the others; the hair-style and the attitude are deliberately
modern. There is even an oddly schematic *Head of a man* wearing a kind of 233
bonnet, sketched in lead pencil. A *Self-portrait* is related to the port scenes
in both the technique and the medium of pen and ink. In this the artist is 234
shown with a short beard, and an expression half aggressive, half sad.

A series of nudes also belongs to the 1902–1904 phase, and can be classified
in various ways. There are some with smooth, undulating outlines that seem
to foreshadow Matisse to a certain extent. In almost every one the head is
treated as a patch of black in striking contrast with the rest of the figure. 258
Others are sketches of nude women standing alone or in groups of three or 268
four, done in ink or pencil. They all have a poetic conception of the female
form, transfiguring it without distorting it. Among them is a wonderful
Reclining nude, perfect in composition, with opulent but not excessive 237

232. Head of a woman (trimmed).
Barcelona, 1902.

233. Head of a man. Barcelona or
Paris, c. 1902.

234. Self-portrait (trimmed). Barcelona or
Paris, 1902–3.

235. Portrait of a woman. Barcelona, 1902.

236. The sculptor Fontbona. Paris or
Barcelona, 1902.

237. Reclining nude. Barcelona or
Paris, 1902–3.

238

239

240

238. Sketch related to 'The Embrace'.
Barcelona, III-1903.

239. The passionate embrace.
Barcelona or Paris, c. 1900.

240. Outline of a horse. Paris or
Barcelona, c. 1902.

241. *Seated woman*. Album 17. Paris, 1900?

242. *Back view of a woman*. Album 17.
Paris, 1900?

243. *Woman with a hat and boa*. Album 17.
Paris, 1900?

244. *Girl with a hat-box*. Album 17.
Paris, 1900?

245. *The green stockings*. Barcelona?, 1902.

curves. A very naturalistic *Head of a child* and a wonderful *Portrait of a woman* in pen and ink both belong to 1903; the latter is large enough to fill the whole picture. A *Nude woman* in pen and ink, drawn simply in outline yet with an effect of vigour and depth, is one of the best drawings of this period. The same can be said of the gaunt silhouette of a horse, seen from behind, which belongs to the same phase.

We end our study of the drawings of the period with a series of sketches for three works. They all date from 1903. The first group is of sketches for the decoration of a fireplace, consisting of three in pen and ink, one of them showing the whole fireplace, with the two sides naturally symmetrical, and one beautiful pastel of an old woman warming herself (one of the subjects of the decoration), in flesh tints on a blue background.

There is great nobility and strength of line in the two preliminary studies for the picture *The Embrace* painted in 1903 (Paris, Musée de L'Orangerie) in which a bearded man holds out his arms to a pregnant woman. What seem to be the same characters, treated in the same way and the same medium (pencil) appear in another drawing with quite a different subject, in which the man, more Herculean in appearance, is striking the crouching woman.

We come finally to the studies for the famous picture *La Vie* in the Cleveland Museum of Art, dating from 1903 or the beginning of 1904. Two are in pen and ink, one with the figure of a woman alone, very beautifully drawn in an attitude of mourning, and the other with three sketches of the united couple. The other two preliminary studies in Conté already give a clear image of the general structure of the painting. The male figure on the right is Casagemas; this was replaced in the final painting by the older woman with a

241

242

243

244

245

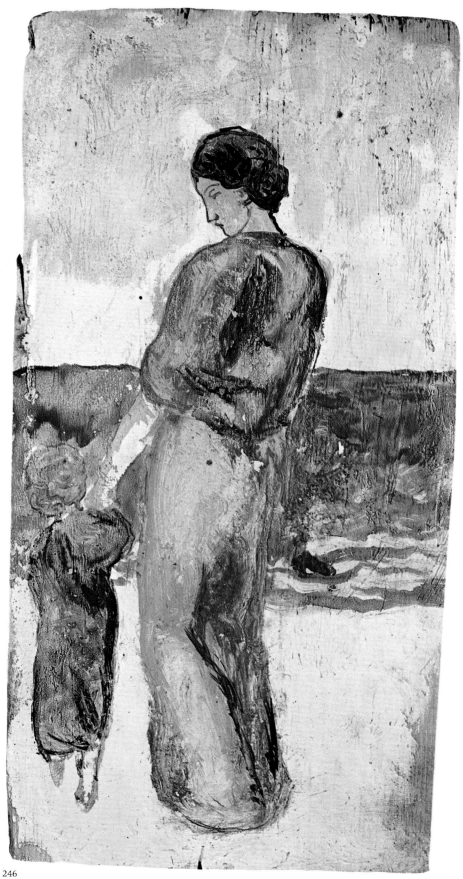

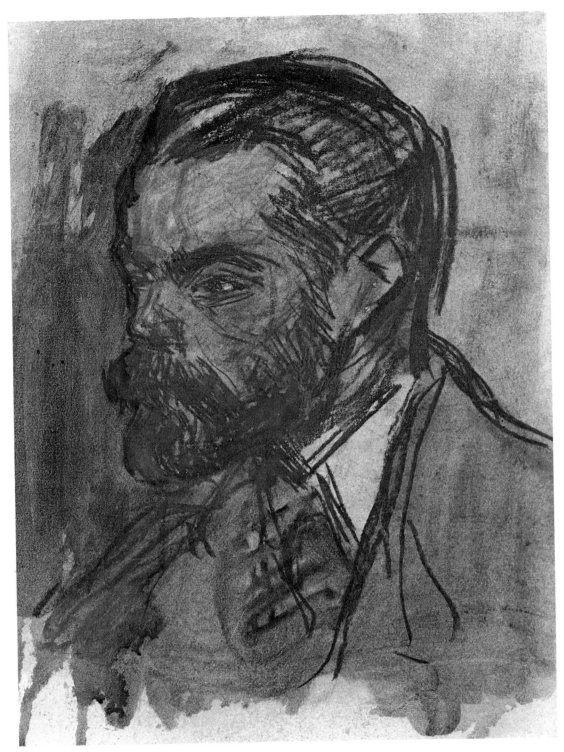

247

child in her arms. There are at least two more preliminary sketches for *La Vie*, but these were published by Zervos and are not in the donation.

Two more works come at the very end of the period: the *Portrait of the concierge at the Bateau-Lavoir* (1904), a small picture in gouache on paper, 215 and a print of the beautiful etching *The frugal meal* (1904), which has 251 frequently been published and so does not need to be described here.

248

246. *Mother and son by the sea.* Barcelona?, 1902.

247. *Portrait of Joaquin Mir.* Barcelona, c. 1901.

248. Sketch for the decoration of a fireplace (trimmed). Barcelona, 1903.

249. Head of a child. Barcelona?, 1903.

250. Preparatory drawing for the decoration of a fireplace. Barcelona, 1903.

251. The frugal meal. Paris, 1904.

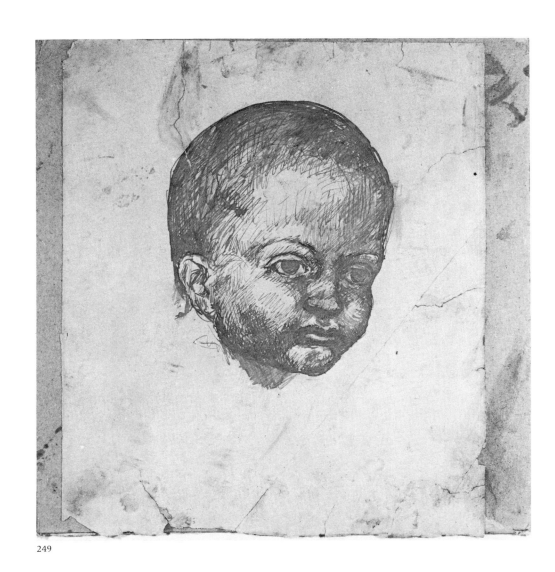

249

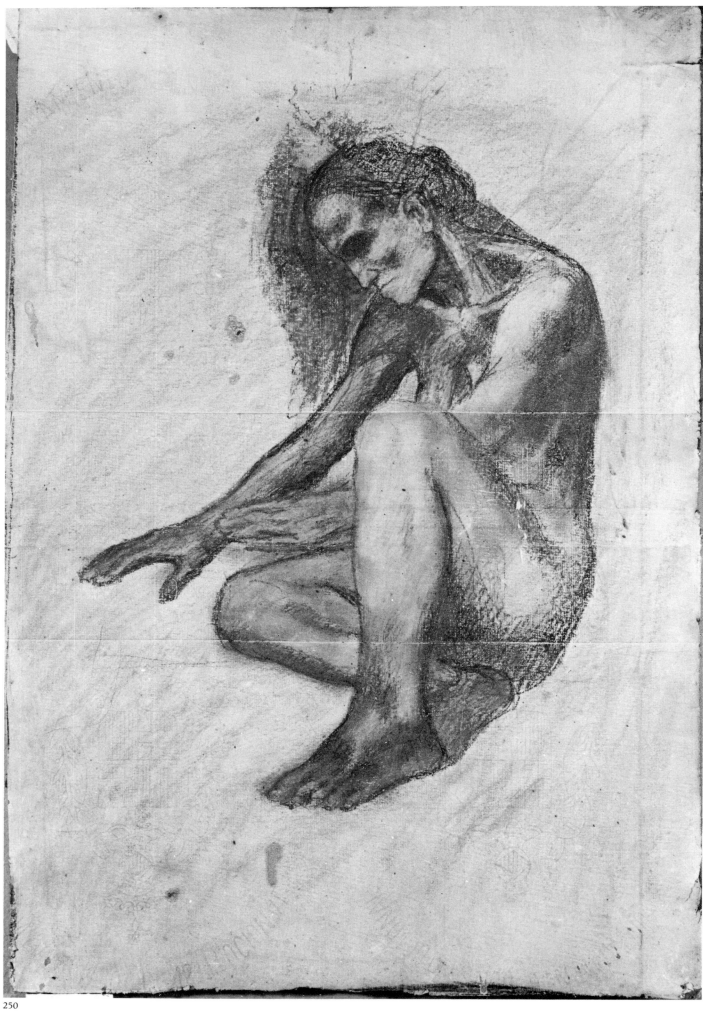

250

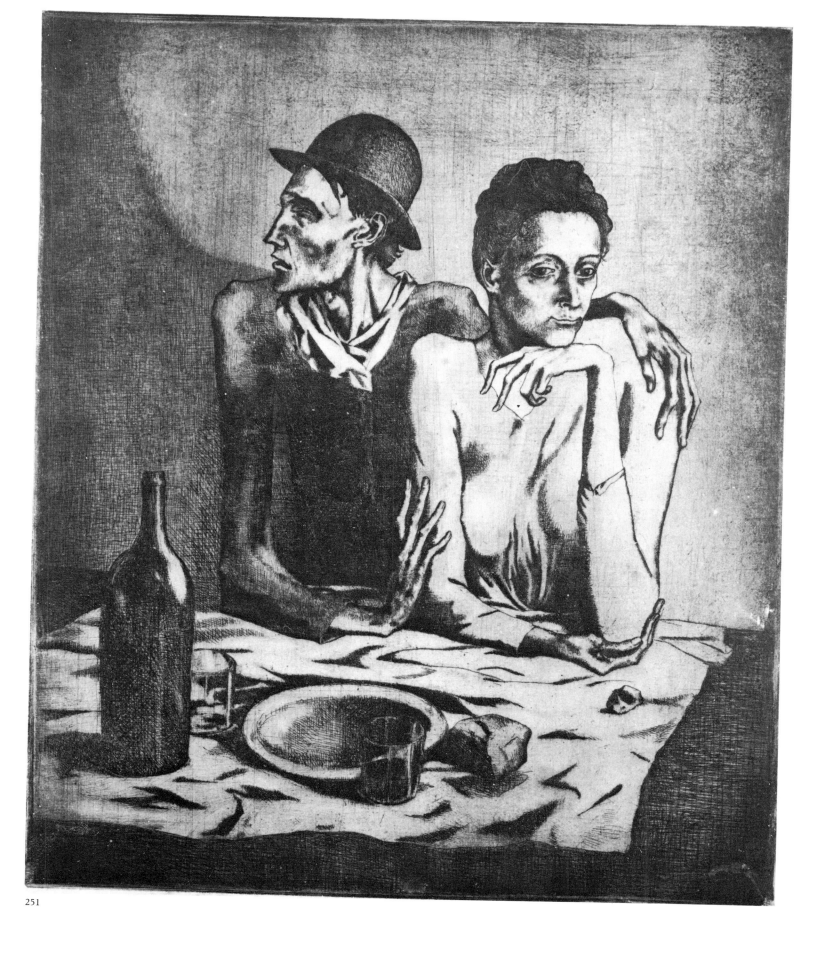

251

252

253

254

255

256

257

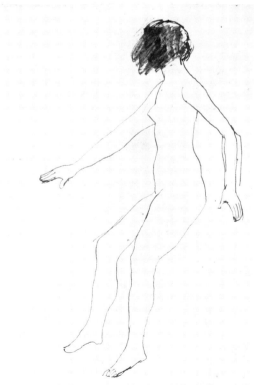

252. Masculine figure. Barcelona or
Paris, 1901–2.

253. Figure from the back. Barcelona or
Paris, 1901–2.

254. Seated figure. Barcelona or
Paris, 1901–2.

255. Woman and child. Barcelona or
Paris, 1901–2.

256. Life study of a figure. Barcelona or
Paris, 1902.

257. Nude. Barcelona or Paris, 1902–3.

258. Nude. Barcelona, 1903.

258

259

260

261

259. A quay. Barcelona or Paris, 1901–3.

260. Seated woman (trimmed). Barcelona or Paris, 1902.

261. Sketch for 'The Death of Casagemas'. Barcelona or Paris, 1901.

262. Preparatory sketches for 'La Vie'. Barcelona, 1903.

263. Sketch for 'The Embrace'. Barcelona, 1903.

264. Sketch for 'The Embrace'. Barcelona, 1903.

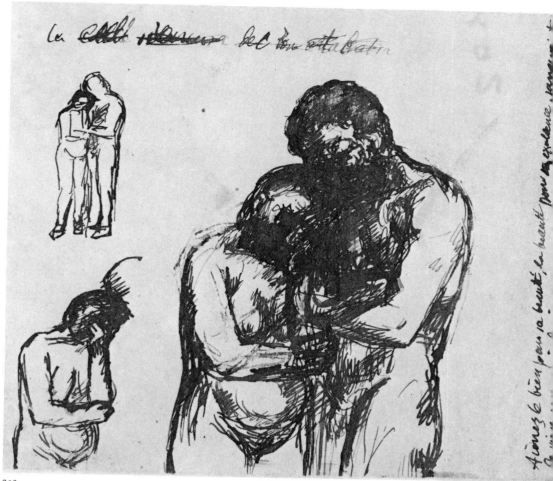

262

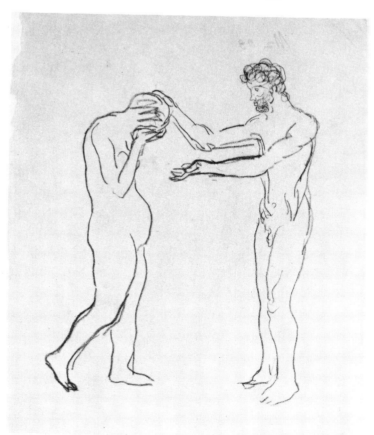

263

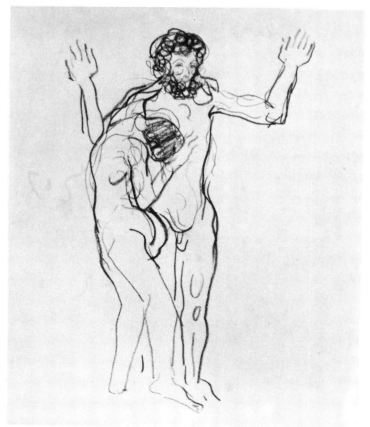

264

151

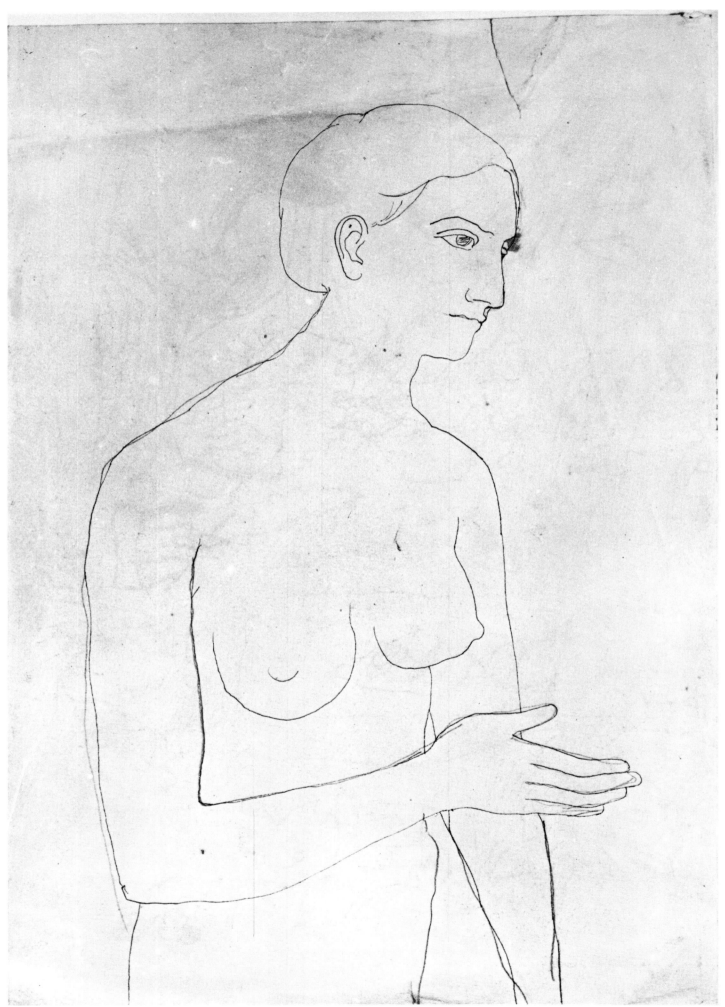

265

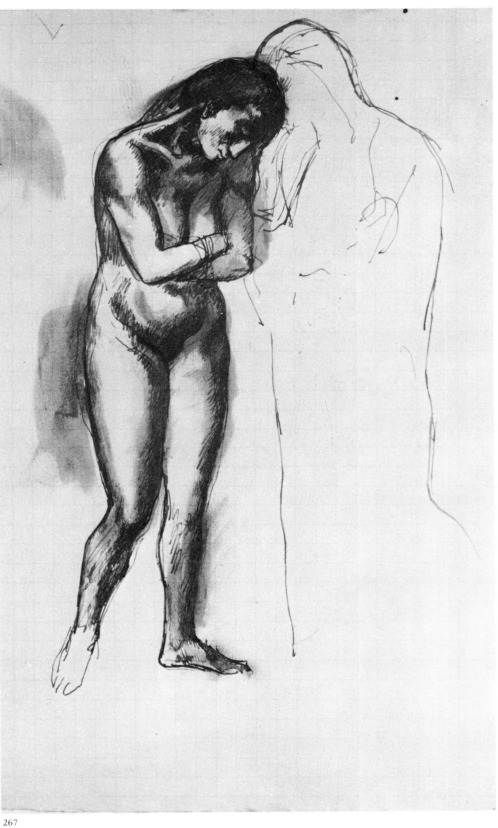

265. Nude. Barcelona or Paris, 1902–3.

266. Sketch for 'La Vie'. Barcelona, 1903.

267. Preparatory drawing for 'La Vie'.
Barcelona, 1903.

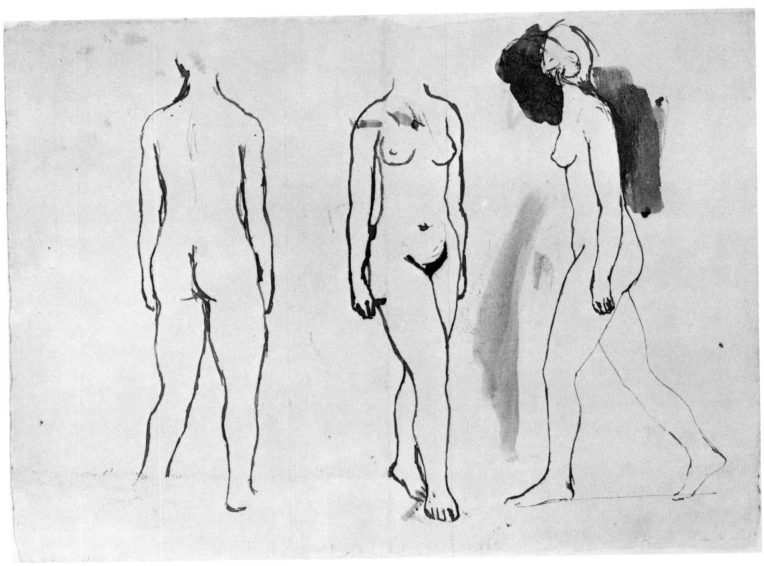

268

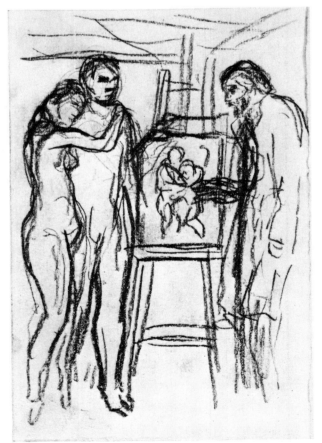

269

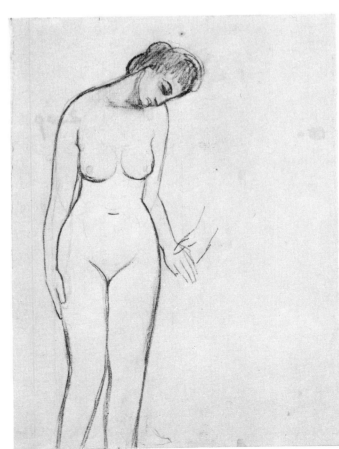

270

271

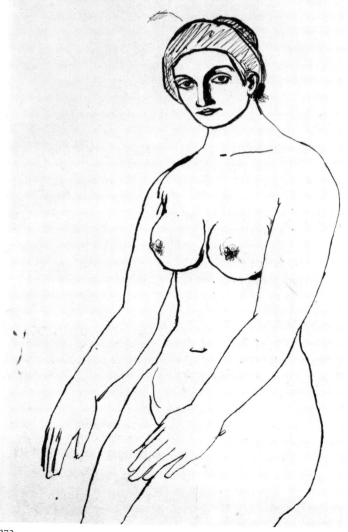

268. Three nudes. Barcelona or Paris, 1902–3.

269. Sketch for 'La Vie'. Barcelona, 1903.

270. Nude. Barcelona or Paris, 1902.

271. Sketches of female nudes.
Barcelona, 1903.

272. Large nude. Barcelona?, 1902–3.

272

155

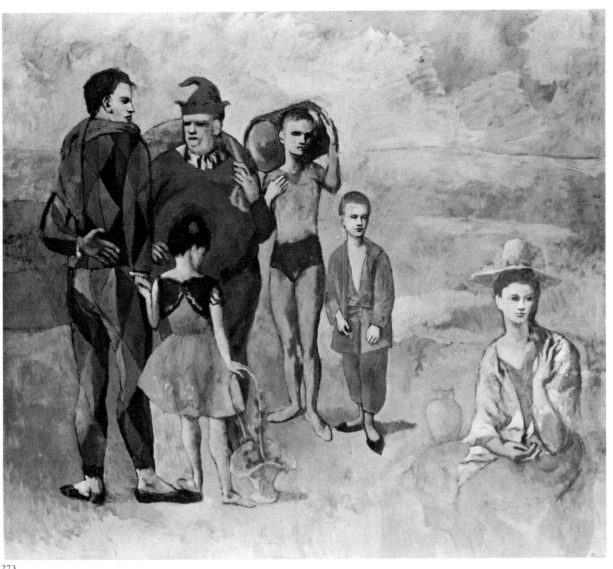

273

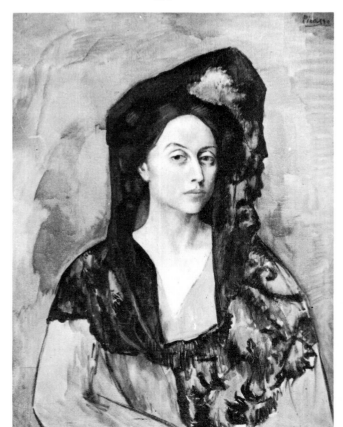

274

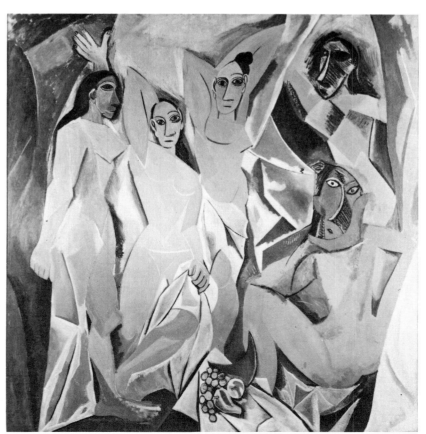

275

Interlude (1904–1916)

The object of this book is to study the development of Picasso's art through the works given by him to the Picasso Museum in Barcelona. However, after the gouache and the etching just mentioned there is a long gap in the donation until we reach a group of ten important works done in 1916 and 1917 (eight oil-paintings, a gouache, and a large drawing in charcoal on canvas). We thought it best, therefore, to give a brief summary of Picasso's development during the 'interlude' from 1904 to 1916, not relating the events of his life nor analysing a large number of works, but explaining the changes which determined his various 'periods'. Picasso is so universally known that such a summary may not be thought absolutely necessary, but we feel nevertheless that it may be useful. Without it, the contrast between the works of 1890–1904 and those of 1916–1917 may seem shockingly abrupt to most art-lovers, even though they may be intellectually aware of the gradual way in which the artist of *Les Demoiselles d'Avignon* began his innovations. 275

In 1904, Picasso passed through a phase of gradual, subtle changes which has been called his 'Blue-Rose' phase because its most characteristic paintings show a combination of the two colours. Shades of blue contrast with rose (which had already appeared in flesh-tints) and with white, which took on a distinctly ghostly aspect. The lines have become attenuated. The subjects are taken from everyday life, but there are also circus scenes, which are 273
more frequent in the Rose Period (1905–1906). A typical picture of this period is *Woman ironing* (Guggenheim Museum, New York) painted in 1905. White, which is generally used to convey an impression of light and gaiety, here suggests misery and a sense of physical and moral exhaustion.

There is more gaiety in some of the works of the following phase, such as *Young acrobat and child* (Guggenheim Museum, New York) of 1905, a marvellous symphony in pink and white with a little blue. All that year, and throughout the winter and spring of 1906, Picasso continued to work within the same colour-range, seeking to convey a sense of movement or of intimacy. Sometimes the colour is so rich that pink ceases to be dominant, but it always appears, sometimes resulting from optical mixtures based on other colours.

There is a break in continuity between the summer of 1906 and the later months of that year. Picasso visited Spain in the summer with Fernande Olivier, lived close to nature in the village of Gósol in Lérida, and on his return a certain change was noticeable. Forms became rather harder and more geometrical, and the colour, though still pink, moved towards reddish ochre or orange. A particularly exuberant work of the period is *The Harem* (Cleveland Museum of Art), a wonderful group of female nudes with a vigorous male figure seated on the ground on the right. The movement towards greater strength and a more geometrical style led to works like the

273. *Family of Saltimbanques.* 1905.

274. *Portrait of Senora Canals.* 1904.

275. *Les Demoiselles d'Avignon.* 1907.

276

impressively three-dimensional *Portrait of Gertrude Stein* (Metropolitan Museum, New York).

From 1904 to 1906 Picasso was evidently in close touch with artistic circles in Paris, but his orbit was completely independent of theirs, and the notorious exhibition of the Fauves in October 1905 had not the slightest effect on his style. Cubism was a different matter. He and Braque were the founders of the movement, and we might almost say that it was he who gave it its first impetus. He had an innate tendency to use geometrical forms, which Braque never did before Cubism. We can follow this tendency, as we have already noted, throughout his work from 1895 onwards. For example, his admirable *Portrait of Señora Canals* (Picasso Museum, Barcelona) which some critics 274 date from 1905 and others from 1904—which is more likely since it belongs to the 'Blue-Rose' phase—has a Cubist infrastructure, upon which the naturalistic, but gracefully idealized picture of this beautiful woman is superimposed.

Several causes, or rather stimuli, have been suggested for the birth of Cubism: an exhibition of Iberian sculpture, the growing interest in Negro art, and above all Cezanne's great posthumous exhibition in 1907. Picasso's statement about the trend would seem to suggest a lack of creative purpose or of sincerity, but it is absolutely true if we look at it in the context of his natural bent for geometrical forms, and also of his temperament, which is intuitive rather than reflective, and has always led him to act—to wonderful effect—and only then to think about what he has done. What Picasso said was: 'When we invented Cubism, we had no intention of inventing it, only of expressing what we felt.' He might have added 'in the way we thought most fitting', though that is implicit in his words.

But before his excursion into Cubism, Picasso passed through a short phase beginning with *Les Demoiselles d'Avignon* in 1907 (Museum of Modern Art, New York) and continuing with a series of studies of figures, heads and still-life groups. There are also compositions with figures which have been called 'negroid', although their construction is an inextricable mixture of Iberian stylization, African sculpture and his own independent use of geometrical shapes. A good example of this style in its advanced phase is *Three Women* (Pushkin Museum, Moscow) painted in 1908. Picasso began to use geometrical shapes regularly in landscapes when, in the summer of 1909, he returned to Horta de Ebro, the village of his old friend Manuel Pallarés. There he painted the so-called *Reservoir* (private collection, Paris), 2 which is without a doubt on the threshold of Cubism. Sometimes working in close touch with Braque, he produced works in which forms are broken down in order to show them from different angles which would normally be impossible to reconcile with each other. This is 'simultaneism'. In the so-called Analytical Cubism (1910–1912) the superimposition of different views of the object carries less weight than the breakdown of the forms. The image appears as though reflected in a broken mirror. Detail is treated by means of various techniques, sometimes by a series of tiny lines or dots, inherited from the neo-Impressionism of Seurat (1859–1891). Picasso used this technique in 1901, as in *The Dwarf* (Picasso Museum, Barcelona), and again in 1916–1917. He comes very close to the abstract in works like the *Portrait of Henry Kahnweiler* (1910, Art Institute, Chicago) and even closer in others, but he never seeks to repudiate the reality of the external world. As the Analytical images tend to be incomprehensible, subjects are chosen which can be recognized by significant detail or by the simplicity of their

276. Reservoir at Horta de Ebro. 1909.

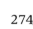

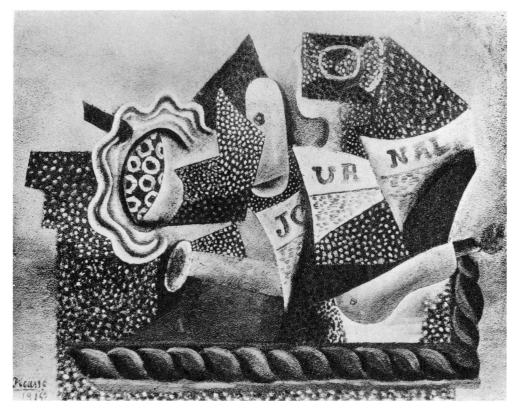

278

277

form (guitar, violin, vase, bottle, etc.). 277

In the winter of 1911–1912 Picasso made his first collage, and later he and Braque worked by this method, inserting 'fragments of reality' into their oils, watercolours or drawings, or imitating the properties of materials with calculated skill. Then the planes were defined and superimposed one on the other. The cameo shades of the Analytical period (brown, ochre, white, cream and sometimes green and red) gave place to a richer colour-range, although some works belonging to the period of Synthetic Cubism (1913–1914) are still in only two or three colours; an example is Picasso's painting *Cut pear, vase and ace of clubs* (1914, private collection, Paris). When the First World War broke out, Braque was called up, but Picasso went on working. As always, he worked in several styles at the same time, but we can safely say that *Mandolin and guitar*, painted as late as 1924 (Guggenheim Museum, New York) is directly derived from his Synthetic Cubism. In between come important paintings like *Harlequin* (1915, Museum of Modern Art, New York), and *Italian woman* (1917, Bührle collection, Zurich).

278

But during this last phase Picasso was using, side by side with Cubism, a straightforward naturalistic style which, in its purest form, has been likened to that of Ingres. In January 1915 he drew a realistic portrait of Max Jacob, then one of Vollard in August of the same year, and in 1916 he did the same for Cocteau and Apollinaire, for his friends included the most famous French writers of the period.

We come now to the last group of works in the donation, which will be discussed in the next chapter.

277. *The Guitarist*. 1910.

278. *Still Life with Fruit, Glass, Knife and Newspaper*. 1914.

279

The works of 1916–1917

We know that Picasso went back to Spain at least twice—first to Gósol in 1906 and then to Horta de Ebro in 1909. It is possible that he also returned in 1912 when he was staying in Céret. Palau Fabre, in *Picasso i els seus amics catalans*, in which he modifies some of the results of his earlier investigations of the artist's life, says that he spent Christmas 1916 and the following New Year with his family in Barcelona, returning to Paris about January 15, 1917. He left there in February to go to Rome with Cocteau and Stravinsky to work on the ballet *Parade*, with which the Diaghilev ballet opened at the Châtelet in Paris on May 12. In June the company, and Picasso with them, went to Madrid to give a few performances of the ballet, and then to Barcelona, where *Parade* was danced at the Liceo. Picasso, who was in love with the ballerina Olga Koklova, persuaded her to resign from the company, and when Diaghilev left for South America the couple remained in Barcelona until November; so Picasso was in Spain on this occasion for more than five months. He married Olga in Paris in the following year.

It is hardly probable that Picasso painted all the Cubist works in the donation during his short visit to Spain at Christmas 1916, but since some of them may have been painted then rather than when he was in Spain from June to November 1917, we prefer to date them 1916 and 1917. At this stage Picasso was passing through the final phases of Cubism—although as we know he continued in that direction for another seven years. At the same time he was developing his drawing in the Ingres manner, with natural repercussion on his painting, before reaching the point where exaggeratedly monumental forms caused the critics to speak of 'gigantism'. Possibly his visit to Italy reminded him of the greatness of classical art; Picasso has always reacted strongly to his environment.

As I have said, there are ten works of this period in the donation. We may begin with the five Cubist works. One, a *Portrait of Blanquita Suarez*, is smaller than the others (which are all the same size) and more frankly representational. Daix published the preliminary sketch for this work with the title *Woman with a fan*. This oil-painting clearly shows that the artist's aim was to replace three-dimensional modelling by a system of projection of geometrically-formed shadows. The figure too is schematically constructed in curved lines. The colour is intense and flat, with black, white, green and purplish brown predominating. Perspective is achieved by means of advancing or receding gradations of tonal values. It is most interesting that a work built up in so rigid a pattern should have gracefulness as its main quality.

The other four pictures are fairly large, and are all based on practically the same artistic concepts: superimposition of planes, a predominance of black set against ochres, greys and red, and geometrical shapes very sharply pointed and stylized. The forms are in themselves representational and the

280

279. Cubist figure. Barcelona, 1917.

whole is monumental in conception. The most representational work is a portrait in which the face is indicated by a line which forms two small ovals for the eyes, descends at an angle and ends in a horizontal line for the mouth. This picture is lighter in colour, with a marked preference for curved shapes; it is not as rigidly architectonic as the other three canvases. The next most representational is *Seated man*, a little narrower than the other works of the group, built up of sharp angular planes. It belongs to the Synthetic phase, growing out of the breakdown of planes in the 'simultaneism' of 1900–1912. Red predominates, with black and orange-ochre. The flesh is left in its natural tints. Planes bounded by concave or convex arcs are superimposed on each other. The lower area is very fine, and so is the background, which is not flat but shows an interplay of carmine and black, ochre and cream or grey on creamy white. More mysterious and dramatic is the *Figure with a fruit dish*, in which an almost realistic hand at the bottom of the picture is aggressively grasping a fork. All the rest of the body, including the head, is represented by a black trapezoid, though the head is completed by a grey triangle bearing the black hollow of an eye. A red border on the left with convex arcs balances the orange-ochre area on the right. The fruit dish is clearly, though synthetically indicated. *Figure in an armchair*, which completes this group, rejects or even completely destroys the representational element. But Picasso, in giving a realistic title to this assemblage of coloured planes, which is in my opinion the finest work of the four, is telling us that he has created something equivalent to representation by purely plastic means, without going as far as a completely abstract system. We believe that Picasso's repudiation of the abstract is due among other things to his constant obsessive interest in the material world and his lack of interest in abstract ideas and symbols. In this work, curved forms are broken by sharply triangular ones in black, and the lower area of the painting consists of short grey strokes on yellowish white. Red, various shades of ochre, white and a slightly bluish grey are co-ordinated with the dominant colour, black.

Next come two somewhat smaller pictures, of equal size, which might be called post-Cubist. They are in a style which is brilliantly developed in the *Windows* somewhat later. Their technique includes the pointillism (not divisionism, as there are no optical mixtures) which Picasso used relatively often in his Cubist works; it is used with unexampled vigour in the two female figures of 1901 in the possession of the Picasso Museum in Barcelona. One of these paintings shows the *Paseo de Colón* seen through an open window. A Spanish flag fluttering in the wind provides the only colourful note in the picture. All the rest is in shades of ochre, grey, white and blue, with the black iron balcony in the foreground. We see the statue of Columbus, in ochre so dark as to be almost black, and in the background the sea and sky shown in small broken lines. The other work, *Fruit dish*, is made up of wonderful formal arabesques. The colour-range and technique are the same as in the work just described, and the object, seen in the round, is given great importance, filling almost the whole of the picture. It is a symphony in shades of cream, grey and off-white, contrasted with black, green, red and blue.

The donation also includes a painting of regular shape and size, combining pointillism with lyrical naturalism, *Woman with a mantilla*. The lower part of the work is unfinished; other details, such as the left eye, may be considered as unfinished or not, according to the observer's taste. It is a marvellous work, both in the purity of line that exactly conveys the

perfection of the model's face and in its technical virtuosity. The clear, pure oval of the face, the curve of the mouth, the graceful pose, full-face but slightly turned to the left, are less important than the twofold use of pointillism and the incomparable freedom of colour. The background— which does not cover all the canvas—the inside of the flowing mantilla held by a large comb, and part of the young woman's dress, are treated with a pointillism of the type we have already described, in red, blue, green and yellow-ochre. The face is done by means of the technique called 'divisionism', a form of pointillism which acts on the retina of the observer's eye to give optical mixtures. The rose-colour and the interplay of white and pale green thus produced are utterly amazing.

There is also a head in gouache which we believe to be a study for the *Harlequin* of 1917 (Picasso Museum, Barcelona). Despite the slight grey tinge 285 in the white, it is a very beautiful work, and the three-dimensional appearance of the face recalls certain sketches done in 1895, in which the fourteen-year-old Picasso had already achieved a perfect impression of depth.

Lastly there is the large drawing in charcoal on wood (sepia) of an un-happy *Gored horse*, 'the victim of the fiesta'. It is sketched in powerful 287 strokes, perfectly assured and perfectly clear, and its beauty of form is equalled only by its dramatic power. It shows the disembowelled horse about to fall on the sharp horn that points upwards in the direction of its heart. It is the forerunner of other gored horses painted in oils years after-wards; one, for example, dated 1923, and the famous *Guernica* example (1937, at present exhibited in the Museum of Modern Art, New York).

Leaving aside the fact that in 1917 Picasso was in the second stage of development of his long and prolific career, all these works show, without a doubt, the culmination of the gradual expansion of forms which we have mentioned several times throughout this book. This development un-questionably moves in step with a growing freedom and strength, and the consciousness of victory as he mastered and passed beyond one style after another (19th-century academic style, direct naturalism, Modernism, neo-classicism, Cubism and so on). The victory was already complete; only the frontiers have been widened between 1917 and the 1970s. But this is a process spread over more than fifty years, and so is outside the scope of this book.

Conclusion

Obviously we do not need the works in the donation to tell us that before flinging himself into the whirlpool of 20th-century art, Picasso had worked to a traditional pattern. We already knew that, from the few works done before the Modernist period that have been seen up till now. If we assumed that Picasso's work as we know it did not begin until the Blue Period, after his first visit to Paris, then even the Modernist Period would be no more than an introduction to the 'real' Picasso.

But now we can see, from the enormous quantity of works in the donation, and their supreme quality, that it was not simply a question of extraordinary natural gifts, though of course they were there. Between 1894 and 1898 Picasso had worked systematically within regular academic disciplines, at the La Guarda school in Corunna, at La Lonja in Barcelona, and at the Royal Academy of San Fernando in Madrid. Since childhood he had poured out works in abundance, not only drawings, but sketches on wood and oil-paintings on canvas. He had treated every kind of subject, never confining himself to any one in particular. He had tried out different means of expression *at the same time*, as in 1916–1917 when he was practising Cubism, pointillism and lyrical naturalism side by side; earlier on he had used them in the large-scale academic type of painting and in the tender lyrical productions of his phase before Modernism. And sometimes, without warning, he would produce a work that was amazing not only for his age, but for any age, like the portrait of *Aunt Pepa,* and *Hillside in Málaga* with its preliminary sketch, all painted in 1896. About 1899, when he was eighteen, he began to consider himself a professional painter, by virtue of his age rather than the quality of his work, which was already very good. But he still continued to work from life, judging himself by academic standards—by his version of academic standards, that is, for even simple studies from life were inevitably touched with his own special genius.

The donation thus casts new light on all Picasso's work. It helps us to understand why he never wished to have much to do with such extreme movements as Surrealism—still less abstract art. For one thing this presupposes narrow specialization, because there is no difference between devoting oneself to still-life in the 17th century and to rectangles in the 20th, and for another it implies the rejection, if not total ignorance, of the fundamental rules of drawing and painting. An artist like Picasso, who has worked seriously, continuously and intensively within the traditional system, can, and does, invent any variations he likes on the form of his subject, on the impression of space which the eye receives, and on the natural relationships of colours one to the other. But he could not be expected completely to deny the forces that had moulded him, or to turn his back on his father's memory. This is the reason for the contradictions in Picasso. He is the complete revolutionary, but he followed traditional paths, and did not start from

280. *Portrait of Blanquita Suarez.* Barcelona, 1917.

281. *Seated man.* Barcelona, 1917.

282. *Figure in an armchair.* Barcelona, 1917.

283. *Fruit dish.* Barcelona, 1917.

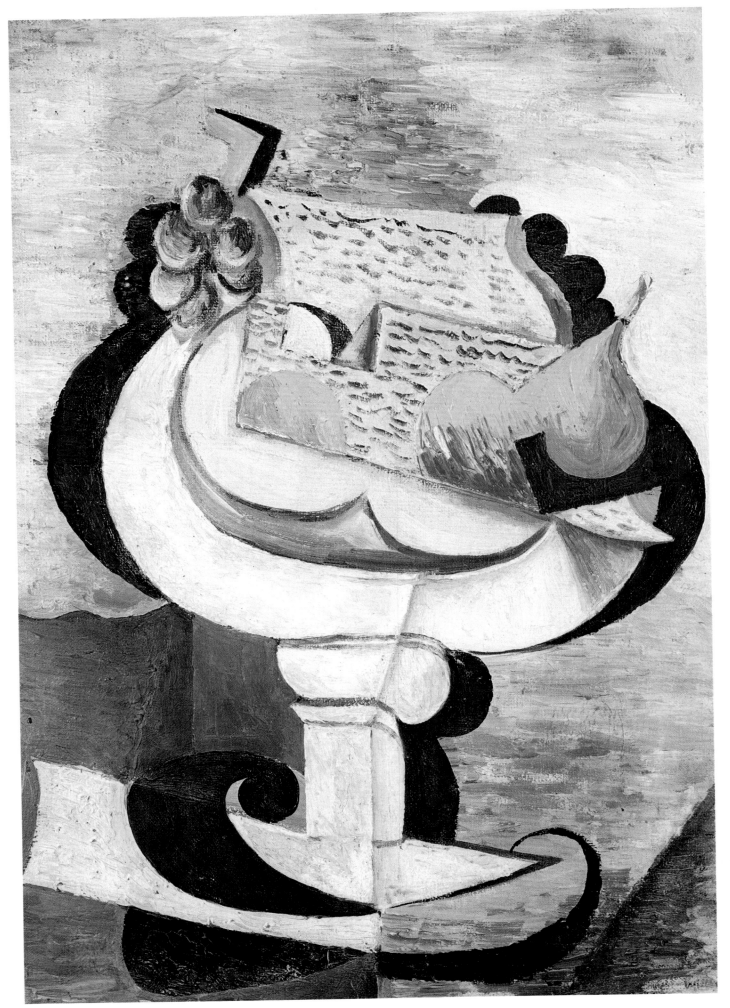

283

285

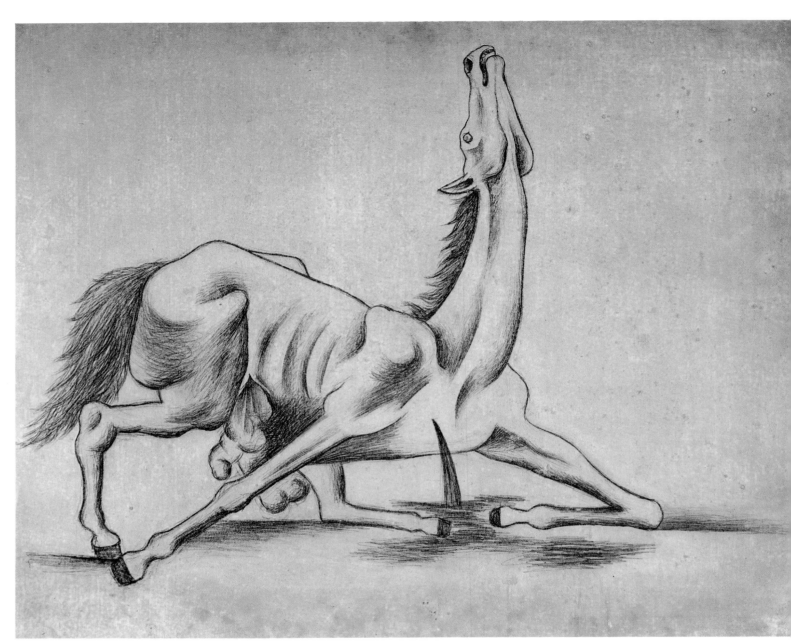

287

scratch, which would doubtless have been easier. We mean no disrespect towards those who, with different mental attitudes and different intellectual backgrounds, have reached different conclusions. But it must be understood that Picasso has always been Picasso. He was just as much himself when painting the coast on the journey from Málaga to Barcelona in 1895 as when drawing goats at Horta de Ebro, painting his sister in white by a window, or breaking the chains of dogma with a lilac *Mask* or a *Blue Nude*.

And so the artist gathered strength, and was able to turn to his own use the undercurrent of ambivalence that always governs the relationship between father and son. There is a Picasso who keeps his work representational out of loyalty to the great ghosts of the painters of the past. But there is another Picasso who distorts this very representation in rebellion against these ghosts, and perhaps also against the whole universe, against the power that gives us life and takes it away, that never fails to give us pain to go with pleasure, and hate to go with love.

But art has its own transubstantiation. This negative impulse towards distortion and revolt is transformed in the end into the supreme affirmation of the spirit that struggles to conquer it. The true artist needs this struggle, as he needs the food he eats and the air he breathes. Such an artist is Picasso.

284. *El Paseo Colón*. Barcelona, 1917.

285. *Study for 'Harlequin'*. Barcelona, 1917.

286. *Woman with a mantilla*. Barcelona, 1917.

287. *Gored horse*. Barcelona, 1917.

Chronology (1881–1917)

1881

Born on October 25 in Málaga in the Plaza de la Merced. Son of the painter José Ruiz Blasco (1841–1913), teacher of drawing at the school of San Telmo at Málaga, restorer and curator at the Málaga museum, and his wife Maria Picasso Lopez (1855–1939) who were married in 1880.

1884

Birth of his sister Lola (d. 1958).

1887

Birth of his sister Conchita (d. 1895).

1891

Picasso's father accepted a post at the La Guarda Institute in Corunna. The family went to Corunna by sea (about September 15, 1891) and took up residence at 14 Calle Payo Gomez. Picasso went to the secondary school, where he studied for his school-leaving certificate and at the same time worked under his father at the La Guarda school.

1895

In July Picasso went to Madrid for the first time, staying only a few days.

Spent the rest of the summer in Málaga until September. By an order of March 17, 1895, Don José Ruiz Blasco moved to Barcelona as professor at the School of Fine Arts at La Lonja, taking up his appointment on April 16, 1895. Picasso, aged 13, arrived in Barcelona by sea in September 1895 with his mother and his sister Lola. They went to live in Calle Cristina, moving to 4 Calle Llauder, and in 1896 to 3 Calle de la Merced. Picasso entered the school of La Lonja where his father was teaching. On September 15 and 30 he took the examination for the advanced course.

1896

First studio at 4 Calle de la Plata.

Summer in Málaga.

1897

Founding of 'Els 4 Gats' (June 12), an establishment on the lines of the intellectual 'café-concert' (the 'Mirliton' in Paris and the 'Überbrettl' in Berlin) which became the meeting-place of Picasso and his friends from March 1899.

Summer in Málaga.

Went to Madrid for the second time in October. Entered the advanced course at the Royal Academy of San Fernando. His principal teacher was Moreno Carbonero.

1898

Ill with scarlet fever. Returned to Barcelona in June. On June 24 accompanied his friend Pallarés to Horta de Ebro, Tarragona, where he remained until February 1899.

1899

Returned to Barcelona in February. Quarrelled with his family, and moved to the studio of the sculptor Cardona's brother at 1 Calle de Escudillers Blancs.

1900

At the beginning of the year Picasso moved with Carlos Casagemas to a studio at 17 Riera de San Juan. Remained there until October. About the end of October, first visit to Paris with Carlos Casagemas. Pallarés came to Paris about 13 to 20 days later. They took the studio which had belonged to Nonell.

December 24: Returned to Barcelona with Carlos Casagemas.

December 30: To Málaga with Carlos Casagemas.

1901

January: Picasso arrived in Madrid, lodging at 4 Calle Caballero de Gracia, and later in Calle Zurbarán.

February: Carlos Casagemas, who had gone back to Paris, committed suicide.
Beginning of May: Picasso returned to Barcelona.
Middle of June: Second visit to Paris with Jaime Andreu Bonsoms. Stayed at a studio at 130 ter Boulevard de Clichy.
1902
January: Picasso returned to Barcelona to live with his family with whom he was completely reconciled. Shared a studio with his friend Angel Fernández de Soto at 6 Calle Conde del Asalto.
October: third visit to Paris with Sebastian Junyer Vidal (Hotel du Maroc, 57 Rue de Seine; Hotel des Écoles, Rue Champollion). Went to stay with Max Jacob in a fifth floor flat on Boulevard Voltaire.
1903
End of January: returned to Barcelona. Lived with his family and worked with Angel Fernández de Soto in the studio at 17 Riera de San Juan—the same one as he had shared with Carlos Casagemas.
1904
At the beginning of the year acquired a studio to himself at 28 Calle Comercio.
April: went to Paris for the fourth time, with Sebastian Junyer Vidal, and finally settled there, living in Montmartre, 13 Rue Ravignan ('Bateau-Lavoir'). Made the acquaintance of Fernande Olivier.

1905
Friendship with Apollinaire and with Gertrude and Leo Stein.
Went to Holland in the summer at the invitation of the writer Tom Schilperoort and stayed a month in the village of Schoorldam, near Alknar.
1906
Picasso returned to Barcelona with Fernande Olivier at the end of April. He was then in his Rose Period.
May-August: they stayed at Gósol (Lérida).
Autumn: they returned to Paris.
At this point Picasso—after his formative years (1890–1898), the Modernist Period (1899–1900), the Blue Period (1901–1904) and the Rose Period (1905–1906)—began to work in a more monumental style, and his forms became more geometrical. In 1907 this tendency was accentuated under the influence of the great Cézanne exhibition, and of Iberian and Negro art, giving rise to Cubism, which continued from 1908 to 1914. Its traces persisted until 1924, simultaneously with lyrical naturalism (1906–1920) and the monumental style (1920–1924).
1907
Picasso made the acquaintance of Kahnweiler and Braque.
1909
Summer in Horta de Ebro.
1910
Summer in Cadaqués with Derain.
1912
Friendship with Marcelle Humbert (Eva). Stay in Céret.
1913
Death of Picasso's father, Don José Ruiz Blasco. His mother continued to live with her daughter Lola, by then the wife of Dr Juan Vilato Gómez. Picasso again stayed in Céret.

1916–1917
Picasso spent Christmas and the New Year in Barcelona, returning to Paris around January 13, 1917.
1917
Picasso did the décor and costumes for the ballet *Parade* by Cocteau and Stravinsky, which opened at the Châtelet in Paris on May 12 of that year, performed by the Diaghilev company. Went with the company to Italy and then to Spain, where he stayed from June to November. Made the acquaintance of the dancer Olga Koklova, whom he married the following year.

The donation contains works done between 1890 and 1904, together with a few dated 1916 and 1917.

Select bibliography

General Works

Apollinaire, G., *Les peintres cubistes*, Paris, 1913
Brandi, C., *Carmineo della pittura*, Florence, 1947
Cirlot, J. E., *Pintura catalana contemporánea*, Barcelona, 1961
Cirlot, J. E., 'La pintura catalana moderna 1850–1936' in *Historia de la Pintura en Cataluna* by Gudiol, Alcolea and Cirlot, Madrid, s.f. (1956)
Cirlot, J. E., *Arte Contemporáneo*, Barcelona, 1958
Einstein, C., *Die Kunst des 20. Jahrhunderts*, Berlin, 1926
Francastel, P., *Peinture et societé*, Lyons, 1951
Kahnweiler, D. H., *Confessions esthétiques*, Paris, 1963
Lafuente Ferrari, E., *Breve historia de la pintura española*, Madrid, 1953
Marés, F., *Dos siglos de enseñanza artística en el Principado*, Barcelona, 1964
Martinell, C., *La Escuela de La Lonja en la vida artística barcelonesa*, Barcelona, 1951
Peña Hinojosa, B., *Pintores malagueños en el siglo XIX*, Malaga, 1964
Quatre Gats, Primer Salón 'Revista', Barcelona, 1954
Ráfols, J. F., *El arte modernista en Barcelona*, Barcelona, 1943
Ráfols, J. F., *Modernismo y modernistas*, Barcelona, n.d.
Salmon, A., *La jeune peinture française*, Paris, 1919

Works on Picasso

Ainaud, J., *Carnet La Coruña (1894–5)*, Barcelona, 1971
Argan, G. C., *Sculture di Picasso*, Venice, 1953
Arnheim, A., *Picasso's Guernica: the genesis of a painting*, Los Angeles, 1962
Barr, A. H., *Picasso, Forty years of his Art*, New York, 1939
Barr, A. H., *Picasso, Fifty years of his Art*, New York, 1946
Barr, A. H., *Picasso, 75th anniversary*, New York, 1957
Berger, J., *Success and failure of Picasso*, London, 1965
Bertram, A., *Pablo Picasso*, New York, 1937
Blunt, A. and Pool, P., *Picasso, the formative years, a study of his sources*, London, 1962
Boeck, W., *Picasso*, Paris, 1955
Bollinger, *Picasso 'Suite Vollard'*, Barcelona, 1956
Boudaille, G., *Picasso, première époque 1881–1906*, Paris, 1964
Bouret, J., *Picasso dessins*, Paris, 1950
Brassai, *Conversations avec Picasso*, Paris, 1964
Camon Aznar, J., *Picasso y el cubismo*, Madrid, 1956
Carrá, C., Prampolini, E., Severini, G. and Soffici, A., *Cinquanta disegni di Picasso*, Novara, 1943
Cassou, J., *Picasso*, Paris, 1940

288. *Self-portrait*. Barcelona, 1896.

289. *The artist's sister Lola at night.* Barcelona, c. 1896.

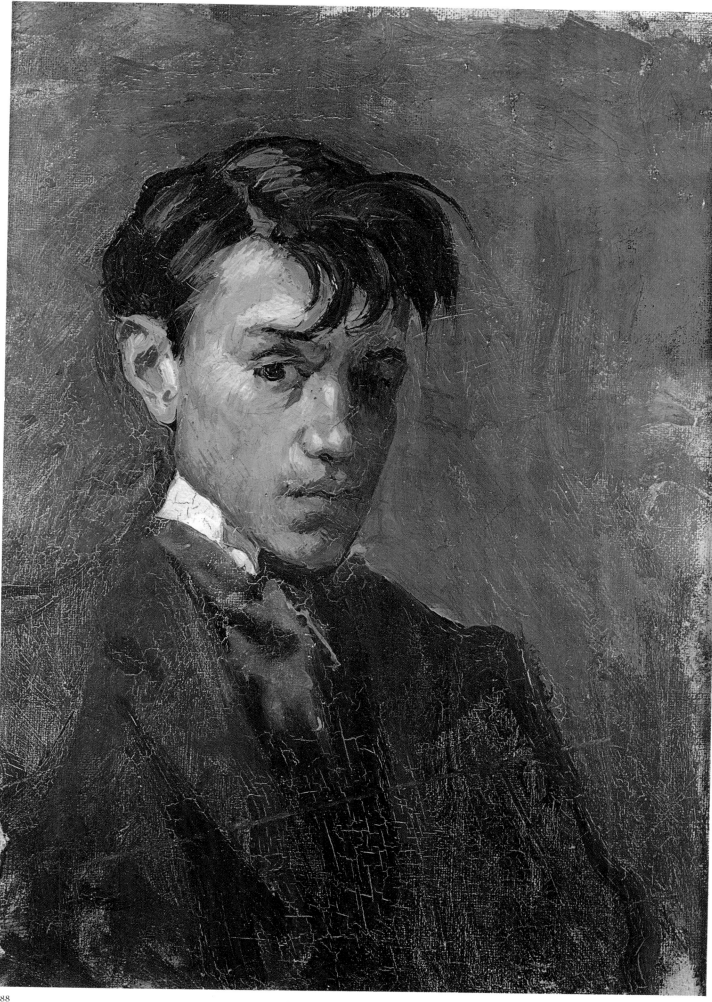

289

290

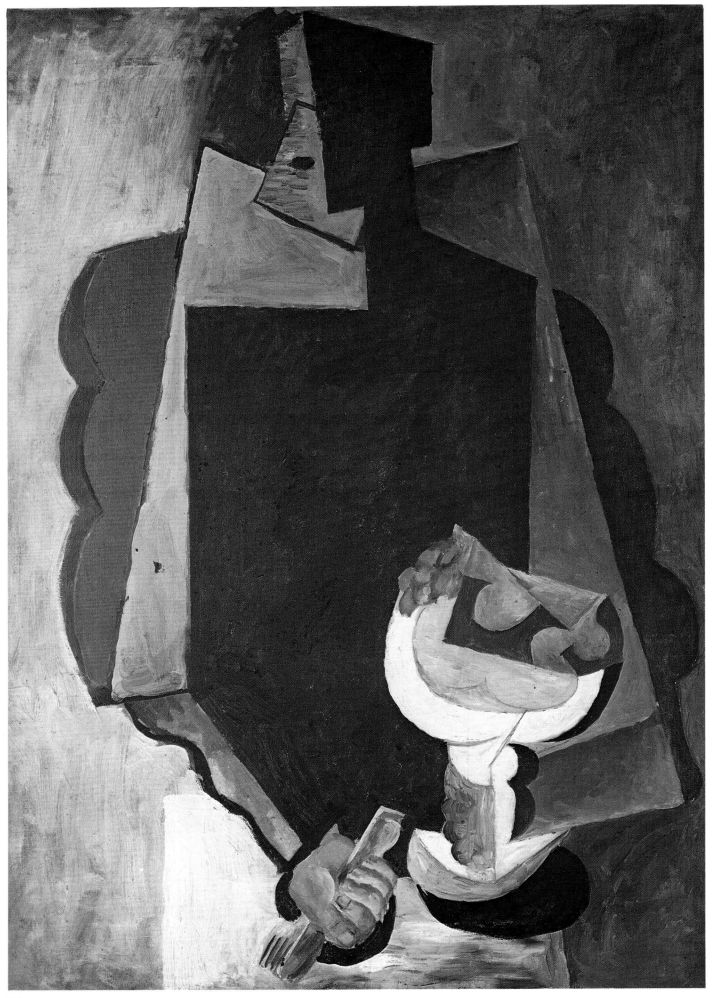

291

Champris, P. G. de, *Picasso, ombre et soleil,* Paris, 1960
Char, R. and Feld, C., *Picasso: dibujos,* Barcelona, 1969.
Chevalier, D., *Picasso: blue and rose periods,* Lugano, 1969
Cirici-Pellicer, A., *Picasso avant Picasso,* Paris, 1950
Cocteau, J., *Picasso,* Paris, 1923
Cogniat, R., *Picasso: figures,* Lausanne, 1959
Cooper, D., *Preface de Picasso,* Marseilles, 1959
Cooper, D., *Picasso theatre,* London, 1968
Daix, P., *Picasso,* Paris, 1964
Dale, M., *Picasso,* New York, 1930
Damase, J., *Pablo Picasso,* Buenos Aires, 1968
Danz, L., *Personal revolution and Picasso,* New York, 1941
Descargues, P., *Picasso, témoin du XXe siècle,* Paris, 1956
Desnos, R., *Picasso: seize peintures, 1939–43,* Paris, 1943
Diehl, G., *Picasso,* Paris, 1960
Dominguin, L. M. and Boudaille, G., *Toros y toreros,* Paris, 1961
Dor de la Souchère, *Picasso à Antibes,* Paris, 1960
D'Ors, E., *Pablo Picasso,* Paris, 1930
Duncan, D. Douglas, *Picasso's Picassos,* New York, 1961
Elgar, F., *Picasso: Epocas azul y rosa,* Barcelona, 1956
Elgar, F., *Picasso: Epoca cubista,* Barcelona, 1957
Elgar, F. and Maillard, R., *Picasso,* London, 1956
Eluard, P., *A Pablo Picasso,* Paris, 1947
Eluard, P., *Picasso. Dessins,* Paris, 1952
Erben, W., *Picasso und die Schwermut,* Heidelberg, 1947
Gaya Nuno, J. A., *Bibliografia critica y antológica de Picasso,* S. Juan de Puerto Rico, 1966
Geiser, B., *55 years of his graphic art,* London, 1955
Geiser, B., *Picasso: graphic works,* London, 1967
George, W., *Picasso: dessins,* Paris, 1926
George, W., *Picasso,* Rome, 1924
Gieure, M., *Initiation à l'oeuvre de Picasso,* Paris, 1951
Gomez de la Serna, R., *Picasso,* Turin, 1945
Guichard-Meili, J., *Picasso. De Barcelona a la época rosa,* Barcelona, 1968
Jaffé, H.L., *Pablo Picasso,* Florence, 1969
Janis, H. and S., *Picasso, the recent years,* New York, 1946
Jardot, M., *Picasso. Drawings,* New York, 1959
Kahnweiler, D.H., *The rise of cubism,* New York, 1949
Kahnweiler, D. H., *Les sculptures de Picasso,* London, 1949
Kay, H., *Picasso's world of children,* London, 1965
Lafuente Ferrari, E., *De Trajano a Picasso,* Barcelona, 1962
Lambert, J.C., *Picasso, dessins du tauromachie, 1917–1960,* Paris, 1960
Lassaigne, J., *Picasso,* Paris, 1949
Leiris, M., *Brisées,* Paris, 1966
Leonhard and Bollinger, *Picasso, su obra grafica, 1954–1965,* Barcelona, 1967
Level, A., *Picasso,* Paris, 1928
Lieberman, W.S., *Picasso and the ballet,* New York, 1946
Lieberman, W.S., *Pablo Picasso: blue and rose periods,* London, 1955
Merli, J., *Picasso,* Buenos Aires, 1942
Micheli, M. de, *Picasso,* Florence, 1967
Moravia A. and Lecaldano, P., *Picasso, azul y rosa,* Barcelona, 1969
Olivier, F., *Picasso et ses amis,* Paris, 1933

290. *Urban view.* Barcelona, 1897.

291. *Figure with a fruit dish.* Barcelona, 1917.

Palau Fabre, J., *Picasso en Cataluña*, Barcelona, 1966
Palau Fabre, J., *Doble ensayo sobre Picasso*, Barcelona, 1968
Palau Fabre, J., *Picasso i els seus amics catalans*, Barcelona, 1971
Parmelin, H., *Picasso says*, London, 1968
Parmelin, H., *Picasso: the artist and his model and other recent works*, New York, 1968
Parmelin, H., *Les dames de Mougins*, Paris, 1964
Parmelin, H., *Picasso: intimate secrets of a studio at Notre Dame de Vie*, London, 1968
Parmelin, H., *Picasso sur la place*, Paris, 1959
Penrose, R., *Picasso, his life and work*, London, rev. edn. 1971
Penrose, R., *Portrait of Picasso*, London, 1956
Penrose, R., *The sculpture of Picasso*, New York, 1967
Prampolini, E., *Picasso, scultore*, Rome, 1943
Prévert, J., *Portraits de Picasso*, Milan, 1959
Quinn, E. and Penrose, R., *Picasso at Work*, London, 1965
Raphaël, *Von Manet zu Picasso*, Munich, 1919
Raphaël, M., *Proudhon, Marx, Picasso*, Paris, 1933
Raynal, M., *Picasso*, Paris, 1922
Raynal, M., *Picasso*, London, 1953
Reverdy, P., *Pablo Picasso*, Paris, 1924
Richardson, J., *Pablo Picasso: watercolours and gouaches*, London, 1964
Rodriguez Aguilera, C., *Picasso 85*, Barcelona, 1968
Russoli, F., *Pablo Picasso*, Milan, 1954
Sabartés, J., *Picasso*, Paris, 1946
Sabartés, J., *Picasso en su obra*, Madrid, 1936
Sabartés, J., *Picasso. Portraits et souvenirs*, Paris, 1946
Sabartés, J., *Picasso, les Menines et la vie*, Paris, 1958
Sabartés, J., *De Llotja au musée Picasso*, Paris, 1963
Sabartés, J. and Eluard, P., *Picasso, à Antibes*, Paris, 1948
Salmon, A., *Souvenirs sans fin*, Paris, 1955–6
Schmidt, G., *Pablo Picasso*, Basle, 1952
Schurer, O., *Pablo Picasso*, Leipzig, 1927
Soffici, A., *Ricordi de vita artistica e litteraria*, Florence, 1942
Solmi, S., *Disegni di Picasso*, Milan, 1945
Stein, G., *Picasso*, New York, 1938
Sutton, D., *Picasso. Blue and pink periods*, London, 1948
Takashina, S., *Picasso*, Tokyo, 1964
Tardieu, J., *L'espace et la flute, variations, sur douze dessins de Picasso*, Paris, 1958
Tzara, T., *Pablo Picasso et les chemins de la connaissance*, Geneva, 1948
Uhde, W., *Picasso et la tradition française*, Paris, 1928
Vallentin, A., *Picasso*, London, 1963
Vercors, *Picasso, oeuvres, des Musées de Leningrad et de Moscou*, Paris, 1955
Verdet, A., *Faunes et nymphes de Pablo Picasso*, Geneva, 1952
Verdet, A., *L'homme au mouton de Pablo Picasso*, Paris, 1950
Weill, B., *Pan! . . . dans l'oeil*, Paris, 1933
Zervos, C., *Dessins de Picasso, 1892–1948*, Paris, 1949
Zervos, C., *Picasso*, Vols I-XXI, Paris, 1932–70
Agenda 1971, edited for the Corporation of Barcelona, 1971 (with illustrations)

Catalogue of paintings and drawings

292

293

294

295

296

297

298

299

300

301

302

303

304

305

306

307

1895

186

308

309

310

311

312

313

314

315

1895—1896

316

317

318

319

320

321

322

323

1895–1896 188

324

325

326

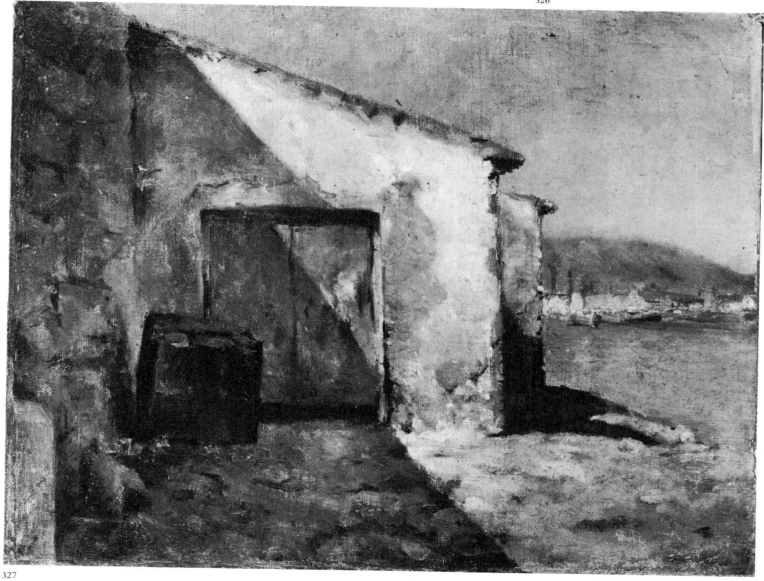

327

328

329

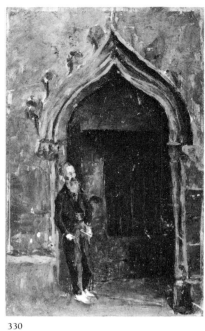

330

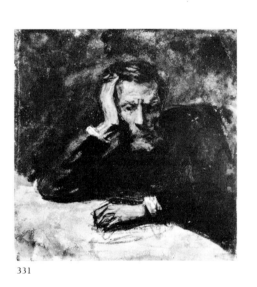

331

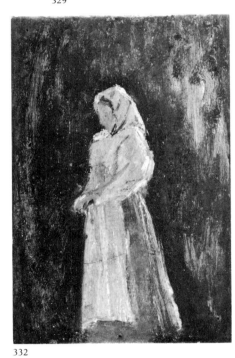

332

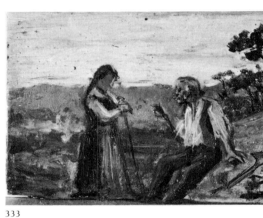

333

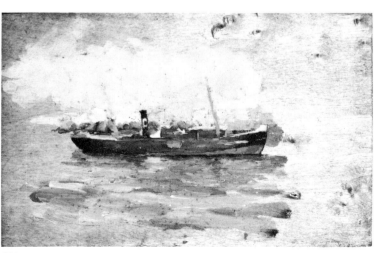

334

335

1895–1896 190

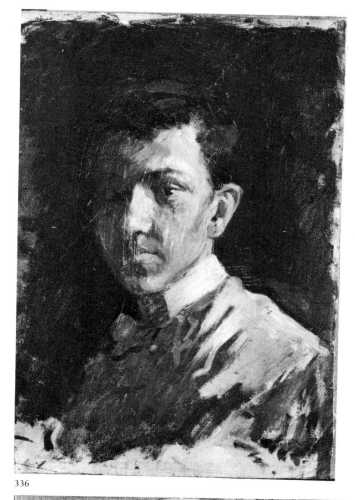

336

337

338

339

340

191

341

342

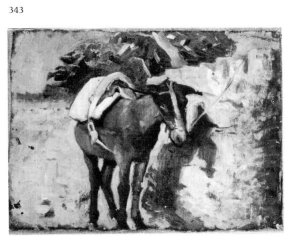

343

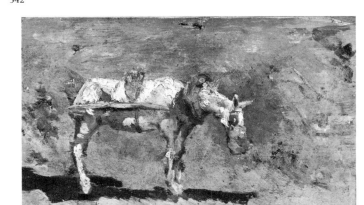

344

345

346

347

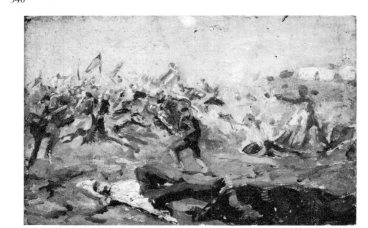

348

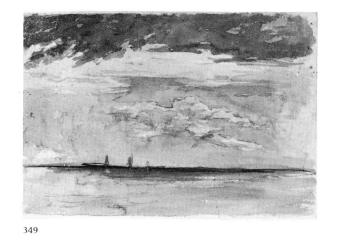

349

350

351

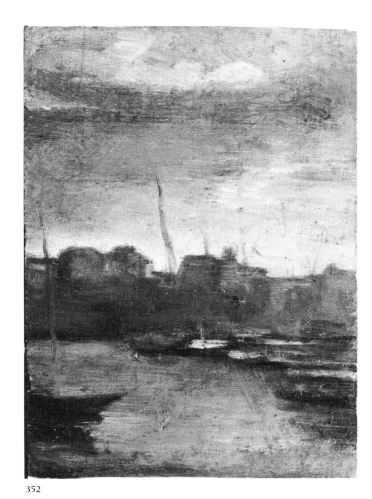

352

353

354

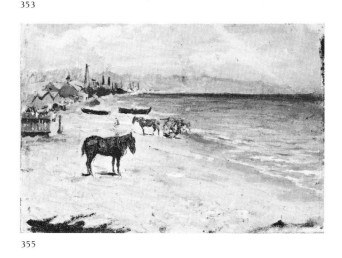

355

356

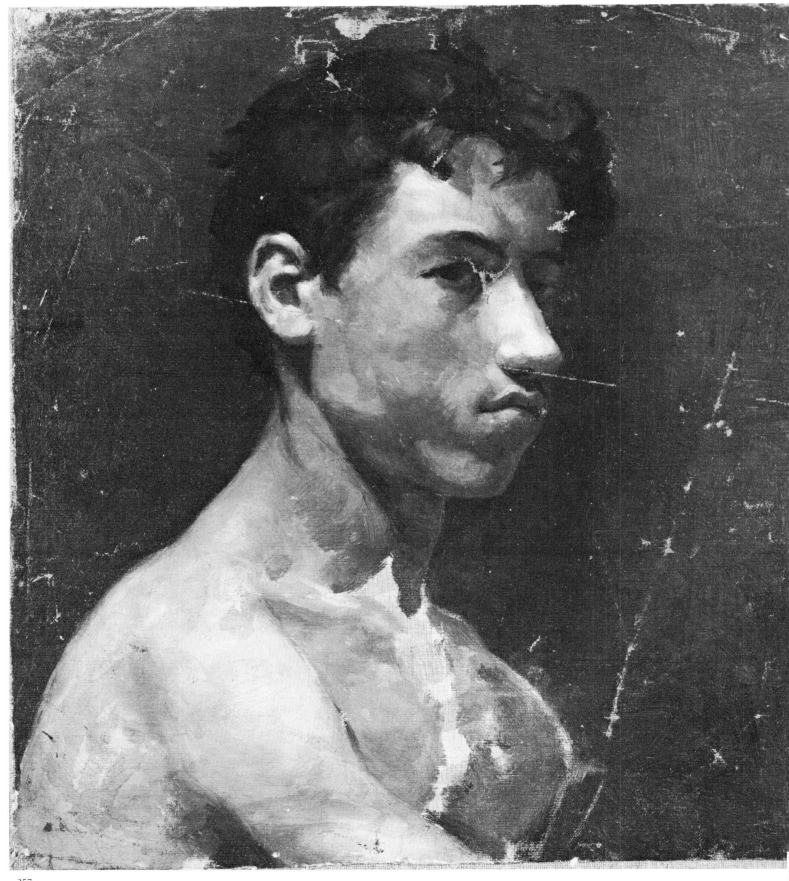

357

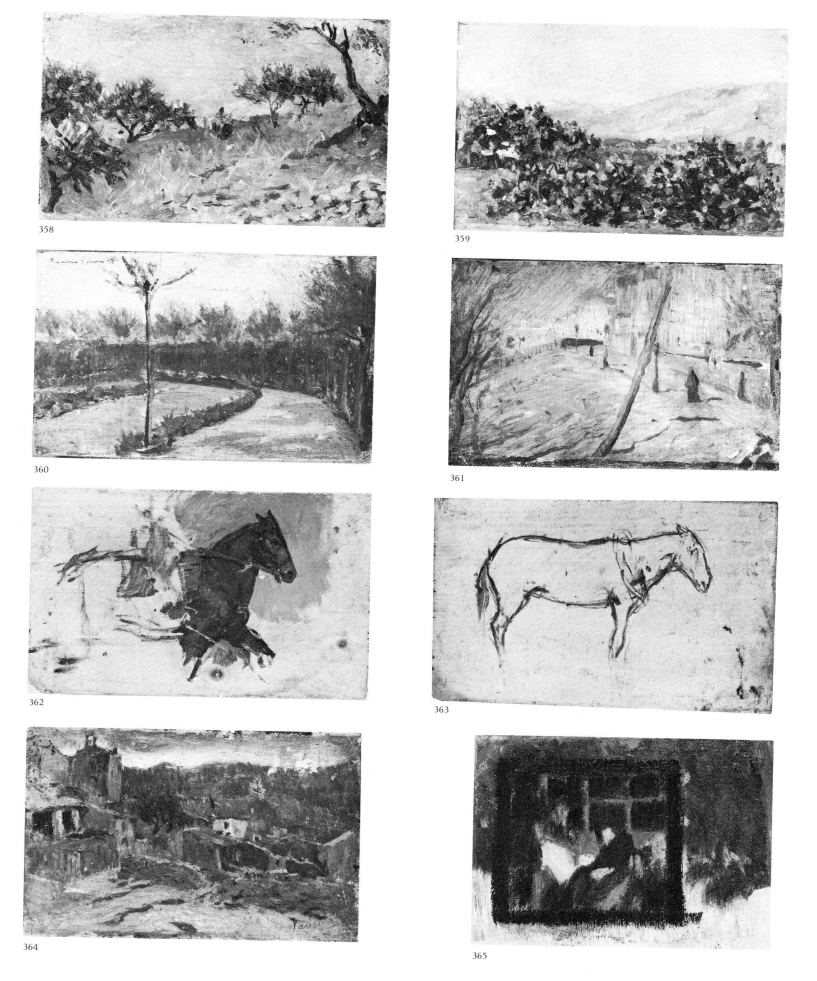

358

359

360

361

362

363

364

365

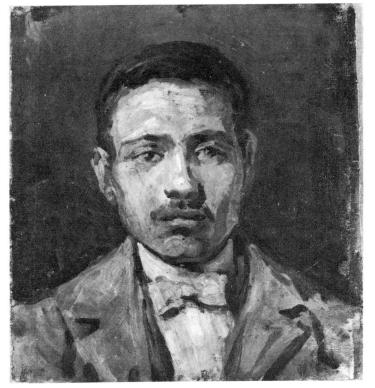

366

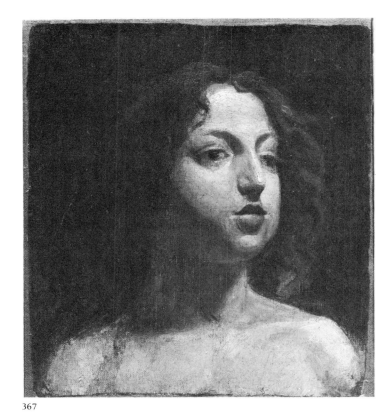

367

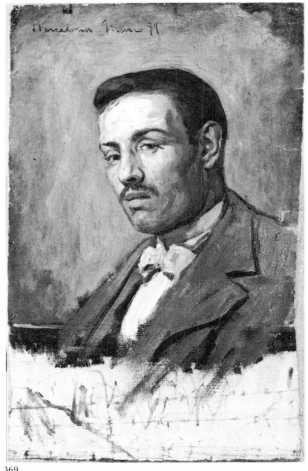

368

369

370

371

372

373

374

375

376

377

378

379

380

381

382

383

384

385

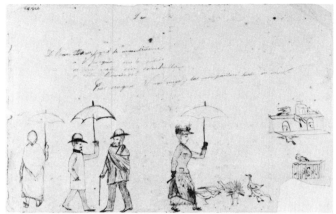

386

387

388

389

390

391

392

393

394

395

396

397

398

399

400

401

1893–1895

402

403

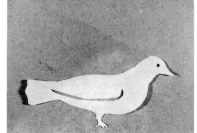

404

405

406

407

408

409

410

411

412

413

414

415

416

417

418

419

420

421

422

423

424

425

426

427

428

429

430

431

432

433

434

435

436

437

1895–1896

438

439

440

441

442

443

444

445

446

447

448

449

450

451

452

453

1895–1896

454

455

456

457

458

459

460

461

462

463

464

465

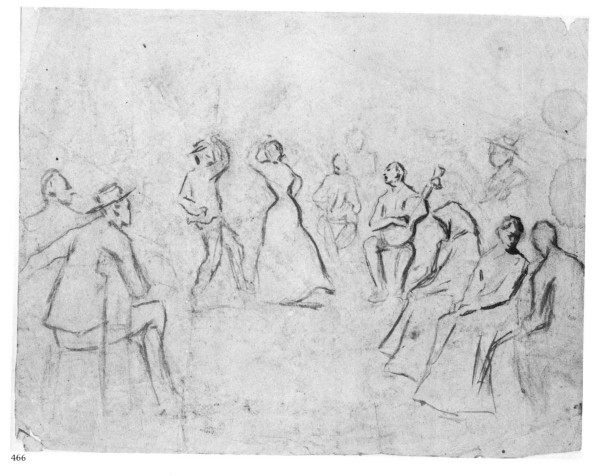

466

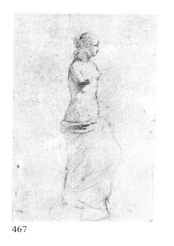

467

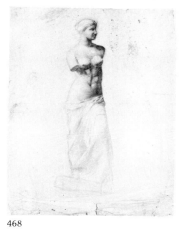

468

469

470

471

472

1895-1897

473

474

475

476

477

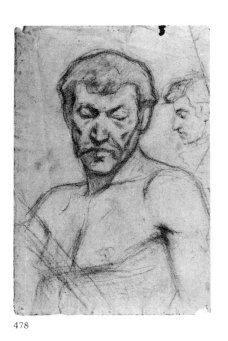

478

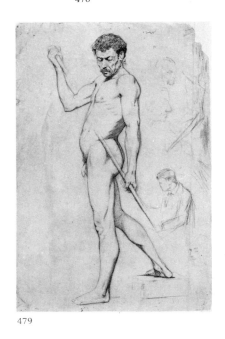

479

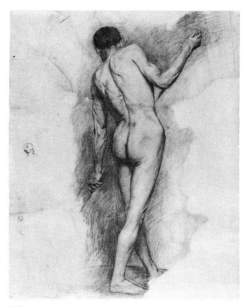

480

1895–1897 208

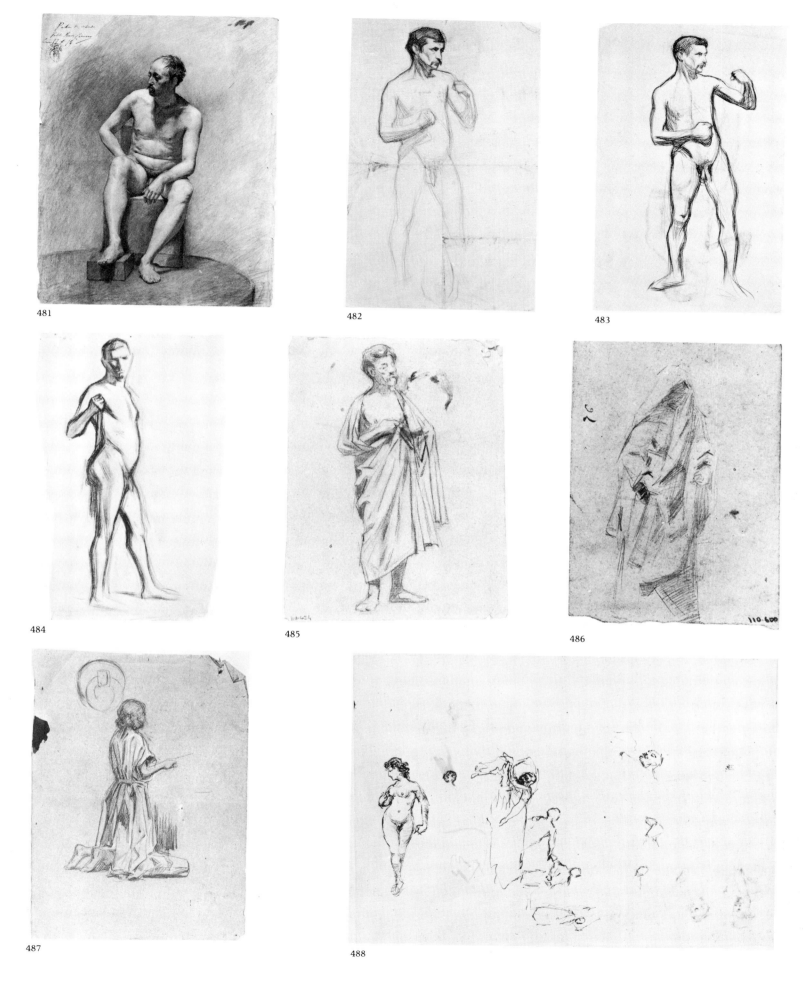

481

482

483

484

485

486

487

488

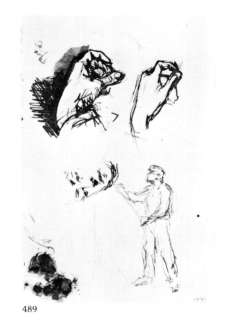

489

490

491

492

493

494

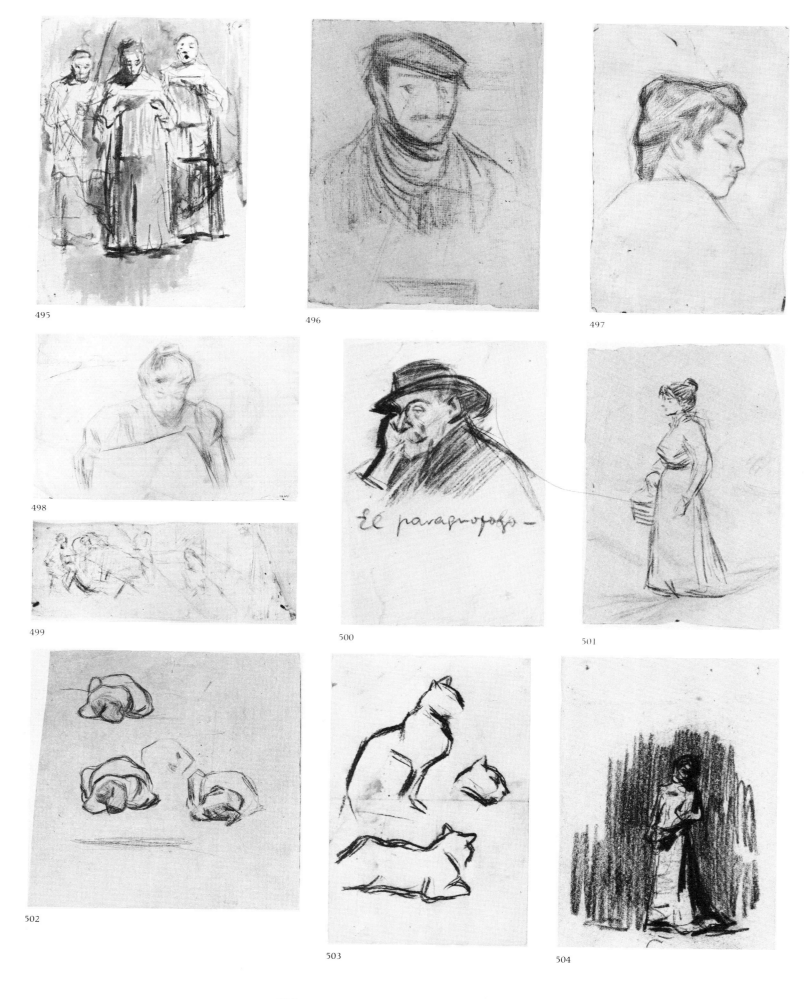

495

496

497

498

499

500

El paraguas—

501

502

503

504

1896–1897

505

506

507

508

509

510

511

512

513

514

515

516

517

518

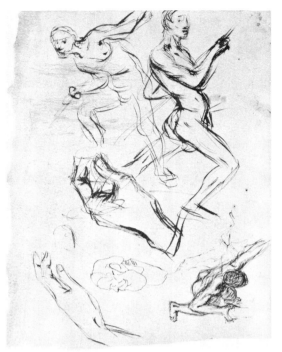

519

520

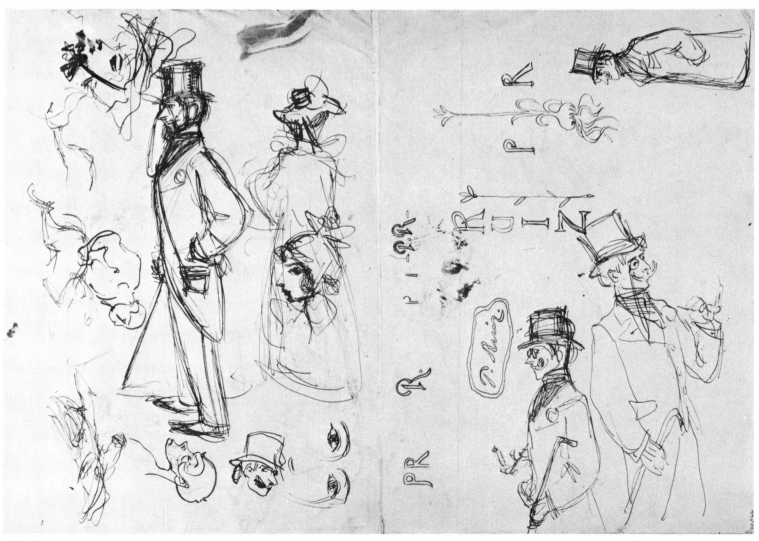

521

522

523

524

525

526

527

528

529

530

531

532

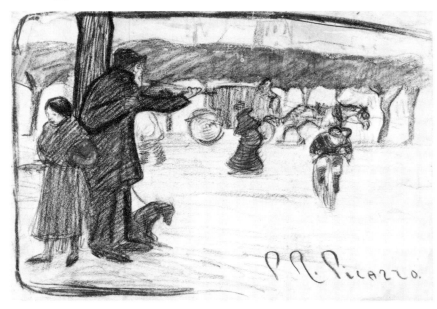

533

534

535

536

537

538

539

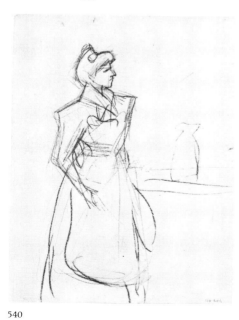

540

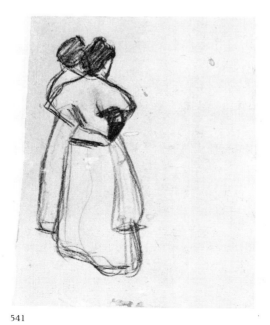

541

217

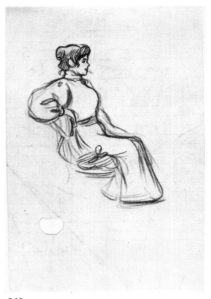

542

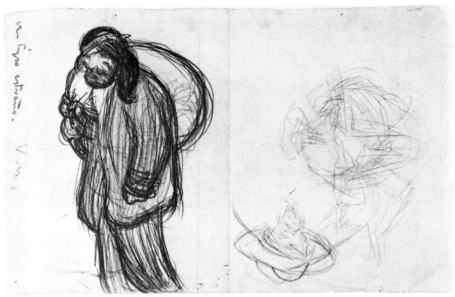

543

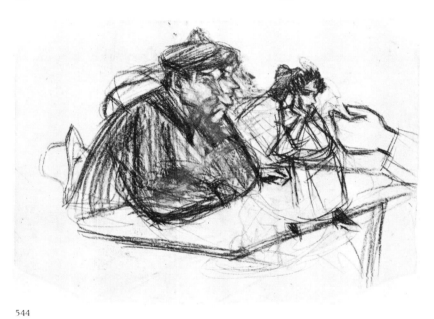

544

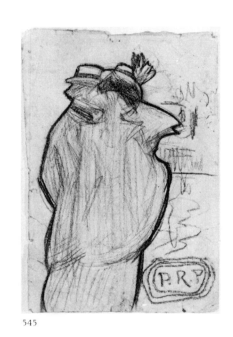

545

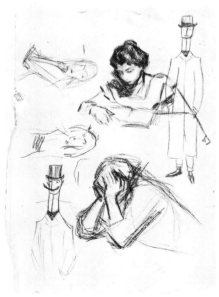

546

547

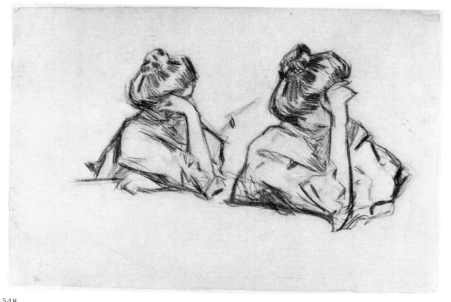

548

549

550

551

552

553

554

555

556

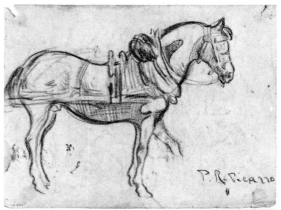

557

558

559

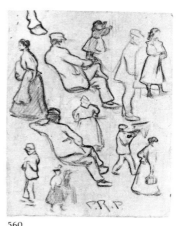

560

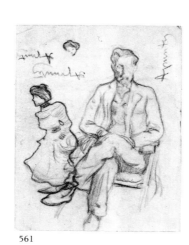

561

562

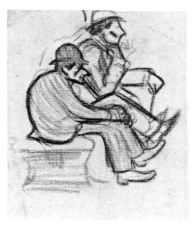

563

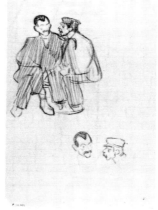

564

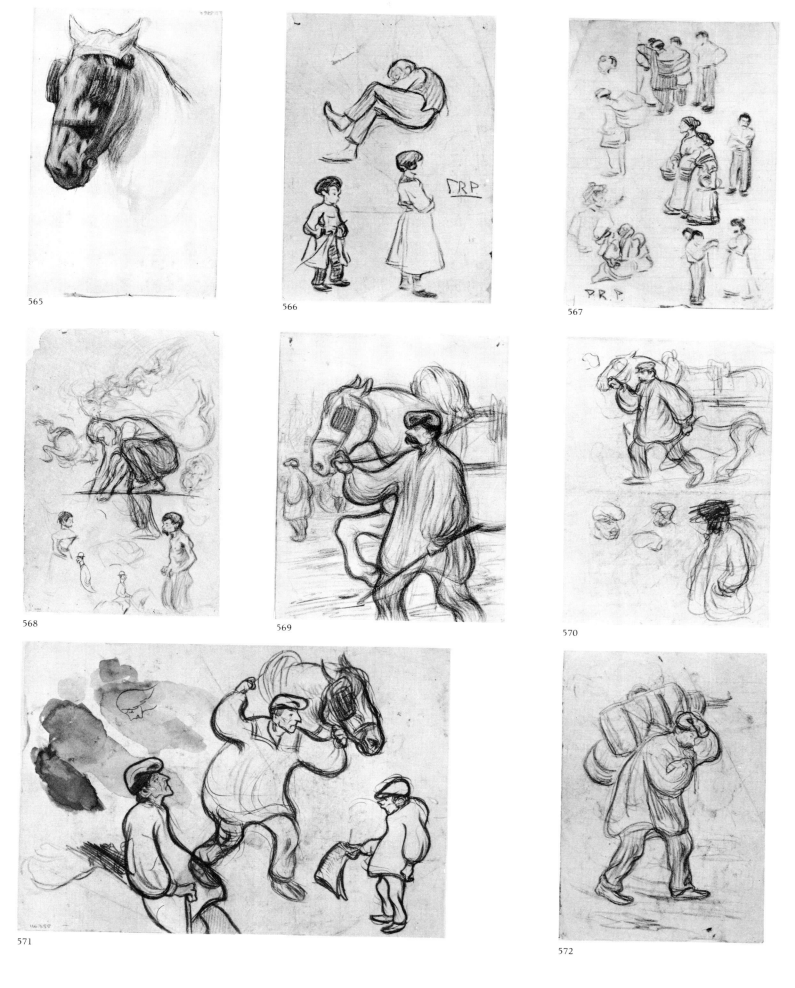

565

566

567

568

569

570

571

572

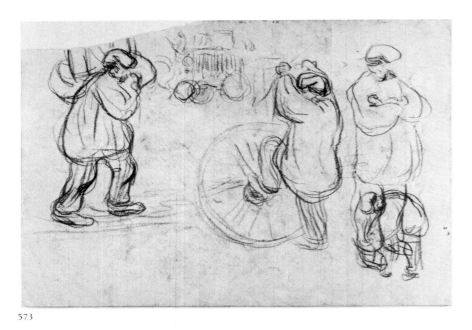

573

574

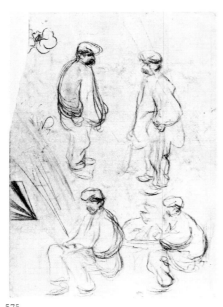

575

576

577

578

579

580

581

582

583

584

585

586

1897–1899

587

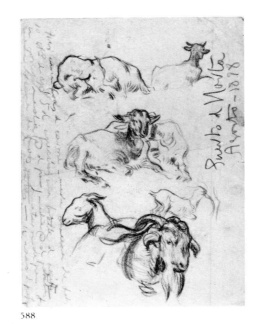

588

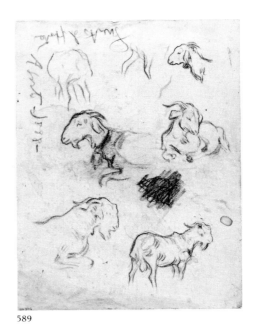

589

590

591

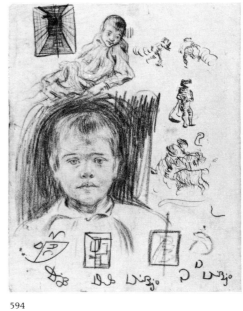

592

593

594

595

596

597

598

599

600

601

602

603

604

605

606

608

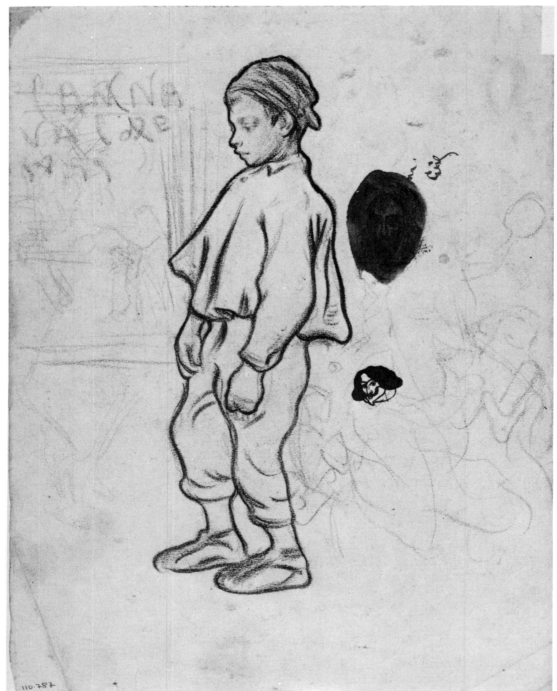

607

609

610

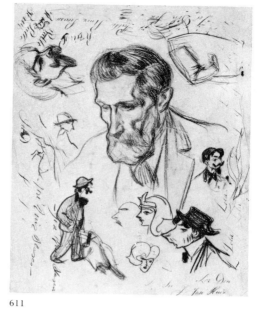

611

612

613

614

615

616

617

1897–1899

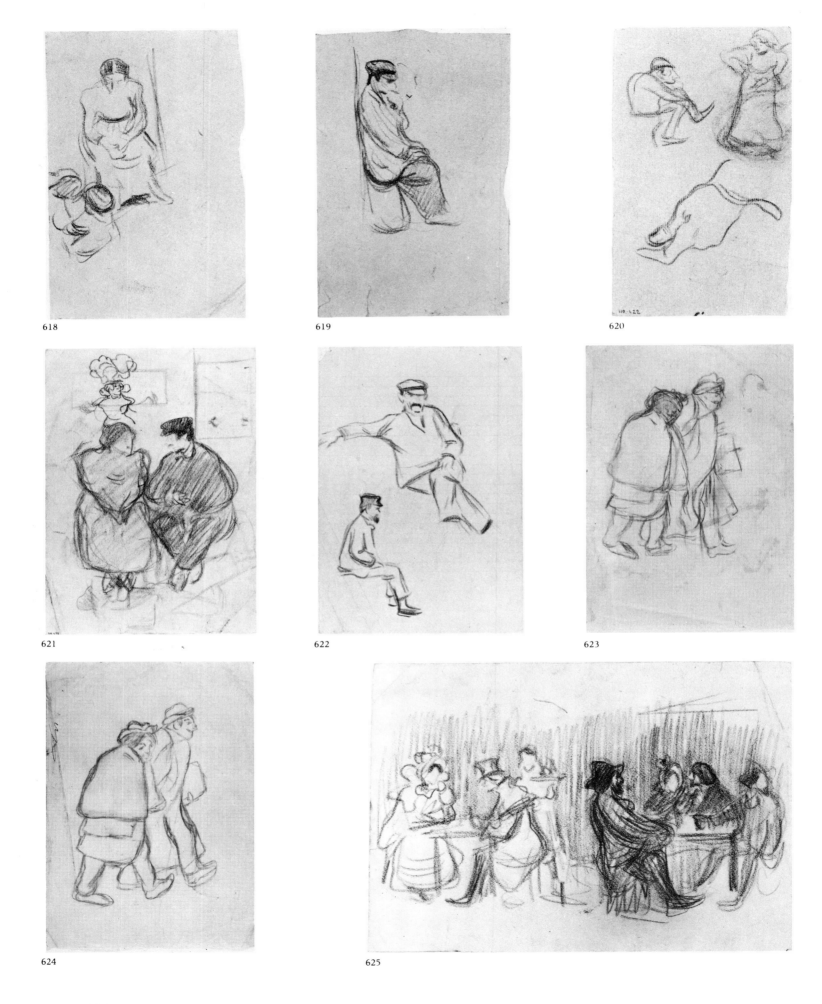

618

619

620

621

622

623

624

625

626

627

628

629

630

631

632

633

634

635

636

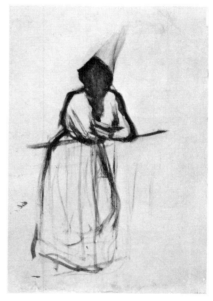

637

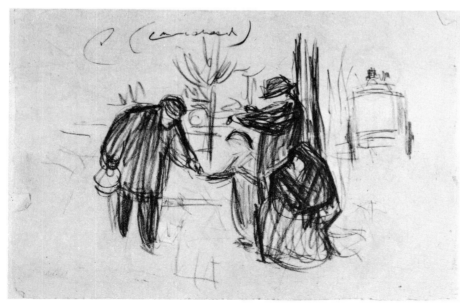

638

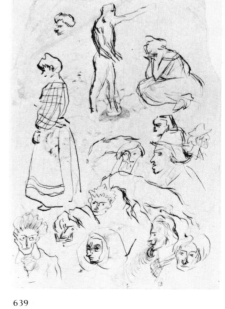

639

640

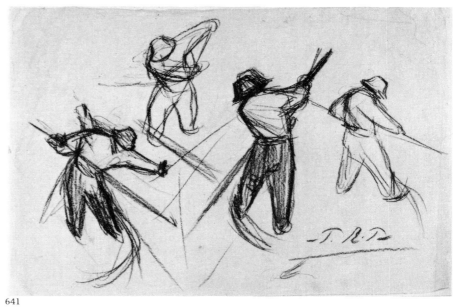

641

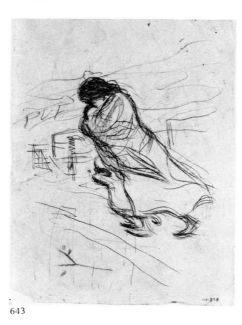

642

643

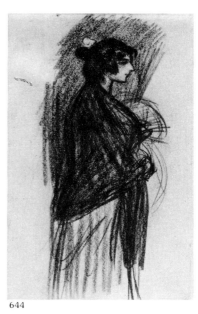

644

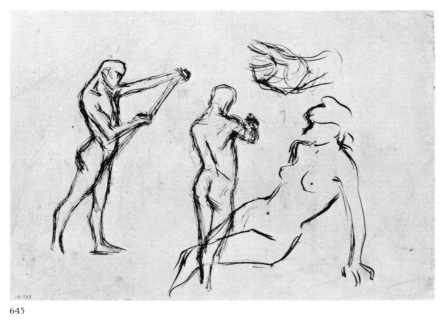

645

646

647

648

649

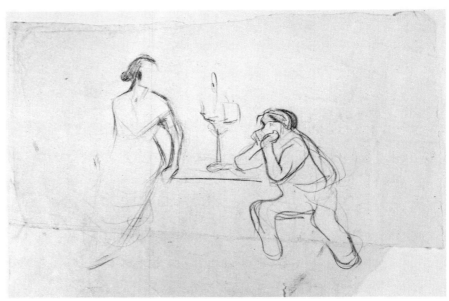

650

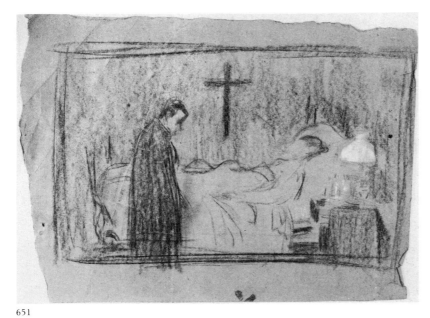

651

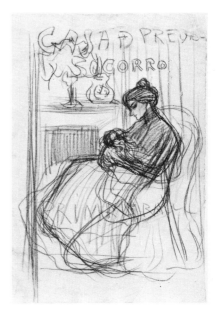

652

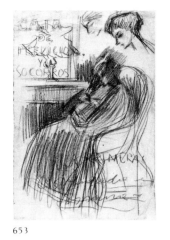

653

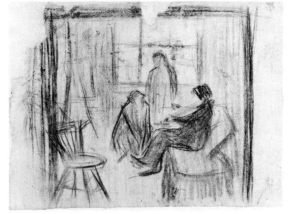

654

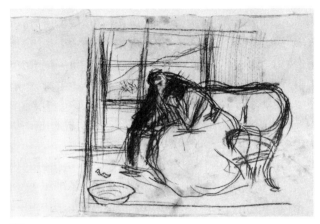

655

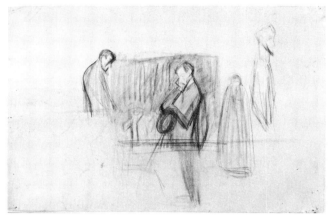

656

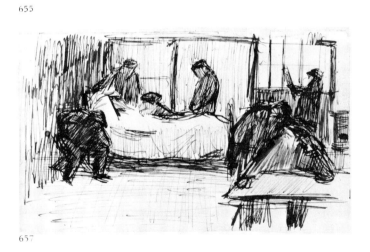

657

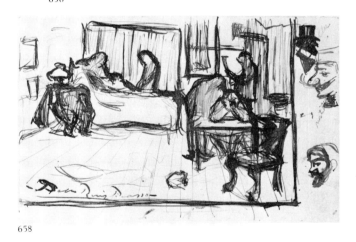

658

659

660

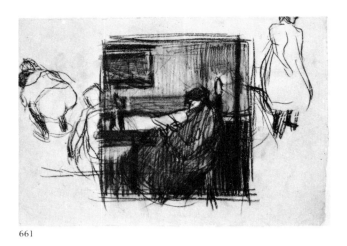

661

662

663

664

665

666

667

668

669

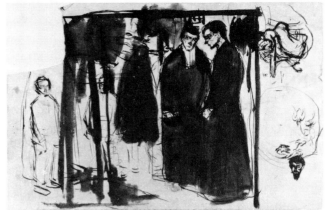

670

671

672

673

674

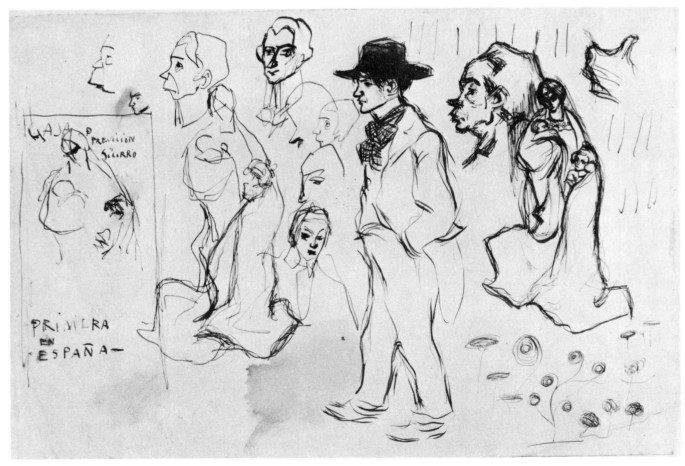

675

676

677

678

679

680

681

682

683

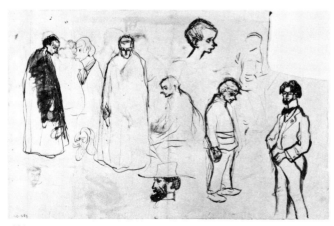

684

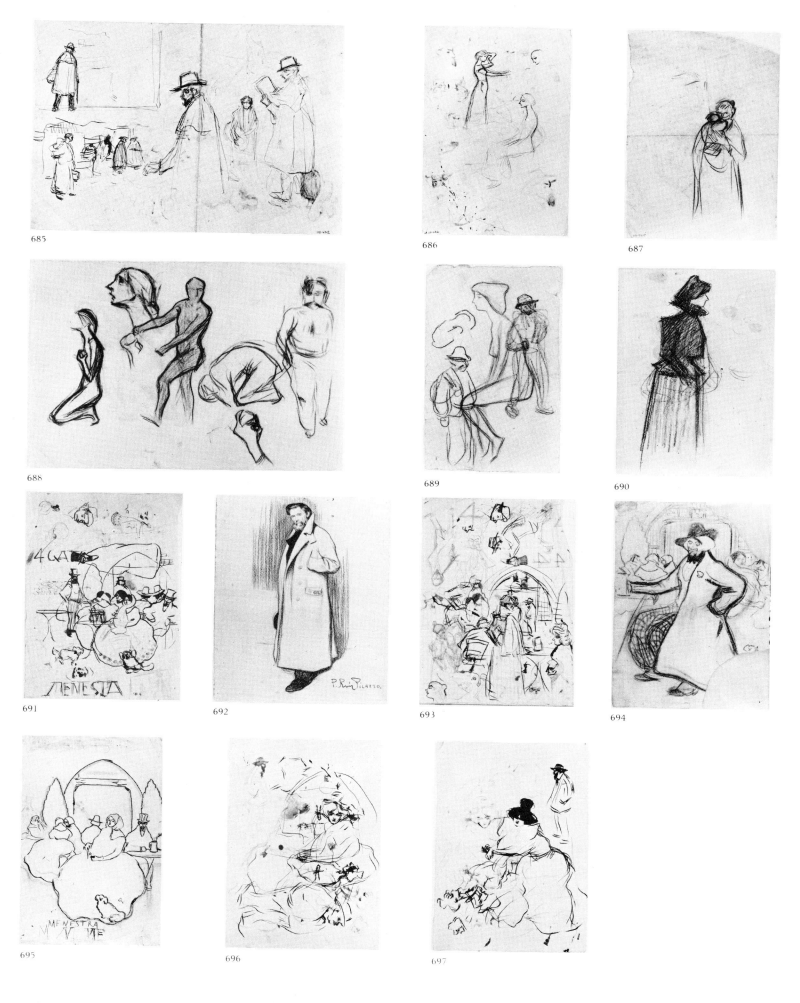

685

686

687

688

689

690

691

692

693

694

695

696

697

698

699

700

701

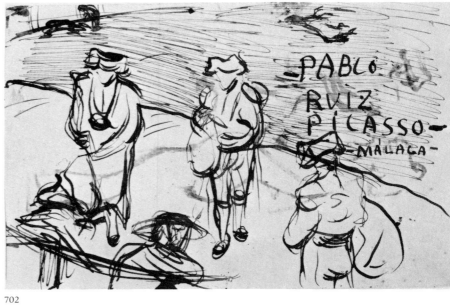

702

703

704

705

706

707

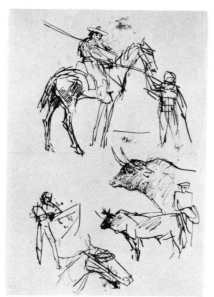

708

709

710

711

1899—1901

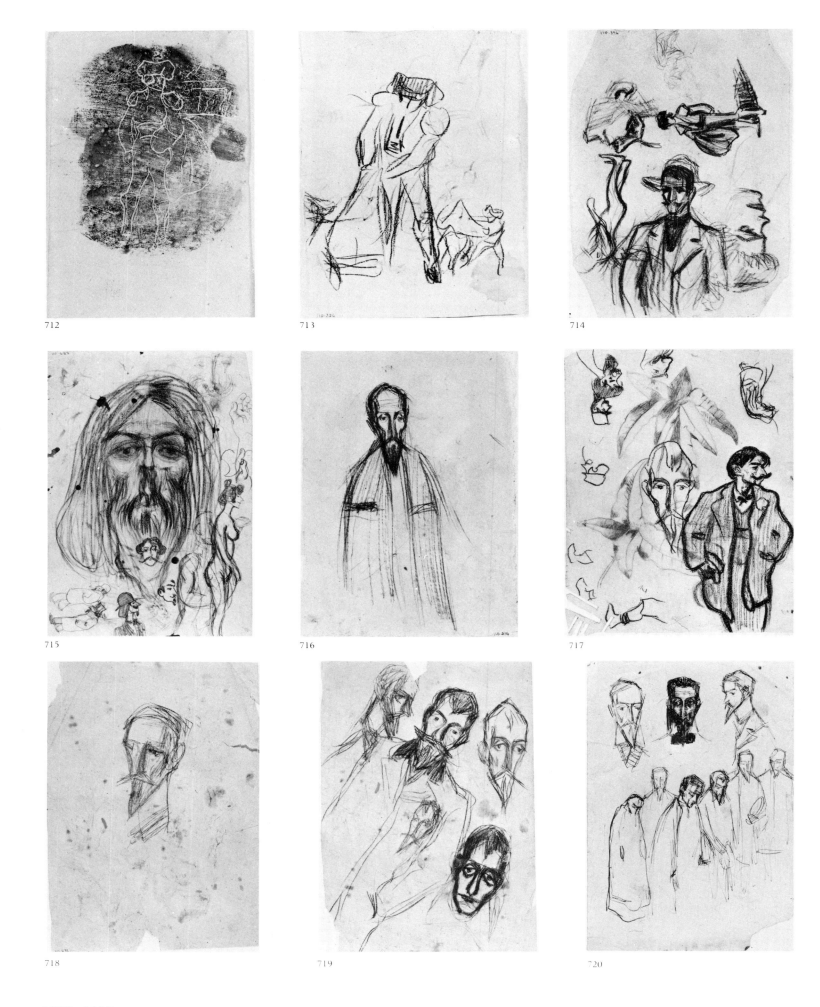

712

713

714

715

716

717

718

719

720

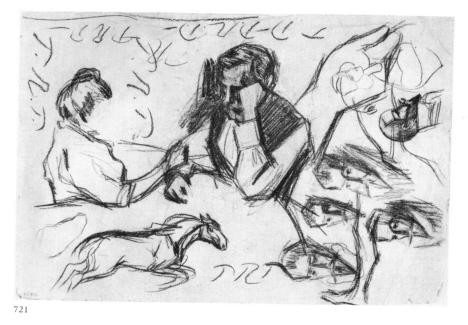

721

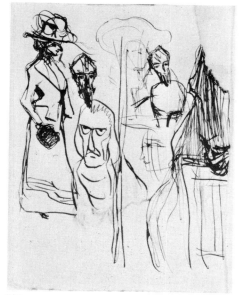

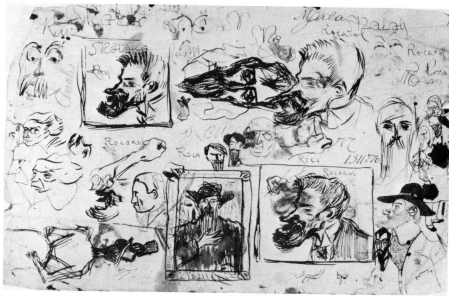

723

724

725

726

727

728

729

730

731

732

733

734

735

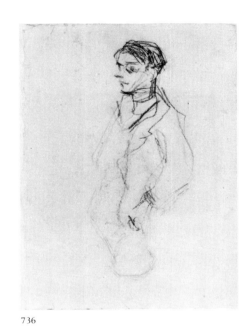

736

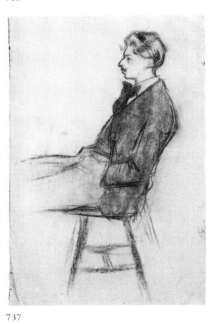

737

738

739

1899—1900

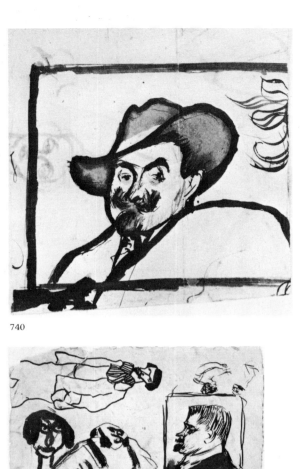

740

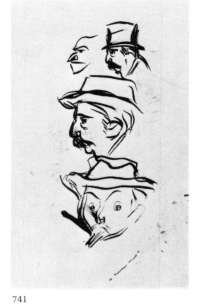

741

742

743

744

745

746

747

748

749

750

751

752

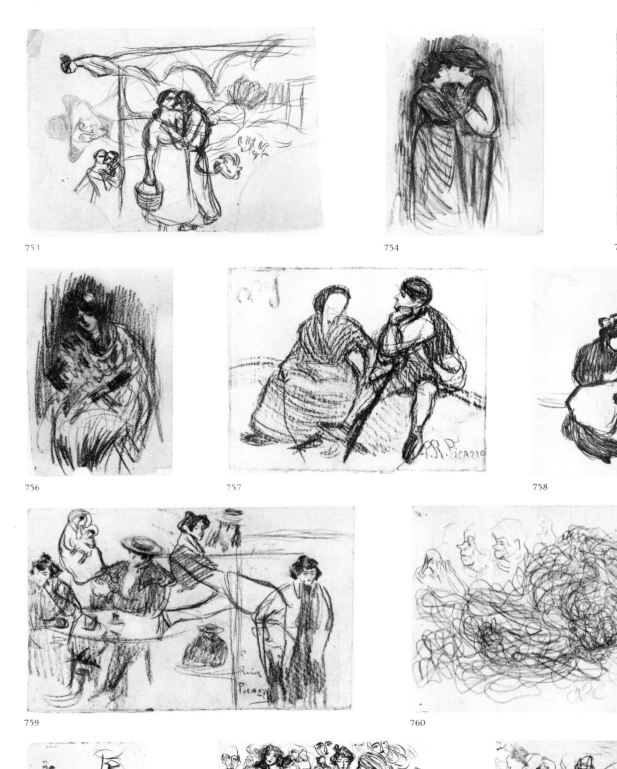

753

754

755

756

757

758

759

760

761

762

763

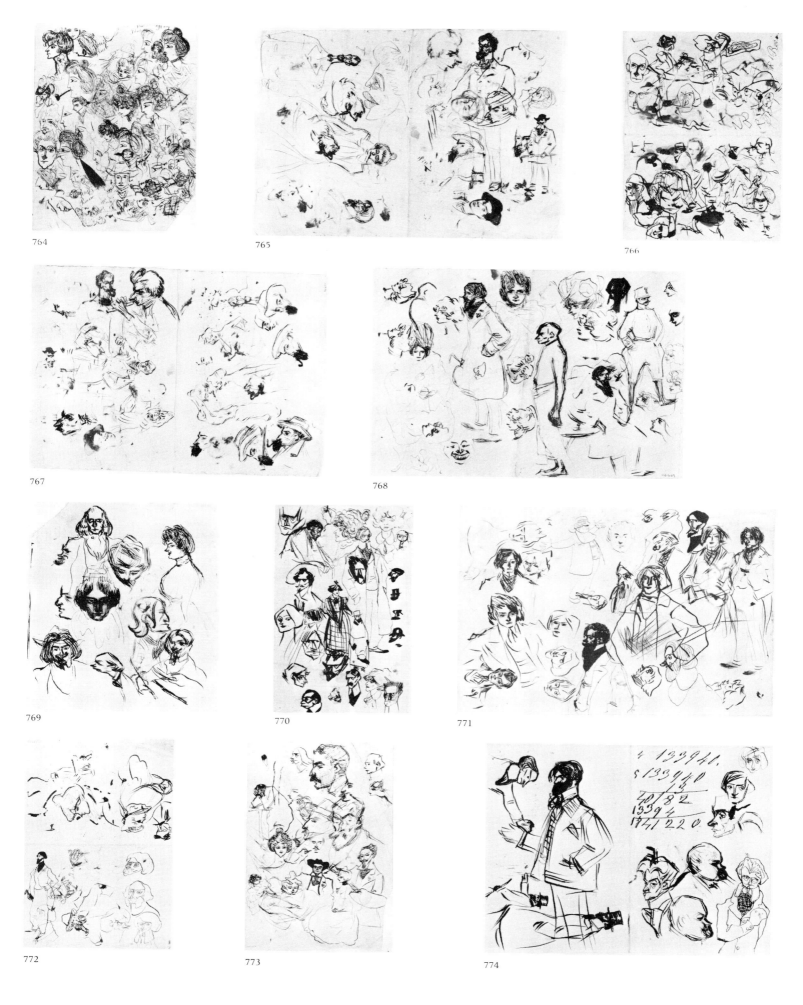

764

765

766

767

768

769

770

771

772

773

774

775

776

777

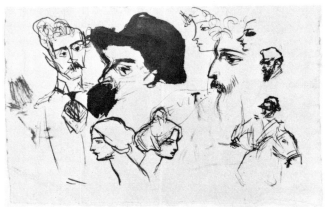

778

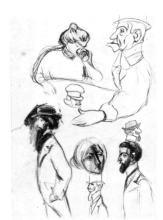

779

780

781

782

783

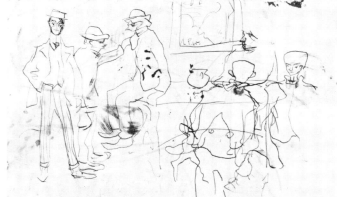

784

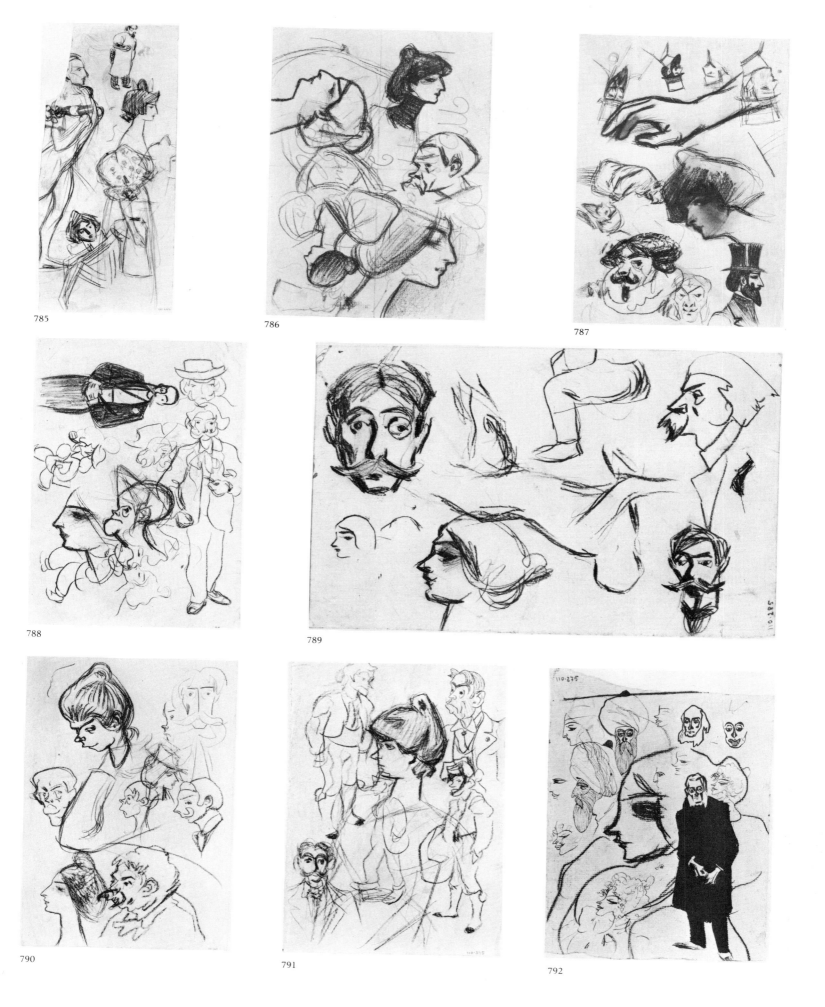

785

786

787

788

789

790

791

792

1899—1900

793

794

795

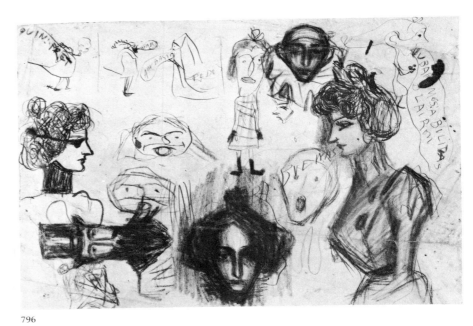

796

797

798

799

800

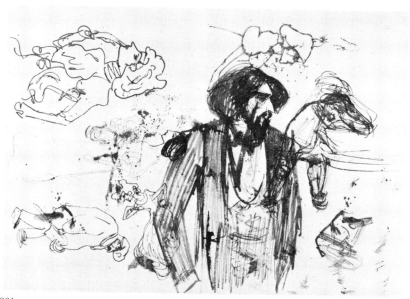

801

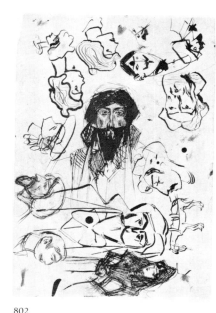

802

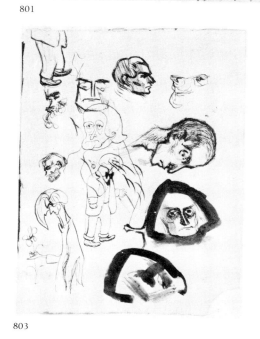

803

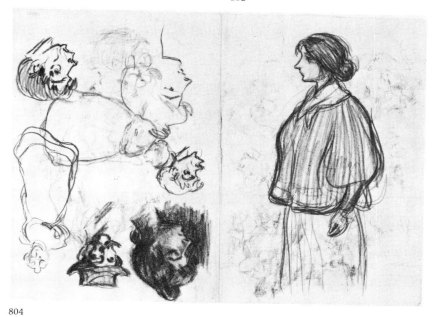

804

1899–1900

805

806

807

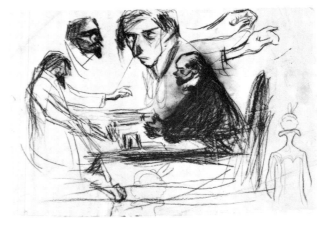

808

809

810

811

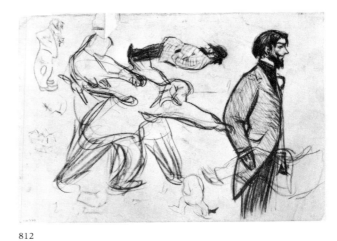

812

813

814

815

816

817

818

819

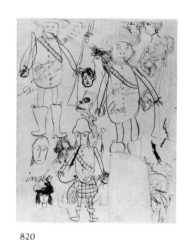

820

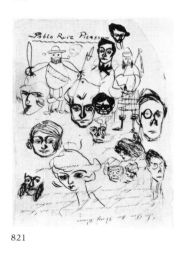

821

822

823

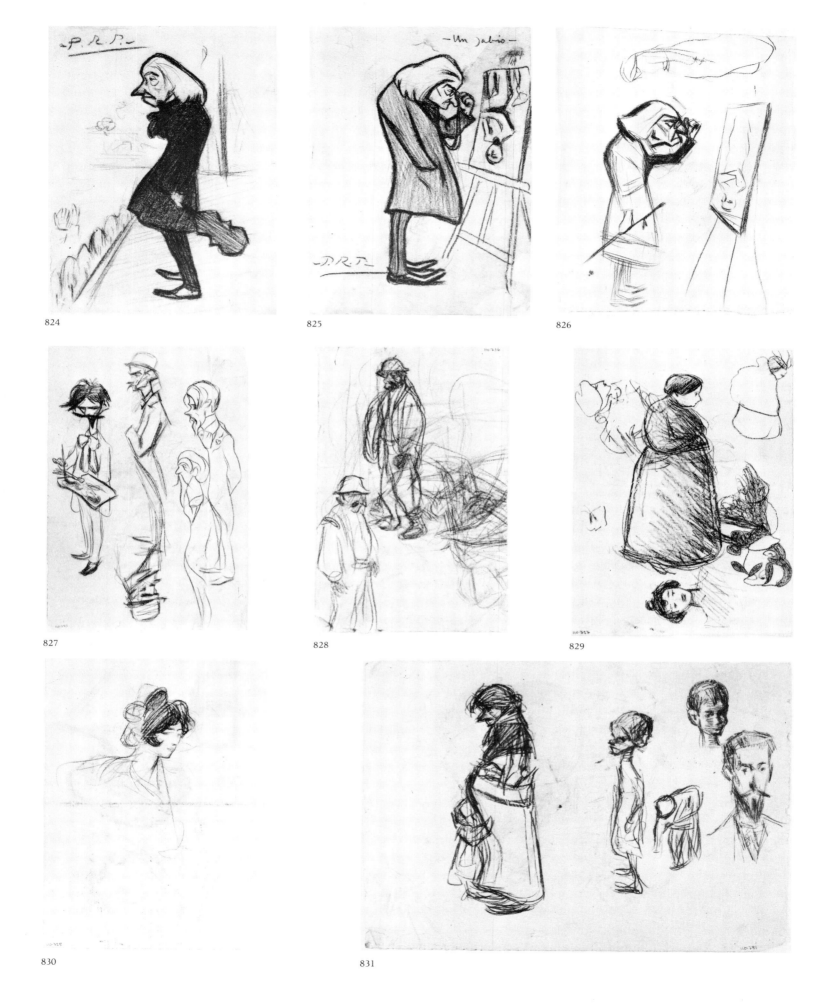

824

825

826

827

828

829

830

831

832

833

834

835

836

837

838

839

840

1899–1900

841

842

843

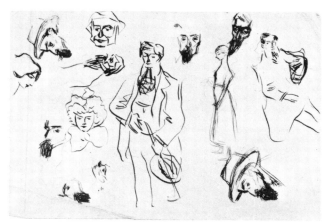

844

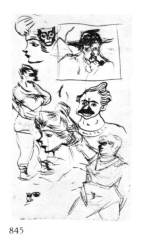

845

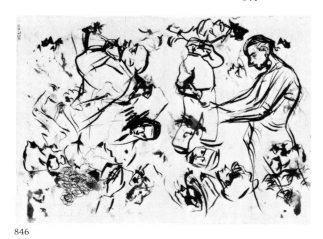

846

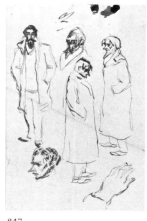

847

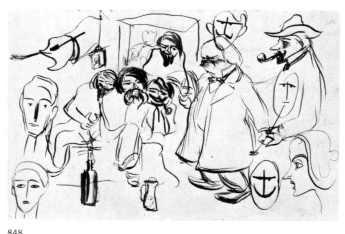

848

849

850

851

852

853

854

855

856

857

858

859

860

257

1899—1900

861

862

863

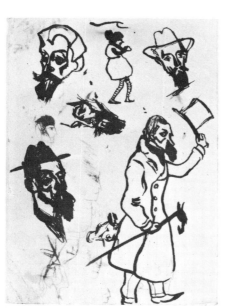

864

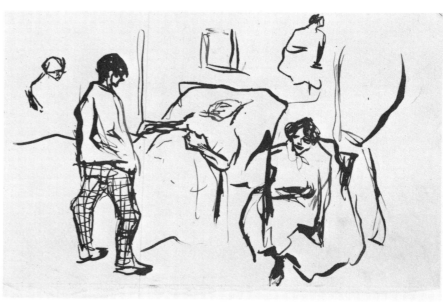

865

866

867

1899–1900

258

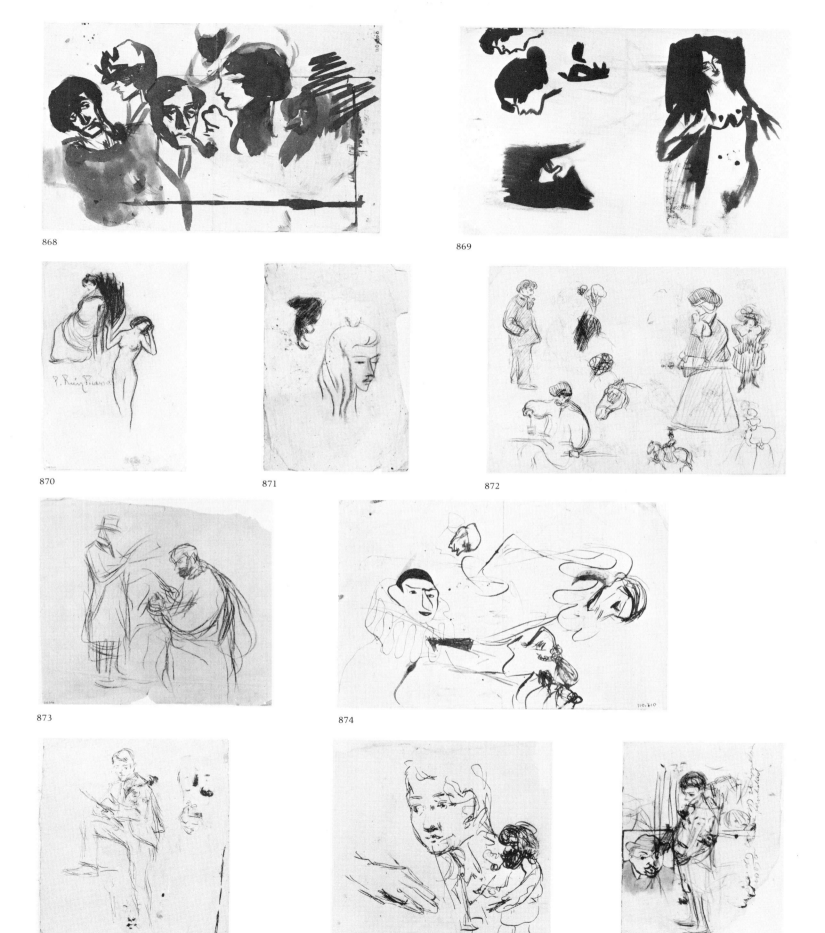

868

869

870

871

872

873

874

875

876

877

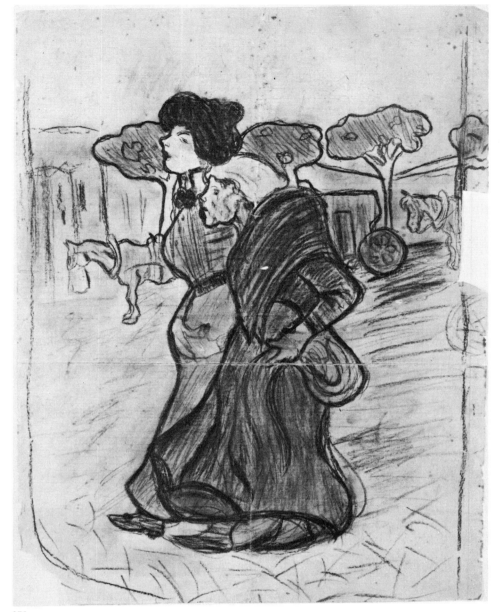

878

880

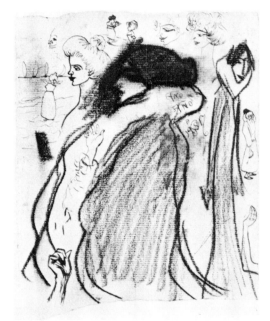

881

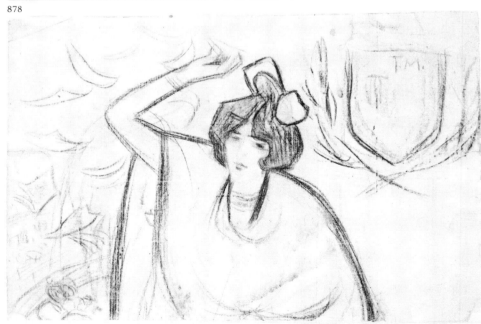

879

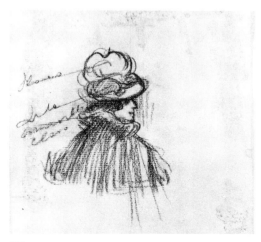

882

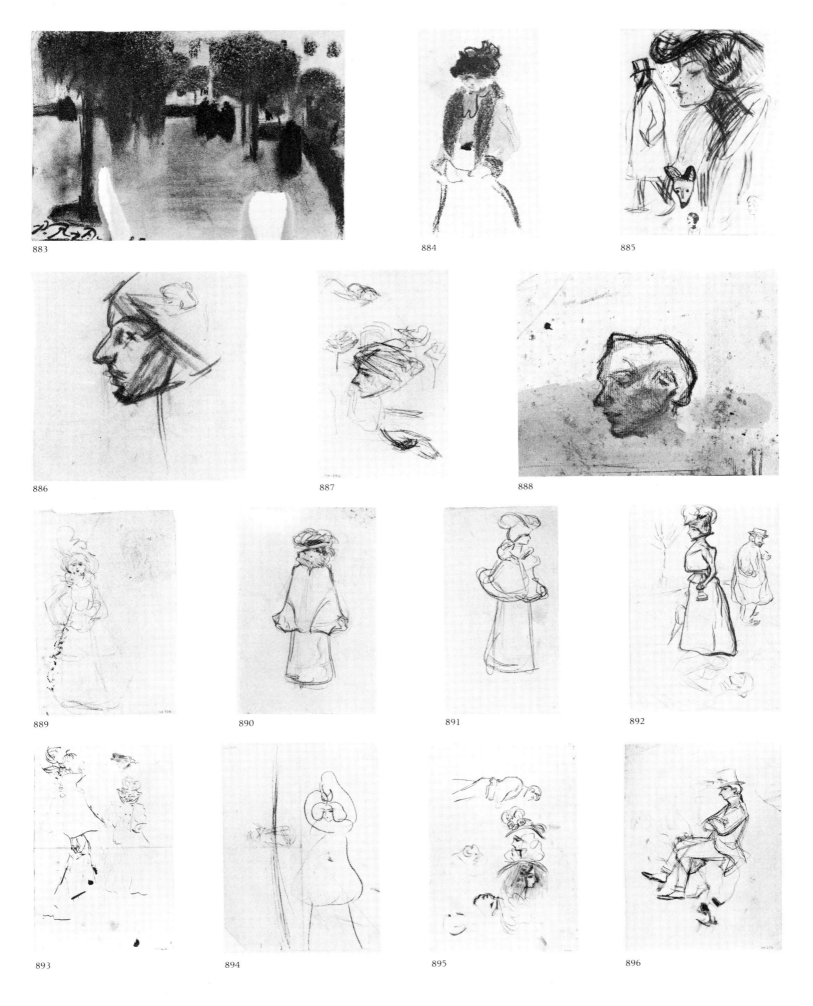

883

884

885

886

887

888

889

890

891

892

893

894

895

896

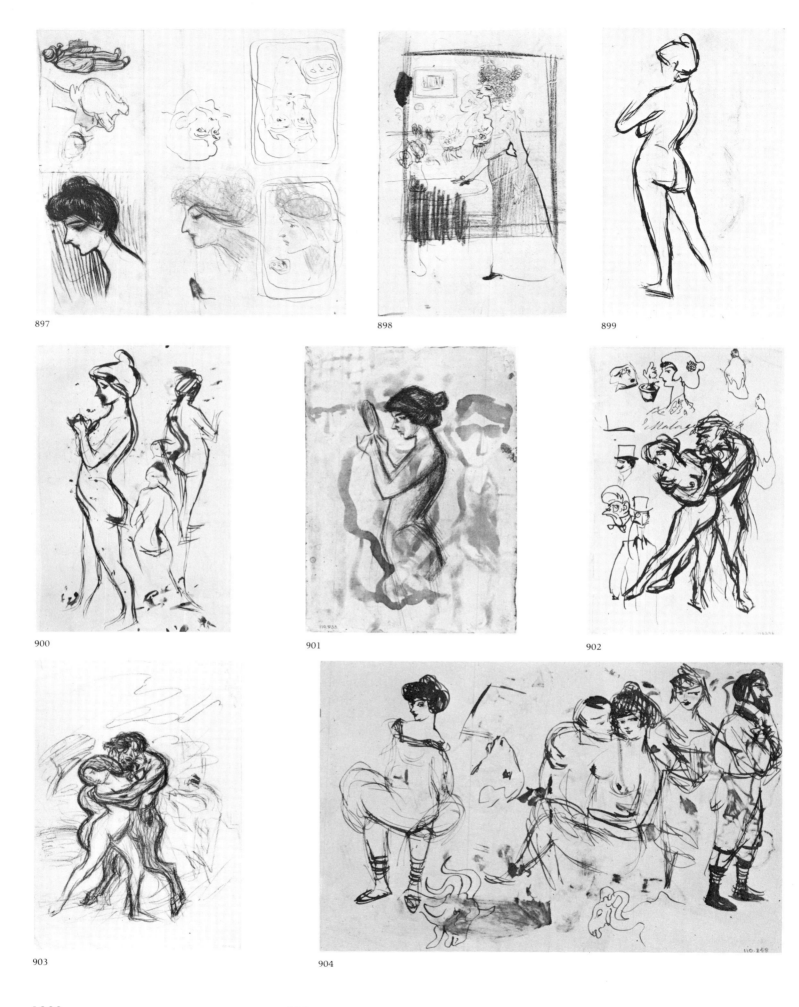

897

898

899

900

901

902

903

904

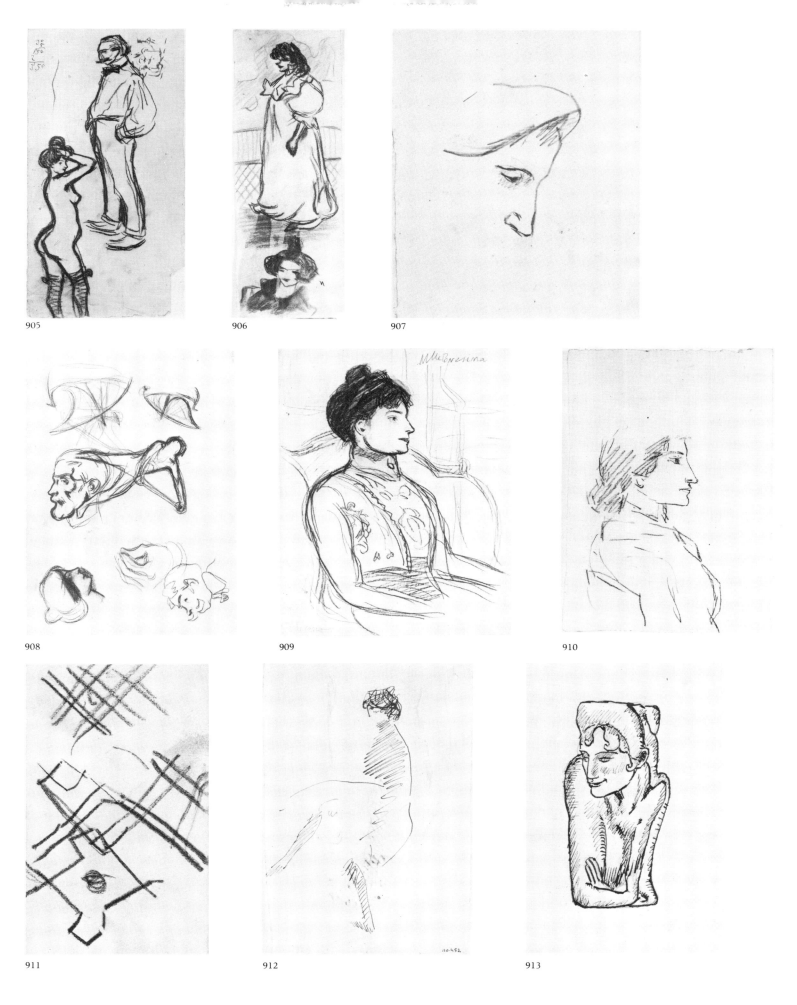

905

906

907

908

909

910

911

912

913

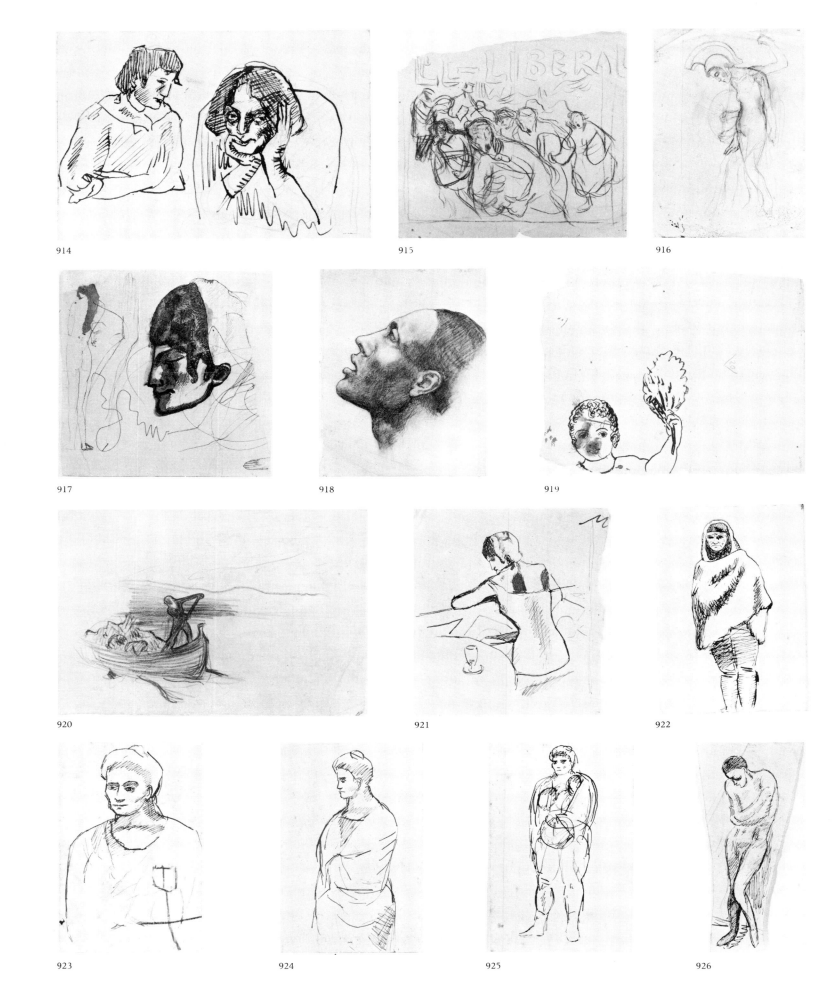

914

915

916

917

918

919

920

921

922

923

924

925

926

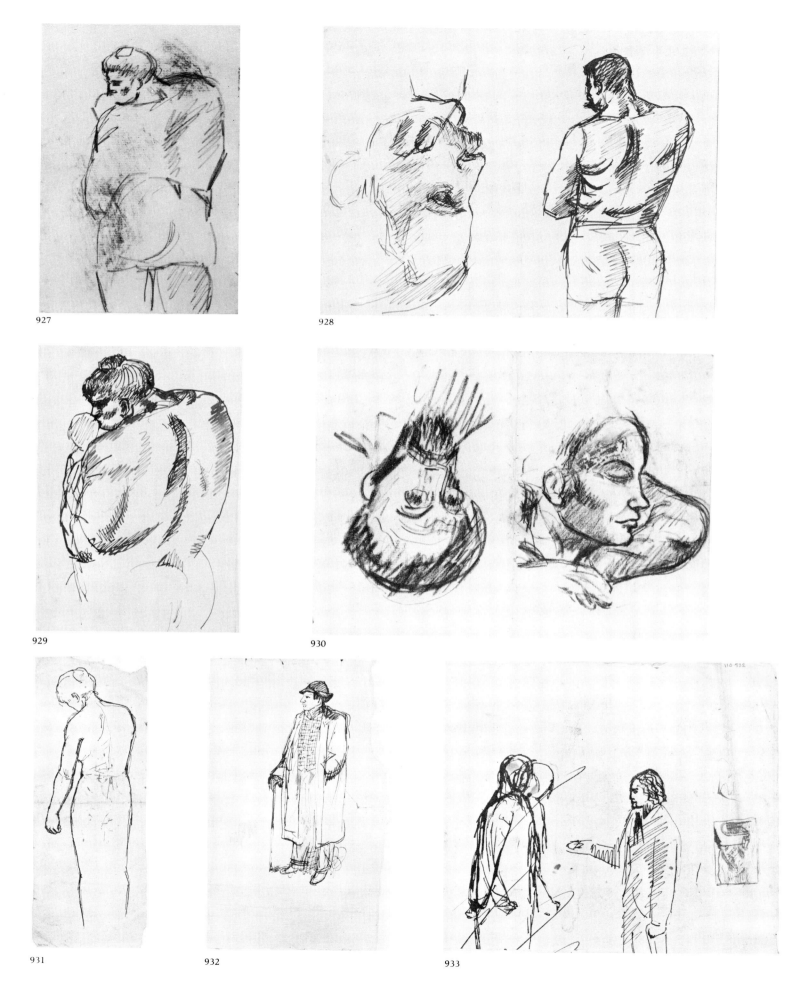

927

928

929

930

931

932

933

1901–1902

934

935

936

937

938

939

940

941

1902–1903

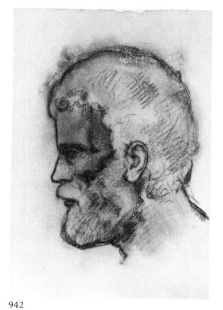

942

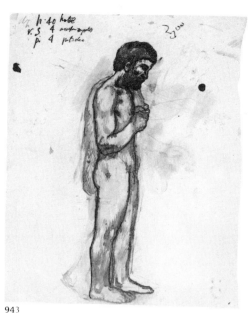

943

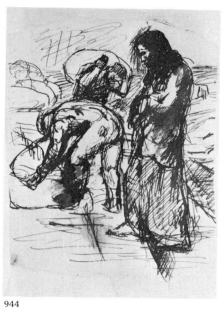

944

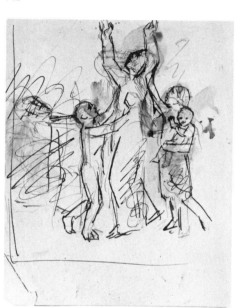

945

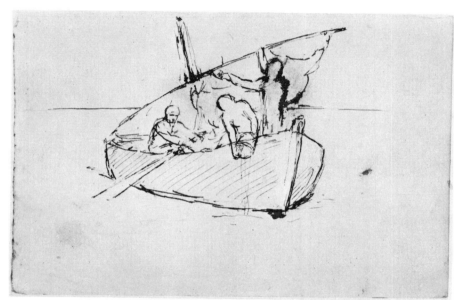

946

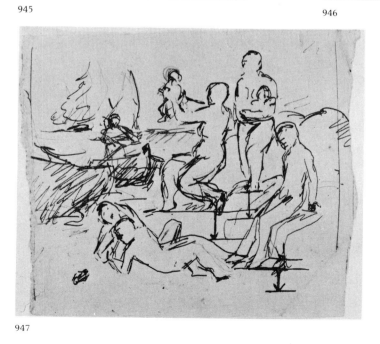

947

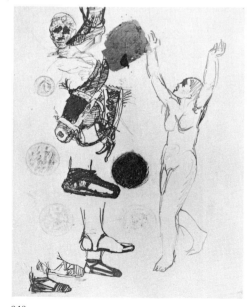

948

1902—1903

949

950

951

952

953

954

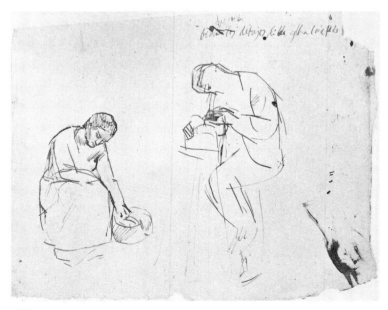

955

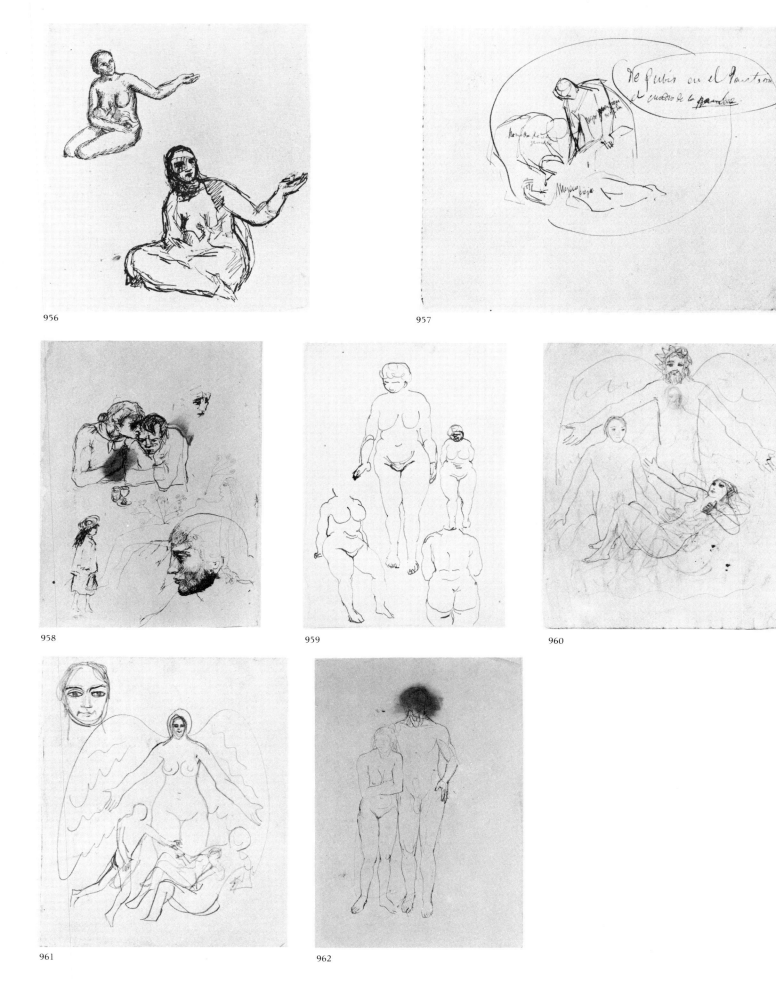

956

957

958

959

960

961

962

269

1902–1903

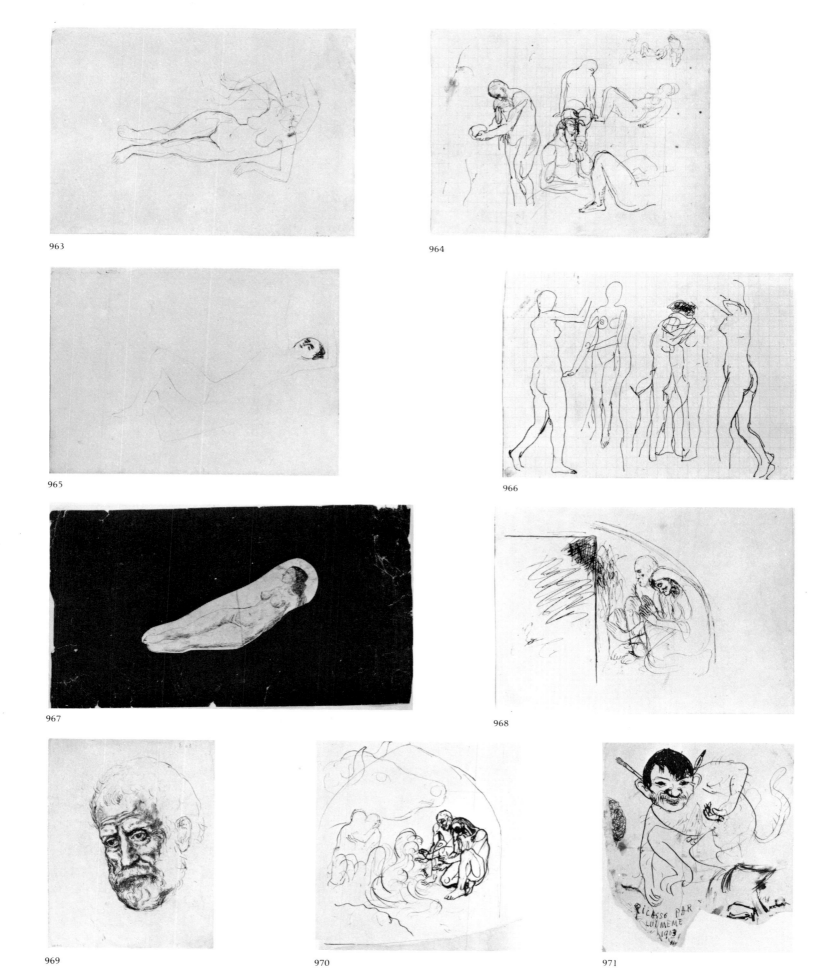

963

964

965

966

967

968

969

970

971

List of illustrations

Colour illustrations are indicated by italic type, as are the six paintings (273–278) which are not part of the donation.

1. Hercules. Malaga, XI-1890.
Pencil on paper. 49.5 × 32 cm. (MAB 110.842, A)

2. Female profile and other sketches. Album 3. Barcelona, 1895.
Pen on paper. 12 × 8.2 cm. (MAB 110.912)

3. Studies of hands. Barcelona?, 1895–7.
Pen on paper. 10.6 × 7.5 cm. (MAB 110.243)

4. Study for an illustration for 'El clam de les verges'. Barcelona, 1900.
Conté crayon on paper. 32 × 22 cm. (MAB 110.669, A)

5. Doves. Malaga, 1890.
Pencil on paper. 11 × 22 cm. (MAB 110.867, A)

6. Bullfight scene and doves. Malaga, 1890.
Pencil on paper. 13.5 × 20.2 cm. (MAB 110.869, A)

7. 'Asul y Blanco'. Corunna, 1893.
Pen on paper. 20.3 × 26.5 cm. (MAB 110.863, R)

8. Head of a cat (trimmed). Corunna, 1891–2.
Pencil on paper. 16.4 × 20.2 cm. (MAB 110.998)

9. Country house. Corunna, c. 1893.
Oil on canvas. 15.8 × 23 cm. (MAB 110.103)

10. Fencers and caricatured heads. Corunna, 1893–4.
Pencil on paper. 10.3 × 13.3 cm. (MAB 110.870, R)

11. Seventeenth-century scene. Corunna, 1893–4.
Pencil on paper. 10.6 × 15.2 cm. (MAB 110.246, A)

12. Battle scene. Corunna, 1893–4.
Pen on paper. 13.3 × 21 cm. (MAB 110.610, A)

13. Breakers. Corunna, 1894–5.
Oil on canvas. 10 × 17.8 cm. (MAB 110.115)

14. 'Salon del Prado'. Madrid, 1895.
Oil on wood. 10 × 15.5 cm. (MAB 110.160)

15. Boy's head and other sketches. Album 1. Corunna, 1894.
Pen and pencil on paper. 19.5 × 13.5 cm. (MAB 110.919)

16. A bull (trimmed). Album 1. Corunna, 1894.
Pencil on paper. 19.5 × 13.5 cm. (MAB 110.919)

17. Moroccan scene. Album 1. Corunna, 1894.
Pencil on paper. 19.5 × 13.5 cm. (MAB 110.919)

18. Hercules. Album 2. Corunna, 1894–5.
Pen on paper. 19.5 × 13.5 cm. (MAB 110.923)

19. Man with a beret. Corunna, 1895.
Oil on canvas. 50.5 × 36 cm. (MAB 110.058)

20. The painter's palette, used in Corunna or Barcelona, c. 1895.
44.5 × 27.5 cm. (MAB 110.994)

21. Head of a man. Corunna, c. 1894.
Oil on canvas. 34.4 × 29 cm. (MAB 110.072)

22. Interior in the house of D. Raimundo Perez Costales. Corunna, 1895.
Oil on wood. 9.9 × 15.5 cm. (MAB 110.193)

23. Bedroom in the house of D. Raimundo Perez Costales. Corunna, 1895.
Oil on wood. 9.7 × 15.2 cm. (MAB 110.194)

24. Birds. Corunna, 1895.
Oil on wood. 9.5 × 15.5 cm. (MAB 110.133)

The vertical measurement of a work precedes that of the horizontal, except in the following cases: 46, 61–2, 120, 135, 144, 154, 174, 184, 194, 201, 240, 264, 273, 286, 293, 331, 354, 371–3, 377, 379, 386, 391, 397, 412, 426–7, 429, 437, 442, 488, 491, 498–9, 505, 516, 520–1, 528–9, 533, 535, 537, 543, 558, 560, 570–1, 573–4, 576, 578, 580, 586, 589, 601, 604, 613–4, 621, 635, 643, 645–6, 659–61, 665–7, 671, 676, 679–80, 683, 685–6, 704, 714, 727, 731, 736, 738, 746, 749, 753, 760, 763, 765–8, 775, 783, 790–1, 794, 805, 807, 823, 827, 832, 839, 853–4, 865, 867–8, 872, 924, 927, 929, 965

25. A dove. Corunna, 1895.
Oil on wood. 9.9 × 15.4 cm. (MAB 110.131)

26. The artist's friend Pallarés (trimmed). Barcelona, 1895.
Pencil on paper. 31 × 24.4 cm. (MAB 110.360, A)

27. Outside the lottery shop. Corunna, 1895.
Pen on paper. 27.4 × 19.9 cm. (MAB 110.377)

28. The notary. Barcelona?, 1895.
Oil on canvas. 52 × 43.8 cm. (MAB 110.937)

29. Self-portrait with a wig. Barcelona, 1896.
Oil on canvas. 55.8 × 46 cm. (MAB 110.053)

30. Self-portrait. Barcelona, 1896.
Oil on wood. 22.1 × 13.7 cm. (MAB 110.205)

31. Sketch of the Venus de Milo. Album 4. Barcelona, 1895.
Pencil on paper. 12 × 8 cm. (MAB 110.913)

32. Portrait of the artist's mother. Album 5. Barcelona, III-VI 1896.
Watercolour on paper. 19.5 × 12 cm. (MAB 110.921)

33. Sketch of a man. Album 3. Barcelona, 1895.
Pencil on paper. 12 × 8.2 cm (MAB 110.912)

34. Sketch of the artist's grandmother Dña Inés, (trimmed). Barcelona, 1895–6.
Pencil on paper. 10 × 12.7 cm. (MAB 110.431, A)

35. Portrait of an old man. Corunna, 1895.
Oil on canvas. 58.5 × 42.8 cm. (MAB 110.014)

36. Seascape. Barcelona, 1896.
Oil on canvas. 19.7 × 26.5 cm. (MAB 110.093)

37. Seascape. Barcelona, 1896.
Oil on canvas. 12 × 19.2 cm. (MAB 110.108)

38. Seated nude (copy from a detail of a painting by Mas y Fontdevila). Barcelona, 1895.
Oil on wood. 22.3 × 13.7 cm. (MAB 110.039)

39. Portrait of the artist's mother, Dña Maria Picasso Lopez. Barcelona, 1896.
Pastel on paper. 49.8 × 39 cm. (MAB 110.016)

40. Portrait of Aunt Pepa. Malaga, 1896.
Oil on canvas. 57.5 × 50.5 cm. (MAB 110.010)

41. Study for 'Science and Charity'. Barcelona, 1896–7.
Oil on canvas. 23.7 × 26 cm. (MAB 110.009)

42. Study for 'Science and Charity'. Barcelona, 1896–7.
Watercolour on paper. 22.8 × 28.6 cm. (MAB 110.089, A)

43. Study for 'Science and Charity'. Barcelona, 1896–7.
Oil on wood. 19.6 × 27.3 cm. (MAB 110.229)

44. Study for 'Science and Charity'. Barcelona, 1896–7.
Oil on wood. 13.7 × 22.3 cm. (MAB 110.214)

45. Science and Charity. Barcelona, 1897.
Oil on canvas. 197 × 249.4 cm. (MAB 110.046)

46. The First Communion. Barcelona, 1896.
Oil on canvas. 118 × 166 cm. (MAB 110.001)

47. Sketches including a preliminary study for 'The First Communion'.
Album 5. Barcelona, III-VI 1896.
Pen and pencil on paper. 19.5 × 12 cm. (MAB 110.921)

48. Hagiographical painting. Barcelona, IV-1896.
Oil on canvas. 33.7 × 53 cm. (MAB 110.059)

49. Hagiographical painting. Barcelona, 1896.
Oil on canvas. 35.5 × 52 cm. (MAB 110.060)

50. Study of a plaster bust. Barcelona?, 1895.
Charcoal, Conté crayon and chalk on paper. 63 × 47.3 cm. (MAB 110.873, A)

51. 'Colour tests'. Barcelona, 31-I-1896.
Conté crayon and chalk on paper. 47.5 × 31 cm. (MAB 110.852)

52. Various studies. Album 7. Barcelona, 1896–7.
Pen on paper. 10.5 × 7.5 cm. (MAB 110.911)

53. Studies of hands. Album 6. Barcelona, VI-1896.
Pencil on paper. 18.5 × 13 cm. (MAB 110.918)

54. Studies of hands. Barcelona?, 1895–7.
Pen on paper. 20.5 × 13.1 cm. (MAB 110.615, R)

55. The studio. Album 8. Barcelona, 1896–7.
Charcoal on paper. 10.5 × 7.5 cm. (MAB 110.914)

56. Two women. Album 8. Barcelona, 1896–7.
Pencil on paper. 10.5 × 7.5 cm. (MAB 110.914)

57. Old woman receiving holy oil from a choir-boy. Barcelona?, 1896.
Oil on canvas pasted on cardboard. 29.2 × 20.2 cm. (MAB 110.078)

58. Sketch for 'Old woman receiving holy oil from a choir-boy'. Barcelona, 1895–6.
Pen on paper. 21 × 16 cm. (MAB 110.308, A)

59. Sketch for 'Old woman receiving holy oil from a choir-boy'. Barcelona, 1895–6.
Pencil and watercolour on paper. 27.5 × 19.7 cm. (MAB 110.332)

60. Sketch for 'The choir-boy'. Barcelona, 1895–6.
Pen and pencil on paper. 14 × 10.2 cm. (MAB 110.264, A)

61. Sketch for a history scene. Album 6. Barcelona, 1896.
Pencil on paper. 18.5 × 13 cm. (MAB 110.918)

62. Flight. Barcelona, 1896.
Pen, Conté crayon and chalk on grey paper. 31.2 × 25.3 cm. (MAB 110.655, A)

63. Man with a cloak in profile. Barcelona, c. 1896.
Pen on paper. 24 × 15.4 cm. (MAB 110.640, A)

64. The artist's father. Barcelona, 1896.
Watercolour on paper. 25.5 × 17.8 cm. (MAB 110.331)

65. Bust of a woman in profile (detail). Barcelona, 1896.
Ink on paper. 15.7 × 7.5 cm. (MAB 110.270, R)

66. Various sketches. Album 6. Barcelona, VI-1896.
Pencil on paper. 18.5 × 13 cm. (MAB 110.918)

67. Interior with seated figure. Barcelona, 1896.
Oil on wood. 15.5 × 10 cm. (MAB 110.146)

68. The artist's sister Lola. Barcelona, 1899–1900.
Conté crayon on paper. 48.5 × 32.3 cm. (MAB 110.597, A)

69. The artist's sister Lola (trimmed). Barcelona, c. 1897.
Conté crayon and pencil on paper. 22.2 × 16.3 cm. (MAB 110.831)

70. The artist's sister Lola. Barcelona, c. 1897.
Conté crayon on paper. 22.1 × 16.8 cm. (MAB 110.721, R)

71. The artist's sister Lola. Barcelona, c. 1899.
Conté crayon on paper. 33.8 × 23.1 cm. (MAB 110.809, A)

72. Sketched scene. Barcelona?, c. 1897.
Conté crayon on paper. 17.3 × 24.8 cm. (MAB 110.642)

73. Street scene. Barcelona?, 1897.
Conté crayon on paper. 15.5 × 21.5 cm. (MAB 110.719)

74. The artist's dog Klipper. Corunna, 1895.
Oil on canvas. 21.7 × 33 cm. (MAB 110.083)

75. Family scene. Corunna or Barcelona, 1895.
Oil on wood. 13.8 × 22.1 cm. (MAB 110.038)

76. Galician peasants. Corunna, 1894.
Oil on paper. 12.8 × 19 cm. (MAB 110.109, A)

77. View of Cartagena. En voyage, IX-1895.
Oil on canvas. 28 × 34.7 cm. (MAB 110.074)

78. Head of a woman. Barcelona, 1896.
Oil on wood. 15.5 × 10.1 cm. (MAB 110.141)

79. Roses. Barcelona, 1895–6.
Oil on wood. 22.7 × 35.5 cm. (MAB 110.031)

80. 'La Barceloneta'. Barcelona, I-1897.
Oil on wood. 13.8 × 22.4 cm. (MAB 110.220)

81. Urban view. Barcelona, IV-1896.
Oil on canvas. 20.2 × 28.1 cm. (MAB 110.087)

82. Sunset. Barcelona, 1896.
Oil on wood. 9.8 × 15.5 cm. (MAB 110.143, R)

83. Sunset. Barcelona, 1896.
Oil on wood. 9.9 × 13.9 cm. (MAB 110.130, A)

84. A candle. Barcelona, 1896.
Oil on wood. 21.6 × 13.5 cm. (MAB 110.204)

85. Corner of the cloister of San Pablo del Campo. Barcelona, XII-1896.
Oil on wood. 15.5 × 10.1 cm. (MAB 110.195)

86. Scene in a park. Barcelona or Malaga, 1896.
Oil on wood. 9.9 × 15.6 cm. (MAB 110.128)

87. The kitchen. Malaga, 1896?
Oil on wood. 9.9 × 15.5 cm. (MAB 110.183, A)

88. A woman from behind. Barcelona, 1896.
Oil on wood. 15.6 × 10.2 cm. (MAB 110.175)

89. Landscape with trees. Barcelona, 1896–7.
Oil on canvas. 56.6 × 40.8 cm. (MAB 110.055, A)

90. *Portrait of D. José Ruiz Blasco, the artist's father*. Barcelona, 1896.
Watercolour on paper. 18 × 11.8 cm. (MAB 110.281, A)

91. *Study of a hillside*. Malaga, 1896.
Oil on canvas stuck on cardboard. 28.2 × 39.8 cm. (MAB 110.081)

92. *Hillside*. Malaga, 1896.
Oil on canvas. 60.7 × 82.5 cm. (MAB 110.008)

93. *Scene with trees*. Malaga, 1896.
Oil on wood. 10.3 × 13.7 cm. (MAB 110.167)

94. *Trees*. Malaga, 1896.
Oil on wood. 10.1 × 15.6 cm. (MAB 110.181)

95. *Modernist landscape with figure*. Barcelona, c. 1897.
Oil on canvas. 28.3 × 20.2 cm. (MAB 110.088)

96. A bullfight. Barcelona, 1896.
Oil on wood. 13.8 × 22.1 cm. (MAB 110.208)

97. Two figures in a landscape. Barcelona or Malaga, 1896.
Oil on paper. 12.8 × 17.3 cm. (MAB 110.117, A)

98. Bull and bull's head. Malaga, 1896.
Oil on wood. 13.8 × 22.1 cm. (MAB 110.210)

99. Fisherman and children. Barcelona or Malaga, 1896.
Oil on wood. 10.1 × 15.7 cm. (MAB 110.159)

100. Bull before a fight. Malaga, 1896.
Oil on canvas. 17.7 × 26.4 cm. (MAB 110.098)

101. El Retiro. Madrid, 1897–8.
Oil on fabric stuck on cardboard. 16 × 25.2 cm. (MAB 110.227)

102. A lake at El Retiro. Madrid, 1897–8.
Oil on canvas. 19.5 × 26.7 cm. (MAB 110.055, A)

103. Copy of Velasquez's portrait of Philip IV (1652–3). Madrid, 1897–8.
Oil on canvas. 54.2 × 46.7 cm. (MAB 110.017)

104. A carter. Album 11. Madrid, 1897–8.
Conté crayon on paper. 18.5 × 13 cm. (MAB 110.922)

105. Profile of a woman, a 'Manola' (detail). Madrid, II-1898.
Conté crayon and pen on paper. 31.5 × 48 cm. (MAB 110.810, R)

106. Chimneys. Album 13. Madrid, 1897–8.
Charcoal on paper. 13.5 × 9 cm. (MAB 110.916)

107. Women dancing. Album 13. Madrid, 1897–8.
Pen and sepia on paper. 13.5 × 9 cm. (MAB 110.916)

108. Portrait of Pepe Illo. Album 14. Madrid, III-1898.
Pencil on paper. 17.5 × 10.5 cm. (MAB 110.917)

109. 'Rechs prerafaelista'. Album 15. Madrid, III-1898.
Pencil on paper. 19.5 × 12 cm. (MAB 110.920)

110. Copy of one of Goya's 'Caprichos'. Album 14. Madrid, III-1898.
Pencil on paper. 17.5 × 10.5 cm. (MAB 110.917)

111. The balcony. Album 14. Madrid, IV-1898.
Pencil on paper. 17.5 × 10.5 cm. (MAB 110.917)

112. *Dome of the Iglesia de la Merced*. Barcelona, I-1897.
Pastel, Conté crayon and pen on paper. 17.8 × 25.4 cm. (MAB 110.949)

113. *Urban view with cupulas*. Barcelona, 1897.
Oil on canvas. 31 × 46.5 cm. (MAB 110.064)

114. *View with cypresses*. Barcelona, c. 1897.
Oil on canvas. 18.5 × 26.5 cm. (MAB 110.097)

115. *A hillside*. Barcelona, I-1899.
Oil on canvas stuck on wood. 22.4 × 27.3 cm. (MAB 110.102)

116. *Mountain landscape*. Horta de Ebro?, 1898–9.
Oil on canvas. 28 × 39.5 cm. (MAB 110.065)

117. *Mountain stream*. Horta de Ebro?, 1898–9.
Oil on canvas. 16.5 × 22 cm. (MAB 110.105)

118. *Landscape with a house*. Horta de Ebro, 1898–9.
Oil on canvas. 33 × 44 cm. (MAB 110.936)

119. *Interior with carts*. Horta de Ebro, 1898–9.
Oil on canvas. 31.2 × 47.5 cm. (MAB 110.935)

120. View of Horta de Ebro. Album 16. Horta de Ebro, 1898–9.
Charcoal on paper 20 × 16 cm. (MAB 110.926)

121. Olive-oil plant belonging to the Pallarés family. Horta de Ebro, 1898–9.
Conté crayon and pen on paper. 15.7 × 21.8 cm. (MAB 110.717, A)

122. Three washerwomen. Barcelona or Horta de Ebro, 1896–8.
Oil on wood. 10 × 15.6 cm. (MAB 110.168)

123. Market scene. Horta de Ebro?, 1896–8.
Oil on canvas pasted on wood. 19.3 × 27.8 cm. (MAB 110.080)

124. Studies of goats and other sketches. Horta de Ebro, VIII-1898.
Conté crayon and pencil on paper. 32.3 × 24.5 cm. (MAB 110.787, A)

125. Tree at El Retiro. Album 15. Madrid, III-1898.
Pencil on paper. 19.5 × 12 cm. (MAB 110.920)

126. The artist's sister Lola. Barcelona, 1898.
Conté crayon on paper. 32.2 × 24.7 cm. (MAB 110.575)

127. Sketch of the artist's father (trimmed). Barcelona, 1898–9.
Conté crayon on paper. 22 × 16.4 cm. (MAB 110·726, A)

128. The artist's sister Lola. Barcelona, c. 1899.
Pen on paper. 14.5 × 12.8 cm. (MAB 110.841)

129. Street fight. Madrid, 1897–8.
Conté crayon on paper. 20.1 × 26.2 cm. (MAB 110.335)

130. Street fight (detail). Madrid, XII-1897.
Pen on squared paper. 20 × 25.1 cm. (MAB 110.752)

131. Onlookers. Barcelona?, 1897–9.
Conté crayon on squared paper. 21 × 16.8 cm. (MAB 110.734)

132. Beggars. Barcelona?, 1897–9.
Conté crayon on paper. 34 × 23.4 cm. (MAB 110.791)

133. Street scene. Madrid, 1897–8.
Pen on squared paper. 20.4 × 25.9 cm. (MAB 110.384, A)

134. Various sketches. Madrid, 1897–8.
Brown ink on paper. 26.2 × 20.3 cm. (MAB 110.652, A)

135. Study of a hillside. Horta de Ebro, 1898–9.
Conté crayon on paper. 24.5 × 16 cm. (MAB 110.744, A)

136. Washerwomen. Horta de Ebro, 1898–9.
Conté crayon on paper. 12.2 × 16.2 cm. (MAB 110.747, A)

137. Landscape with a peasant. Horta de Ebro, 1898–9.
Conté crayon on paper. 16.2 × 24.4 cm. (MAB 110.743)

138. Landscape with a peasant. Horta de Ebro, 1898–9.
Conté crayon on paper. 21.3 × 31.8 cm. (MAB 110.774, A)

139. View in the village of Horta de Ebro?, 1898–9.
Oil on canvas. 27 × 40 cm. (MAB 110.066)

140. A passageway. Horta de Ebro?, 1898–9.
Oil on canvas. 19.3 × 27.6 cm. (MAB 110.090)

141. Landscape. Barcelona or Horta de Ebro, 1898–9.
Oil on canvas. 28.5 × 39.5 cm. (MAB 110.067)

142. Woodland. Barcelona or Horta de Ebro, 1896–8.
Oil on canvas. 27.8 × 37.5 cm. (MAB 110.071).

143. Café interior. Barcelona, 1897–9.
Charcoal on paper. 15.5 × 20.9 cm. (MAB 110.558)

144. 'Peace'. Barcelona?, c. 1899.
Pen on paper. 20.9 × 13.4 cm. (MAB 110.836, R)

145. Figure and street scene. Album 16. Horta de Ebro or Barcelona, 1898–9.
Charcoal on paper. 20 × 16 cm. (MAB 110.926)

146. The artist's father. Album 16. Horta de Ebro or Barcelona, 1898–9.
Pencil and charcoal on paper. 20 × 16 cm. (MAB 110.926)

147. Printed menu for 'Els 4 Gats'. Barcelona, 1899–1900.
21.8 × 32.8 cm. (MAB 110.995)

148. Seated man. Album 10. (?), 1897–9.
Pencil and charcoal on paper. 19.5 × 12 cm. (MAB 110.925)

149. Street figures. Album 10. (?), 1897–9.
Coloured pencil. 19.5 × 12 cm. (MAB 110.925)

150. *El Greco figure*. Barcelona, 1899.
Oil on canvas. 34.7 × 31.2 cm. (MAB 110.034)

151. *Calle Riera de San Juan*. Barcelona, 1900.
Oil on wood. 22.1 × 13.8 cm. (MAB 110.213, A)

152. *Seated woman reading*. Barcelona, 1899.
Watercolour. 19.1 × 13.9 cm. (MAB 110.238)

153. *The window*. Barcelona, 1899.
Oil on wood. 22 × 13.7 cm. (MAB 110.218)

154. Profile of a seated woman and a cock. (?), 1897–9.
Conté crayon on paper. 12.7 × 17.5 cm. (MAB 110.424, A)

155. Portrait of the writer Ramon Reventos. Barcelona, 1899.
Watercolour, charcoal and Conté crayon on paper. 66.5 × 30.1 cm. (MAB 110.872, A)

156. Closed window. Barcelona, IV-1899.
Oil on canvas. 38.5 × 28 cm. (MAB 110.069, A)

157. Portrait of Carlos Casagemas. Barcelona, 1899.
Oil on canvas. 55 × 45 cm. (MAB 110.022)

158. Portrait of an unknown man. Barcelona, 1899.
Oil on canvas. 47.5 × 35.2 cm. (MAB 110.026)

159. Kissing the corpse. Barcelona, 1899–1900.
Oil on canvas. 23.5 × 35 cm. (MAB 110.082)

160. Interior by candlelight. Barcelona, 1899–1900.
Oil on canvas. 26 × 33.5 cm. (MAB 110.075)

161. Various sketches of heads. Barcelona, 1899.
Conté crayon on paper. 22.2 × 16.3 cm. (MAB 110.725, A)

162. A beggar. Barcelona, 1899–1900.
Conté crayon on paper. 22 × 16.6 cm. (MAB 110.634)

163. Life study of a girl. Barcelona, 1899.
Conté crayon on paper. 48.5 × 32 cm. (MAB 110.845, A)

164. Portrait of Santiago Rusiñol. Barcelona, 1899–1900.
Pen and watercolour on paper. 10.3 × 9.4 cm. (MAB 110.433)

165. Portrait of Pujolá y Vallés? Barcelona, 1899–1900.
Pen and watercolour on paper. 7.8 × 8.5 cm. (MAB 110.260)

166. Portrait of Joaquín Mir. Barcelona, 1899–1900.
Pen and watercolour on paper. 9 × 7.9 cm. (MAB 110.435, A)

167. Portrait of Oriol Marti. Barcelona, 1899–1900.
Conté crayon and pen on paper. 16.7 × 11.4 cm. (MAB 110.271, A)

168. Seated female nude and other sketches. Barcelona, 1899.
Conté crayon on paper. 47.6 × 31.6 cm. (MAB 110.594, A)

169. Back view of a female nude. Barcelona, *c.* 1899.
Conté crayon on paper. 61.8 × 47.5 cm. (MAB 110.878)

170. Female nude. Barcelona, 1899.
Conté crayon on paper. 48 × 30.5 cm. (MAB 110.591, A)

171. Female nude in profile. Barcelona, 1899.
Conté crayon on paper. 31.5 × 21.8 cm. (MAB 110.340, A)

172. Woman with flower. Barcelona, 1899–1900.
Conté crayon on paper. 22 × 15.9 cm. (MAB 11.728, A)

173. Figure of a woman. Barcelona, 1899–1900.
Pencil on paper. 21.6 × 16.1 cm. (MAB 110.723)

174. Female profile. Barcelona, 1899–1900.
Conté crayon on paper. 23.1 × 33.8 cm. (MAB 110.354, R)

175. Sketch for a poster for 'Caja de Prevision y Socorro'. Barcelona, 1899-1900.
Conté crayon and pen on paper. 32.2 × 22.5 cm. (MAB 110.825, A)

176. Kneeling woman and other sketches. Barcelona, 1899–1900.
Conté crayon on paper. 23.5 × 34 cm. (MAB 110.352, A)

177. Sick woman (detail). Barcelona, 1899–1900.
Pencil on paper. 16.1 × 24.8 cm. (MAB 110.749, R)

178. Bullfight. Barcelona or Malaga, *c.* 1900.
Pencil on paper. 20.8 × 26 cm. (MAB 110.513, A)

179. A bullfighter. Barcelona, 1899–1900.
Pen on paper. 20.9 × 13.4 cm. (MAB 110.836, A)

180. Bullfight scene. Barcelona or Malaga, 1899–1901.
Pen and blue pencil. 23.3 × 17.3 cm. (MAB 110.326, A)

181. Picador and his assistant. Barcelona, 1899.
Pen and watercolour on paper. 16.5 × 14.7 cm. (MAB 110.840, A)

182. Self-portrait and other sketches. Barcelona, 1900.
Pen on paper. 32 × 22 cm. (MAB 110.676, A)

183. Self-portrait. Barcelona, 1899–1900.
Conté crayon on paper. 33.8 × 23.4 cm. (MAB 110.690, A)

184. Study for a carnival poster. Barcelona, 1900.
Charcoal and Conté crayon on paper. 42.7 × 62 cm. (MAB 110.883, R)

185. Sketch of an artist and other sketches. Barcelona, 1899–1900.
Conté crayon and pen on paper. 33.6 × 15.2 cm. (MAB 110.680, A)

186. *Interior scene.* Barcelona, 1899–1900.
Oil on canvas. 38.2 × 60.8 cm. (MAB 110.023)

187. *Andalusian courtyard.* Barcelona, 1899–1900.
Oil on canvas. 36.2 × 49.5 cm. (MAB 110.024)

188. *Girl in white by a window* (Lola in the studio of Riera de San Juan).
Barcelona, 1900.
Oil on canvas. 55.5 × 46 cm. (MAB 110.054)

189. *The window.* Barcelona, 1900.
Oil on canvas. 50 × 32.5 cm. (MAB 110.062)

190. *The mask.* ('The bride of El Greco'). Barcelona, 1900.
Oil on canvas. 26.2 × 20 cm. (MAB 110.096)

191. The artist's sister Lola. Barcelona, 1898.
Conté crayon on paper. 63 × 47.3 cm. (MAB 110.873, R)

192. Female figure. Barcelona, 1899.
Conté crayon on paper. 19.3 × 11.5 cm. (MAB 110.282, A)

193. Self-portrait. Barcelona or Paris, 1900.
Charcoal on paper. 22.5 × 16.5 cm. (MAB 110.632, A)

194. The Muse. Barcelona, 1899–1900.
Conté crayon on paper. 23.5 × 33 cm. (MAB 110.586, A)

195. Woman with a Pekinese and other sketches. Barcelona, 1899–1900.
Pen on paper. 31.5 × 21.8 cm. (MAB 110.817, A)

196. Development of a linear sketch. Barcelona, 1899–1900.
Pen on paper. 13.8 × 21 cm. (MAB 110.416, A)

197. Study for an illustration for 'El clam de les verges'. Barcelona, 1900.
Conté crayon on paper. 46.9 × 30.9 cm. (MAB 110.341, R)

198. Dramatic scene. Barcelona, 1899–1900.
Conté crayon and watercolour on paper. 23.5 × 33.6 cm. (MAB 110.778, A)

199. The kiss of death. Barcelona, 1899–1900.
Conté crayon on paper. 15.9 × 24.3 cm. (MAB 110.750, A)

200. Sketch of invalids. Barcelona, 1899–1900.
Charcoal and Conté crayon on paper. 48.5 × 32 cm. (MAB 110.798, R)

201. Invalids. Barcelona, 1899–1900.
Charcoal and Conté crayon on paper. 48.5 × 32 cm. (MAB 110.798, A)

202. Kneeling figure. Barcelona, 1899–1900.
Pen on paper. 10.5 × 13.3 cm. (MAB 110.265)

203. A monk (trimmed). Barcelona, 1899–1900.
Pen on paper. 15.8 × 21.9 cm. (MAB 110.478, R)

204. Sketch for a poster for 'Caja de Prevision y Socorro'. Barcelona, 1899–1900.
Pen on paper. 23.8 × 31 cm. (MAB 110.811, A)

205. Drawing for the magazine 'Joventud'. Barcelona, *c.* 1900.
Pen on ruled paper. 13.4 × 17.4 cm. (MAB 110.839)

206. Preliminary study for 'Andalusian courtyard'. Barcelona, 1899–1900.
Pen on paper. 12.9 × 15.8 cm. (MAB 110.707, A)

207. Fashionable woman. Barcelona, 1899–1900.
Pen on paper. 19 × 13.1 cm. (MAB 110.555)

208. Study of a woman. Album 17. Paris?, 1900.
Pencil, pastel and watercolour on paper. 10.5 × 6 cm. (MAB 110.910)

209. The kiss (a). Barcelona, IV-1899.
Conté crayon and pen on paper. 31.5 × 22 cm. (MAB 110.754, A)

210. Study of a head. Barcelona, 1902.
Charcoal and Conté crayon on paper. 31.2 × 23.5 cm. (MAB 110.529, A)

211. The studio. Barcelona?, 1902.
Pen on paper. 15 × 12.2 cm. (MAB 110.446)

212. Self-portrait with a dog. Barcelona or Paris, *c.* 1902.
Pen on paper. 11.5 × 13 cm. (MAB 110.443)

213. Sketch for 'The Death of Casagemas'. Barcelona or Paris, 1901.
Pencil on paper. 31.4 × 41.9 cm. (MAB 110.547)

214. Sketch for 'The Death of Casagemas' (trimmed). Barcelona or Paris, 1901.
Pen on paper. 13 × 17.3 cm. (MAB 110.467)

215. The concierge of the 'Bateau-Lavoir'. Paris, 1904.
Gouache on paper. 12.8 × 12 cm. (MAB 110.045)

216. Reclining nude. Barcelona or Paris, 1902–3.
Pen on paper. 23.1 × 33.8 cm. (MAB 110.534, A)

217. The couple. Barcelona, 1903.
Pen on paper. 23 × 18 cm. (MAB 110.499, A)

218. The procuress. Barcelona, *c.* 1900.
Pencil on paper. 33.1 × 24 cm. (MAB 110.356)

219. *Portrait of Sebastián Junyent.* Barcelona, 1902.
Oil on canvas. 73 × 60 cm. (MAB 110.018)

220. *The blue goblet.* Barcelona, 1902.
Oil on canvas. 66.1 × 28.5 cm. (MAB 110.009)

221. *Roofs of Barcelona.* Barcelona, 1902.
Oil on canvas. 57.8 × 60.3 cm. (MAB 110.020, A)

222. *Blue nude.* Barcelona, 1901.
Oil on canvas. 62.2 × 34 cm. (MAB 110.021)

223. Nude (trimmed). Barcelona, 1903.
Pen on paper. 33.8 × 23.1 cm. (MAB 110.535)

224. Decoration for a frame. Barcelona, 1900.
Oil on wood. 112.8 × 82 cm. (MAB 110.002)

225. Fishermen. Barcelona or Paris, 1901–2.
Pen on paper. 11.7 × 14.7 cm. (MAB 110.444, R)

226. Self-portrait. Barcelona, *c.* 1901.
Pen and watercolour on paper. 20.8 × 13.1 cm. (MAB 110.300, A)

227. An Amazon (a). Barcelona or Paris, *c.* 1901.
Pen and pencil on paper. 33.8 × 23.2 cm. (MAB 110.542)

228. Sketch for 'La Soupe' and others (detail). Barcelona or Paris, 1902.
Pen on paper. 32.5 × 45 cm. (MAB 110.550)

229. Man with a sack on his back. Barcelona or Paris, 1902.
Conté crayon on paper. 31.2 × 23.5 cm. (MAB 110.531)

230. Pastoral scene. Barcelona or Paris, *c.* 1902.
Pen and watercolour on paper. 21.6 × 40 cm. (MAB 110.546)

231. Head and shoulders of a woman. Barcelona or Paris, 1902.
Pen and watercolour on paper. 14.8 × 18.3 cm. (MAB 110.469)

232. Head of a woman (trimmed). Barcelona, 1902.
Conté crayon on paper. 12.2 × 8 cm. (MAB 110.437)

233. Head of a man. Barcelona or Paris, *c.* 1902.
Pencil on paper. 24 × 19 cm. (MAB 110.500, A)

234. Self-portrait (trimmed). Barcelona or Paris, 1902–3.
Pen on card. 12.8 × 9.8 cm. (MAB 110.438)

235. Portrait of a woman. Barcelona, 1902.
Pen on paper. 15.4 × 14.6 cm. (MAB 110.466)

236. The sculptor Fontbona. Paris or Barcelona, 1902.
Pen on paper. 45.5 × 31.7 cm. (MAB 110.549)

237. Reclining nude. Barcelona or Paris, 1902–3.
Pencil on paper. 16.9 × 26.5 cm. (MAB 110.502)

238. Sketch related to 'The Embrace'. Barcelona, III-1903.
Blue pencil on paper. 23 × 18.2 cm. (MAB 110.511)

239. The passionate embrace. Barcelona or Paris, *c.* 1900.
Pen on paper. 20.6 × 12.7 cm. (MAB 110.295, A)

240. Outline of a horse. Paris or Barcelona, *c.* 1902.
Pencil on paper. 22.6 × 16.2 cm. (MAB 110.486)

241. *Seated woman.* Album 17. Paris, 1900?
Pencil, watercolour and pastel on paper. 10.5 × 6 cm. (MAB 110.910)

242. *Back view of a woman.* Album 17. Paris, 1900?
Pastel on paper. 10.5 × 6 cm. (MAB 110.910)

243. *Woman with a hat and boa.* Album 17. Paris, 1900?
Pastel on paper. 10.5 × 6 cm. (MAB 110.910)

244. *Girl with a hat-box.* Album 17. Paris, 1900?
Watercolour and pastel on paper. 10.5 × 6 cm. (MAB 110.910)

245. *The green stockings.* Barcelona?, 1902.
Oil on wood. 27.2 × 12.5 cm. (MAB 110.036)

246. *Mother and son by the sea.* Barcelona?, 1902.
Oil on wood. 26.8 × 13.4 cm. (MAB 110.037)

247. *Portrait of Joaquin Mir.* Barcelona, *c.* 1901.
Pencil and watercolour on paper. 20.8 × 15.5 cm. (MAB 110.403, A)

248. Sketch for the decoration of a fireplace (trimmed). Barcelona, 1903.
Pen on paper. 21.3 × 30.5 cm. (MAB 110.517)

249. Head of a child. Barcelona?, 1903.
Pen on paper. 24.5 × 23.5 cm. (MAB 110.527)

250. Preparatory drawing for the decoration of a fireplace. Barcelona, 1903.
Pastel on paper. 60 × 40 cm. (MAB 110.015)

251. The frugal meal. Paris, 1904.
Etching. 50.9 × 41 cm. (MAB 110.011)

252. Masculine figure. Barcelona or Paris, 1901–2.
Pen on paper. 16.7 × 11 cm. (MAB 110.455)

253. Figure from the back. Barcelona or Paris, 1901–2.
Pen on paper. 16 × 11.1 cm. (MAB 110.452, A)

254. Seated figure. Barcelona or Paris, 1901–2.
Pen on paper. 16.1 × 11.1 cm. (MAB 110.461)

255. Woman and child. Barcelona or Paris, 1901–2.
Pen on paper. 16 × 11 cm. (MAB 110.453)

256. Life study of a figure. Barcelona or Paris, 1902.
Pen and watercolour on paper. 23.1 × 18.5 cm. (MAB 110.498)

257. Nude. Barcelona or Paris, 1902–3.
Pencil on paper. 29.7 × 21 cm. (MAB 110.521)

258. Nude. Barcelona, 1903.
Pen on paper. 23 × 21.2 cm. (MAB 110.518)

259. A quay. Barcelona or Paris, 1901–3.
Pen on paper. 15.1 × 23 cm. (MAB 110.492)

260. Seated woman (trimmed). Barcelona or Paris, 1902.
Pen and brown ink on paper. 18.4 × 13.7 cm. (MAB 110.464)

261. Sketch for 'The Death of Casagemas'. Barcelona or Paris, 1901.
Pen on paper. 10 × 13.2 cm. (MAB 110.442)

262. Preparatory sketches for 'La Vie'. Barcelona, 1903.
Pen on paper. 15.3 × 18.5 cm. (MAB 110.470)

263. Sketch for 'The Embrace'. Barcelona, 1903.
Conté crayon on paper. 23 × 18 cm. (MAB 110.512)

264. Sketch for 'The Embrace'. Barcelona, 1903.
Conté crayon on paper. 17.8 × 23 cm. (MAB 110.510)

265. Nude. Barcelona or Paris, 1902–3.
Pen on paper. 33.8 × 23.1 cm. (MAB 110.539, A)

266. Sketch for 'La Vie'. Barcelona, 1903.
Conté crayon on paper. 17.1 × 9.5 cm. (MAB 110.508)

267. Preparatory drawing for 'La Vie'. Barcelona, 1903.
Pen and watercolour on squared paper. 33.5 × 22.8 cm. (MAB 110.540)

268. Three nudes. Barcelona or Paris, 1902–3.
Pen on paper. 17.9 × 23 cm. (MAB 110.496)

269. Sketch for 'La Vie'. Barcelona, 1903.
Conté crayon on paper. 14.5 × 9.5 cm. (MAB 110.507)

270. Nude. Barcelona or Paris, 1902.
Pencil on paper. 21.7 × 16.1 cm. (MAB 110.483)

271. Sketches of female nudes. Barcelona, 1903.
Pen on paper. 33.8 × 23.2 cm. (MAB 110.537)

272. Large nude. Barcelona?, 1902–3.
Pen on paper. 22.5 × 15.5 cm. (MAB 110.485, R)

273. *Family of Saltimbanques.* 1905. Not in the donation.
234 × 222 cm. *National Gallery of Art, Washington. Chester Dale Collection.*

274. *Portrait of Senora Canals.* 1904. Not in the donation.
90.5 × 70.5 cm. *Museo Picasso, Barcelona.*

275. *Les Demoiselles d'Avignon.* 1907. Not in the donation.
244 × 233 cm. *Museum of Modern Art, New York.*

276. *Reservoir at Horta de Ebro.* 1909. Not in the donation.
60 × 50 cm. *Private collection, Paris.*

277. *The Guitarist.* 1910. Not in the donation.
100 × 73 cm. *Musèe Nationale d'Art Moderne, Paris.*

278. *Still Life with Fruit, Glass, Knife and Newspaper.* 1914. Not in the donation.
35.4 × 42 cm. *Collection of Mr and Mrs David Lloyd Kreeger, Washington.*

279. Cubist figure. Barcelona, 1917.
Oil on canvas. 116 × 89.2 cm. (MAB 110.003)

280. *Portrait of Blanquita Suarez.* Barcelona, 1917.
Oil on canvas. 73.3 × 47 cm. (MAB 110.013)

281. *Seated man.* Barcelona, 1917.
Oil on canvas. 104.2 × 54.2 cm. (MAB 110.005)

282. *Figure in an armchair.* Barcelona, 1917.
Oil on canvas. 92.5 × 64.4 cm. (MAB 110.007)

283. *Fruit dish.* Barcelona, 1917.
Oil on canvas. 40 × 28.1 cm. (MAB 110.029)

284. *El Paseo Colón.* Barcelona, 1917.
Oil on canvas. 40.1 × 32 cm. (MAB 110.028)

285. *Study for 'Harlequin'.* Barcelona, 1917.
Gouache on paper. 30.5 × 22.8 cm. (MAB 110.231)

286. *Woman with a mantilla.* Barcelona, 1917.
Oil on canvas. 89 × 116 cm. (MAB 110.004)

287. *Gored horse.* Barcelona, 1917.
Charcoal on canvas. 80.2 × 103.3 cm. (MAB 110.012)

288. *Self-portrait.* Barcelona, 1896.
Oil on canvas. 32.7 × 23.6 cm. (MAB 110.076)

289. *The artist's sister Lola at night*. Barcelona, c. 1896.
Oil on wood. 21.6 × 13.7 cm. (MAB 110.039)

290. *Urban view*. Barcelona, c. 1897.
Oil on canvas. 21.3 × 22.5 cm. (MAB 110.102)

291. *Figure with a fruit dish*. Barcelona, 1917.
Oil on canvas. 100 × 70.2 cm. (MAB 110.006)

292. Group of children. Corunna, 1893–4.
Oil on wood. 9.4 × 15.4 cm. (MAB 110.126)

293. Seated girl. Corunna, 1893–4
Oil on canvas. 9.5 × 13.8 cm. (MAB 110.121)

294. Haycart. Corunna, 1894?
Oil on silk. 17.5 cm. (MAB 110.116)

295. Figure painted on a tambourine. Corunna, 1894–5.
Oil on skin. 14.5 cm. (MAB 110.907)

296. Birds. Corunna, 1894–5.
Oil on wood. 9.9 × 15.7 cm. (MAB 110.155)

297. Houses on the outskirts of the town. Corunna, IV-1895.
Oil on wood. 10 × 15.6 cm. (MAB 110.152)

298. A country cottage. Corunna, 1895.
Oil on wood. 10 × 15.6 cm. (MAB 110.151)

299. Birds. Corunna, 1895.
Oil on wood. 10 × 15.6 cm. (MAB 110.156)

300. A vulture. Corunna or Barcelona, 1895.
Oil on wood. 15.6 × 10.1 cm. (MAB 110.161)

301. Seated man with a dog. Barcelona?, 1895.
Oil on wood. 15.6 × 10.1 cm. (MAB 110.144, R)

302. Vulture and lamb. Corunna or Barcelona, 1895.
Oil on wood. 17.1 × 20.9 cm. (MAB 110.199)

303. Seated woman from behind. Barcelona?, 1895.
Oil on wood. 15.2 × 8 cm. (MAB 110.189)

304. Head of a man. Barcelona?, 1895.
Oil on wood. 16.6 × 9.4 cm. (MAB 110.123)

305. Profile of a woman. Barcelona?, 1895.
Oil on wood. 15.4 × 10 cm. (MAB 110.187, A)

306. Head of a youth. Barcelona, 1895.
Oil on wood. 21.9 × 13.3 cm. (MAB 110.215, A)

307. Woman from behind. Barcelona?, 1895.
Oil on wood. 15.6 × 10 cm. (MAB 110.140)

308. Harbour. Alicante (en voyage). IX-1895.
Oil on wood. 9.9 × 15.4 cm. (MAB 110.182)

309. Seascape. Valencia (en voyage). 1895.
Oil on wood. 10.1 × 15.5 cm. (MAB 110.166)

310. Landscape. Barcelona, 4-X-1895.
Oil on wood. 10 × 15.4 cm. (MAB 110.172, A)

311. Harbour. Barcelona?, 1895–6.
Oil on wood. 10 × 15.4 cm. (MAB 110.171, A)

312. The Ciudadela park. Barcelona, 1895–6.
Oil on wood. 13.1 × 16.6 cm. (MAB 110.198)

313. The Ciudadela park. Barcelona, 1895–6.
Oil on wood. 10 × 15.6 cm. (MAB 110.184, A)

314. Landscape. Barcelona?, 1895–6.
Oil on wood. 9.9 × 15.6 cm. (MAB 110.138)

315. Theatre interior. Barcelona, 1895–6.
Oil on wood. 10.1 × 15.5 cm. (MAB 110.137, A)

316. Seascape. Barcelona?, 1895–6.
Oil on wood. 9.2 × 15.6 cm. (MAB 110.125)

317. Figure on the beach. Barcelona, 1895–6.
Oil on wood. 9.7 × 15.5 cm. (MAB 110.162)

318. Mountain landscape. (?), 1895–6.
Oil on wood. 10.1 × 15.5 cm. (MAB 110.150)

319. Mountain landscape. (?), 1895–6.
Oil on wood. 9.7 × 15.7 cm. (MAB 110.127)

320. Landscape. Barcelona?, 1895–6.
Oil on wood. 13.8 × 22.3 cm. (MAB 110.224)

321. Landscape. Barcelona?, 1895–6.
Oil on wood. 10 × 15.4 cm. (MAB 110.169, R)

322. A thicket. Barcelona?, 1895–6.
Oil on wood. 10.1 × 15.7 cm. (MAB 110.142)

323. Landscape. Barcelona?, 1895–6.
Oil on paper. 12.7 × 17.9 cm. (MAB 110.113)

324. Exit from the theatre. Barcelona, 1895–6.
Oil on wood. 17.4 × 11.2 cm. (MAB 110.197)

325. A lily. Barcelona, 1895–6.
Oil on wood. 15.6 × 9.3 cm. (MAB 110.132)

326. Detail of cloister, Barcelona cathedral. c. 1896.
Oil on wood. 22:1 × 13.8 cm. (MAB 110.219)

327. An outhouse. Barcelona, 1896.
Oil on canvas. 23.5 × 29.4 cm. (MAB 110.086, A)

328. Sky over flat roofs. Barcelona, 1895–6.
Oil on fabric stuck on card. 15.5 × 25.1 cm. (MAB 110.228)

329. A tree. Barcelona, c. 1896.
Oil on canvas. 31.8 × 22.1 cm. (MAB 110.084, A)

330. Gothic doorway. Barcelona, c. 1896.
Oil on wood. 20.2 × 12.8 cm. (MAB 110.203)

331. The artist's father. Barcelona, 1895–6.
Pen and watercolour on paper. 15 × 16.5 cm. (MAB 110.307)

332. Female figure. Barcelona, c. 1896.
Oil on wood. 15.6 × 10 cm. (MAB 110.149)

333. Shepherds. Barcelona or Malaga, 1896.
Oil on wood. 10 × 15.5 cm. (MAB 110.139)

334. A boat. Barcelona, 1896.
Oil on wood. 10 × 15.4 cm. (MAB 110.169, A)

335. Coastal landscape. Malaga, 1896.
Oil on wood. 10.3 × 15.4 cm. (MAB 110.136)

336. Self-portrait. Barcelona, 1895–6.
Oil on canvas. 46.5 × 31.5 cm. (MAB 110.063)

337. The artist's father. Barcelona, 1896.
Oil on canvas stuck on cardboard. 42.3 × 30.8 cm. (MAB 110.027)

338. Garden scene. Barcelona, IV-1896.
Oil on canvas. 38.5 × 27.4 cm (MAB 110.070)

339. Landscape. Malaga, VI-1896.
Oil on wood. 10.2 × 15.5 cm. (MAB 110.174)

340. Landscape with trees. Malaga, 1896.
Oil on wood. 10 × 15.6 cm. (MAB 110.158, A)

341. Landscape. Malaga, VI-1896.
Oil on wood. 10.2 × 15.6 cm. (MAB 110.177)

342. A kitchen. Malaga, VI-1896.
Oil on wood. 13.7 × 22.1 cm. (MAB 110.207)

343. Village scene. Malaga?, 1896.
Oil on wood. 13.6 × 22.4 cm. (MAB 110.221)

344. A mule. Barcelona, 1896.
Oil on wood. 9.8 × 15.5 cm. (MAB 110.143, A)

345. A donkey. Malaga?, 1896.
Oil on canvas. 27.7 × 36.4 cm. (MAB 110.933).

346. Landscape. Barcelona, c. 1896.
Oil on wood. 13.7 × 22.1 cm. (MAB 110.222)

347. Landscape. Barcelona, c. 1896.
Oil on wood. 9.4 × 15.5 cm. (MAB 110.124, A)

348. Battle scene. Barcelona, c. 1896.
Oil on wood. 10 × 15.5 cm. (MAB 110.153)

349. Seascape. Barcelona, 1896.
Watercolour. 17.9 × 25.3 cm. (MAB 110.232)

350. Landscape. Barcelona?, 1896.
Oil on canvas. 25.2 × 27.7 cm. (MAB 110.091)

351. Head of a female saint. Barcelona, 1896.
Oil on wood. 15.7 × 10.1 cm. (MAB 110.148)

352. The harbour. Barcelona, 1896.
Oil on wood. 18 × 12.7 cm. (MAB 110.201)

353. Landscape. Barcelona, 1896.
Oil on wood. 10.1 × 15.6 cm. (MAB 110.164, A)

354. The boat's cabin. En voyage, 1896.
Oil on wood. 22.1 × 13.6 cm. (MAB 110.209)

355. Beach scene. Barcelona, 1896.
Oil on canvas. 24.4 × 34 cm. (MAB 110.073)

356. A cave. Barcelona?, 1896.
Oil on wood. 10.2 × 15.5 cm. (MAB 110.185)

357. Bust of a youth. Barcelona, 1896–7.
Oil on canvas. 43 × 39.3 cm. (MAB 110.056)

358. Trees. Barcelona?, 1896.
Oil on wood. 13.6 × 22.2 cm. (MAB 110.225)

359. Landscape. Barcelona, XII-1896.
Oil on wood. 7.5 × 15.6 cm. (MAB 110.196, A)

360. Gardens. Barcelona, XII-1896.
Oil on wood. 13.8 × 22.5 cm. (MAB 110.226)

361. Suburban street. (?), 1896–7.
Oil on wood. 10.1 × 15.6 cm. (MAB 110.180)

362. Unfinished study of a horse. (?), c. 1897.
Oil on wood. 13.8 × 22.1 cm. (MAB 110.217)

363. Silhouette of a horse. (?), c. 1897.
Oil on wood. 13.8 × 22 cm. (MAB 110.223)

364. View of a village. Horta de Ebro?, c. 1898.
Oil on wood. 10 × 15.5 cm. (MAB 110.173)

365. Interior scene. Barcelona, 1899–1900.
Oil on canvas. 19.6 × 27 cm (MAB 110.095)

366. Portrait of an unknown person. Barcelona, 1896–7.
Oil on canvas. 38 × 34 cm. (MAB 110.061)

367. Head of a girl. Barcelona, 1896–7.
Oil on canvas stuck on card. 29.8 × 26.1 cm. (MAB 110.077)

368. 'The poor genius!' Barcelona, 1899–1900.
Oil on canvas. 23 × 30.5 cm. (MAB 110.085)

369. Portrait of an unknown person. Barcelona, III-1897 (or III-1899).
Oil on canvas. 63.5 × 39 cm. (MAB 110.051)

370. Bullfight scene. Malaga, 1890.
Pencil on paper. 13.5 × 20.2 cm. (MAB 110.869, R)

371. Spanish scene and other sketches. Malaga, 1890.
Pencil on paper. 13.7 × 21.1 cm. (MAB 110.862, A)

372. The procession and other sketches. Malaga, 1890.
Pencil on paper. 13.3 × 20.6 cm. (MAB 110.865, A)

373. Doves and other sketches. Malaga, 1890.
Pencil and pen on paper. 13.3 × 20.6 cm. (MAB 110.865, R)

374. Doves. Malaga, 1890.
Pencil on paper. 31 × 21.1 cm. (MAB 110.477, R)

375. The young pigeon. Malaga, 1890.
Pencil on paper. 13.2 × 10.4 cm. (MAB 110.871, R)

376. Drawings of doves. Malaga, 1890.
Pencil on paper. 13.2 × 10.4 cm. (MAB 110.871, A)

377. Doves and other sketches. Malaga, 1890.
Pencil on paper. 13.2 × 20.3 cm. (MAB 110.864, R)

378. Marginal sketches in a book. Corunna, 1891–3.
Pencil on printed paper. 22.2 × 14.5 cm. (MAB Libro 110.930 p. 81)

379. Bulls drawn in a book. Corunna, 1891–2.
Pencil on paper. 21.3 × 15.6 cm. (MAB Libro 110.929 p. 149)

380. Marginal drawings in a book. Corunna, 1891–3.
Pen on printed paper. 27.1 × 18.6 cm. (MAB Libro 110.866, A)

381. 'Asul y Blanco'. Corunna, 1893.
Pen. 20.3 × 26.5 cm. (MAB 110.863, A)

382. Roman soldiers. Corunna, 1893–4.
Pen on paper. 13.3 × 21 cm. (MAB 110.610, R)

383. Country people and cart. Corunna, 9-I-1893.
Pencil on paper. 12.9 × 20.6 cm. (MAB 110.868, A)

384. Moroccan scene. Corunna, 1893–5.
Watercolour on paper. 12 × 18.3 cm. (MAB 110.419, R)

385. The dialogue. Corunna, c. 1894.
Pencil on paper. 10.3 × 13.3 cm. (MAB 110.870)

386. People with umbrellas, and birds. Corunna, c. 1894.
Pencil on paper. 32 × 21.9 cm. (MAB 110.860, R.)

387. A barge and other sketches. Corunna, 1893–5.
Pen and pencil on paper. 19.3 × 27.8 cm. (MAB 110.374, A)

388. An oration and other sketches. Corunna, 1893–5.
Pen on paper. 19.6 × 20.5 cm. (MAB 110.829, R)

389. Sketches of horses and men with knives. Corunna, 1893–5.
Pen and brown ink on paper. 12.5 × 20.7 cm. (MAB 110.609, A)

390. The pantheon. Corunna, 1893–5.
Pen on paper. 13 × 20.7 cm. (MAB 110.255, A)

391. Sketches of various figures. Corunna, 1893–5.
Pen on paper. 19.3 × 27.8 cm. (MAB 110.374, R)

392. Two scenes from 'El Quijote'. Corunna, 1893–5.
Pencil on paper. 32 × 21.9 cm. (MAB 110.860, A)

393. Two figures (trimmed). Corunna, 1894.
Ink on paper. 12.8 × 19 cm. (MAB 110.109, R)

394. Sketches and caricatures. Corunna, 1893–5.
Pen on ruled paper. 26.2 × 20.9 cm. (MAB 110, 381, A)

395. Worldly scene. Corunna, c. 1894.
Pencil on paper. 25.2 × 15.5 cm. (MAB 110.391, A)

396. Head of a Moor (detail). Corunna, 19-IV-1894.
Marginal pencil sketch in a book. 20.3 × 14.5 cm. (MAB Libro 110.928 p. 5)

397. Figure study. Corunna, 1894–5.
Pencil and Conté crayon on paper. 13 × 20.8 cm. (MAB 110.902, R)

398. Sketches and caricatures. Corunna, c. 1894.
Pen, Conté crayon and watercolour on paper. 31.5 × 27.7 cm. (MAB 110.648, R)

399. Sketches of various figures. Corunna, 1894–5.
Pen on squared paper. 25.2 × 19.8 cm. (MAB 110.382)

400. Sketches and caricatures. Corunna, 1894–5.
Pen on paper. 19.9 × 27.8 cm. (MAB 110.375, A)

401. Three people (detail). Corunna, 1895.
Pen on paper. 19 × 21.9 cm. (MAB 110.376, R)

402. The wooers. Corunna, 1895.
Aquatint on paper. 19 × 21.9 cm. (MAB 110.376, A)

403. A dog. Corunna, 1893–4.
Cut-out paper. 4.8 × 8.5 cm. (MAB 110.239, A)

404. A dove. Corunna, 1893-4.
Cut-out paper. 5.6 × 9.3 cm. (MAB 110.239, B)

405. Life study (or cast) of an arm. Corunna, 1894.
Charcoal and Conté crayon on paper. 45 × 33.4 cm. (MAB 110.843)

406. Detail of the artist's entrance paper for La Lonja. Barcelona, 1895.
Charcoal, Conté crayon and pen on paper. 47.4 × 61.5 cm. (MAB 110.886, A)

407. Study of hands. Album 2. Corunna, 1894.
Pen on paper. 19.5 × 13.5 cm. (MAB 110.923)

408. The artist's sister Lola. Barcelona?, 1895.
Pen, Conté and coloured pencil on paper. 19.6 × 20.5 cm. (MAB 110.829, A)

409. Portrait of a girl. Barcelona?, 1895.
Pencil on paper. 11.5 × 8.1 cm. (MAB 110.600, A)

410. Female profile and other sketches. Album 3. Barcelona, 1895.
Conté crayon on paper. 12 × 8.2 cm. (MAB 110.912)

411. Seated girl. Barcelona?, 1895.
Conté crayon on grey paper. 31.5 × 18.4 cm. (MAB 110.828, A)

412. Back view of a girl. Barcelona?, 1895.
Pen and watercolour on paper. 19.9 × 27.8 cm. (MAB 110.375, R)

413. The maid Carmen Mendoza. Malaga, 1895.
Pencil on paper. 12.3 × 8.1 cm. (MAB 110.432)

414. Portrait of the artist's mother Doña Maria Picasso. Barcelona?, 1895.
Picasso's first watercolour. 30.5 × 23.8 cm. (MAB 110.234, A)

415. Head of a man. Barcelona?, 1895.
Pencil, Conté crayon and pen on paper. 14.3 × 20.3 cm. (MAB 110.607, A)

416. Study of the artist's father and other studies. Barcelona?, 1895.
Pencil on paper. 22.5 × 16 cm. (MAB 110.630)

417. Don José Ruiz Blasco, the artist's father. Barcelona?, 1895.
Pencil on paper. 12.3 × 8.1 cm. (MAB 110.245, A)

418. Study of a woman. Barcelona?, 1895.
Conté crayon on paper. 17 × 11.2 cm. (MAB 110.602, A)

419. Various sketches. Barcelona?, 1895.
Pen on paper. 26.8 × 20.9 cm. (MAB 110.380, R)

420. A bullfight and various sketches. Barcelona?, 1895.
Pen, pencil and watercolour on paper. 31.5 × 27.7 cm. (MAB 110.648, A)

421. Ball scene. Barcelona, IX-1895.
Pen on paper. 16.5 × 23.4 cm. (MAB 110.274)

422. Various sketches. Barcelona?, 1895.
Pen on paper. 20.9 × 13.6 cm. (MAB 110.411, A)

423. Boats. Barcelona?, 1895–6.
Conté crayon on paper. 23.5 × 33.8 cm. (MAB 110.785, A)

424. Boats (trimmed). Barcelona?, 1895–6
Conté crayon on paper. 23.5 × 33.8 cm. (MAB 110.785, R)

425. Castle and landscape study. Barcelona, 1895–6.
Pencil on paper. 23.8 × 30.6 cm. (MAB 110.355)

426. Landscape study. Barcelona, 1895–6.
Pencil on paper. 26.5 × 36.5 cm. (MAB 110.348)

427. Study of trees. Barcelona, 1895–6.
Conté crayon on paper. 24 × 31.5 cm. (MAB 110.359)

428. Sketch of the artist's mother and caricatures. Barcelona, 1895.
Pen on paper. 21.9 × 31.4 cm (MAB 110.322, A)

429. 'Between two fires' and other sketches. Barcelona, 1895.
Pen on paper. 31.4 × 21.4 cm. (MAB 110.364, R)

430. Various sketches. Barcelona, 1895–6.
Pen on paper. 20.3 × 13.5 cm. (MAB 110.405)

431. Various studies. Barcelona, 1895–6.
Pen on paper. 20.9 × 13.6 cm. (MAB 110.411, R)

432. Seated woman and two heads. Barcelona, 1895–6.
Pencil and pen on canvas. 31.8 × 22.1 cm. (MAB 110.084, R)

433. Sketches of the artist's father and others. Barcelona, 1895–6.
Pen on paper. 13 × 12.7 cm. (MAB 110.427, A)

434. Portrait of the artist's father. Barcelona, 1895–6.
Pen on paper. 20.7 × 15.4 cm. (MAB 110.624, A)

435. Sketches of the artist's family. Barcelona, 1895–6.
Pen on paper. 20.5 × 13.1 cm. (MAB 110.615, A)

436. Sketches of the artist's mother and other sketches. Barcelona, 1895–6.
Pen on paper. 20.5 × 13.3 cm. (MAB 110.614, A)

437. Various sketches. Barcelona, 1895–6.
Pen on paper. 13.9 × 20.5 cm. (MAB 110.608, A)

438. Sketch of the artist's mother and other sketches. Barcelona, 1895–6.
Pen on paper. 20.5 × 13.3 cm. (MAB 110.614, R)

439. Men, horses and bulls. Barcelona, 1895–6.
Pen on paper. 18.1 × 12.7 cm. (MAB 110.252, A)

440. Nude woman, and other sketches. Barcelona, 1895–6.
Pen on paper. 19.8 × 14.9 cm. (MAB 110.620, R)

441. Head of a man and other sketches. Barcelona, 1895–6.
Pen and watercolour on paper. 19.8 × 15.3 cm. (MAB 110.622, A)

442. Sketches of hands, and a caricature. Barcelona, 1895–6.
Pencil and pen on paper. 22.4 × 26.3 cm. (MAB 110.650, R)

443. Various studies and sketches. Barcelona, 1895–6.
Watercolour on paper. 48 × 21.3 cm. (MAB 110.235)

444. Various sketches. Barcelona?, 1895–6.
Pen on paper. 22.2 × 15.8 cm. (MAB 110.631, R)

445. Various sketches. Barcelona, 1895–6.
Pen on paper. 21.9 × 31.4 cm. (MAB 110.322, R)

446. Sketches of the artist's mother and his sister Lola. Barcelona, 1895–6.
Pen on paper. 22.1 × 17.2 cm. (MAB 110.321)

447. The soldier's farewell and other sketches. Barcelona, 1895–6.
Pen on paper. 19.8 × 14.9 cm. (MAB 110.620, A)

448. Self-portrait and other sketches. Barcelona, 1895–6.
Pen on paper. 31 × 24.7 cm. (MAB 110.665, A)

449. Divine allegory. Barcelona, 1895–6.
Watercolour, pen and pencil on paper. 25.2 × 15.5 cm. (MAB 110.391, R)

450. Sketch of the artist's mother reading and his sister Lola. Barcelona, 1895–6.
Pen on paper. 22.2 × 15.8 cm. (MAB 110.631, A)

451. Various sketches. Barcelona, 1895–6.
Pen and watercolour on paper. 19.8 × 15.3 cm. (MAB 110.622, R)

452. Various sketches. Barcelona, 1895–6.
Pen on paper. 32 × 22 cm. (MAB 110.676, R)

453. A procession. Barcelona, 1895–6.
Pen on paper. 22 × 22.3 cm. (MAB 110.673, R)

454. A procession. Barcelona, 1895–6.
Pen on paper. 20 × 23.9 cm. (MAB 110.646)

455. Sketch of an altarpiece. Barcelona, 1895–6
Pen on paper. 11 × 12.2 cm. (MA 110.702 A)

456. A Moroccan. Barcelona, 1895–6.
Watercolour on paper. 25.4 · 17.9 cm. (MAB 110.236)

457. The battle of Covadonga. Barcelona, 1895–6.
Pen on paper. 22.4 × 17.9 cm. (MAB 110.639)

458. Battle scene. Barcelona, 1895–6.
Pen, watercolour and Conté crayon on paper. 31 × 47.5 cm. (MAB 110.697, A)

459. Choir-boy and girl. Barcelona, 1895–6.
Conté crayon on paper. 27.8 × 19.6 cm. (MAB 110.333)

460. Nude woman and other sketches. Barcelona, 1895–6.
Pen on paper. 14 × 10.2 cm. (MAB 110.264, R)

461. Life study of a man. Barcelona, 1896.
Conté crayon and chalk on grey paper. 31.2 × 23.5 cm. (MAB 110.655)

462. Sketches for a religious scene. Barcelona, 1895–6
Conté crayon and chalk on paper. 65 × 50.1 cm. (MAB 110.700, A)

463. Seated figure. Barcelona, c. 1896.
Watercolour, pen and Conté crayon on paper. 51 × 42.5 cm. (MAB 110.892)

464. Studies of hands. Barcelona, 1895–6.
Conté crayon on grey paper. 31.2 × 29.3 cm. (MAB 110.858, A)

465. Ancient horseman, academy study. Barcelona, 1895.
Pencil and Conté crayon on paper. 28.3 × 29.3 cm. (MAB 110.694, R)

466. A Spanish dance. Barcelona, 1895–6.
Watercolour and pen on paper. 41.5 × 51.1 cm. (MAB 110.896)

467. Sketch of the Venus de Milo. Barcelona, 1895–7.
Pencil on grey paper. 23.8 × 16 cm. (MAB 110.392)

468. Drawing of the Venus de Milo. Barcelona, 1895–7.
Conté crayon and charcoal on paper. 61.8 × 47.7 cm. (MAB 110.876, A)

469. Sketch of the head and shoulders of the Venus de Milo. Barcelona, 1895–7.
Conté crayon on paper. 30.7 × 47.8 cm. (MAB 110.856, A)

470. Study of a plaster cast of a male torso. Barcelona, 1895.
Charcoal and Conté crayon on paper. 63 × 47.5 cm. (MAB 110.877, A)

471. Study of a plaster cast of a reclining torso. Barcelona, 1895–7.
Charcoal and Conté crayon on paper. 47.4 × 61.5 cm. (MAB 110.886, R)

472. Study of a plaster cast. Barcelona, 1895.
Charcoal on paper. 63 × 47.5 cm. (MAB 110.598)

473. Study of a plaster cast of a forearm. Barcelona, 1895–7 (or 1899?).
Charcoal on paper. 66.5 × 30.1 cm. (MAB 110.872, R)

474. Study of a plaster cast of a foot. Barcelona, 1895–7.
Charcoal and Conté crayon on paper. 33.1 × 49.6 cm. (MAB 110.799, A)

475. Study of a plaster cast of a foot. Barcelona, 1895–7.
Charcoal and Conté crayon on paper. 26.8 × 32.8 cm. (MAB 110.793, A)

476. Life study of a flute-player. Barcelona, 1895–7.
Conté crayon and charcoal on paper. 47 × 30.8 cm. (MAB 110.854, R)

477. Life study of a negro. Barcelona, 1895–7.
Charcoal and Conté crayon on paper. 47.3 × 31.8 cm. (MAB 110.853)

478. Life drawing of a man's head and shoulders. Barcelona, 1895–7.
Charcoal on paper. 47.8 × 31 cm. (MAB 110.850, A)

479. Life drawing of a male figure. Barcelona, 1895–7.
Conté crayon and pen on paper. 48.3 × 31.5 cm. (MAB 110.849, A)

480. Life study of a man from behind. Barcelona, 1896.
Charcoal and Conté crayon on paper. 61.5 × 47.5 cm. (MAB 110.880)

481. Life study of a seated man. Barcelona, 1896.
Charcoal and Conté crayon on paper. 60 × 47 cm (MAB 110.874)

482. The boxer. Barcelona, 1895–7.
Conté crayon on paper. 53.5 × 33.7 cm. (MAB 110.893, A)

483. The boxer. Barcelona, 1895–7.
Conté crayon on paper. 53.5 × 33.7 cm. (MAB 110.893, R)

484. Figure of a man. Barcelona, 1896–7.
Charcoal and Conté crayon on paper. 62 × 38.7 cm. (MAB 110.879)

485. Figure with a cloak. Barcelona, 1896.
Conté crayon on paper. 20.7 × 15.4 cm. (MAB 110.624, R)

486. Study of a draped figure. Barcelona, 1896.
Pencil on paper. 11.5 × 8.1 cm. (MAB 110.600, R)

487. Kneeling figure. Barcelona, 1896.
Pencil and chalk on grey paper. 21.5 × 15.7 cm. (MAB 110.625)

488. Various sketches. Barcelona, 1895–6.
Pen on paper. 31.4 × 21.4 cm. (MAB 110.364, A)

489. Various sketches. Barcelona, c. 1896.
Pen on paper. 21.3 × 13.6 cm. (MAB 110.711, A)

490. Girl and other sketches. Barcelona, c. 1896.
Watercolour and pen on paper. 15.8 × 22 cm. (MAB 110.311, A)

491. Sketch for a Resurrection. Barcelona, c. 1896.
Pen on paper. 17.4 × 13.5 cm. (MAB 110.903, R)

492. Sketch for a St Sebastian. Barcelona, c. 1896.
Pen and pencil on paper. 12.8 × 17.3 cm. (MAB 110.117, R)

493. Sketch for an Annunciation. Barcelona, c. 1896.
Pen on paper. 17.4 × 13.5 cm. (MAB 110.903, A)

494. Sketch for a Descent from the Cross. Barcelona, c. 1896.
Conté crayon on ruled paper. 19.8 × 26.4 cm. (MAB 110.647, A)

495. 'La Cantoria'. Barcelona, 1896.
Watercolour on paper. 25.4 × 17.9 cm. (MAB 110.643, A)

496. Man with a cap. Barcelona, 1896–7.
Conté crayon on paper. 15.8 × 12 cm. (MAB 110.273, A)

497. Head of a woman. Barcelona, 16-X-1896.
Conté crayon on paper. 24.3 × 16.5 cm. (MAB 110.562)

498. The artist's mother reading. Barcelona, 1896–7.
Conté crayon on paper. 33.8 × 23.4 cm. (MAB 110.690, R)

499. Sketch for 'Science and Charity'. Barcelona, c. 1897.
Conté crayon on paper. 27.7 × 10.5 cm. (MAB 110.387, A)

500. 'El paraguofago'. Barcelona, 1896–7.
Conté crayon and coloured pencil on paper. 16.3 × 11 cm. (MAB 110.272)

501. Female figure. Barcelona, 1896–7.
Conté crayon on grey paper. 17.9 × 11.5 cm. (MAB 110.423, A)

502. Sketches of dogs. Barcelona, 1896–7.
Blue pencil on grey paper. 20.5 × 21 cm. (MAB 110.388)

503. Sketches of cats. (?), c. 1897.
Conté crayon on paper. 20.1 × 13.8 cm. (MAB 110.619)

504. Female figure. Album 7. Barcelona, 1896–7.
Charcoal on paper. 10.5 × 7.5 cm. (MAB 110.911)

505. A goat and other drawings. Barcelona, 1896?
Pen on paper. 21.3 × 13.6 cm. (MAB 110.711, R)

506. Sketches of women. Barcelona, 1896?
Pen on paper. 10.1 × 16.2 cm. (MAB 110.268, R)

507. Girl and goat. Barcelona, 1896?
Pen on paper. 11 × 12.2 cm. (MAB 110.702, R)

508. Studies of the artist's parents. Barcelona, c. 1897.
Conté crayon on paper. 33.6 × 21.5 cm. (MAB 110.583, A)

509. Various sketches. Barcelona, 1896–7.
Pencil, Conté crayon and ink on paper. 32 × 47.5 cm. (MAB 110.699, A)

510. Various sketches. Barcelona, 1896–7.
Pen on paper. 23.4 × 34 cm. (MAB 110.686, A)

511. Sketches of heads. Barcelona, 1896–7.
Pen on paper. 17.7 × 11.6 cm. (MAB 110.605, A)

512. Sketches of heads. Barcelona, after I-1897.
Pen on paper. 32 × 21.8 cm. (MAB 110.633, A)

513. Seated women and other figures. Barcelona, 1896–7.
Conté crayon and pen on paper. 30.8 × 24 cm. (MAB 110.574, A)

514. Self-portrait. Barcelona, 1897?
Conté crayon, charcoal and purpurin. 20.3 × 15.2 cm. (MAB 110.237, A)

515. Various sketches. Barcelona, 1897?
Watercolour on paper. 23.2 × 34 cm. (MAB 110.684)

516. Sketch of a woman and others (from the Casagemas exhibition catalogue).
Barcelona, c. 1899.
Pen on paper. 20.1 × 27.5 cm. (MAB 110.408)

517. Sketch of a woman and a hand. (?), c. 1897.
Conté crayon on paper. 34 × 23.5 cm. (MAB 110.900)

518. Seated couple. Madrid or Barcelona, c. 1897.
Conté crayon on paper. 22 × 16.5 cm. (MAB 110.635)

519. Various studies. (?), c. 1897.
Pen on paper. 16.1 × 12.1 cm. (MAB 110.249, A)

520. Various sketches including the artist's father. Madrid, 1897–8.
Pen and brown ink on ruled paper. 26.2 × 20.3 cm. (MAB 110.652)

521. Various sketches. Madrid, 1897–8?
Pen on paper. 31.5 × 22 cm. (MAB 110.366, R)

522. Seated man and other sketches. (?), c. 1897.
Pen on paper. 20.5 × 13.4 cm. (MAB 110.291, R)

523. Sketches of figures. (?), c. 1897.
Conté crayon on paper. 30.5 × 46.6 cm. (MAB 110.588, A)

524. Group around sofa. Madrid, 1897–8.
Conté crayon on paper. 16.5 × 24.7 cm. (MAB 110.389, A)

525. Rider and two figures. Barcelona?, 1897–9.
Pencil and Conté crayon on ruled paper. 32 × 22.4 cm. (MAB 110.824, A)

526. Rider and various sketches. Barcelona?, 1897–9.
Conté crayon on paper. 33.7 × 23.3 cm. (MAB 110.808, A)

527. Lady in a cape and other sketches. Madrid?, 1897–8?
Pen on paper. 20.5 × 13.4 cm. (MAB 110.291, A)

528. Various sketches. Madrid, 1897–8.
Conté crayon on paper. 23.5 × 33.5 cm. (MAB 110.585, A)

529. Two figures. Madrid, 1897–8.
Conté crayon on paper. 16.5 × 24.7 cm. (MAB 110.389, R)

530. Sketches of a quarrel. Madrid, 1897–8.
Pen and Conté crayon on squared paper. 20.2 × 25.8 cm. (MAB 110.385, R)

531. Sketch of a quarrel. Madrid, 1897–8.
Pen on squared paper. 20.4 × 25.9 cm. (MAB 110.384)

532. The quarrel. Madrid, 1897–8.
Pen on squared paper. 20.2 × 25.8 cm. (MAB 110.385, A)

533. Various sketches. Madrid?, 1897–8.
Conté crayon on paper. 24.5 × 32.1 cm. (MAB 110.775, R)

534. The street violinist. Madrid, 1897–8.
Conté crayon and watercolour on paper. 23.5 × 33.5 cm. (MAB 110.784, A)

535. Various sketches. Madrid, 1897–8.
Pencil and Conté crayon on paper. 28.3 × 29.5 cm. (MAB 110.694, A)

536. Manola and sketches. Madrid, 1897–8.
Pen on paper. 22.2 × 31.6 cm. (MAB 110.830, A)

537. Sketch of a woman and the reverse of Manola. Madrid, 1897–8.
Pen on paper. 22.2 × 31.6 cm. (MAB 110.830, R)

538. Fight in a café. (?), 1897–9.
Conté crayon and red paint on paper. 22.9 × 33.5 cm. (MAB 110.346, A)

539. Man walking seen from behind. (?), 1897–9.
Conté crayon on paper. 22.2 × 15.6 cm. (MAB 110.731)

540. Female figure. (?), 1897–9.
Conté crayon on paper. 21 × 15.5 cm. (MAB 110.404, R)

541. Two women from behind. (?), 1897–8.
Conté crayon on paper. 20 × 16.3 cm. (MAB 110.402)

542. Seated woman. (?), 1897–8.
Conté crayon on paper. 32.1 × 22.2 cm. (MAB 110.758, A)

543. 'A strange type' and other sketches. (?), 1897–9.
Conté crayon on paper. 48.5 × 32.3 cm. (MAB 110.597, R)

544. Sketch of figures seated at table. (?), 1897–9.
Conté crayon on paper. 15.7 × 22 cm. (MAB 110.396, A)

545. Couple from behind. (?), 1897–8.
Conté crayon on paper. 24.4 × 16.6 cm. (MAB 110.561, A)

546. Group and still-life. (?), 1897–9.
Conté crayon on paper. 16 × 22.1 cm. (MAB 110.315, R)

547. Various sketches including the artist's sister Lola. Barcelona, c. 1897.
Conté crayon on paper. 34 × 24.7 cm. (MAB 110.689, A)

548. Sketches of the artist's sister Lola. Barcelona, c. 1897.
Conté crayon on paper. 23 × 33.9 cm. (MAB 110.353)

549. Woman from behind. Album 11. Madrid, 1897–8.
Pencil on paper. 18.5 × 13 cm. (MAB 110.922)

550. The mug of beer. (?), 1897–9.
Conté crayon on paper. 16.8 × 11.4 cm. (MAB 110.250, A)

551. Velasquez figures. Madrid?, 1897–8.
Conté crayon on paper. 15.9 × 22 cm. (MAB 110.398, A)

552. Two women and other sketches. Madrid?, 1897–8.
Conté crayon on paper. 32.2 × 22.2 cm. (MAB 110.658, R)

553. Sketch of labourers and women's heads. (?) c. 1897.
Conté crayon on paper. 33.8 × 23.2 cm. (MAB 110.788, R)

554. Seated woman. Album 9. Barcelona, 1897.
Pencil on paper. 12 × 8 cm. (MAB 110.915)

555. A horse with nosebag. (?), 1897–9.
Conté crayon on paper. 23.8 × 33.5 cm. (MAB 110.580, A.)

556. A horse in harness. (?), 1897–9.
Conté crayon on paper. 23.5 × 33.5 cm. (MAB 110.585, R)

557. A horse in harness. (?), 1897–9.
Conté crayon and pen on paper. 24.5 × 32 cm. (MAB 110.579, R)

558. A horse in harness. (?), 1897–9.
Conté crayon on paper. 23.6 × 16.7 cm. (MAB 110.779, R)

559. Study of a horse. (?), 1897–9.
Conté crayon on paper. 23.5 × 33 cm. (MAB 110.586, R)

560. Various sketches. (?), 1897–9.
Conté crayon on paper. 23.8 × 31.1 cm. (MAB 110.572)

561. Sketch of the artist's father and a female figure. (?), 1897–8.
Conté crayon on paper. 32 × 24.7 cm. (MAB 110.576, A)

562. Street figures. Barcelona, 1897–9.
Conté crayon on paper. 22.5 × 32 cm. (MAB 110.768, A)

563. Two seated men. (?), 1897–9.
Conté crayon on paper. 15.7 × 12.7 cm. (MAB 110.554, A)

564. Two men talking, and two heads. (?), 1897.
Conté crayon on ruled paper. 32.2 × 22.4 cm. (MAB 110.759, A)

565. Head of a horse. Album 12. Madrid, 1897–8.
Pencil on paper. 20 × 12 cm. (MAB 110.924)

566. Three figures. (?), 1897–9.
Conté crayon on ruled paper. 32.2 × 22.4 cm. (MAB 110.824, R)

567. Street sketches. (?), c. 1899.
Conté crayon on ruled paper. 32.2 × 22.2 cm. (MAB 110.342, A)

568. Stooping youth and other sketches. (?), 1897–9.
Pencil, Conté crayon and pen on paper. 48.3 × 31.5 cm. (MAB 110.849, R)

569. A carter. (?), 1897–9.
Conté crayon on paper. 32.1 × 24.6 cm. (MAB 110.792, A)

570. A carter and other sketches. (?), 1897–9.
Conté crayon on paper. 22.4 × 32.1 cm. (MAB 110.756, A)

571. A carter and other rough sketches. (?), 1897–9.
Pencil, pen and watercolour on ruled paper. 32.2 × 22 cm. (MAB 110.755, A)

572. A porter. (?) 1897–9.
Pencil on ruled paper. 32.2 × 22 cm. (MAB 110.755, R)

573. Various types. (?) 1897–9.
Conté crayon on ruled paper. 32.1 × 22.3 cm. (MAB 110.767, A)

574. Various rough sketches. (?), 1897–8.
Conté crayon on ruled paper. 22.5 × 32 cm. (MAB 110.768, R)

575. Various rough sketches of figures. (?), 1897–9.
Conté crayon on ruled paper. 32.1 × 22.3 cm. (MAB 110.76, R)

576. Various rough sketches. (?), 1897–8.
Conté crayon on paper. 32.2 × 22.2 cm. (MAB 110.757, A)

577. Juxtaposed sketches. (?), 1897–8.
Conté crayon on paper. 16 × 11 cm. (MAB 110.904, A)

578. Street scene. (?), 1897–8.
Conté crayon on paper. 47 × 30.8 cm. (MAB 110.854, R)

579. A crowd of men. (?), 1897–8
Conté crayon on ruled paper. 13.1 × 21 cm. (MAB 110.712, A)

580. Various sketches including one of the artist's father. (?), 1897–8.
Conté crayon on paper. 32 × 24.7 cm. (MAB 110.576, R)

581. A group reading (trimmed). (?), 1897–8.
Pen on paper. 21 × 13.4 cm. (MAB 110.409, R)

582. Study of a tree and other sketches. Barcelona?, c. 1897.
Pencil on paper. 19.8 × 27.5 cm. (MAB 110.649, A)

583. Trees. Horta de Ebro?, 1898–9.
Pen and Conté crayon on paper. 15.7 × 21.8 cm. (MAB 110.718, A)

584. Landscape. Horta de Ebro?, 1898–9.
Conté crayon on paper. 23.5 × 33.5 cm. (MAB 110.578)

585. Landscape. Horta de Ebro?, 1898–9.
Conté crayon on paper. 24.5 × 32.1 cm. (MAB 110.775, A)

586. Landscape. Horta de Ebro?, 1898–9.
Conté crayon on paper. 31 × 24 cm. (MAB 110.773, A)

587. Figure in the countryside. Horta de Ebro?, 1898–9.
Pencil on paper. 23.3 × 17 cm. (MAB 110.390)

588. Studies of goats. Horta de Ebro, VIII-1898.
Conté crayon on paper. 32.2 × 24.5 cm. (MAB 110.786, A)

589. Rough sketches of goats. Horta de Ebro, VIII-1898.
Conté crayon on paper. 21.3 × 31.8 cm. (MAB 110.774, R)

590. A sleeping dog. Horta de Ebro, 1898–9.
Conté crayon on paper. 15.7 × 13.4 cm. (MAB 110.709, A)

591. Rough sketches of goats. Horta de Ebro, 1898–9.
Conté crayon on paper. 16.1 × 24.8 cm. (MAB 110.745, A)

592. Pallarés and other sketches. Horta de Ebro, 1898–9.
Conté crayon on paper. 21.8 × 15.6 cm. (MAB 110.730, A)

593. Seated figure. Horta de Ebro?, 1897–9.
Conté crayon on paper. 24.8 × 16.3 cm. (MAB 110.746, A)

594. A boy and some rough sketches. Horta de Ebro?, 1898–9.
Conté crayon and pen on paper. 32 × 24.5 cm. (MAB 110.577, A)

595. A boy and other sketches. Horta de Ebro?, 1898–9.
Conté crayon on paper. 32.2 × 24.5 cm. (MAB 110.786, R)

596. A man and a dog. Horta de Ebro?, 1898–9.
Conté crayon on paper. 25 × 16.2 cm. (MAB 110.740)

597. 'Charity' and other sketches. (?), 1898–9.
Conté crayon on paper. 21.8 × 15.8 cm. (MAB 110.732)

598. Sketches of Aragonese woodcutters. Horta de Ebro?, 1898–9.
Conté crayon on paper. 24.9 × 16.5 cm. (MAB 110.739, A)

599. Sketches of Aragonese peasants. Horta de Ebro?, 1898–9.
Conté crayon on paper. 24.9 × 16.5 cm. (MAB 110.739, R)

600. Sketches of Aragonese men. Horta de Ebro?, 1898–9.
Conté crayon on paper. 24.9 × 16.5 cm. (MAB 110.738, R)

601. Sketch of a man. Horta de Ebro?, 1898–9.
Pencil on paper. 16.6 × 24.8 cm. (MAB 110.748, R)

602. Sketches of Aragonese peasants. Horta de Ebro?, 1898–9.
Conté crayon on paper. 24.5 × 16.4 cm. (MAB 110.741, A)

603. Sketches of men. Horta de Ebro?, 1898–9.
Conté crayon on paper. 24.8 × 16 cm. (MAB 110.738, A)

604. Various sketches. Horta de Ebro?, 1898–9.
Conté crayon on paper. 12.2 × 16.2 cm. (MAB 110.747, R)

605. Street quarrel. (?), 1898–9.
Conté crayon on paper. 23.5 × 33.5 cm. (MAB 110.345, R)

606. Various sketches. Horta de Ebro?, 1898–9.
Conté crayon on paper. 21.8 × 15.6 cm. (MAB 110.730, R)

607. Boy at the 'Carnival de 1899'. Horta de Ebro or Barcelona, 1899.
Conté crayon and pen on paper. 32.3 × 24.5 cm. (MAB 110.787, R)

608. Various sketches. Horta de Ebro or Barcelona, 1898–9.
Conté crayon and pen on paper. 32 × 24.5 cm. (MAB 110.577, R)

609. Various sketches. (?), 1898–9.
Conté crayon on paper. 24.5 × 16 cm. (MAB 110.744, R)

610. Back view of painter. Horta de Ebro or Barcelona, 1898–9.
Conté crayon on paper. 15.5 × 8.3 cm. (MAB 110.552)

611. Sketch of the artist's father and others (Casagemas on the right). (?), 1898–9.
Conté crayon and pen on paper. 40.2 × 32.1 cm. (MAB 110.590, A)

612. Figures over landscape sketches. (?), 1898–9.
Conté crayon on paper. 15.9 × 22 cm. (MAB 110.398, R)

613. Two compositions. (?), 1897–9.
Conté crayon on paper. 24.8 × 16.3 cm. (MAB 110.746, R)

614. Various sketches. Horta de Ebro?, 1898–9.
Conté crayon on paper. 23.8 × 33.5 cm. (MAB 110.580, R)

615. Two figures. (?), 1897–9.
Conté crayon on paper. 17.5 × 12 cm. (MAB 110.425, A)

616. Masculine figure. (?), 1897–9.
Conté crayon on paper. 17.2 × 11.8 cm. (MAB 110.704)

617. A girl. (?), 1897–9.
Conté crayon on grey paper. 18 × 10.9 cm. (MAB 110.422, A)

618. Seated woman. (?), 1897–9.
Conté crayon on grey paper. 17.2 × 11.4 cm. (MAB 110.603, A)

619. Seated man. (?), 1897–9.
Conté crayon on grey paper. 17.5 × 11.3 cm. (MAB 110.705)

620. Three rough sketches. (?), 1897–9.
Conté crayon on grey paper. 18 × 10.9 cm. (MAB 110.422, R)

621. Seated couple. (?), 1897–9.
Conté crayon on paper. 23.5 × 33.5 cm. (MAB 110.681, R)

622. Two seated men. (?), 1897–9.
Conté crayon on ruled paper. 32.2 22.4 cm. (MAB 110.759, R)

623. Two walkers (a). (?), 1897–9.
Conté crayon on squared paper. 31.5 × 22 cm. (MAB 110.677)

624. Two walkers (b). (?), 1897–9.
Conté crayon on squared paper. 31.5 × 22 cm. (MAB 110.569)

625. Café scene. (?), 1897–9.
Conté crayon on paper. 23.5 × 33.5 cm. (MAB 110.681, A)

626. Torso of a youth. (?), 1898.
Conté crayon and pen on paper. 31.5 × 48 cm. (MAB 110.810, A)

627. Seated girl. Barcelona, 1899.
Conté crayon on paper. 48.5 × 32 cm. (MAB 110.845, A)

628. Front view of a man. Barcelona, IV-1899.
Conté crayon on paper. 49 × 32.7 cm. (MAB 110.844)

629. Side view of a man. Barcelona, 1899.
Conté crayon on paper. 48.2 × 31.3 cm. (MAB 110.846)

630. Side view of an old man. Barcelona, III-1899.
Conté crayon on paper. 48.5 × 32 cm. (MAB 110.848)

631. Female nude. Barcelona, 1899.
Charcoal and Conté crayon on paper. 48.5 × 32.5 cm. (MAB 110.595)

632. Seated female nude. Barcelona, 1899.
Charcoal on paper. 48 × 30.8 cm. (MAB 110.593, A)

633. The artist's father and other sketches. Barcelona, c. 1899.
Conté crayon on paper. 34 × 24 cm. (MAB 110.790)

634. Rough sketch of the artist's father. Barcelona, c. 1899.
Conté crayon on paper. 33.8 × 23.4 cm. (MAB 110.789)

635. Two seated women. Barcelona, c. 1899 (cover of an exercise-book).
Conté crayon on board. 23 × 16.8 cm. (MAB 110.230)

636. Two women and a caricature. Barcelona, 1899.
Conté crayon on paper. 22.6 × 27.6 cm. (MAB 110.753)

637. Girl on a balcony. Barcelona, 1899.
Pen and Conté crayon on paper. 33.8 × 23.1 cm. (MAB 110.809, R)

638. 'Charity'. Barcelona, c. 1899.
Conté crayon on paper. 23.2 × 33.8 cm. (MAB 110.783, A)

639. Various sketches. Barcelona?, c. 1899.
Pen on paper. 32 × 22 cm. (MAB 110.358, A)

640. Various sketches. Barcelona, c. 1899.
Conté crayon on paper. 22.9 × 33.5 cm. (MAB 110.346, R)

641. Sweepers. Barcelona?, c. 1899.
Conté crayon on paper. 23.3 × 33.7 cm. (MAB 110.782)

642. Two figures. Barcelona, 1899.
Conté crayon on paper. 32.2 × 22.2 cm. (MAB 110.766, A)

643. Woman walking against the wind. Barcelona, 1899.
Conté crayon and pen on paper. 17 × 22.7 cm. (MAB 110.393, R)

644. Manola. Album 10. (?), 1897–9.
Charcoal on paper. 19.5 × 12 cm. (MAB 110.925)

645. Various sketches. Barcelona?, c. 1899.
Pen and Conté crayon on paper. 31.8 × 22 cm. (MAB 110.363, R)

646. Various sketches. Barcelona?, c. 1899.
Conté crayon on paper. 16 × 22.1 cm. (MAB 110.315, A)

647. Seated figures. Barcelona?, c. 1899.
Conté crayon on paper. 16.8 × 22.1 cm. (MAB 110.394, A)

648. Various sketches. Barcelona?, c. 1899.
Pen and Conté crayon on paper. 18.5 × 12.9 cm. (MAB 110.279, R)

649. Man running. Barcelona?, c. 1899.
Conté crayon on paper. 20 × 16 cm. (MAB 110.310, R)

650. A couple by candlelight. Barcelona?, c. 1899.
Conté crayon on paper. 22.5 × 33.9 cm. (MAB 110.682, A)

651. The death-bed. Barcelona, 1899–1900.
Conté crayon, charcoal and chalk on paper. 30 × 39.8 cm. (MAB 110.797)

652. Study for a poster for 'Caja de Previsión y Socorro' (a). Barcelona, 1899–1900.
Conté crayon on paper. 48 × 31.3 cm. (MAB 110.800, A)

653. Study for a poster for 'Caja de Previsión y Socorro' (b). Barcelona, 1899–1900.
Conté crayon on paper. 48 × 31.3 cm. (MAB 110.800, R)

654. Interior with figures. Barcelona, 1899–1900.
Conté crayon on paper. 24.4 × 31.7 cm. (MAB 110.362)

655. On the sofa. Barcelona, 1899–1900.
Conté crayon on paper. 21.3 × 30.4 cm. (MAB 110.371, A)

656. Beside the grave. Barcelona, 1899–1900.
Charcoal and Conté crayon on paper. 33.1 × 49.6 cm. (MAB 110.799, R)

657. At the sick-bed (a). Barcelona, 1899–1900.
Pen on paper. 13.3 × 20.7 cm. (MAB 110.714)

658. At the sick-bed (b). Barcelona, 1899–1900.
Pen on paper. 14 × 21 cm. (MAB 110.716)

659. Dramatic scene. Barcelona, c. 1899.
Conté crayon on paper. 23.6 × 16.7 cm. (MAB 110.779, A)

660. Various sketches. Barcelona?, c. 1899.
Conté crayon on paper. 33.6 × 21.5 cm. (MAB 110.582, R)

661. Various sketches. Barcelona, 1899–1900.
Pen and Conté crayon on paper. 31.8 × 22 cm. (MAB 110.363, A)

662. Kneeling figure at bedside. Barcelona, 1899–1900.
Conté crayon on paper. 17.2 × 22.8 cm. (MAB 110.742, A)

663. The visitor. Barcelona, 1899–1900.
Conté crayon on paper. 15.8 × 21.8 cm. (MAB 110.314, A)

664. The kiss of death. Barcelona, 1899–1900.
Conté crayon on paper. 23.5 × 33.6 cm. (MAB 110.778, R)

665. Dramatic scene. Barcelona, 1899–1900.
Conté crayon on paper. 33.5 × 23.5 cm. (MAB 110.587, R)

666. The kiss of death and other sketches. Barcelona, 1899–1900.
Conté crayon on paper. 23 × 33 cm. (MAB 110.776, A)

667. Sick woman. Barcelona, 1899–1900.
Pen on paper. 20 × 21.8 cm. (MAB 110.751, A)

668. By the sick-bed. Barcelona, 1899–1900.
Pen on paper. 13.6 × 21 cm. (MAB 110.715, A)

669. Sick youth and other sketches. Barcelona, 1899–1900.
Conté crayon on ruled paper. 31.8 × 22.3 cm. (MAB 110.765, A)

670. Priests. Barcelona, 1899–1900.
Pen on paper. 22 × 32 cm. (MAB 110.772, A)

671. Woman and dramatic scene. Barcelona, 1899–1900.
Conté crayon on paper. 26.8 × 32.8 cm. (MAB 110.793, R)

672. Kneeling man and other sketches. Barcelona, 1899–1900.
Pen and Conté crayon on paper. 40.5 × 30 cm. (MAB 110.796, A)

673. A procession. Barcelona, 1899–1900.
Pen on paper. 12.8 × 15.8 cm. (MAB 110.708)

674. Kneeling figure and other sketches. Barcelona, 1899–1900.
Pen and Conté crayon on paper. 15.8 × 21.9 cm. (MAB 110.478, A)

675. Self-portrait and various sketches, some for a poster. Barcelona, 1899–1900.
Pen and watercolour on paper. 22.3 × 32 cm. (MAB 110.814)

676. Woman writing and other sketches. Barcelona, 1899–1900.
Conté crayon on paper. 33.7 × 23.3 cm. (MAB 110.808, R)

677. Head of a woman and various sketches. Barcelona, 1899–1900.
Pencil on paper. 46.8 × 31.3 cm. (MAB 110.589, A)

678. Sketches of priests and others. Barcelona, 1899–1900.
Conté crayon and pen on paper. 31.7 × 21.8 cm. (MAB 110.762, A)

679. Sketches of a seated woman and other sketches. Barcelona, 1899–1900.
Pen on paper. 31.5 × 21.8 cm. (MAB 110.771, A)

680. Various sketches. Barcelona, 1899–1900.
Pen on paper. 31.5 × 21.8 cm. (MAB 110.771, R)

681. Nudes and various sketches. Barcelona, 1899–1900.
Pen on paper. 21.8 × 31.4 cm. (MAB 110.367, R)

682. Various sketches. Barcelona, 1899–1900.
Pen on paper. 23 × 33.3 cm. (MAB 110.683, R)

683. Various sketches. Barcelona, 1899–1900.
Pen on paper. 32.2 × 22 cm. (MAB 110.668, R)

684. Various figures. Barcelona, 1899–1900.
Pen on paper. 22 × 32 cm. (MAB 110.772, R)

685. Various sketches. Barcelona, 1899–1900.
Pen on paper. 31.5 × 22 cm. (MAB 110.672, A)

686. Seated woman and other sketches. Barcelona, 1899–1900.
Pen on paper. 22.3 × 32.2 cm. (MAB 110.656, R)

687. Woman and child. Barcelona, 1899–1900.
Conté crayon on paper. 30 × 21 cm. (MAB 110.565, R)

688. Kneeling woman and other figures. Barcelona, 1899–1900.
Conté and red crayon on paper. 23.5 × 33.5 cm. (MAB 110.345, A)

689. Seated nude and other sketches. Barcelona, 1899–1900.
Conté crayon on paper. 23.8 × 15.3 cm. (MAB 110.736, A)

690. Drawing of a woman. Barcelona, 1899–1900.
Conté crayon on paper. 22.4 × 16.7 cm. (MAB. 110.727, A)

691. Sketch for the menu of 'Els 4 Gats'. Barcelona, 1899–1900.
Pen and pencil on paper. 32.1 × 22.7 cm. (MAB 110.820)

692. Portrait of the artist's father, D. José Ruiz Blasco. Barcelona, 1899.
Paris pencil on paper. 30.5 × 24.7 cm. (MAB 110.032)

693. Sketch for the menu of 'Els 4 Gats'. Barcelona, 1899–1900.
Pen on paper. 32.1 × 22.7 cm. (MAB 110.820, R)

694. Sketch for the menu of 'Els 4 Gats'. Barcelona, 1899–1900.
Conté crayon on paper. 43.7 × 31 cm. (MAB 110.804, A)

695. Sketch for the menu of 'Els 4 Gats'. Barcelona, 1899–1900.
Pen on paper. 46.7 × 22.7 cm. (MAB 110.802, R)

696. Sketches at 'Els 4 Gats'. Barcelona, 1899–1900.
Pen on paper. 32.2 × 22.7 cm. (MAB 110.822, A)

697. Sketches at 'Els 4 Gats'. Barcelona, 1899–1900.
Pen on paper. 32.2 × 22.7 cm. (MAB 110.822, R)

698. Sketches for the menu of 'Els 4 Gats'. Barcelona, 1899–1900.
Pen and coloured pencil. 32 × 22.4 cm. (MAB 110.823, A)

699. Sketches for the menu of 'Els 4 Gats'. Barcelona, 1899–1900.
Pen on paper. 32.2 × 22.5 cm. (MAB 110.818, A)

700. Sketches for the menu of 'Els 4 Gats'. Barcelona, 1899–1900.
Pen on paper. 32 × 22 cm. (MAB 110.819, A)

701. Rough sketches at 'Els 4 Gats'. Barcelona, 1899–1900.
Pen on paper. 32 × 22 cm. (MAB 110.819, R)

702. Bullfighters in the plaza. Malaga, c. 1900.
Pen on paper. 11.6 × 17.5 cm. (MAB 110.251, A)

703. Rough sketches at 'Els 4 Gats'. Barcelona, 1899–1900.
Pen on paper. 32.2 × 22.5 cm. (MAB 110.818, R)

704. Bullfighter, nude, and other sketches. Malaga?, c. 1900.
Pen on paper. 11.6 × 17.5 cm. (MAB 110.251, R)

705. Rough sketches of bulls and bullfighters. Barcelona, 1899–1900.
Pen on paper. 20.7 × 12.9 cm. (MAB 110.298, A)

706. Frieze of bullfighters. Barcelona or Malaga, 1899–1900.
Pen on paper. 15.9 × 21.8 cm. (MAB 110.312)

707. A picador. Malaga or Barcelona, 1899–1901.
Conté crayon on paper. 21 × 15.5 cm. (MAB 110.404, A)

708. Bullfight sketches. Barcelona or Malaga, 1899–1901.
Pen on ruled paper. 20.7 × 13.3 cm. (MAB 110.412)

709. Bullfight scene and other sketches. Barcelona or Malaga, 1899–1901.
Pen on paper. 13.6 × 20.9 cm. (MAB 110.256, R)

710. Various sketches of a picador and others. Malaga or Barcelona, 1899–1901.
Conté crayon and pen on paper. 21 × 13.6 cm. (MAB 110.289, A)

711. Bullfight scene. Barcelona or Malaga, 1899–1901.
Pen on paper. 13.6 × 20.9 cm. (MAB 110.256, A)

712. Silhouette of a bullfighter. Barcelona, 1899–1900.
Xylography on paper. 20.6 × 13.6 cm. (MAB 110.292)

713. Sketches of bullfighters. Barcelona, 1899–1900.
Pen and blue pencil on paper. 23.3 × 17.3 cm. (MAB 110.326, R)

714. Head and shoulders of a man and other sketches. Barcelona, 1899–1900.
Conté crayon on paper. 15.7 × 22 cm. (MAB 110.396, R)

715. Head of a bearded man and other sketches. Barcelona, 1899–1900.
Pen and Conté crayon on paper. 33.5 × 22.8 cm. (MAB 110.687, R)

716. El Greco figure. Barcelona, 1899–1900.
Conté crayon and watercolour on paper. 21.8 × 15.5 cm. (MAB 110.316, R)

717. El Greco head among other sketches. Barcelona, 1899–1900.
Conté crayon and pen on paper. 31 × 23.8 cm. (MAB 110.571, A)

718. Head of an El Greco figure. Barcelona, 1899–1900.
Conté crayon and coloured pencil on paper. 30.6 × 22 cm. (MAB 110.671, R)

719. Sketch of an El Greco figure and heads. Barcelona, 1899–1900.
Conté crayon and coloured pencil on paper. 30.6 × 22 cm. (MAB 110.671, A)

720. Sketch of an El Greco head and others. Barcelona, 1899–1900.
Pen on paper. 31.5 × 21.8 cm. (MAB 110.675)

721. Sketch of the artist's parents, El Greco heads and others. Barcelona, 1899–1900.
Conté crayon on paper. 23.3 × 33.7 cm. (MAB 110.812, R)

722. El Greco heads among other sketches. Barcelona, 1899–1900.
Pen on paper. 17.5 × 12.6 cm. (MAB 110.280, A)

723. Various sketches (portrait of Rusiñol, etc). Barcelona, 1899–1900.
Pen on paper. 23 × 33.3 cm. (MAB 110.683, A)

724. Sketch of an El Greco head and others. Barcelona, 1899–1900.
Conté crayon on paper. 31 × 23.8 cm. (MAB 110.571, R)

725. Two sketches of El Greco heads. Barcelona, 1899–1900.
Pencil on paper. 22 × 16.4 cm. (MAB 110.729, A)

726. Heads of El Greco figures and other sketches. Barcelona, 1899–1900.
Conté crayon on paper. 21.4 × 31.5 cm. (MAB 110.659)

727. Portrait of Hermen Anglada Camarasa. Barcelona, 1899–1900.
Pen and watercolour on paper. 10.7 × 9.6 cm. (MAB 110.434)

728. Rough sketch of Anglada Camarasa and others. Barcelona, 1899–1900.
Pen on paper. 13.5 × 9.3 cm. (MAB 110.263, A)

729. Portrait of Santiago Rusiñol and other sketches. Barcelona, 1899–1900.
Pen on paper. 32.2 × 22 cm. (MAB 110.688, A)

730. 'Pere Romeu. Montesion. Barna' and other sketches. Barcelona, 1899–1900.
Pen on paper. 17.5 × 17.1 cm. (MAB 110.488)

731. Portrait of Santiago Rusiñol. Barcelona, 1899–1900.
Pen on paper. 11.2 × 12 cm. (MAB 110.266, A)

732. Caricature of Joaquin Mir. Barcelona, 1899–1900.
Pen on paper. 21.8 × 31.6 cm. (MAB 110.365)

733. 'A Paris'. Picasso and Pallarés. Barcelona, c. 1900.
Pen on paper. 8.8 × 11.1 cm. (MAB 110.996, A)

734. 'The decadents'. Barcelona, 1899–1900.
Pen on paper. 20.6 × 12.7 cm. (MAB 110.297, A)

735. Caricature of Picasso and Pallarés. Barcelona, c. 1900.
Pen on paper. 13.3 × 21 cm. (MAB 110.414, A)

736. Unidentified portrait. Barcelona, 1899–1900.
Conté crayon on paper. 15.9 × 22.1 cm. (MAB 110.313, A)

737. Portrait of Evelio Torent. Barcelona, 1899–1900.
Charcoal and Conté crayon on paper. 47.5 × 31.4 cm. (MAB 110.855)

738. Portrait and caricature. Barcelona, 1899–1900.
Conté crayon on paper. 17.2 × 22.8 cm. (MAB 110.742, R)

739. Rough sketch of Zola. Barcelona or Paris, 1900.
Green pencil on grey paper. 14 × 8.8 cm. (MAB 110.441)

740. Portrait of Pompeyo Gener. Barcelona, 1899–1900.
Ink and watercolour on paper. 8.4 × 7.8 cm. (MAB 110.240, A)

741. Rough sketches of Oriol Martí and others. Barcelona, 1899–1900.
Pen on paper. 20.6 × 15.2 cm. (MAB 110.623, A)

742. Rough sketches of Oriol Martí. Barcelona, 1899–1900.
Pen and watercolour on paper. 23 × 17 cm. (MAB 110.636, A)

743. Drawings and caricatures. Barcelona, 1899–1900.
Pen on paper. 31.5 × 26.5 cm. (MAB 110.899, A)

744. Rough sketch of Torent. Barcelona, 1899–1900.
Pen on paper. 20.5 × 10 cm. (MAB 110.421, A)

745. El Greco portrait and others. Barcelona, 1899–1900.
Conté crayon on paper. 24 × 16 cm. (MAB 110.641, A)

746. Caricature of Joaquin Mir (detail). Barcelona, 1899–1900.
Pen on paper. 17.5 × 12.6 cm. (MAB 110.280, R)

747. Rough sketches for portraits. Barcelona, 1899–1900.
Pen on paper. 21.1 × 11.7 cm. (MAB 110.284, A)

748. Rough sketch for a portrait. Barcelona, 1899–1900.
Conté crayon and watercolour on paper. 21.8 × 15.5 cm. (MAB 110.316, A)

749. Rough sketch for a portrait and various sketches. Barcelona, 1899–1900.
Pen on paper. 32 × 21.8 cm. (MAB 110.633, R)

750. Sketch for a carnival poster. Barcelona, 1900.
Conté crayon on paper. 48 × 30.5 cm. (MAB 110.591, R)

751. Sketch for a carnival poster. Barcelona, 1900.
Pen on paper. 21 × 13.5 cm. (MAB 110.710, A)

752. Caricature. Barcelona, 1899–1900.
Conté crayon on paper. 13.7 × 10.2 cm. (MAB 110.267)

753. The kiss and other sketches. Barcelona, 1899–1900.
Conté crayon on paper. 43.7 × 31 cm. (MAB 110.804)

754. The kiss (b). Barcelona, 1899.
Conté crayon on paper. 23 × 16.7 cm. (MAB 110.735, A)

755. The kiss. Barcelona, 1900.
Pencil on paper 22.4 × 16.5 cm. (MAB 110.724, A)

756. Manola. Barcelona, 1899–1900.
Conté crayon on paper. 24.4 × 16.2 cm. (MAB 110.737, A)

757. Seated couple. Barcelona, 1899–1900.
Conté crayon on paper. 10.8 × 13.3 cm. (MAB 110.703, A)

758. Half-caricatured scene. Barcelona, 1899–1900.
Conté crayon on paper. 23.5 × 34 cm. (MAB 110.781, R)

759. Seated couple and other sketches. Barcelona, 1899–1900.
Conté crayon on paper. 16.6 × 24.8 cm. (MAB 110.748, A)

760. Caricatures and intricate design. Barcelona, c. 1899.
Conté crayon on paper. 32.1 × 24.6 cm. (MAB 110.792, R)

761. Various sketches. Barcelona, 1899–1900.
Pen on paper. 21.5 × 11.7 cm. (MAB 110.305, R)

762. Various sketches. Barcelona, 1899–1900.
Pen on paper. 23 × 21.9 cm. (MAB 110.337, A)

763. Spanish scene and other sketches. Barcelona, 1899–1900.
Conté crayon and pen on paper. 31.2 × 23.5 cm. (MAB 110.529, R)

764. Various sketches. Barcelona, 1899–1900.
Pen on paper. 28.2 × 22 cm. (MAB 110.674, A)

765. Various sketches. Barcelona, 1899–1900.
Pen on paper. 43.5 × 31.5 cm. (MAB 110.657, A)

766. Various sketches. Barcelona, 1899–1900.
Pen on paper. 11.1 × 16 cm. (MAB 110.720, R)

767. Sketch of a flute-player and other sketches. Barcelona, 1899–1900.
Pen on paper. 43.5 × 31.5 cm. (MAB 110.657, R)

768. Various sketches. Barcelona, *c.* 1900.
Pen on paper. 32 × 22 cm. (MAB 110.669, R)

769. Various sketches. Barcelona, 1899–1900.
Pen on paper. 23.4 × 20.3 cm. (MAB 110.386, A)

770. Various sketches. Barcelona, 1899–1900.
Pen on paper. 20.7 × 14 cm. (MAB 110.299, A)

771. Self-portraits and other sketches. Barcelona, 1899–1900.
Pen on paper. 22.2 × 32.3 cm. (MAB 110.816, A)

772. Sketches and caricatures. Barcelona, 1899–1900.
Pen on paper. 31.5 × 21.9 cm. (MAB 110.760, R)

773. Various sketches. Barcelona, 1899–1900.
Pen on paper. 32 × 22 cm. (MAB 110.358, R)

774. Various sketches, 1899–1900.
Pen on paper. 16.5 × 22.4 cm. (MAB 110.397)

775. Sketches and caricatures. Barcelona, 1899–1900.
Pen on paper. 13.5 × 21 cm. (MAB 110.302, A)

776. Various sketches. Barcelona, 1899–1900.
Conté crayon on paper. 32.2 × 22.2 cm. (MAB 110.658, A)

777. Various sketches. Barcelona, 1899–1900.
Pen on paper. 21.2 × 13.4 cm. (MAB 110.616, R)

778. Various sketches. Barcelona, 1899–1900.
Pen on paper. 12 × 18 cm. (MAB 110.277. A)

779. Sketches and caricatures. Barcelona, 1899–1900.
Pen on paper. 20.6 × 12.7 cm. (MAB 110.295)

780. Caricature sketches. Barcelona, 1899–1900.
Conté crayon and watercolour on paper. 33.9 · 23 cm. (MAB 110.692, A)

781. Caricature sketches. Barcelona, 1899–1900.
Pen and Conté crayon on paper. 23.4 · 33.8 cm. (MAB 110.350, A)

782. Three figures. Barcelona, 1899–1900.
Pen on paper. 23 × 17 cm. (MAB 110.637, A)

783. The Fernandez de Soto brothers in 'Els 4 Gats'. Barcelona, 1899–1900.
Pen on paper. 21 × 13.5 cm. (MAB 110.612, A)

784. Bust of a woman. Barcelona, 1899–1900.
Conté crayon on paper. 24.3 × 15.5 cm. (MAB 110.560, A)

785. Various sketches. Barcelona, 1899–1900.
Conté crayon and pen on paper. 33.6 · 15.2 cm. (MAB 110.680, R)

786. Studies of heads. Barcelona, 1899–1900.
Conté crayon on paper. 22.1 · 16.4 cm. (MAB 110.320, A)

787. Sketches of heads and a hand. Barcelona, 1899–1900.
Charcoal and Conté crayon on paper. 31.7 × 21.8 cm. (MAB 110.566, A)

788. Sketches and caricatures. Barcelona, 1899–1900.
Conté crayon on paper. 21.8 × 31.6 cm. (MAB 110.369, A)

789. Various sketches. Barcelona, 1899–1900.
Conté crayon on paper. 13.3 × 20.9 cm. (MAB 110.285, R)

790. Caricatures of heads. Barcelona, 1899–1900.
Conté crayon on paper. 21.8 × 31.6 cm. (MAB 110.369, R)

791. Sketches and caricatures. Barcelona, 1899–1900.
Conté crayon on paper. 15.9 × 22.2 cm. (MAB 110.395, R)

792. An old man and other sketches. Barcelona, 1899–1900.
Pen and pencil on paper. 17.3 × 12.8 cm. (MAB 110.275, R)

793. Seated woman reading and other sketches. Barcelona, 1899–1900.
Conté crayon on paper. 33.8 × 23.3 cm. (MAB 110.691, A)

794. Roughly-sketched heads. Barcelona?, *c.* 1899.
Conté crayon on paper. 16.5 × 14.7 cm. (MAB 110.792, R)

795. Nude and other sketches. Barcelona, 1899–1900.
Conté crayon on paper. 31.6 × 22 cm. (MAB 110.570, A)

796. Various sketches. Barcelona, 1899–1900.
Pen, Conté crayon and coloured pencil on paper. 22 · 31.8 cm. (MAB 110.622, A)

797. Various sketches. Barcelona, 1899–1900.
Pen on paper. 23.4 × 20.3 cm. (MAB 110.386, R)

798. Seated figures. Barcelona, 1899–1900.
Conté crayon on paper. 21.3 × 30.4 cm. (MAB 110.371, R)

799. Pierrots and other sketches. Barcelona, 1899–1900.
Conté crayon on paper. 23.5 · 33.8 cm. (MAB 110.685, R)

800. Various sketches. Barcelona, 1899–1900.
Conté crayon on paper. 32.5 × 24.6 cm. (MAB 110.349, A)

801. Masculine figure and other sketches. Barcelona, 1899–1900.
Pen on paper. 21 × 27.9 cm. (MAB 110.651, A)

802. Various sketches. Barcelona, 1899–1900.
Pen and pencil and Conté crayon on paper. 33.5 × 22.8 cm. (MAB 110.687, A)

803. Sketches and caricatures. Barcelona, 1899–1900.
Pen on paper. 17.6 × 13.1 cm. (MAB 110.417, A)

804. Female figure and various sketches. Barcelona, 1899–1900.
Conté crayon on paper. 22.3 × 32 cm. (MAB 110.821, R)

805. Various sketches. Barcelona, 1899–1900.
Conté crayon and pen on paper. 40.2 × 32.1 cm. (MAB 110.590, R)

806. Sketches and caricatures. Barcelona, 1899–1900.
Pen on paper. 13.5 × 20.9 cm. (MAB 110.257, A)

807. Sketches and caricatures. Barcelona, 1899–1900.
Pen on paper. 20.2 · 16.2 cm. (MAB 110.557, R)

808. Caricature sketches. Barcelona, 1899–1900.
Conté crayon on paper. 16 · 20 cm. (MAB 110.309, A)

809. Caricatures. Barcelona, 1899–1900.
Conté crayon on paper. 23.1 · 33.8 cm. (MAB 110.354, A)

810. Two people talking and other sketches. Barcelona, 1899–1900.
Conté crayon on paper. 22.5 × 31.6 cm. (MAB 110.770, A)

811. Men walking and other sketches. Barcelona, 1899–1900.
Pen and Conté crayon on paper. 23.7 × 33.5 cm. (MAB 110.351. A)

812. Various sketches. Barcelona, 1899–1900.
Conté crayon on paper. 22.5 × 31.6 cm. (MAB 110.770, R)

813. Two figures and other sketches. Barcelona, 1899–1900.
Conté crayon on paper. 13.3 × 20.9 cm. (MAB 110.285, A)

814. Standing figure and other sketches. Barcelona, 1899–1900.
Pen and Conté crayon on paper. 21.8 ⁄ 25.6 cm. (MAB 110.826, A)

815. Various sketches. Barcelona, 1899–1900.
Conté crayon on paper. 34 × 23.4 cm. (MAB 110.777, A)

816. Various sketches. Barcelona, 1899–1900.
Conté crayon on paper. 33.8 × 23.3 cm. (MAB 110.691, R)

817. Rider and horse and another figure. Barcelona?, *c.* 1899.
Conté crayon on paper. 23.3 × 33.7 cm. (MAB 110.812, A)

818. Rider and horse and other sketches. Barcelona?, *c.* 1899.
Pen and Conté crayon on paper. 21.6 × 16 cm. (MAB 110.834, R)

819. Horseman 'ART'. Barcelona?, *c.* 1899.
Conté crayon and watercolour. 33.9 × 23.5 cm. (MAB 110.806, A)

820. Caricature of the Boer War. Barcelona, *c.* 1900.
Pen on paper. 29.3 × 22 cm. (MAB 110.338, A)

821. Various sketches and caricatures of Boers. Barcelona, *c.* 1900.
Pen on paper. 22 × 16 cm. (MAB 110.399, A)

822. Caricature. Barcelona, 1899–1900.
Conté crayon on paper. 33.8 × 23.2 cm. (MAB 110.788, A.)

823. Various sketches. Barcelona, 1899–1900.
Conté crayon on paper. 33.6 × 21.5 cm. (MAB 110.583, R)

824. Caricature of a violinist. Barcelona, 1899–1900.
Conté crayon on paper. 22.9 × 16.9 cm. (MAB 110.325, A)

825. 'Un sabio'. Barcelona, 1899–1900.
Conté crayon on paper. 22.9 × 16.7 cm. (MAB 110.324, A)

826. Caricature of a critic. Barcelona, 1899–1900.
Conté crayon on paper. 29.5 × 23.5 cm. (MAB 110.339, A)

827. Caricatures. Barcelona, 1899–1900.
Conté crayon on paper. 23.2 × 33.8 cm. (MAB 110.783, R)

828. Two figures and other sketches. Barcelona, c. 1899.
Conté crayon on paper. 23.8 × 15.3 cm. (MAB 110.736, R)

829. Woman and other sketches. Barcelona?, c. 1899.
Conté crayon on paper. 22.4 × 16.7 cm. (MAB 110.727, R)

830. Head of a woman. Barcelona?, c. 1899.
Conté crayon on paper. 22.2 × 16.3 cm. (MAB 110.725, R)

831. Various sketches. Barcelona, 1899–1900.
Conté crayon on paper. 23.5 × 34 cm. (MAB 110.811, R)

832. Three rough sketches. Barcelona, 1899–1900.
Conté crayon on paper. 11.4 × 19.4 cm. (MAB 110.283)

833. Mateo Fernandez de Soto? Barcelona, 1899–1900.
Conté crayon on paper. 30 × 21 cm. (MAB 110.565, A)

834. Various sketches. Barcelona?, c. 1899.
Conté crayon on paper. 46.8 × 30.5 cm. (MAB 110.801, A)

835. Two inverted figures. Barcelona, 1899–1900.
Conté crayon on paper with a green varnished background. 22.1 × 16.4 cm.
(MAB 110.320, A)

836. Gentleman and others. Barcelona, 1899–1900.
Pen and pencil on paper. 20.6 × 12.7 cm. (MAB 110.297, R)

837. Sketch of a couple. Barcelona, 1899–1900.
Pencil on ruled paper. 30.8 × 21.6 cm. (MAB 110.827, A)

838. Sketch of a woman and others. Barcelona, 1899–1900.
Pen on paper. 31.5 × 22 cm. (MAB 110.672, R)

839. Bust of a woman and various sketches. Barcelona, 1899–1900.
Pen on squared. 13.5 × 21.3 cm. (MAB 110.304)

840. Caricatures. Barcelona, 1899–1900.
Pen on paper. 20.6 × 13.7 cm. (MAB 110.254, A)

841. Sketches and caricatures. Barcelona, 1899–1900.
Pen on paper. 21.8 × 31.4 cm. (MAB 110.367, A)

842. Sketches and caricatures. Barcelona, 1899–1900.
Pen on paper. 13.5 × 20.9 cm. (MAB 110.257, R)

843. Four figures. Barcelona, 1899–1900.
Pen on paper. 13.6 × 21 cm. (MAB 110.715, R)

844. Various sketches. Barcelona, 1899–1900.
Pen on paper. 22.3 × 32.2 cm. (MAB 110.656, A)

845. The jeweller Vallmitjana and other sketches. Barcelona, 1899–1900.
Pen on paper. 21.5 × 11.7 cm. (MAB 110.305, A)

846. Various sketches. Barcelona, 1899–1900.
Pen on paper. 11.1 × 16 cm. (MAB 110.720, A)

847. Various figures. Barcelona, 1899–1900.
Pen on paper. 21 × 13.3 cm. (MAB 110.618)

848. Sketches and caricatures. Barcelona, 1899–1900.
Pen on paper. 13.5 × 21 cm (MAB 110.302, R)

849. Various sketches. Barcelona, 1899–1900.
Pen and red pencil on paper. 21.8 × 16 cm. (MAB 110.319, A)

850. Various sketches. Barcelona, 1899–1900.
Pen on paper. 21 × 13.5 cm. (MAB 110.612, R)

851. Groups of figures. Barcelona, 1899–1900.
Pen on paper. 31.5 × 21.9 cm. (MAB 110.760, A)

852. A lion-tamer(?) and other figures. Barcelona, 1899–1900.
Pen on paper. 20 × 21.8 cm. (MAB 110.751, R)

853. Various sketches. Barcelona, 1899–1900.
Conté crayon on paper. 20.8 × 15.5 cm. (MAB 110.403, R)

854. Various sketches. Barcelona, 1899–1900.
Conté crayon and pen on paper. 21 × 13.6 cm. (MAB 110.289, R)

855. Woman in front of a mirror (trimmed). Barcelona, 1899–1900.
Pen on paper. 13.8 × 21 cm. (MAB 110.416, R)

856. Lola, the artist's sister, and the artist's hand. Barcelona, 1899–1900.
Pen on paper. 21 × 13.5 cm. (MAB 110.617)

857. Three drawings showing a girl's head and hens. Barcelona, 1899–1900.
Pen and coloured pencil on paper. 25.8 × 13.3 cm. together. (MAB 110.329, R)

858. Woman's head and other sketches. Barcelona, 1899–1900.
Pen and Conté crayon on paper. 48 × 43 cm. (MAB 110.897, R)

859. Masculine figure and other sketches. Barcelona, 1899–1900.
Pen on paper. 23.1 × 9 cm. (MAB 110.323, A)

860. Elegant woman. Barcelona?, c. 1899.
Conté crayon on paper. 22.1 × 16.8 cm. (MAB 110.721, A)

861. Village type and other sketches. Barcelona, 1899–1900.
Pen on paper. 20.5 × 12.9 cm. (MAB 110.294, A)

862. Village type and other sketches. Barcelona, 1899–1900.
Pen on paper. 12.9 × 15.8 cm. (MAB 110.707, R)

863. The salutation. Barcelona, 1899–1900.
Pen on paper. 22.3 × 9 cm. (MAB 110.244)

864. A salutation and other sketches. Barcelona, 1899–1900.
Pen on paper. 20 × 13.5 cm. (MAB 110.253, A)

865. At the sick bed. Barcelona, 1899–1900.
Pen on paper. 20.9 × 13.5 cm. (MAB 110.611)

866. Head of a woman and other sketches. Barcelona, 1899–1900.
Pen on paper. 31.5 × 26.5 cm. (MAB 110.899, R)

867. The fall. Barcelona, 1899–1900.
Conté crayon and watercolour on paper. 20 × 16 cm. (MAB 110.310, A)

868. Rough sketches of heads. Barcelona, 1899–1900.
Pen on paper. 20.8 × 13.1 cm. (MAB 110.300, R)

869. Nude and rough sketches of heads. Barcelona, c. 1900.
Pen on paper. 46.9 × 30.9 cm. (MAB 110.341, A)

870. Sketches of two women. Barcelona, c. 1899.
Conté crayon on paper. 24.5 × 16.4 cm. (MAB 110.741, R)

871. Head of a girl. Barcelona, c. 1900.
Conté crayon on paper. 48.5 × 32 cm. (MAB 110.845, R)

872. Various sketches. Barcelona?, c. 1899.
Conté crayon on paper. 32.2 × 22.2 cm. (MAB 110.757, A)

873. Two men reading. Barcelona, c. 1900.
Conté crayon on paper. 33.7 × 36.3 cm. (MAB 110.696, R)

874. Pierrots and other sketches. Barcelona, c. 1900.
Pen on paper. 13.5 × 21 cm. (MAB 110.710, R)

875. Self-portrait. Barcelona, 1899–1900.
Pen on paper. 31 × 24.7 cm. (MAB 110.665, R)

876. Caricature of a painter and a sketched portrait. Barcelona, 1899–1900.
Pen on paper. 13.7 × 13.5 cm. (MAB 110.269)

877. Child and sketch of Oriol Martí. Barcelona, 1899–1900.
Conté crayon on paper. 23 × 17 cm. (MAB 110.636, R)

878. Two peasant women. Barcelona, 1899–1900.
Conté coloured crayon. 35.8 × 27.1 cm. (MAB 110.805)

879. Head and shoulders of a dancer. Barcelona, 1899–1900.
Conté crayon on paper. 29.7 × 44.4 cm. (MAB 110.795)

880. Figure of an elegant woman and other sketches. Barcelona, 1899–1900.
Conté crayon on paper. 33.5 × 23.5 cm. (MAB 110.587, A)

881. Lady in a cape and other sketches. Barcelona, 1899–1900.
Pen and Conté crayon on paper. 17.3 × 12.8 cm. (MAB 110.275, A)

882. Sketch of the bust of a woman (trimmed). Barcelona, 1899–1900.
Conté crayon on paper. 20.3 × 15.2 cm. (MAB 110.237, R)

883. Street scene. Barcelona, c. 1900.
Charcoal and Conté crayon on paper. 16.2 × 23.4 cm. (MAB 110.628, A)

884. Sketch of a woman. Album 17. Paris, 1900?
Watercolour and pastel on paper. 10.5 × 6 cm. (MAB 110.910)

885. Head of a woman and other sketches. Barcelona, 1899–1900.
Conté crayon, pen and coloured pencils. 21.8 × 16 cm. (MAB 110.318, A)

886. Sketch of a head. Barcelona, c. 1900.
Green pencil, Conté crayon and chalk. 20.8 × 20.2 cm. (MAB 110.334, A)

887. Heads and other sketches. Barcelona, c. 1900.
Conté crayon on paper. 19.3 × 11.5 cm. (MAB 110.282, R)

888. Sketch of a head (trimmed). Barcelona, *c.* 1900.
Pencil on paper. 14.6 × 22.8 cm. (MAB 110.559, R)

889. Figure of a woman. Barcelona, *c.* 1900.
Conté crayon on paper. 24.6 × 16.8 cm. (MAB 110.328, R)

890. Figure of a woman. Barcelona, *c.* 1900.
Conté crayon on paper. 33.6 × 21.5 cm. (MAB 110.582, A)

891. Figure of a woman. Barcelona, *c.* 1900.
Conté crayon on paper. 33.7 × 17.5 cm. (MAB 110.581, A)

892. Figures of a woman and a man. Barcelona, *c.* 1900.
Conté crayon and crayon on ruled paper. 31.7 × 22.2 cm. (MAB 110.815, A)

893. Two elegant women. Barcelona, *c.* 1900.
Pen on paper. 24 × 15.4 cm. (MAB 110.640, R)

894. Rough sketch of an elegant woman. Barcelona, *c.* 1900.
Conté crayon on paper. 21.9 × 16 cm. (MAB 110.832, R)

895. Various sketches. Barcelona, 1899–1900.
Conté crayon on paper. 31.6 × 22 cm. (MAB 110.570, R)

896. Seated man. Barcelona, *c.* 1900.
Pen on paper. 23 × 17 cm. (MAB 110.637, R)

897. Six sketches of heads and a figure. Barcelona, *c.* 1900.
Pen, coloured pencil and Conté crayon on paper. 31.6 × 33.5 cm. (MAB 110.695, A)

898. Elegant woman. Barcelona, *c.* 1900.
Pen and coloured pencils on paper. 21.2 × 13.4 cm. (MAB 110.616, A)

899. Nude woman from behind. Barcelona, *c.* 1900.
Pen on paper. 19.6 × 11.8 cm. (MAB 110.420, A)

900. Sketches of three nudes. Barcelona, *c.* 1900.
Pen on paper. 20.6 × 12.6 cm. (MAB 110.296, A)

901. Nude in front of a mirror. Barcelona, *c.* 1900.
Conté crayon on paper. 22.2 × 16 cm. (MAB 110.833, R)

902. A passionate embrace and other sketches. Barcelona, *c.* 1900.
Pen on paper. 20.6 × 12.6 cm. (MAB 110.296, R)

903. Passionate embrace. Barcelona or Paris, *c.* 1900.
Conté crayon on paper. 32 × 22.2 cm. (MAB 110.342, R)

904. Saucy scene and other drawings. Barcelona, *c.* 1900.
Pen on paper. 13.3 × 20.8 cm. (MAB 110.258, R)

905. Two figures. Barcelona, *c.* 1900.
Conté crayon on paper. 31.2 × 16.2 cm. (MAB 110. 564, A)

906. Woman and female bust. Barcelona?, *c.* 1900.
Conté crayon and watercolour on paper. 35.3 × 12.6 cm. (MAB 110.794, A)

907. Indeterminate profile. Barcelona or Paris, 1901–1.
Conté crayon. 16.7 × 11.1 cm. (MAB 110.458, A)

908. Boats and other sketches. Barcelona or Paris, 1900–1.
Conté crayon on paper. 22 × 31.6 cm. (MAB 110.769, R)

909. Mlle. Bresina. Barcelona or Paris, 1900–1.
Conté crayon on paper. 32.5 × 25 cm. (MAB 110.544, A)

910. Sketch of Mlle. Bresina. Barcelona or Paris, 1900–1.
Conté crayon on paper. 16 × 11.3 cm. (MAB 110.454)

911. Free sketches. Album 17. Paris?, 1900.
Conté crayon on paper. 10.5 × 6 cm. (MAB 110.910)

912. Sketch of dancer. Barcelona or Paris, 1900–1.
Pen on paper. 16 × 11.1 cm. (MAB 110.452, R)

913. Head and shoulders of a woman. Barcelona or Paris, 1901.
Pen on paper. 15.9 × 11.1 cm. (MAB 110.451)

914. Head and shoulders of two women. Paris or Barcelona, 1901–2.
Pen on paper. 11.1 × 16.1 cm. (MAB 110.449)

915. 'El Liberal'. Barcelona, 1900–2.
Conté crayon on paper. 33.7 × 36.3 cm. (MAB 110.696, A)

916. An Amazon (b). Barcelona or Paris, *c.* 1901.
Pencil on paper. 33.8 × 23.1 cm. (MAB 110.538)

917. Female profile and a nude sketch. Barcelona or Paris, 1903.
Pen on paper. 17.3 × 16.8 cm. (MAB 110.487)

918. Study of a head. Barcelona or Paris, 1902.
Conté crayon on paper. 31.2 × 24.3 cm. (MAB 110.530)

919. Head of a boy. Barcelona or Paris, 1902.
Pen on paper. 28.5 × 36 cm. (MAB 110.545, R)

920. A boat. Barcelona or Paris, *c.* 1901.
Conté crayon on paper. 22 × 31.6 cm. (MAB 110.769, A)

921. A woman from behind. Barcelona or Paris, 1901–2.
Pen on paper. 13.5 × 12 cm. (MAB 110.445)

922. Figure with a cloak. Barcelona or Paris, 1901–2.
Pen on paper. 16 × 11 cm. (MAB 110.450)

923. Head and shoulders of a woman. Barcelona or Paris, 1900–1.
Pen and blue pencil on paper. 16.7 × 11 cm. (MAB 110.460)

924. Profile of a woman. Barcelona or Paris, 1901–2.
Pen on paper. 16.8 × 22 cm. (MAB 110.456, A)

925. Female figure. Barcelona or Paris, 1901–2.
Pen on paper. 16.7 × 11 cm. (MAB 110.459)

926. Hunched figure. Paris or Barcelona, 1902.
Pen on paper. 16.2 × 7.7 cm. (MAB 110.448)

927. A woman from behind. Barcelona or Paris, 1901–2.
Pencil on paper. 16.7 × 22.5 cm. (MAB 110.457, A)

928. Portrait of Julio Gonzalez and a figure from behind. Barcelona or Paris, 1900–2.
Pen on paper. 16.7 × 22.1 cm. (MAB 110.479)

929. A woman and child from behind. Barcelona or Paris, 1901–2.
Pen on paper. 16.8 × 22 cm. (MAB 110.456, R)

930. Two studies of heads. Barcelona or Paris, 1901–2.
Conté crayon on paper. 16.7 × 22.4 cm. (MAB 110.489, A)

931. Woman from behind. Barcelona or Paris, 1901–2.
Pen on paper. 41.3 × 15.5 cm. (MAB 110.548, R)

932. Self-portrait. Barcelona or Paris, *c.* 1902.
Pen and violet ink on paper. 32.5 × 19 cm. (MAB 110.901)

933. Fontbona and other sketches. Barcelona or Paris, 1902.
Pen on paper. 22.9 × 31.4 cm. (MAB 110.532, A)

934. A stove. Barcelona or Paris, *c.* 1902.
Pen on paper. 11.7 × 7.6 cm. (MAB 110.906)

935. 'Hunger'. Barcelona or Paris, *c.* 1902.
Pen on paper. 13.5 × 21.1 cm. (MAB 110.472)

936. Figure of a woman and other sketches. Barcelona or Paris, *c.* 1902.
Pen and Conté crayon on paper. 32 × 22.5 cm. (MAB 110.526)

937. Eros and a bird. Barcelona or Paris, *c.* 1902.
Ink and watercolour on paper. 20.8 × 26.9 cm. (MAB 110.514)

938. Group of people. Barcelona or Paris, *c.* 1902.
Conté crayon on paper. 24.5 × 16 cm. (MAB 110.491, A)

939. Woman and children. Barcelona or Paris, 1903.
Conté crayon on paper. 30.8 × 23 cm (MAB 110.528, A)

940. Man and child. Barcelona or Paris, 1902.
Conté crayon on paper. 17.4 × 13.3 cm. (MAB 110.462)

941. Man loading a sack. Barcelona or Paris, *c.* 1902.
Pencil on paper. 12.9 × 10.4 cm. (MAB 110.439)

942. Profile of a man's head. Barcelona or Paris, *c.* 1902.
Charcoal on paper. 24 × 15.9 cm. (MAB 110.490)

943. Male nude. Barcelona or Paris, *c.* 1902.
Pen and watercolour on paper. 26 × 20 cm. (MAB 110.503)

944. Figures on a dockside. Barcelona or Paris, 1902–3.
Pen on paper. 22 × 15.4 cm. (MAB 110.481)

945. Imploring women and children. Barcelona or Paris, 1902.
Pen on paper. 26 × 20.5 cm. (MAB 110.519)

946. A boat. Barcelona or Paris, 1902–3.
Pen on paper. 15.8 × 23.6 cm. (MAB 110.493)

947. Scene at a harbour. Barcelona or Paris, 1902–3.
Pen on paper. 12.6 × 14.5 cm. (MAB 110.447)

948. Imploring woman and other sketches. Barcelona or Paris, 1902–3.
Pen on paper. 26 × 20 cm. (MAB 110.504)

949. Entreating woman, other sketches and writings. Paris or Barcelona, *c.* 1902.
Pen on paper. 20.4 × 9.7 cm. (MAB 110.471)

950. Imploring figure. Paris or Barcelona, *c.* 1902.
Pen on paper. 17.6 × 11.3 cm. (MAB 110.463)

951. Two women. Barcelona or Paris, 1902.
Pencil on paper. 25.3 × 26 cm. (MAB 110.543).

952. Study of a nude and writings. Paris or Barcelona, 1903.
Pencil and ink on paper. 27.5 × 20.4 cm. (MAB 110.520)

953. Shepherds. Paris or Barcelona, 1903.
Pen on paper. 13.5 × 21.1 cm. (MAB 110.473)

954. Figure, head, guitar and writings. Paris or Barcelona, 1902–3.
Pen and blue pencil on paper. 31.5 × 22.1 cm. (MAB 110.525)

955. Two figures. Barcelona or Paris, 1902–3.
Pen on paper. 28.5 × 36 cm. (MAB 110.545, A)

956. Two begging women. Barcelona or Paris, 1902.
Pen on paper. 19.5 × 17.3 cm. (MAB 110.497)

957. Three figures. Barcelona or Paris, 1902–3.
Pen on paper. 14.6 × 18.1 cm. (MAB 110.468)

958. The confidence and other sketches. Paris or Barcelona, 1903.
Pen on paper. 21.9 × 16 cm. (MAB 110.482)

959. Female nudes. Barcelona or Paris, 1902–3.
Pen on squared paper. 20.9 × 14 cm. (MAB 110.474)

960. Allegorical sketch. Barcelona, V-1902.
Pencil on paper. 28 × 22.5 cm. (MAB 110.523)

961. Allegorical sketch and a head. Barcelona, V-1902.
Pencil on paper. 28 × 22.8 cm. (MAB 110.522, A)

962. Nude couple. Barcelona, 1903.
Pen on paper. 33.8 × 23.2 cm. (MAB 110.536)

963. Study of a nude. Barcelona, VI-1903.
Pen on paper. 33.8 × 23.2 cm. (MAB 110.541)

964. Sketches of nude figures. Barcelona?, *c.* 1903.
Pen on squared paper. 17 × 22.5 cm. (MAB 110.495)

965. Reclining nude. Paris or Barcelona, *c.* 1903.
Pencil on paper. 29.5 × 21 cm. (MAB 110.516)

966. Studies of nudes. Barcelona or Paris, 1902–3.
Pen on squared paper. 16.8 × 22.7 cm. (MAB 110.509)

967. Reclining nude. Barcelona or Paris, *c.* 1903.
Pen on sticky paper varnished blue. 19.3 × 33.8 cm. (MAB 110.533)

968. Sketch for the decoration of a fireplace. Barcelona, 1903.
Pen on paper. 17 × 23 cm. (MAB 110.494)

969. Head of an old man. Barcelona or Paris, *c.* 1903.
Conté crayon on paper. 32.5 × 25 cm. (MAB 110.544, R)

970. Sketch for the decoration of a fireplace. Barcelona, 1903.
Pen on paper. 24.5 × 23.1 cm. (MAB 110.505)

971. Caricature of the artist. Barcelona or Paris, *c.* 1903.
Pen on paper, 11.8 × 10.7 cm. (MAB 110.440, A)

Index